"I recommend it to everyone, whether already a Simpsons fan or not. You'll be surprised at what wisdom lurks in these pages."

—TOM MORRIS,
author of *If Aristotle Ran General Motors*

"Fans of The Simpsons *are certain to find this book to be the perfect rebuttal for those who dismiss the show as a no-brainer."*

— PUBLISHERS WEEKLY

"Not only is The Simpsons and Philosophy *highly educational, it enhances the viewing and re-viewing of the Simpsons episodes, and sheds a new light on the series."*

— PROFESSOR PER BROMAN,
Butler University, Indianapolis

*"*The Simpsons and Philosophy *is a great place to begin any program in Simpsons studies. A serious look at a funny subject."*

— MARK I. PINSKY,
author of *The Gospel According to The Simpsons*

"The Simpsons and Philosophy *is a terrific book. Philosophers and non-philosophers come together to show that some very interesting philosophical issues arise from the characters, the thoughts, and the plots of* The Simpsons. *The essays are well written, many times provocative, reflective, intelligent without being elitist and, perhaps most valuable, a lot of fun to read. Not a* Simpsons *love-fest by any stretch (for example, could Bart be a Nietzschean hero or Heideggerian thinker?), this book is serious philosophy applied to a sometimes serious (and seriously funny) television show.*

"There are also papers devoted to more literary sorts of concerns, such as parody, allusion, and irony, with attempts to show how The Simpsons *can be compared with other forms of art, such as cinema. There are some splendid comparisons of* The Simpsons *with numerous other television series, for instance* Seinfeld, Leave It to Beaver, The Jack Benny Show, *and* MASH, *as well as films such as* Psycho, Pulp Fiction, Goodfellas, *and* The Picture of Dorian Gray.

"I recommend this book to anyone who's ever been caught off guard by an example of Homer being logically challenged, or Bart pulling a "dirty trick," or a poignant remark by Lisa. I recommend this book to anyone interested in using a provocative, and sometimes challenging text in an Introduction to Philosophy class.

"You can learn from this book (now hear Homer's and Bart's voices echoing), "but you don't have to if you don't want to."

———Professor Michael F. Goodman
Humboldt State University

Popular Culture and Philosophy
General Editor: William Irwin

VOLUME 1
Seinfeld and Philosophy: A Book about Everything and Nothing (2000)
Edited by William Irwin

VOLUME 2
The Simpsons and Philosophy: The D'oh! of Homer (2001)
Edited by William Irwin, Mark T. Conard, and Aeon J. Skoble

VOLUME 3
The Matrix and Philosophy: Welcome to the Desert of the Real (2002)
Edited by William Irwin

IN PREPARATION:

Buffy the Vampire Slayer and Philosophy (2003)
Edited by James B. South

The Lord of the Rings and Philosophy (2003)
Edited by Gregory Bassham and Eric Bronson

Woody Allen and Philosophy (2004)
Edited by Mark T. Conard and Aeon J. Skoble

The Simpsons
and Philosophy
The D'oh! of Homer

Edited by

WILLIAM IRWIN, MARK T. CONARD,
and AEON J. SKOBLE

OPEN COURT
Chicago and La Salle, Illinois

Volume 2 in the series, Popular Culture and Philosophy

To order books from Open Court, call toll free 1-800-815-2280.

Chapter 11 was originally published in *Political Theory* 27 (1999), pp. 734–749, and is reprinted here by permission of the author and Sage Publications, Inc.

Open Court Publishing Company is a division of Carus Publishing Company.

Fourteenth printing 2002
Fifteenth printing 2002
Sixteenth printing 2003
Seventeenth printing 2003
Eighteenth printing 2003
Nineteenth printing 2003

Printed and bound in the United States of America

Library of Congress Cataloging-in-Publication Data

The Simpsons and philosophy : the d'oh! of Homer / edited by William Irwin, Mark Conard, and Aeon Skoble.
 p. cm. — (Popular culture and philosophy ; v.2)
 Includes bibliographical references and index.
 ISBN 0-8126-9433-3 (alk. paper)
 1. Philosophy—Miscellanea. 2. Simpsons. (Television program) — Miscellanea. I. Irwin, William, 1970– II. Conard, Mark, 1965– III. Skoble, Aeon J. IV Series
 B68 .S55 2001
 100—dc21
 00-069897

Dedicated to
Lionel Hutz and Troy McClure
(whom you might remember
from such TV shows as *The Simpsons*)

Contents

Acknowledgments ix

Introduction: Meditations on Springfield? 1

Part I
The Characters 5

1. Homer and Aristotle
 RAJA HALWANI 7

2. Lisa and American Anti-intellectualism
 AEON J. SKOBLE 25

3. Why Maggie Matters: Sounds of Silence, East and West
 ERIC BRONSON 34

4. Marge's Moral Motivation
 GERALD J. ERION and JOSEPH A. ZECCARDI 46

5. Thus Spake Bart: On Nietzsche and the Virtues of
 Being Bad
 MARK T. CONARD 59

Part II
Simpsonian Themes 79

6. *The Simpsons* and Allusion: "Worst Essay Ever"
 WILLIAM IRWIN and J.R. LOMBARDO 81

7. Popular Parody: *The Simpsons* Meets the Crime Film
 DEBORAH KNIGHT 93

8. *The Simpsons,* Hyper-Irony, and the Meaning of Life
 CARL MATHESON 108

9. Simpsonian Sexual Politics
 DALE E. SNOW and JAMES J. SNOW 126

Part III
I Didn't Do It: Ethics and *The Simpsons*

145

10. The Moral World of the Simpson Family: A Kantian
 Perspective
 JAMES LAWLER 147

11. *The Simpsons:* Atomistic Politics and the Nuclear Family
 PAUL A. CANTOR 160

12. Springfield Hypocrisy
 JASON HOLT 179

13. Enjoying the so-called "Iced Cream": Mr. Burns, Satan,
 and Happiness
 DANIEL BARWICK 191

14. Hey-diddily-ho, Neighboreenos: Ned Flanders and
 Neighborly Love
 DAVID VESSEY 202

15. The Function of Fiction: The Heuristic Value of Homer
 JENNIFER L. MCMAHON 215

Part IV
The Simpsons and the Philosophers

233

16. A (Karl, not Groucho) Marxist in Springfield
 JAMES M. WALLACE 235

17. "And the Rest Writes Itself": Roland Barthes Watches
 The Simpsons
 DAVID L. G. ARNOLD 252

18. What Bart Calls Thinking
 KELLY DEAN JOLLEY 269

Episode List 283

Based on Ideas By 290

Featuring the Voices Of 296

Index 301

Acknowledgments

The writing, editing, and other miscellaneous tasks involved in producing *The Simpsons and Philosophy* amounted to a fun and stimulating experience. We would like to thank the contributors for keeping both a sense of professionalism and a sense of humor throughout the project. We would sincerely like to thank the good folks at Open Court, particularly David Ramsay Steele and Jennifer Asmuth for their advice and assistance. And, last but not least, we would like to thank our friends, colleagues, and students with whom we discussed *The Simpsons* and philosophy, who helped make the work possible, and who offered valuable feedback on the work in progress. A list such as this is almost inevitably incomplete, but among those to whom we are indebted are: Trisha Allen, Lisa Bahnemann, Anthony Hartle, Megan Lloyd, Jennifer O'Neill, and Peter Stromberg.

Introduction:
Meditations on Springfield?

How many philosophers does it take to write a book about *The Simpsons?* Apparently, about 20 to write it and 3 to edit. But that's not so bad, considering it takes 300 people 8 months, at a cost of 1.5 million dollars, to make a single episode of *The Simpsons*. Seriously, though, don't we have other work to do besides writing about TV shows? The short answer is yes, we do, but we enjoyed writing these essays, and we hope you'll enjoy reading them.

The seeds for this volume were sown a few years ago. When the popular comedy *Seinfeld* was going off the air, William Irwin had a quirky idea—a collection of philosophical essays on the "show about nothing." He and his philosopher pals enjoyed the show and engaged in many humorous and stimulating discussions about it, so why not share the fun in the form of a book? The people at Open Court had the vision, fortitude, and sense of humor to take on the project, and so Irwin found himself editing *Seinfeld and Philosophy: A Book about Everything and Nothing*. The book was a true success, not only among academics, but among the general public as well.

Another television show Irwin and his friends enjoyed and had discussed is *The Simpsons*. They appreciated its irony, its irreverence, and they realized that—like *Seinfeld*—it was a rich and fertile ground for philosophical investigation and discussion. So Irwin decided to put together a second volume, this one on *The Simpsons*, and he asked two of the contributors to the *Seinfeld* book, Mark Conard and Aeon Skoble, to co-edit the work. Once again, Open Court applauded the idea, and if you're reading this, you're obviously at least a little interested in either philosophy, *The Simpsons*, or both. The concept is the same: the show has enough intelligence and depth to warrant some philosophical discussion, and as a popular show, can also serve as a vehicle for exploring a variety of philosophical issues for a general audience.

The Simpsons is rich in satire. Without question it is one of the most intelligent and literate comedies on television today. (We know that's not saying much, but still . . .) It may seem incongruous to those who have dismissed it as a mere cartoon about an oaf and his family (and we've seen plenty of those) to say that the show is intelligent and literate, but attentive viewing reveals levels of comedy far beyond farce. We see layer upon layer of satire, double meanings, allusions to high as well as popular culture, sight gags, parody, and self-referential humor. In response to Homer's criticism of a cartoon that his kids are watching, Lisa replies, "If cartoons were meant for adults, they'd be on in prime time!" Despite Lisa's words, *The Simpsons* is clearly for adults, and it's superficial to dismiss the show merely because it is popular and animated.

Matt Groening studied philosophy in college, but none of the contributors to this book believes there is a deep underlying philosophy to Groening's cartoon. This is *not* "the philosophy of *The Simpsons*" or "*The Simpsons* as philosophy"; it's *The Simpsons and Philosophy*. We're not attempting to convey the intended meaning of Groening and the legion of writers and artists who work on the show. Rather, we're highlighting the philosophical significance of *The Simpsons* as we see it. Some of the essays in this book are the reflections of academics on a show they like and which they think says something about an aspect of philosophy. For example, Daniel Barwick looks to the miserly curmudgeon, Mr. Burns, to determine if we can learn something about the nature of happiness from Burns's unhappiness. Others explore the thought of a philosopher by making use of one of the characters. For instance, Mark Conard raises the question, Can Nietzsche's rejection of traditional morality justify Bart's bad behavior? Still others use the show as a vehicle for developing philosophical themes in a way that is accessible to the non-specialist (an intelligent person who has some interest in philosophical reflection but who doesn't make a living at it). For example, Jason Holt explores "Springfield Hypocrisy" to determine whether hypocrisy is always unethical.

This book is not an attempt to reduce philosophy to the lowest common denominator; we have no "dumbing-down" agenda. On the contrary, we hope to get our non-specialist readers to read more philosophy, the kind that doesn't involve

television shows. We also hope our colleagues who read these essays will find them both thought-provoking and entertaining.

Is it legitimate to write philosophical essays about popular culture? The standard response to that question is to point out that Sophocles and Shakespeare were popular culture in their day, and no one questions the validity of philosophical reflections on their work. But that won't do in the case of *The Simpsons*. (D'oh!) Making that response invites the misperception that we think *The Simpsons* is the equivalent of history's best works of literature, deeply profound in a way that illuminates the human condition as never before. We don't. But it nevertheless is just deep enough, and certainly funny enough, to warrant serious attention. Furthermore, its popularity means that we can use *The Simpsons* as a means of illustrating traditional philosophical issues to effectively reach readers outside the academy.

And please keep in mind that even though we are occasionally charged with impiety and executed, philosophers are people too. Don't have a cow, man.

The Characters

1
Homer and Aristotle

RAJA HALWANI

[M]en, though they look, fail to see what is well-being, what is the good in life.

— Aristotle, *Eudemian Ethics,* 1216a10

I can't live the button-down life like you. I want it all! The terrifying lows, the dizzying highs, the creamy middles! Sure, I might offend a few of the blue-noses with my cocky stride and musky odors—Oh, I'll never be the darling of the so-called "City Fathers" who cluck their tongues, stroke their beards, and talk about "What's to be done with this Homer Simpson?"

— Homer Simpson, "Lisa's Rival"

Homer Simpson does not fare well when evaluated morally. This is especially true if the focus is on his *character* rather than on his acts (although he does not exactly shine in the latter category either). Yet, somehow, there is something that is still ethically admirable about Homer. This raises the following puzzle: If Homer Simpson fares badly morally, in what ways is he admirable? Let's investigate this.

Aristotle's Character Types

Aristotle gave us a logical categorization of four types of char-
acter.[1] Roughly speaking, and putting aside the two extreme
types of the superhuman and the bestial characters, we have the
virtuous, the continent, the incontinent, and the vicious charac-
ter. To best understand each type, let's contrast them with one
another in terms of how each character manifests itself in
actions, decisions, and desires. Let's also consider one situation
as an example and see how each character would respond to it.

Suppose someone, let's call her "Lisa," were walking down
the street and found a wallet with a substantial amount of
money in it. Now if Lisa were virtuous, she would not only
make the decision to turn in the wallet to the proper authorities,
she would *gladly* do so. Lisa's desires would be in accordance
with her right decision and action. Consider now Lenny, who is
continent: if Lenny were to find the wallet, he would be able to
make the right decision—to return the wallet intact—and he
would be able to act on his decision to do so, but he would
have to go against his desires to not do so. This is the mark of
the continent person: he has to struggle against his desires to be
able do the right thing.

With the incontinent and the vicious types, things get worse.
The incontinent person is able to reach the right decision about
what to do but would suffer from weakness of will. In the wal-
let case, and supposing Bart is our incontinent character, he
would succumb to his desire to keep the wallet and so fail to
act properly, even though he knows that keeping it is wrong.
With the vicious person, there is no struggle against one's
desires and there is no weakness of will. The reason, however,
is that the vicious person's decision is morally wrong, and his
desires are fully co-operative with it. If Nelson were vicious, he
would decide to keep the money (and either throw away the
rest of the wallet, or return it but lie about its original contents),

[1] My remarks on Aristotle are primarily derived from his *Nichomachean Ethics,*
Books I, II, V, and VIII, translated by Terence Irwin (Indianapolis: Hackett,
1985) and his *Politics* (translated by B. Jowett, in Jonathan Barnes (ed.), *The
Complete Works of Aristotle,* volume 2 (Princeton: Princeton University Press,
1984). Specific references are in the body of the paper. Needless to say, much
of what I say on Aristotle is subject to debate.

would fully desire to do so, and would actually do so.

Let's take a closer look at what it is that constitutes a virtuous character. A virtuous person is one who has and exercises the virtues. The virtues, moreover, are states (or traits) of character that dispose their possessor to act in the right ways and to react emotionally in the right ways also. Given this, we see why Aristotle insisted that the virtues are states of character concerned with both action and feeling (*Ethics*, Book II, especially 1106b15–35). For example, if one has the virtue of benevolence, then one will be disposed to be charitable to the right people under the right circumstances. One would not give money to just anyone who asked for it. The virtuous person must perceive that his recipient is in need of the money, and that he will use it properly. Furthermore, the virtuous person's emotional reaction is appropriate to the situation. This means that the benevolent person in our example would give the money gladly, not regret giving it, and would be moved to give it by the plight of his recipient. By contrast, a continent person would not easily part with his money, and this is so not because he needs it and cannot spare it, but because he is disposed to be greedy, or to over-estimate how much he might need the money in the future.

But notice that, given the above account, reason has a crucial role to play. For, if to be virtuous one needs to have perceptive abilities regarding the situations one is faced with, then the virtuous person cannot be stupid or naive. He must have critical reasoning abilities that would allow him to notice differences in situations and so be able to respond accordingly. Indeed, this is one reason why Aristotle emphasized the idea that the subject-matter of ethics does not admit of rigorous precision (*Ethics*, 1094b13–19). The role of practical reason (*phronesis*) is something that Aristotle insisted upon: if one were virtuous by, so to speak, impulse, one would not possess "full" virtue but at most "natural" virtue (*Ethics*, 1144b3–15), and to possess natural virtue is to be inclined to do the right thing by accident, to put it loosely.[2]

[2] One must resist the temptation to think that the vicious person also has practical wisdom. The vicious person, according to Aristotle, does not have *phronesis*; rather, he has cleverness. To Aristotle, practical reason has norma-

If we now bring in Aristotle's conditions for right action, we will be in a position to round out our account. Aristotle states, "First [the agent] must know that he is doing virtuous actions; second, he must decide on them, and decide on them for themselves; and, third, he must also do them from a firm and unchanging character" (*Ethics*, 1105a30–1105b). Briefly, what Aristotle had in mind here is the following. First, the agent must, when acting virtuously know that his action is virtuous; he acts under the description that "such-and-such an action is just (or generous, or honest)." The second condition seems to embody two, and not one, conditions. The agent must act voluntarily, and he must do so because the action is virtuous. So even if one were to act under the description that "this action is fair," one's action would not be virtuous unless one also acted because the action is fair. The third stated condition is crucial, and it brings us to the start of this discussion: a virtuous person acts virtuously not only when the action is fair and because it is so, but he acts virtuously because *he* is a *fair person*. He is the type of person who is disposed to behave morally correctly when the situation requires it. This is (part of) what it means to have a "firm and unchanging" character.

Homer's Character: D'oh!, D'oh!, and Double D'oh!

Given Aristotle's account of virtue, things look quite dim for Homer Simpson (and I will not later rescind this judgment; so don't expect some ingenious distinction that will overhaul this claim). Consider, as a start, the virtue of temperance (moderation) which, basically though somewhat contentiously, covers the ability to moderate our bodily appetites. It does not require astute observation to realize that Homer is far from being a temperate man. Not only is he not virtuous with respect to his bodily appetites, but he is quite vicious. This is particularly true with regard to Homer's consumption of food and drink, rather than sexual activity. His desires impel him to constantly gorge him-

tive force and does not just play a means-end role. *Phronesis* allows us to know what things are important and ethical in life. That is why Aristotle says repeatedly that what is right is what appears to be so to the virtuous agent (see for example *Ethics* 1176a16–19).

self, and he succumbs willingly to these desires. For instance, in "Homer's Enemy,"[3] he wholeheartedly ate half of a sandwich that belonged to his temporary co-worker Frank Grimes—or "Grimey"—even though the sandwich bag was clearly marked to the effect that it belonged to the latter. Still worse, even after Grimes pointed this out to him, Homer managed to take two extra bites out of the sandwich before putting it back in the bag. Homer's desire for food also leads him to create some interesting recipes. Witness, for example, his wrapping a half-cooked waffle around a whole stick of butter and, of course, eating it ("Homer the Heretic"). Homer's health *was* jeopardized by bad eating habits, to the point where he had to undergo a bypass operation ("Homer's Triple Bypass"), but he has not relented. Indeed, even when enduring immediate and obvious physical pain, Homer does not relent. Witness his eating bad meat at the Kwik-E-Mart, getting sick, and being rushed to the hospital. Instead of pursuing his complaint against Apu, he was immediately appeased ("Woo-hoo!") by Apu's offer of ten free pounds of rancid shrimp. Homer knew that the shrimp smelled "funny," ate it anyway, and was then rushed again to the hospital ("Homer and Apu"). Homer's gluttony is so much a part of his character, that he consumes food even while half-asleep. In "Rosebud," Homer, half asleep, walks into the kitchen, opens the door of the fridge, comments, "Mmm . . . 64 slices of American cheese," and proceeds to eat them for the duration of the night. The point about Homer's intemperance needs no further explanation; his name has come to be synonymous with his love of food and (Duff) beer.

Homer is also a habitual liar; he lacks honesty. In "Duffless," he lied to his family about his plans for the day, telling them that he was going to work when he was actually planning to go take the Duff Brewery tour. To catalogue some of Homer's other fibs: He lied to Marge about the fact that he never graduated from high school ("The Front"), he lied to her about his financial losses in investments ("Homer vs. Patty and Selma"), and he

[3] See the Episode Guide at the end of this book for an ordered list of the episodes. Many of the quotations and all of the episode titles in my paper are from *The Simpsons: A Complete Guide to Our Favorite Family*, edited by Ray Richmond (New York: Harper Collins, 1997), and *The Simpsons Forever*, edited by Scott M. Gimple (New York: Harper Collins, 1999).

consistently lied to Marge about getting rid of the gun he bought ("The Cartridge Family"). Homer also once involved Apu in a large web of lies to the latter's mother, telling her that he was already married to Marge, thus also forcing Marge to go along with the scheme ("The Two Mrs. Nahasapeemapetilons").

Homer also lacks sensitivity to the needs and claims of others; he seems to lack both benevolence and justice. In "When Flanders Failed," he continuously pushed Ned Flanders to sell him his furniture for dirt-cheap prices, even though he knew that Ned was broke and desperately needed money. In "Bart the Lover," he advised Bart, in his alias as Woodrow (Mrs. Krabappel's secret pen-lover), to break up with Mrs. Krabappel by writing her a note saying, "Dear Baby, Welcome to Dumpsville. Population: you" (he prefaces this by saying to Bart that sensitive love letters are his specialty). He's not inclined towards generosity, either; he once said to Bart, "You gave both dogs away? You know how I feel about giving!" ("The Canine Mutiny"). And Homer decided not to vote guilty on Freddy Quimby's assault charges, not because he thought that Quimby was innocent, but because he realized that if he did so, the jury would be deadlocked and he would get to stay for free at the Springfield Palace Hotel ("The Boy Who Knew Too Much").

Homer has a number of buddies, but he does not have friends. Aristotle emphasized the importance of friendship due to his beliefs that without friends we cannot exercise virtue and that without friends we cannot lead full, flourishing lives. Homer does not have a single genuine friend. At most he has drinking buddies (Barney, Lenny, and Carl), but he has no one with whom he shares his goals, activities, joys, and sorrows.[4] Indeed, it is something of a problem even to claim that Homer has goals and activities, other than drinking, that is.

Homer's marital and parenting skills also leave much to be desired (Aristotle seemed to have included spouses and children within the purview of friendship; see *Ethics* 1158b9–16). Let's consider some of Homer's blunders. He tried to win Lisa's love

[4] Marge might be thought to fit this description, given Homer's conclusion that she is his soul mate ("The Mysterious Voyage of Homer"), but most other episodes of the show actually indicate how much the two diverge in terms of their goals, interests, and activities.

by buying her a pony ("Lisa's Pony"). He resented Bart for getting a "Bigger Brother" and so became a Bigger Brother himself to Pepi (whom he called "Pepsi") ("Brother from the Same Planet"). He sent Bart to work at a burlesque salon as a form of punishment ("Bart After Dark"). Homer fueled the fire of sibling rivalry when Lisa found out she had a knack for ice hockey: "This Friday Lisa's team is playing Bart's team. You're in direct competition. And don't go easy on each other just because you're brother and sister. I want to see you both fighting for your parents' love" ("Lisa on Ice"). Let's not forget his numerous throttlings of Bart, preceded by, "Why you little . . . !" (although once, in "Mother Simpson," it was, "I'll Kwanza you . . . !"). Last, but certainly not least, Homer continuously forgets that Maggie exists.[5]

Homer's marital skills are no better. He's either unsupportive of or indifferent to Marge's projects; he professed as much to Marge in "A Streetcar Named Marge." His refusal to go to artistic shows and exhibits once led Marge to seek the companionship of Ruth Powers; their friendship landed both women in a police chase *à la Thelma and Louise*. Homer did apologize to Marge, but his apology is quite revealing: "Look, Marge, I'm sorry I haven't been a better husband, I'm sorry about the time I tried to make gravy in the bathtub, I'm sorry I used your wedding dress to wax the car, and I'm sorry—oh well, let's just say I'm sorry for the whole marriage up to this point" ("Marge on the Lam"). In "Secrets of a Successful Marriage," Homer reached a new peak. He realized what it was that he could uniquely offer Marge, and that is "complete and utter dependency." Indeed, even when he tries to be supportive, he ends up bungling things: Homer once tried to help Marge's pretzel business by going to the Springfield mafia for help, thus landing Marge in the position of having to deal with Fat Tony and his cohorts ("The Twisted World of Marge Simpson").

Furthermore, any hope for Homer that he might acquire the moral virtues would be dashed by the recognition that he lacks the one intellectual virtue necessary for an ethical character, namely, that of practical wisdom *(phronesis)*. *Phronesis* is not theoretical knowledge, although Homer certainly lacks this, too.

[5] See Chapter 3 of this volume.

Nor is it the knowledge of facts, although Homer certainly lacks this as well. Practical wisdom is the ability to steer one's way through the world intelligently, morally, and in a goal-oriented way. A few examples will suffice. First, Homer subscribes to some highly dubious nuggets of wisdom. In "There's No Disgrace Like Home," he states, "When will I learn? The answers to life's problems aren't at the bottom of a bottle. They're on TV!" And—while on the topic of bottles—he once famously toasted, "To alcohol! The cause of—and solution to—all of life's problems" ("Homer vs. the Eighteenth Amendment"). In "The Otto Show," he told Bart that "If something's hard to do, then it's not worth doing." And in "Realty Bites," he told Marge that "Trying is the first step towards failure."

Second, Homer seems to lack minimal powers of inference. He once inferred that Timmy O'Toole (the fictitious boy whom Bart claimed fell down a well) was a real hero from the mere "fact" that he had fallen down a well and couldn't get out ("Radio Bart"). He once inferred that Mayor Quimby's policy of having a Bear Patrol was successful from the mere fact that there were no bears roaming the streets of Springfield! When Lisa pointed out that his reasoning was specious, he thought she was complimenting him ("Much Apu About Nothing"). Homer once reasoned against Lisa's claim that stealing cable is wrong by "arguing" that Lisa is a thief, given that she herself does not pay for her meals at home and for the clothes she wears ("Homer vs. Lisa and the 8th Commandment").

Third, Homer lacks one of the most crucial aspects of practical reasoning: the ability to organize one's life around important and worthy goals, and to pursue them responsibly and morally. He does have many life-long dreams, such as becoming a monorail conductor ("Marge vs. the Monorail") and owning the Dallas Cowboys ("You Only Move Twice"), but dreams are not goals, and Homer does not have any of the latter. In any event, he certainly does not have any goals that are worthy of pursuit. He seems to be content with being an incompetent safety inspector, working in sector 7G in Burns's power plant, watching some of his underlings being promoted ahead of him. Indeed, he was willing ("King-Size Homer") to fatten himself so that he could be on disability and work from home. If Homer has one goal in life, it is that of the worthless life of eating, drinking, and being lazy. Add to all of this Homer's supreme

gullibility (just consider how many times Bart is able to con him), and you emerge with someone having minimal reasoning capacities.

Homer's Character: The Glimmer of a Few Woo-hoos

We should not, however, be too hard on Homer, for he does sometimes act admirably. Paradoxically, for example, even though he forgets that Maggie exists, his work station is covered with pictures of her, pictures which he himself hung up out of love for her ("And Maggie Makes Three"). Homer has also never knowingly committed adultery, even though he could have on a few occasions ("Colonel Homer" and "The Last Temptation of Homer").[6] Also, he is often affectionate and loving towards Marge: he re-married her (after divorcing her) in order to make up for their original, "crummy" wedding ("A Milhouse Divided"). Homer also has some success bonding with Lisa. Consider the following: his support of her plan to unveil the web of lies surrounding Jebediah Springfield's origins ("Lisa the Iconclast"), supporting her confidence by entering her in the Little Miss Springfield Pageant ("Lisa the Beauty Queen"), twice sacrificing buying an air conditioner so as to get her a saxophone—twice ("Lisa's Sax"), and taking her stealthily into the Springsonian Museum so that she can finally get to see the "Treasures of Isis" exhibit ("Lost Our Lisa").

On occasion Homer exhibits courage. Consider the following: he lashed out at Mr. Burns for demanding too much of him ("Homer the Smithers") and for not remembering his name ("Who Shot Mr. Burns?"), and he pummeled George Bush (his real reasons for doing so are not clear; they're not because of party allegiances, since he befriends Gerald Ford who is also a Republican) ("Two Bad Neighbors"). Homer also exhibits acts of kindness, even for people he usually hates. In "When Flanders Failed," he helped Ned by boosting sales at the latter's Leftorium; in "Homer Loves Flanders," he stood up for Ned in

[6] I say "knowingly" because in "Viva Ned Flanders" Homer wakes up in a hotel in Las Vegas to discover that he had, during the drunkenness of the past evening, married a cocktail waitress, and it is left unclear whether he actually had sex with her.

church (". . . this man has turned every cheek on his body"); and in "Homer vs. Patty and Selma," he pretended that he was the one smoking so that Patty and Selma would not get fired for smoking at their workplace.

Homer sometimes even displays intelligence and theoretical wisdom. As examples of the former, he concocted an elaborate scheme to bring bootleg alcohol to Springfield and became the famous "Beer Baron" ("Homer vs. the Eighteenth Amendment"), and he devised a scheme to make money off of the skeleton of an "angel" ("Lisa the Skeptic"). As an example of the latter, Homer displayed rare insights on the nature of religion by deciding to stop going to church, since—as he reasoned—God is everywhere. He even cited, though without remembering his name, Jesus as someone who went against orthodox practices and yet was right to do so ("Homer the Heretic"). Homer even displays rare moments in which he seems to know his own lim-itations. He once asked Marge, "You're here to see me, right?" when she showed up at the plant, thus revealing his belief that since he was a man of humble properties, he needed to make sure that Marge was there to see *him* ("Life on the Fast Lane"). And he double—and triple—checked Lurleen Lumpkin's flirting with him to make sure that she really was sexually interested in him ("Colonel Homer").

Assessment: Judging Homer

What are we to make of all of this? How exactly does Homer stand up to ethical evaluation? Homer is not an evil person. While he is not a paradigm of virtue, he certainly is not mali-cious. The harshest reaction we can have towards him is pity. There are at least two reasons for this. The first reason is that Homer's upbringing leaves much to be desired. To begin with, he grew up mostly in Springfield, a town whose inhabitants— with the rare exception of Lisa—have serious and severe char-acter flaws, ranging from stupidity to malice, to being simply incompetent and clueless in the ways of the world (even Marge, who is a good candidate for being another exception to the inhabitants of Springfield, is very conventional and often lacks critical abilities[7]). Consider that even when the members of the

[7] For an Aristotelian view of Marge's character, see Chapter 4 of this volume.

Springfield chapter of Mensa governed the town (after Mayor Quimby fled), they managed to propose unfair, restrictive, and highly idealistic rules. Needless to say, chaos ensued ("They Saved Lisa's Brain").[8]

The effect of being raised in such an environment could be detrimental to one's future character formation and intellectual abilities. Furthermore, being raised in a healthy environment is one of the main claims that grounds Aristotle's project in the *Politics*: "Our purpose is to consider what form of political community is best of all for those who are most able to realize their ideal of life" (1260b25). Indeed, Aristotle's *Ethics* is also aimed at the statesman who is to think of what the best ethical character is, so as to design a political community able to produce such a character. If this is correct, then one reason why we tend to pity Homer is because we think that this aspect of his upbringing, namely, Springfield, is beyond his control.

In addition, Homer's rearing at home leaves much to be desired. His mother left him when he was young, and his father never encouraged him to become anything of worth; when Homer did have some aspirations, his father shot them down ("Mother Simpson" and "Bart Star"). Moreover, one quality about Homer that he *certainly* could not control is the Simpson gene, which apparently causes a Simpson to grow more stupid as he ages. It "is defective only on the Y-chromosome" and not on the X one, and that is why Lisa and other Simpson women have been smart and successful ("Lisa the Simpson"). If so, then there is little that Homer could do to better himself. And these factors explain why we tend to look at Homer with pity rather than with disdain or hatred.

The second reason why our judgment of Homer's character is not harsh, even though he is not virtuous, is that he is not generally a malicious person. He is selfish, he is a glutton, he is greedy, and he can be quite dumb, but he is rarely one of those people who are envious of others and who wish them ill-will. It is true that he often acts with deliberate intent to harm some people, but we think that these people somehow are not worthy of better treatment. The scorn, for example, which Homer heaps on Selma and Patty seems to be appropriate, given the

[8] For the vices of Springfield, see Chapter 12 of this volume.

way they treat him and given their scornful attitude towards him. Homer also dislikes (though he also fears) Mr. Burns. And whatever else can be said about Burns, he is the paradigm case of a greedy, evil, and ruthless capitalist who is willing to walk on a path of corpses to attain his ends.[9] Lastly, Homer treats Flanders in indecent ways, ranging from indifference to disdain. But then again, Flanders is an over-bearing, naive, ever-preaching person.[10] This is not to say that Homer's treatment of him is justified, but it is to say that it is understandable. With these exceptions in mind, Homer is generally not an evil person and he does not treat people with malice. This is another reason why, though he falls short of having an ethical character, Homer does not provoke negative reactions in us.

We can, then, make a qualified judgment to the effect that Homer is not a vicious person in the sense of being ruled by vice. I say "qualified" because there is one exception to this judgment: when it comes to bodily appetites for food and drink, Homer is vicious. He does not take pleasure in eating and drinking moderately, and this rules out virtue in this domain. He rarely, if ever, has the belief to the effect that he should refrain from excessive eating and drinking, and this rules out continence and incontinence. In addition, he does not seem to think there's anything wrong (other than occasional immediate health considerations) with indulging in food and drink, even in inappropriate venues; thus he once said to Marge, "If God didn't want us to eat in church, He would've made gluttony a sin" ("King of the Hill"). These considerations should allow us to safely conclude that Homer exhibits vice in the domain of bodily appetites for food and drink.

Given the abundance of evidence and examples, we can arrive at the following judgment: Homer is not a virtuous person. A number of factors allow us to reach this conclusion, but perhaps the most salient one is that Homer does not have the *stability* of character that marks the virtuous person. One simply cannot count on him to do the right thing, not even with respect to actions towards his family members. Furthermore, the judgment that Homer is not virtuous is, unlike the one that he is not

[9] And he'll never be happy either. See Chapter 13 of this volume.
[10] On Flanders's character, see Chapter 14 of this volume.

vicious, not qualified. For even though Homer sometimes acts correctly, his reasons for doing so are usually skewed, or at best ambiguous (his acts of courage are a prime example of this). And, as far as his family is concerned, even when Homer does what we think a good father or husband would do, there are simply too many examples which illustrate otherwise. Homer simply lacks the kind of stable character that is necessary for being virtuous.

We must also remember that in many of the cases in which Homer does do the right thing, especially as far as his family is concerned, he has to struggle against his desires to not do otherwise. Both times when he bought Lisa her saxophones, he had to struggle against his desire to buy an air-conditioner ("Lisa's Sax"). Sometimes, despite his knowledge of what ought to be done, he chooses to do the wrong thing, thus exhibiting what the Greeks called *akrasia*, or "weakness of will." For example, in "The War of the Simpsons," he chooses to go fishing during his retreat at Catfish Lake even though he knew that his attention should be focused on Marge and on their marriage.

Homer is not a virtuous person. He exhibits vice when it comes to appetites for food and drink, and as for the other spheres of life, he shuttles back and forth between continence and incontinence. This, of course, does not show that Aristotle's division of character types was too tidy or unrealistic or simplistic, because Aristotle's division was a *logical* one, not a description of what types of people there *actually* are. Homer instantiates different character types, depending on the area of life with respect to which the question is raised.

Conclusion: The Importance of Being Homer

At the beginning of this essay, I claimed that there is something ethically admirable about Homer Simpson. But this claim poses a problem: How can it be true if Homer is not virtuous? For if the paradigm of an ethically admirable character is being virtuous, and if Homer falls short of this standard, then the claim that he is ethically admirable seems patently false. Furthermore, even if we do not think that Homer is malicious, and even if we think that his character formation was—at least mostly—beyond his

control, these factors are not enough to make him ethically admirable. For this last claim to be at least plausible, something else must be at work. And this something else cannot be the fact that Homer sometimes does the right thing, because the claim is about *him*, his character, and not about a subset of his actions.

In "Scenes from the Class Struggle in Springfield," Marge realizes her error in trying to pressure her family to conform to an elitist social circle she has recently joined. In accepting her family members for who they are, she enumerates the qualities that she likes about them (she couldn't, though, find one for Bart). The quality she mentions of Homer is his "in-your-face humanity," and this quality, if understood broadly enough, is not only true of him, but also goes a long way in explaining in what ways he is ethically admirable.

This quality does not just encompass those traits that lead Homer to do things in public that many of us would, to different degrees, shy away from doing, such as belching, releasing flatulence, scratching our behinds, and eating and drinking to the point of losing our senses. If it were just that, Homer would simply be a boor. Rather, it covers Homer's love and enjoyment of life, in its most basic elements, while at the same time not giving much, if any, attention to what people think. Homer generally does not care about etiquette or about what people think of him. He is set on enjoying life—or his version of it—to the fullest. This zest for life is not calculated on his part, nor is he even necessarily conscious of it. But it manifests itself in his actions, in his attitudes, in his lack of malice, and in his childlike (maybe even childish) behavior, and, indeed, it can be found in most of the examples cited in this essay. When we add to this the fact that Homer is a struggling, "upper-lower-middle-class" citizen, working in a factory under the tyranny of a ruthless capitalist, and when we also add the fact that Homer lives in Springfield, a town which should make one stop and think before one decides that life is worth being loved, we arrive at a person who has much to be admired.

This quality that explains Homer's admirability—let's call it "love of life," following Ned Flanders's labeling of it as Homer's "intoxicating lust for life" ("Viva Ned Flanders")—is not a virtue as such. This is so not because it does not appear on Aristotle's list, but because, as we well know, such a quality, if unharnessed, can be dangerous both to others and to its possessor

(as, I think, it is in Homer's case). Much like ambition, it is a positive quality, and an admirable one at that. It is also an ethical quality. It enhances, if properly possessed, the life of the person who has it by making his life more pleasurable, and it makes the rest of us want to be in this person's company, not just so that some of it may rub off on us, but also because it is simply pleasurable to be around such people. If those qualities which contribute to a person's happiness and overall flourishing are plausibly construed as ethical, then a quality such as love of life would fit this bill, if used and regulated by practical reason. In Homer's case, the quality does not come harnessed by reason and it does come with other traits that make its possession dangerous. But we nevertheless do admire Homer for having it, and for having it against all of his odds.[11]

In addition, this quality, and especially because it comes unharnessed in Homer, leads him to be bluntly honest about his desires and his wants—even to a fault. Where others scheme and connive while also pretending to be socially conformist, Homer is open, honest, and even blunt about who he is, what he wants, and what he thinks of others. He knows his limitations, he loves his family—in his own morally attenuated ways—and he is an in-your-face type of person.

However, I do not wish to be misunderstood. I am not arguing that Homer is, as such, an admirable person, but only that he has an admirable trait. It is tempting to slide from the latter claim to the former one, because, first, while Homer is not virtuous, he is also neither malicious nor, except for bodily appetites, vicious; second, the fact that Homer loves life despite his financially and economically modest means, and despite his growing up and living in a town such as Springfield (which is not conducive to a good life), might make us think that he is admirable for retaining his love of life in the face of these difficult situations. But the temptation must be resisted, and this is so for three reasons.

[11] The odds here include being of moderate intellectual and financial means and of living among the inhabitants of Springfield. We should keep in mind also that we might admire Homer's character for other reasons. It is, most obviously, quite humorous. We might also admire him because we see an exaggerated sense of who we—or some of us—are in him.

First, and as I already emphasized, the quality of love of life in Homer's case is unregulated by reason, and this could make having it morally dangerous. Second, enjoying life is not the same as living a flourishing one. A person could indeed enjoy life to the fullest yet not lead a flourishing life. Think of someone who is fully happy spending his life counting blades of grass or collecting bottle-caps, yet who is capable of pursuing worthier goals. No matter how happy that person is, no matter how much *he* is enjoying his life, we surely do not want to say of his life that it is well-lived. Given the examples mentioned in the third section above, Homer is clearly capable of living a better life than the one he leads. Third, there is a logical reason: having an admirable trait does not, as such, entail that its possessor is admirable. Villains often have the trait of overcoming fear in the face of risk, and while this trait is admirable, we do not usually think of villains as admirable. Indeed, that is why we sometimes say of a ruthless person, "Well, at least he's being consistent," thus recognizing consistency as an admirable trait while also recognizing that it is not sufficient to make its possessor an admirable *person.*

Furthermore, a moment's reflection should tell us that Homer is, indeed, not an admirable person as such. He is not virtuous, and this fact alone is enough to undermine any serious attempt to ascribe admirability to him as an overall judgment. However, sometimes non-virtuous people are nevertheless called admirable if they compensate for their lack of virtue, by, for example, giving the world artistic masterpieces. The traditional example given in this regard is of the artist Gauguin, who left his family to fend for itself while he pursued making art in Tahiti. Such extenuating factors, however, do not apply to Homer: What *lasting* contribution has he given the world by way of compensating for his lack of virtue so as to deserve the description "admirable"?

But Homer's love of life is nevertheless a highly admirable trait, and this conclusion is not trivial, for many people are tempted to see in Homer nothing but buffoonery and immorality. Moreover, Homer's love of life stands out as an important quality *especially* in our age, an age in which political correctness, over-politeness, lack of willingness to judge others, inflated obsession with physical health, and pessimism about what is good and enjoyable about life reign more or less

supreme. In this age, Homer Simpson—whose bumper sticker says "Single 'n' Sassy"—shines as someone who flouts these "truths." He is not politically correct, he is more than happy to judge others, and he certainly does not seem to be obsessed with his health. These qualities might not make Homer an admirable *person*, but they do make him admirable in some ways, and, more importantly, make us crave him and the Homer Simpsons of this world.[12]

[12] I wish to thank the following: the editors of this volume for very helpful comments, especially Bill Irwin for also giving me constant support and encouragement; Steve Jones for engaging me in excellent conversations about Homer Simpson and for tolerating (and sometimes enjoying) my constant use of Homeric quotes in my regular speech; my brilliant students at the School of the Art Institute of Chicago for discussing the topic of this paper with me on numerous occasions (involving much intemperate indulgence in food and drink), for using examples from *The Simpsons* show in their philosophy papers, and for their infectious joy at simply knowing that I was writing this paper: Annika Connor, Ted Dumitrescu, Christopher Koch, Cory Poole, Sara Puzey, Austin Stewart, and Dahlia Tulett (this paper is dedicated to them).

2

Lisa and American Anti-intellectualism

AEON J. SKOBLE

American society has generally had a love-hate relationship with the notion of the intellectual. On the one hand, there is a sense of respect for the professor or the scientist, but at the same time there is great resentment of the "ivory tower" or the "bookish"; a defensiveness about intelligent or learned people. The republican ideals of the Founders presuppose an enlightened citizenry, yet today, the introduction of even remotely sophisticated analysis of political topics is decried as "elitism." Everyone respects a historian, yet a historian's opinion may be disregarded on the grounds that it is "no more valid" than that of the "working man." Populist commentators and politicians frequently exploit this resentment of expertise while relying on it as it suits them, for example when a candidate attacks his opponent for being an "Ivy League elitist" while in fact being a product of (or relying on advisers from) a similar educational background.

Similarly, a hospital may consult a bioethicist, or it may reject the counsel of bioethicists, on the grounds that they are too abstract and unconnected to the realities of medicine. Indeed, it seems as though most people like being able to support their positions by citing experts, but then invoke populist sentiment when the experts don't support their view. For instance, I may lend support to my argument by citing an expert who agrees with me, but if an expert disagrees, I may respond "what does he know?" or "I'm entitled to my opinion too." Oddly, we see

anti-intellectualism even among intellectuals. For example, at many universities today, both among the student body and the faculty, the role of the classics, and humanities generally, has been greatly diminished. The trend has clearly been to develop pre-professional programs and emphasize "relevance"; whereas traditional humanities classes are regarded as a luxury or an enhancement, but not truly necessary features of a college education. At best they are seen as vehicles for developing "transferable skills" such as composition or critical thinking.

There seem to be periodic pendulum swings: in the 1950s and early 1960s, there was tremendous respect for scientists, as the nation found itself competing against the Soviets in such areas as space exploration. Today, it seems the pendulum has reversed swing, as the current *Zeitgeist* holds all opinions to be equally valid. But at the same time, people still seem interested in what alleged experts have to say. A cursory review of TV talk shows or newspaper letters-to-the-editor reveals this ambivalence. The talk show will book an expert because, presumably, people will be interested in that person's analysis or opinion. But the panelists or audience members who disagree with the expert will argue that their opinions, their perspectives, are just as worthwhile. A newspaper will run an opinion column by a specialist, whose analysis on a situation may be better informed than the average person's, but the letters from people who disagree will often be based on the underlying (if unstated) premise that "No one really knows anything" or "It's all a matter of opinion, and mine counts too." This last rationale is particularly insidious: in fact, if it were true that everything were merely a matter of opinion, then it actually would follow that mine is as relevant as the expert's; indeed there would be no such thing as expertise.

So, it is fair to say that American society is conflicted about intellectuals. Respect for them seems virtually to go hand in hand with resentment. This is a puzzling social problem, and also one of great importance, for we seem to be on the verge of a new "dark ages," where not only the notion of expertise, but all standards of rationality are being challenged. This clearly has significant social consequences. As a vehicle for exploring this issue, it may be surprising to choose a TV show which, at first glance, seems devoted to the idea that dumber is better; but actually, of the many things that *The Simpsons* skillfully

illustrates about society, the American ambivalence about expertise and rationality is clearly one of them.[1]

On *The Simpsons,* Homer is a classic example of an anti-intellectual dolt, as are most of his acquaintances, and his son. But his daughter, Lisa, is not only pro-intellectual, she is smart beyond her years. She is extremely intelligent and sophisticated, and is often seen out-thinking those around her. Naturally, for this she is mocked by the other children at school and generally ignored by the adults. On the other hand, her favorite TV show is the same one as her brother's: a mindlessly violent cartoon. Her treatment on the show, I argue, captures the love-hate relationship American society has with intellectuals.[2] Before turning to the ways in which it does this, let's have a closer look at the problem.

Fallacious Authority and Real Expertise

It is a staple of introductory logic courses that it is a fallacy to "appeal to authority," yet people typically make more out of this than is appropriate. Strictly in terms of logic, it's always a mistake to argue that a proposition is true because so-and-so says it is, but appeals to authority are more commonly used to show that we have good reason to believe the proposition, as opposed to being proof of its truth. Like all fallacies involving relevance, the problem with most appeals to authority is that they are invoking the authority in an irrelevant way. For example, in matters which really are subjective, such as which pizza or soft drink I should buy, invoking anyone else is irrelevant,

[1] Is it anti-intellectual for a Ph.D. in philosophy to write an essay about a TV show? As we argued in the Introduction, not necessarily: it depends on whether or not the show can illuminate some philosophical problem, or serve as an accessible example when explaining a point. If we wanted to adopt an anti-intellectual approach, we could argue that all one needs to know about life can be learned from watching TV, but that's clearly not what we are saying; indeed, we're trying to use people's interest in the show as a way to get them to read more philosophy.

[2] Intellectuals and experts are not the same thing, of course: many intellectuals are not experts in anything. But I suspect that the antipathy towards both is similarly rooted, and that the distinction is lost on those who would be inclined to reject or scorn both.

since I may not have the same tastes.[3] In other cases, the error is in assuming that because a person is an authority about one thing, that person's expertise should carry the day in all areas. We see this in celebrity endorsements for products unrelated to that person's field. For example, Troy McClure endorsing Duff Beer would not constitute a valid appeal to authority, since being an actor doesn't make one an expert on beer. (And experience is not the same as expertise: Barney is not an expert on beer either.) In other cases, the appeal is fallacious on the grounds that some matters cannot be settled by appeal to experts, not because they are subjective, but because they are unknowable, for instance the future of scientific progress. The classic example here is Einstein's claim in 1932 that "there is not the slightest indication that [nuclear] energy will ever be obtainable."[4]

But after building up all this skepticism about appeals to authority, it's worth remembering that some people actually do know more about some things than other people, and in many cases, the fact that an authority on a subject tells us something really is a good reason to believe it. For example, since I have no first-hand knowledge of the Battle of Marathon, I am going to have to rely on what other people tell me, and a classical historian is precisely the sort of person I should go to, whereas a physician probably is not.[5]

Often what people resent is the application of wisdom, especially to moral or social ideals. People may argue that yes, there is such a thing as being an expert on the Greco-Persian Wars, but that doesn't mean that person can inform our discussion about world politics today.[6] You may be an expert on Aristotle's

[3] This is not to address the arguments concerning whether or not there can be objective criteria for judging food, but simply to distinguish between the way in which Smith's preference for chocolate over vanilla is really different from Jones's preference for murder over counseling.

[4] Quoted in Christopher Cerf and Victor Navasky, *The Experts Speak* (New York: Pantheon Books, 1984), p. 215.

[5] Of course, there are the odd cases where the physician in question is, say, as a hobby, also an expert on the Battle of Marathon, but I am speaking here of the physician qua physician.

[6] In case you're wondering, see Peter Green's *The Greco-Persian Wars* (Berkeley: University of California Press, 1996).

moral theory, but that doesn't mean you can tell me how I should live. This sort of resistance to expertise stems partly from the nature of a democratic regime, and the problem is not new, but was identified by philosophers as early as Plato. Since, in a democracy, all voices get heard, this can lead people to conclude that all voices have equal value. Democracies tend to justify themselves by contrast to the aristocracies or oligarchies they replace or resist. In those elitist societies, some presume to know more, or actually to be better people; whereas we democrats know better: all are equal. But of course, political equality doesn't imply that no one can possess knowledge that others lack, and indeed few people think this about most skills, for example plumbing or auto repair. No one, though (they say), can know more than anyone else about how to live, how to be just. Hence a kind of relativism develops: from the rejection of ruling elites, who in fact may not have had any better idea than anyone else about justice, to a rejection of the notion of objective standards of right and wrong entirely. What is right is what I feel is right, what is right-for-me. Today, there is a trend even in the academy to dispute notions of objectivity and expertise. There are said to be no true histories, only different interpretations of history.[7] There are no correct interpretations of literary works, only different interpretations.[8] Even physical science is said to be value-laden and non-objective.[9]

[7] See for example, Mary Lefkowitz's book *Not Out of Africa* (New York: Basic Books, 1996), in which she recounts her experiences as a classicist trying to maintain standards of rational inquiry in the heated area of race-based archeology.

[8] For a rare objective account of artistic interpretation, see William Irwin's *Intentionalist Interpetation: A Philosophical Explanation and Defense* (Westport, CT: Greenwood Press, 1999). Ironically, at the same time the notion of truth and expertise is being challenged within the academy—there are no such things as experts on morality—the talk shows and bestseller lists are populated with experts on such things as relationships, horoscopes, and angels. But these experts are heeded, I think, only to the extent that they confirm a person's predispositions, and rejected on grounds I have outlined when they do not. To be sure, the rejection of knowledge claims in the realm of values is different from the rejection of knowledge claims in physical matters, but what is interesting is that we do see both, and at the same time we also see bogus claims of expertise on a host of inappropriate matters.

[9] See, for example, Alan Sokal and Jean Bricmont, *Fashionable Nonsense: Postmodern Intellectuals' Abuse of Science* (New York: Picador, 1998). The

So we have all these factors contributing to a climate in which the notion of expertise is eroded, yet at the same time we see countervailing trends. If there's no such thing as expertise, and all opinions are equally valid, why are the talk shows and bestseller lists populated by experts on love and angels? Why watch those shows or read books in the first place? Why send the kids to school? Clearly, people do still put some stock in the notion of expertise, and in many cases, yearn for its guidance. People actually seem to have some tendencies towards wanting to be told what to do. Some critics of religion ascribe its influence to this psychological need, but we need look no further than the political realm to see evidence of it. People look to political figures for their "leadership": we're having a problem with unemployment—doesn't anyone know how to do something about that? This person would make a better president than that one because he knows how to reduce crime, end poverty, make our children better, and so on. But the ambivalence shows itself very clearly in these contexts. If candidate Smith bases his appeal on his expertise and ability to "get the job done," candidate Jones will likely charge Smith with being an elite, a "pointy-head." We also see the paradoxical situation wherein celebrities' pronouncements on political matters taken seriously, as if being a talented musician or actor gave greater weight to one's political views, while at the same time the notion of being an expert on government is derided. With whose views are most Americans more familiar, Alec Baldwin and Charlton Heston, or John Rawls and Robert Nozick?

In addition to political expertise, people also yearn for, and seem least ambivalent about, technological expertise. Most people are quick to acknowledge their own incompetence at plumbing, auto repair, and surgery, and happily turn those tasks over to the experts. In the case of the surgeon, we do see another manifestation of the ambivalence I have in mind, namely when people defend alternative medicine or spiritual

springboard for this book was Sokal's now-famous hoax, in which he submitted a bogus essay based on this theme, which was readily accepted by scientifically challenged journal editors as a fine work. That essay was "Transgressing the Boundaries: Toward a Transformative Hermeneutics of Quantum Gravity," originally published in *Social Text* 46–47, (1996), pp. 217–252.

healing—what do doctors know? This is a trickle-down from the currently-fashionable trend in academia which maintains that all science is value-laden and non-objective. But we don't have any advocates of "alternative plumbing" or "spiritual auto repair," so these people's expertise is more generally accepted; and do-it-yourselfers are not a counter-example, since that's more a matter of regarding oneself as that sort of craftsman, rather than denying that anyone else is. Also, since plumbers and mechanics less frequently position themselves as experts in fields beyond their own, as surgeons might position themselves as ethicists, they are less susceptible to being regarded skeptically.[10]

Do We Admire or Laugh at Lisa?

American anti-intellectualism, then, is pervasive but not all-encompassing. As it does with many other aspects of modern society, *The Simpsons* often uses this theme as fodder for its satire. In the Simpson family, only Lisa could really be described as an intellectual. But her portrayal as such is not unequivocally flattering. In contrast to her relentlessly ignorant father, she is often shown having the right answer to a problem or a more perceptive analysis of a situation, for example when she exposes political corruption[11] or when she gives up her dream of owning a pony so that Homer won't have to work three jobs.[12] When Lisa discovers the truth behind the myth of

[10] This also highlights ways in which popular attitudes towards "authorities" and "intellectuals" are not exactly the same. People are less resistant to an authority or expert when the area seems not to be an intellectual one, as for example we all recognize the plumber's expertise; but of course being an expert in anything requires a degree of intellectualism, so the distinction is a fallacious one, and is more a reflection of people's attitudes than a statement about the intellectual level of expert craftsmen. Expert craftsmen obviously do possess wisdom, but are often seen as less threatening to those who don't possess the wisdom. This might be due to the fact that when we speak of "intellectuals" or "smart people," we are describing a general characteristic which sets the person apart, whereas when we speak of an "expert," we are only describing an attribute which we may regard as isolated, and thus feel less threatened. Lisa is an intellectual (valuing the pursuit of wisdom) and very smart, while not specifically an "expert" on anything.

[11] "Mr. Lisa Goes to Washington."

[12] "Lisa's Pony."

Jebediah Springfield, many people are unconvinced, but Homer says, "you're always right about this sort of thing."[13] In "Homer's Triple Bypass," Lisa actually talks Dr. Nick through a heart operation and saves her father's life. But other times, her intellectualism is itself used as the butt of the joke, as if she were "too" smart, or merely preachy. For instance, her principled vegetarianism is revealed as dogmatic and inconsistent,[14] and she uses Bart in a science experiment without his knowledge,[15] evoking examples of the worst sort of arrogance, such as the infamous Tuskegee study.[16] She agitates to join the football team, but it turns out she is more interested in making a point than in playing.[17] So although her wisdom is sometimes presented as valuable, other times it is presented as a case of being sanctimonious or condescending.

One common populist criticism of the intellectual is that "you're no better than the rest of us." The point of this attack seems to be that if I can show that the alleged sage is "really" a regular person, then maybe I don't have to be as impressed with his opinion. Thus the expression "Hey, he puts his pants on one leg at a time just like the rest of us." The implication of this non-sequitur is clearly "he is just a regular person like you and me, so why should we be awed by his alleged expertise?" In Lisa's case, we are shown that she has many of the same foibles as many kids: she joins her non-intellectual brother in revelry as they watch the mindlessly violent *Itchy and Scratchy* cartoon, she worships the teen idol Corey, she plays with Springfield's analogue to the Barbie Doll, Malibu Stacy. So we are given ample opportunity to see Lisa as "no better" in many respects, thus giving us another window for not taking her smarts seriously. Of course, it is true that she is a young girl, and one might argue that this is merely typical young girl behavior, but since in so many other cases she is presented not simply as a prodigy but as preternaturally wise, the fondness for *Itchy and Scratchy*

[13] "Lisa the Iconoclast."
[14] "Lisa the Vegetarian."
[15] "Duffless."
[16] This was a case in which the doctors experimented without consent, and with little regard for the well-being of the "participants," who were infected with syphilis.
[17] "Bart Star."

and Corey seem to be highlighted, taking on greater signifi-
cance. Lisa is portrayed as the avatar of logic and wisdom, but
then she also worships Corey, so she's "no better." In "Lisa the
Skeptic," Lisa is the sole voice of reason when the town
becomes convinced that "the skeleton of an angel" has been
found (it's a hoax), but when it seems to speak, Lisa is as afraid
as everyone else.

Lisa's relationship with the Malibu Stacy doll actually takes
center stage in one episode,[18] and even this highlights an
ambivalence in society about rationalism. It gradually occurs to
Lisa that the Malibu Stacy doll does not offer a positive role
model for young girls, and she presses for (and actually con-
tributes to) the development of a different doll which encour-
ages girls to achieve and learn. But the makers of Malibu Stacy
counter with a new version of their doll, which triumphs on the
toy market. The fact that the "less intellectual" doll is vastly pre-
ferred over Lisa's doll, even though all of Lisa's objections are
reasonable, demonstrates the ways in which reasonable ideas
can be made to take a back seat to "having fun" and "going with
the flow." This debate is often played out in the real world, of
course: Barbie is the subject of perennial criticism along the
lines of Lisa's critique of Malibu Stacy, yet remains immensely
popular, and in general, we often see intellectual critiques of
toys dismissed as "out of touch" or elitist.[19]

Philosopher Kings? D'Oh!

A more specific instance of the way *The Simpsons* reflects
American ambivalence towards the intellectual is found in the
episode "They Saved Lisa's Brain."[20] In this episode, Lisa joins
the local chapter of Mensa, which already includes Professor
Frink, Dr. Hibbert, and the Comic Book Guy. Together they end
up in charge of Springfield. Lisa rhapsodizes about the rule of
the intellectuals, a true rationalist utopia, but too many of their

[18] "Lisa vs. Malibu Stacy."

[19] GI Joe, for example, is criticized for promoting militarism and violence, as
do all "gun" toys, yet parents overwhelmingly reject the calls of some intel-
lectuals that kids should be guided towards different play.

[20] For further discussion of this episode, see Chapter 11 of this volume.

programs alienate the regular citizens of the town (including, of course, Homer, who leads the charge of the idiot brigade). It would be easy enough to see this sequence of events as a satire on the way the average person is too stupid to recognize the rule of the wise, but more than that is being satirized here. Also under attack is the very notion of rule of the wise—the Mensans have some legitimately good ideas (more rational traffic patterns), but also some ridiculous ones (censorship, mating rituals inspired by *Star Trek*), and they squabble amongst themselves. The Mensans offer something of value, especially in contrast to the corrupt regime of Mayor Quimby or the reign of idiocy that Homer represents, and Lisa's intentions are good, but it is impossible to see this episode as unequivocally pro-intellectual, since one theme is clearly that utopian schemes by elites are unstable, inevitably unpopular, and sometimes foolish. As Paul Cantor argues, "the utopia episode embodies the strange mixture of intellectualism and anti-intellectualism characteristic of *The Simpsons*. In Lisa's challenge to Springfield, the show calls attention to the cultural limitations of small-town America, but it also reminds us that intellectual disdain for the common man can be carried too far and that theory can all too easily lose touch with common sense."[21]

It is actually true, however, that utopian schemes by elites tend to be ill-conceived, or are power-grabbing schemes masquerading as the common good. But is the only alternative Homer's mob or Quimby's oligarchy? The framers of the United States Constitution hoped to combine democratic principles (a Congress) with some of the benefits of an undemocratic elite rule (a Senate, a Supreme Court, a Bill of Rights). This has had mixed results, but in contrast to other alternatives seems to have fared well. Is all of our society's ambivalence about intellectuals due to this constitutional tension? Surely not. That is part of it, but, more likely than not, this ambivalence is a manifestation of deeper psychological conflicts. We want to have authoritative guidance, but we also want autonomy. We don't like feeling stupid, yet when we are honest we realize we need to learn some things. We respect the accomplishments of others, but sometimes feel threatened and resentful. We have a respect for

[21] Ibid., p. 178

authorities when it suits us, and embrace relativism in other cases. The "we" here is, of course, a generalization: some people manifest this conflict less than others (or in a few cases not at all), but it seems an apt description of a general social outlook. Unsurprisingly, *The Simpsons,* our most profoundly satirical TV show, both illustrates and instantiates it.

The ambivalence in American society towards the intellectual, if it is indeed a deep-rooted psychological phenomenon, is not likely to go away any time soon. But no one is better off for encouraging or promoting anti-intellectualism. Those who wish to save the republic from the tyranny of Professor Frink and The Comic Book Guy need to find ways to argue against it that do not entail a wholesale attack on the ideal of intellectual development. Those who champion the common man ought not do so in ways that belittle the achievements of the learned. That approach is tantamount to defending Homer's right to live as a stupid person by criticizing Lisa for being smart.[22] That's not a sound idea for the development of the nation or of any individual.[23]

[22] Some argue that, indeed, Homer does not have the right to live as a stupid person. There may be something to this, but it's neither here nor there with respect to the narrower argument I am making here.

[23] I am grateful to Mark Conard and William Irwin for helping me clarify several of my points and reminding me of several useful examples.

3
Why Maggie Matters: Sounds of Silence, East and West

ERIC BRONSON

Nobody even considered Maggie Simpson. And why should they? The signs pointed to someone like Smithers, the brown-nosing admirer, scorned more times than any other man could endure. Or more likely was Homer Simpson, the oafish safety inspector who once threw his boss out of the office window in a fit of rage. It could have been anyone, really.

When the demonic Mr. Burns hatched his most diabolical scheme, when the evil old founder of the nuclear power plant finally figured out how to block the sun from shining on the innocent town of Springfield, everybody had plausible motives for shooting him. That's why when word got around that Mr. Burns was lying in a hospital in critical condition, all of Springfield wanted to know who to blame (or congratulate, as the case might be). The shifty-eyed adults all had dubious alibis and the school children were quick to point fingers at each other. Finally Mr. Burns himself improved enough to set the matter straight. It was little Maggie Simpson who pulled the trigger at point blank range, nearly killing the old man while he "wallowed in his own crapulence" ("Who Shot Mr. Burns? Part Two").

Maggie Simpson shot Mr. Burns. The infant, still too young to walk, protected her lollipop from falling into groping, miserly hands. Was it self-defense? An accident perhaps? After all, the gun did belong to Mr. Burns and only ended up in Maggie's hands due to his own carelessness. Still, the two-part episode

ends on an interrogative note. Just what were the intentions of this young and seemingly innocent girl? Could she knowingly commit such a crime? The answers, or lack thereof, are less than comforting. The camera zooms in on Maggie's mouth, her pacifier blocking any articulation or explanation as the credits begin to roll. The child tries to speak but cannot. It seems as though we'll never know why Maggie shot the most powerful man in Springfield. We'll never get the answers we want, unless of course, her stunted speech is actually all the answer we need.

Is Maggie an Idiot?

The Western world has long had a special fascination with the spoken word. The terrific success of talk shows like *Oprah* and *The Jerry Springer Show* are just the latest, though not the greatest, phenomena to attest to just how much we love to hear people speak about themselves. The more revealing the speech, the more likely we are to hoot our approval. Spoken words carry a certain power that can quickly move us to action. The nineteenth century English poet Emily Dickinson writes:

> A word is dead
> When it is said,
> Some say.
>
> I say it just
> Begins to live
> That day.[1]

Words can take on new meanings and open up whole new lines of thoughts once they are spoken and set free in the public domain.

Why do we take words so seriously? Beginning with the Greek philosopher Socrates, Western philosophy has tended to emphasize discussion and argument as the means for attaining higher truths. For Socrates, it was never enough to refute the

[1] *The Complete Poems of Emily Dickinson,* edited by Thomas Johnson (New York: Little Brown, 1961).

unsound, unsupported arguments of his day. Words had to be carefully chosen and properly spoken for the light of reason to shine most forcefully. Socrates frequently likens philosophy to music in its ability to transform the souls of its listeners. In Plato's *Symposium*, Socrates's eloquent defense of erotic love has just ended when Alcibiades, the heralded warrior of Ancient Greece, crashes the party and says, "[Y]ou're a flute-player, aren't you? In fact, you're a more amazing one than Marsayas . . .[2] The only way you differ from him is that, while you do the same thing he does, you do it using plain words without instruments."[3] Words are like music. Well-reasoned thoughts, conveyed with well-chosen words, can touch us as deeply as a moving symphony or a driving drum beat.

Maggie Simpson doesn't possess language and doesn't speak. In the twentieth century, philosophers concerned with humanity's place in the universe have returned to the relationship between words and thoughts. How do we think, if not in words? Ludwig Wittgenstein tells us, "The limits of my language mean the limits of my world" (*Tractatus* 5.6). For those of us lucky enough to speak freely, our words are inexorably linked to our thoughts. What should I eat for breakfast? Should I go to class today? Why is he acting like such a jerk? Questions like these are continuously asked, discussed, and pondered. Through such internal debate we arrive at conclusions. I will skip breakfast and go to class. Because he is being a jerk, I'm not going to waste my time. Finally, we're ready to act on our conclusions. Our entire thought process seems to be intimately related to a never-ending stream of words.

Now what would happen if the words were taken away? What tools would we have to make even the smallest decisions? Which comes first, the language or the thoughts? In "Brother, Can You Spare Two Dimes?" Homer's brother, played by Danny DeVito, invents a baby-translating device. The idea is that Maggie is capable of everyday thoughts even though she doesn't have the ability to express these thoughts in language. Of course, her ideas are hardly profound (one of her thoughts is

[2] The teacher of Olympus, a well-known musician of mythical lore.
[3] *The Symposium,* 215c, in *The Symposium and the Phaedrus,* translated by William S. Cobb (Albany: SUNY Press, 1993).

that she wants to eat dog food) but the translating machine makes Homer's brother wealthy again. And well it should. Such a machine would go a long way in solving many philosophical questions about the origins of language and its relation to the human thought process.

Words is the title of the twentieth-century French existentialist Jean-Paul Sartre's autobiography. According to Sartre, a person's life is characterized by his or her interactions with other people and such interactions are established largely through words. Therefore, to understand Sartre or any other human being, one has to examine the words. In *The Family Idiot,* a five-volume, 3,000-plus page investigation into the life and times of French novelist Gustave Flaubert, Sartre shows us what happens when words are taken away. The biography was Sartre's last major philosophical work, and one that was never finished despite the incredible volume of material written. In this final work, Sartre practices his existential psychology by examining the author's life's project in light of his childhood upbringing. Flaubert's upbringing, according to Sartre, was characterized by speechlessness and idiocy. Flaubert's childhood development was marked by the late acquisition of speech. Moreover, he had difficulty surmounting his mental infancy because of a speech impediment. Of Flaubert, Sartre writes, "He would sit for hours, a finger in his mouth, looking almost stupid; this calm child who reacts badly when spoken to, feels less than others the need to speak—words, as we say, do not come to him, nor the desire to use them."[4] Speech, Sartre argues, is how human beings first become integrated into human society. Flaubert, already from age six, was set adrift on a sea of isolation due to his speech deficiency and could not articulate his childish emotions and fears. Sartre's argument is not that Flaubert was an idiot, we know he went on to write such enduring classics as *Madame Bovary,* but that his life in writing can be seen as a desperate attempt to overcome his childhood insufficiencies.

According to Sartre, self-worth is partially instilled in us by the words of others. Those who are closest to us naturally have a greater say. Like most children, Flaubert's first connection to the world was through his parents. It was on the surface a lov-

[4] *The Family Idiot* (Vol. 1), translated by Carol Cosman (Chicago: University of Chicago Press, 1981), p. 35.

ing relationship, but Sartre observes that a child needs more. A growing child needs to know that his existence is justified and important. His projects, however small, must be nurtured and criticized, examined and approved through the loving use of language. In this way, the child has guardrails to hold on to, knowing that he is not alone in the universe. "This is not a conjecture," Sartre writes. "A child must have a mandate to live, the parents are the authorities who issue the mandate."[5] One way a parent can communicate this mandate is by constant communication, reinforced by loving words and caring actions. Flaubert seems to have missed out on such parental valorization. Without this attention, the future novelist frustrated easily, turned within, and stayed quiet far longer than the happier children his age.

Though the fictional Springfield is a far cry from the French countryside (as Bart discovered on his miserable study abroad in "The Crepes of Wrath"), Maggie's upbringing does share some similarity with that of Flaubert. Sartre tells us how Flaubert's mother cared for her child's body but never took the time to attend to his innermost needs. Mme. Flaubert is portrayed as "an excellent mother but not a delightful one; punctual, assiduous, adept. Nothing more."[6] How is Maggie loved by her mother? The answer is not so clear. It does seem that Marge Simpson has a deep love for her youngest daughter, but, like Mme. Flaubert, her love is practical, involving little more than feeding, cleaning, dressing, and tucking in to bed. Sometimes it seems as if mother Marge treats her vacuum cleaner with the same care that she lavishes on her children. In the show's weekly opening montage, Maggie is taken out of the grocery cart by the check-out clerk and priced along with all the other items. Marge is relieved to discover that her youngest child, no longer missing, is securely packed into one of her many shopping bags. It is as if getting the groceries and children safely home will adequately fulfill her duty as a mother.

Of course, if Maggie grows up with a low self-esteem Marge will not be entirely to blame. Homer is certainly not the paradigm of the nurturing dad; there's only so much intimacy you can expect from someone who sings "I'd rather drink a beer,

[5] Ibid, p. 133.
[6] *The Family Idiot,* p. 129.

than win Father of the Year" ("Simpsoncalifragilisticexpiala-
D'oh-cious"). True, it is Homer who convinces Mr. Burns to
accept his long lost son Larry (given voice by Rodney
Dangerfield in "Burns, Baby Burns"). Homer insists that
"although kids can be obnoxious and stinky the one thing they
can always count on is a father's love." It's also true that Homer
finally comes to terms with Maggie's existence, and lines his
office with her baby pictures ("And Maggie Makes Three"), but
such momentary bursts of emotions hardly fulfill the require-
ments for "Sartre's guide to good parenting."

It's revealing that in "Home Sweet Homediddly-Dum-
Doodily," in which the Simpsons lose custody of their children
to their upstanding neighbors, the Flanderses, it is Maggie who
begins to flower under the lavish attention.[7] Surrounded by con-
stant care and renewed interest, the silent Maggie suddenly feels
like speaking and, to the surprise of everyone, blurts out "dad-
dily-doodily" in Ned Flanders's car. Earlier in the episode
Maggie's older siblings comment on her positive change after
the child welfare department takes her out of her parents' home.

> BART: I've never seen Maggie laugh like that.
>
> LISA: Well, when was the last time Dad gave her so much
> attention?
>
> BART: When she swallowed a quarter, he stayed with her all
> day.

In this episode, Sartre's point is acted out. Through familial
love and attention, a person begins to express herself through
words. Without this early attention she slips into silence.
Without words she is likely to have a limited concept of her own
self-worth. Such children may or may not be considered inferior,
but as Mr. Burns learned the hard way, they rarely appreciate
people messing with their lollipops.

Is Maggie Enlightened?

Maggie doesn't speak, but, unlike Sartre's Flaubert, she does
seem to exhibit at least a rudimentary thought process. She

[7] For an extended discussion of this episode see Chapter 14 of this volume.

does, after all, help Bart and Lisa overcome the "babysitting bandit," in "Some Enchanted Evening," and again comes to the rescue when the monstrous Grounds Keeper Willie seeks vengeance in one of *The Simpsons'* nightmarish Halloween specials ("Treehouse of Horror VI"). She even shows flashes of genius as she casually plays Tchaikovsky's "Dance of the Sugar Plum Fairies" on her toy xylophone ("A Streetcar Named Marge"). But what, if anything, really goes through her mind is a mystery to the viewers because she cannot speak to us.

Let's leave the West behind for a moment. In Ancient China, philosophers rarely shared our enthusiasm for the spoken word. As the great Chinese philosopher Confucius says, "Hear much, but maintain silence."[8] More forcefully, the Chinese *Tao te Ching* insists,

> Those who know don't talk.
> Those who talk don't know.[9]

Throughout much of the Eastern tradition, words are used merely as signposts for the mystery of life which is forever shrouded in silence. Unlike much of Western Scripture, many Eastern texts long ago claimed silence was the foundation on which our world originated. In the *Bhagavad-Gita*, for example, the Creator of the world is shrouded in mystery and mysticism. The Creator cannot be spoken of, nor grasped intellectually.

> Rarely someone
> sees it,
> rarely another
> speaks it,
> rarely anyone
> hears it—
> even hearing it,
> no one really knows it.[10]

[8] *The Analects of Confucius,* translated by Arthur Waley (New York: Vintage, 1989), 2:18.

[9] *The Tao Te Ching,* translated by Stephen Addiss and Stanley Lombardo (Indianapolis: Hackett, 1993), Chapter 56.

[10] *The Bhagavad-Gita,* translated by Barbara Stoler Miller (New York: Bantam, 1986), p. 33.

Western religions also have their own mystical interpretations of the almighty, though nowhere is silence more rooted in philosophy than in the East.

To be enlightened, then, is to return to our origins, to rid ourselves of worldly attachments and return to the infinite quiet of the world. In the Hindu religion (and later developed by Buddhist sects), the Sanskrit word "Nirvana" often implies a "cooling," a detachment from passions. Words serve only to destroy such inner peace. We become too attached to our words and easily talk away the grandeur and mystery behind our lives. According to many Eastern schools of thought, our earthly unhappiness is caused by too much thinking, too many words. The *Bhagavad-Gita* reminds us that "focusing his mind on the self, he [the man of discipline] should think nothing."[11] It's not as if we are supposed to give up thinking altogether (for that we wouldn't need so many volumes of philosophy), but many Buddhists, in particular, make a distinction between thinking spontaneously and thinking obsessively over concepts. Words are useful, even necessary for the transmission of knowledge. Zen Buddhists in particular use words to help transmit knowledge from teacher to student. But both Hindus and Buddhists alike understand the darker side of poorly used speech. Words breed more words which can lead to further stress and anxiety. Eastern enlightenment often involves a mystical connection with the natural world and such a transformation is rarely concluded with words.

Acting spontaneously without becoming bogged down in the quicksand of words is a necessary beginning on the road to enlightenment according to many Eastern schools. In the West, the temptation is great to lead a life of all talk and no action. In "30 Minutes over Tokyo" Bart has his mind temporarily opened in Japan and Lisa can put together a puzzle of the Taj Mahal at the age of three ("Lisa's Sax"), but neither can seriously be considered enlightened. Unlike her siblings, Maggie is too young to be distracted by words, and can more effectively act spontaneously. However, according to this line of thinking, all babies would be considered enlightened. We have to be careful to distinguish between undeveloped thoughts and rigorously devel-

[11] Ibid, p. 66.

oped non-thoughts. As noted Indian historian Sarvepalli Radhakrishnan points out, "By observing silence a man does not become a sage if he be foolish or ignorant."[12] In Zen Buddhist thought, it takes years and years of disciplined thinking and meditation to reach the ecstatic state of childlike innocence.

Chief Wiggum assures Springfield residents that no jury will convict Maggie of shooting Mr. Burns (except in the state of Texas), because she is too young. She is also, in all likelihood, too young to have properly rid herself from all earthly attachments. However, the residents of Springfield did learn one important lesson. A child without words is not necessarily one without the ability to carry out a rather grave action. While Maggie almost killed Mr. Burns, she has also saved the day on numerous occasions, without the burden of speech. Sometimes silence is a sign of complex thought and profound intuition (though not likely in Maggie's case). If we all practiced it more regularly we might just live a little easier, and we would certainly spend fewer afternoons serving detention, writing repetitively on the blackboard, or sitting in Principal Skinner's office.

What Can Maggie Teach Us?

Western philosophy has its own proponents of silence. From the early Jewish mystics to the contemporary philosophy of Wittgenstein, there has arisen an uneasy tension about when it is best to stay quiet. In The United States, the twentieth century has come to a close with a multitude of contradictory messages. We were told to "stand up and be counted" but "silence is golden." "Knowledge is power" but "no news is good news." "Express yourself" but "talk is cheap." Rarely have we been more unsettled over the question of when to keep our mouths shut.

A century earlier, ancient Eastern philosophy had already seeped into the fertile intellectual soil of Western Europe. Important German philosophers such as Schopenhauer and Nietzsche were students of the Orient and many Eastern allusions can be found in their work. Following this tradition, in 1930, the German philosopher Martin Heidegger gave Eastern

[12] *A Source Book of Indian Philosophy*, edited by Sarvepalli Radhakrishnan and Charles A. Moore (Princeton: Princeton University Press), p. 313.

philosophy a new popularity in the West. While Heidegger is surely placed in the Western tradition, his emphasis on silence has a distinctively Eastern flavor. Silence, Heidegger argued, was essential to humans hoping to live an authentic existence whereas idle talk was a sure sign of inauthentic existence. Heidegger hoped to bridge the East and West by speaking only about the more serious questions of "Existence" and staying quiet about all else.

From all ends of the globe, Heidegger was hailed as a great thinker, one who knew when and when not to speak. By the late 1930s, however, Germany had more pressing concerns than existential theory. Adolf Hitler had come to power and World War II had become an inevitable reality. With a few notable exceptions, Heidegger kept quiet, true to his philosophy, and did not retract his earlier support for National Socialism and the Third Reich. When the Nazis declared war on their neighboring countries, Heidegger refused to speak out. And, when his Jewish students and colleagues were publicly forced out of his university, Heidegger said nothing.[13]

History will condemn Heidegger's silence and so should we. Since World War II, we have learned that speaking out can cause misunderstanding and conflict, but not speaking out can endorse far worse. Nobel Peace Prize winner Elie Wiesel is fond of saying that the opposite of love is not hate, but silence. So it seems as though we are left no better off in determining when to favor Eastern silence and when to rely on Western speech.

In "Lisa's Wedding," Lisa glimpses into her future with the help of a carnival soothsayer. She is about to be to married to the man of her dreams, and at the wedding, Maggie, the grown teenager with the beautiful voice, is set to sing. Just as she takes her first deep breath, however, Lisa calls off the wedding and Maggie symbolically closes her mouth. Once again, family turmoil has drowned out her voice.

In a world of growing bureaucracy and information overload, we too run the danger of having our voices drowned out. In the modern world, the great challenge of both the East and the West is figuring out how to critically respect each other's

[13] For a balanced view of Heidegger's role in the Nazi Party see Richard Wolin's *The Heidegger Controversy* (Cambridge, MA: MIT Press, 1992).

projects in a way that encourages all voices to be heard. More than tolerant, we must be attentive. Otherwise, more people, like Maggie Simpson, will feel left out of society and turn to more destructive means of communication. And, in the real world, we don't always bounce back up so quickly.[14]

[14] Special thanks to Pasquale Baldino for the benefit of his vast *Simpsons* knowledge and research and to Jennifer McMahon for helpful suggestions.

4

Marge's Moral Motivation

GERALD J. ERION and JOSEPH A. ZECCARDI

From the corrupt Mayor "Diamond" Joe Quimby and the incorrigible recidivist Snake to such faithful figures as Reverend Lovejoy and Ned Flanders, Springfield's moral extremes are bound only by the number of characters walking its streets. Bart admits that he doesn't know the difference between right and wrong and bargains with the devil on a first name basis, while Homer takes on one selfish and impulsive project after another, even attempting to convince God of the value of skipping church to watch football. Meanwhile, Flanders consults religious authorities and scriptures to settle every dilemma he faces, from those concerning morality and ethics to those about fashion and breakfast cereal.

Amidst such swirling ethical extremes, Marge stands as a remarkably stable touchstone of morality. To resolve her moral dilemmas, Marge simply allows reason to guide her conduct to a thoughtful and admirable balance between extremes. She differs from Flanders in that Flanders always does as his religion commands, regardless of whether it actually seems right to him to do so. Marge is religious, but her well-developed conscience typically leads her to do only what any decent and reasonable person would do, even when this conflicts with the direction she receives from her religious authorities. These observations suggest that Marge's underlying moral philosophy may share much in common with that of the great ancient Greek philosopher Aristotle; thus, in this essay we will illustrate Aristotelian virtue ethics through a discussion of Marge's life in Springfield.

That said, we do not claim that Marge is some sort of paradigm Aristotelian who carefully and consistently applies Aristotle's moral philosophy at every opportunity. In fact, there are many things that she says and does that are not particularly virtuous (from an Aristotelian standpoint) at all.[1] However, our examination of her moral character should draw not just from isolated actions, but from a broader sample of her behavior. Thus, just as Barney Gumble remains an alcoholic despite his occasional moments of responsibility in "The Days of Whine and D'oh'ses," artistic achievement in "A Star is Burns," and astronaut training with "Deep Space Homer," Marge's overall pattern of behavior can serve as an especially illustrative introduction to Aristotle's moral philosophy.[2]

Virtue and Character

While utilitarianism, Kantian deontology, and other modern moral philosophies typically investigate the qualities that make an action a right action, the ancient Greeks were more likely to focus upon the traits of character that make a person a good person.[3] Aristotle provides one of the most important contributions to this tradition with his *Nicomachean Ethics*. In this book, Aristotle not only compiles a long list of the virtuous personality traits, he also presents a systematic explanation of each virtue as a mean between two extremes. In addition, he attempts to justify the life of virtue, and even offers suggestions to those interested in making their own lives more virtuous.

Given the unique focus of ancient Greek virtue ethics, we can understand an Aristotelian virtue as a character trait that helps to make a person a good person. Such character traits include not only tendencies to act in certain virtuous ways, but also dispositions to experience certain virtuous feelings and

[1] For additional thoughts on this issue, see Chapter 1 of this volume.

[2] Daniel Barwick takes on a similar project in his "George's Failed Quest for Happiness: An Aristotelian Analysis," in William Irwin, ed., *Seinfeld and Philosophy* (Chicago: Open Court, 2000). See also Aeon Skoble's chapter in the same book, "Virtue Ethics and TV's *Seinfeld*."

[3] James Rachels includes a helpful introductory discussion of this distinction in his *Elements of Moral Philosophy* (New York: McGraw Hill, 1999), pp. 175–77.

emotions. In his *Nicomachean Ethics,* Aristotle lists a number of these virtues including: 1. bravery; 2. temperance; 3. generosity (especially when demonstrated on a large scale); 4. proper, self-confident pride in one's own worth; 5. mildness; 6. friendliness; 7. honesty; 8. wit; and 9. modesty.[4] Of course, this list is not exhaustive, and philosophers since Aristotle have added other virtues to it, but it does give us a preliminary grasp of the kinds of personality traits that Aristotle thinks necessary for good character.

We find excellent illustrations of Aristotle's virtuous personality traits in Marge. First, she is clearly a brave woman. Whether breaking up a counterfeit jeans ring run out of her garage by "The Springfield Connection," escaping from a cult commune in "The Joy of Sect," or standing up to a Poe-ssessed "Treehouse of Horror," Marge is rarely short on courage. Her penchant for temperance pervades her daily life, leading her to shop at the Safeway, discount dress barns, and the Ogdenville outlet mall in "Scenes from the Class Struggle in Springfield." Finally, Marge's strong sense of honesty costs the Simpson family millions of dollars in potential legal settlements ("Bart Gets Hit by a Car"). In these examples and many others, then, Marge exhibits the personality traits that Aristotle thought so important to good character.

As Aristotle enumerates his virtues, he also explains each as a mean or balance struck between two vicious extremes, one excessive and the other deficient.[5] For instance, a virtuous sort of bravery lies somewhere between Homer's foolhardy recklessness and his vicious cowardice. Likewise, a person who is virtuously self-controlled has neither Barney's self-indulgence nor Flanders's indifference to physical pleasures, but something between the two. People with the virtue of generosity do not give to others indiscriminately (and thus are not wastefully over-generous, as Homer can sometimes be), but neither are they as

[4] This list appears in Book IV of the *Nicomachean Ethics* (abbreviated hereafter as *NE*); see T. Irwin's translation (Indianapolis: Hackett, 1985), or W.D. Ross and J.O. Urmson's translation in J. Barnes's edition of *The Complete Works of Aristotle: The Revised Oxford Translation* (Princeton: Princeton University Press, 1984).

[5] *NE* 1106a6–1107a25.

stingy as Mr. Burns usually is. We can define any virtue on Aristotle's list, then, by relating it to its two corresponding, vicious extremes.[6]

Likewise, Marge's crime-stopping vigilantism in "The Springfield Connection" and her dangerous escape from the Movementarian commune in "The Joy of Sect" demonstrate that she is genuinely brave, but not foolhardy. She will hop across rivers through snapping alligator jaws *à la* James Bond, but she won't jump from Jimmy's hansom cab to the family car as they both speed though Central Park in "The City of New York vs. Homer Simpson." Though she can be as brave as most any situation needs her to be, she does not simply fight every battle that comes up. She employs diversionary tactics like "that hand thing" ("Blood Feud") when she knows that brute strength will be useless. She also recognizes the value of passive resistance, supporting Lisa as she boycotts Homer's screening of the Watson vs. Tatum II fight ("Homer vs. Lisa and the Eighth Commandment"). Finally, when an edgy new Krusty wrestles with his "Last Temptation" and incites members of his audience to burn their cash, Homer tells Marge to give him all the money she has in her purse. Instead of engaging Homer in a fruitless and unwinnable argument, Marge gives the money to Lisa, telling her to run home and bury it in the back yard.

As for temperance, Marge tends to be more spartan than self-indulgent. As the wife of an occasionally unemployed, incarcerated, and dimensionally-confused husband, Marge has relatively little to work with financially. She shops wherever she thinks she might find a bargain, and she refuses to squander the family's cash on a new pair of shoes that she knows she does not need, semi-lamenting "If only I didn't already own a pair of shoes" in "The City of New York vs. Homer Simpson." She is also shocked by the extravagance of Mr. Burns's estate when the

[6] Aristotle admitted that a virtuous mean does not exist for all character traits. For instance, he claims that spite, shamelessness, and envy can never be virtuous, and that adultery, theft, and murder are always wrong. As he writes, "[Thinking that these admit of a mean] is like thinking that unjust or cowardly or intemperate action also admits of a mean, an excess, or a deficiency. For then there would be a mean of excess, a mean of deficiency, an excess of excess, and a deficiency of deficiency" (*NE* 1107a9–25).

Simpson family house-sits the place, noting that the machine that burns up his unmade bed each morning before pushing a new one out of the wall "seems a little wasteful" ("The Mansion Family"). Nonetheless, she is not nearly as miserly as Mega-Saver Chuck Garabedian, who conserves his cash by partying on an inexpensive yacht that smells like cat pee with beautiful women who used to be men ("Thirty Minutes Over Tokyo"). Garabedian represents a truly vicious frugality that Marge rejects, especially after spoiled food purchased at the 33¢ store leaves Homer convulsing on the floor (yet still craving more).

Given the Simpsons' fluctuating household income, it's perhaps not surprising to find Marge a bit hesitant to donate her family's money to charity; she even refuses to allow Lisa to "waste" a $100 inheritance with a donation to public broadcasting in "Bart the Fink." But as Aristotle writes, "[O]ne who gives less [than another] may still be more generous, if he has less to give," and Marge is as generous as her family's ever-changing financial status allows her to be.[7] For one thing, Marge always makes sure that Homer gives sufficiently to the collection plate at church, scolding him as he tries to substitute a 30¢ Shake 'n' Bake coupon for the family's regular weekly contribution in "Bart's Girlfriend." And even as the family's financial contributions are somewhat sparing, Marge still graciously gives her time, talents, and other resources to those in need. She has taken in Grandpa and Otto the bus driver as borders, scrubbed oil-slicked boulders with Lisa ("Bart after Dark"), volunteered to do telephone counseling for the Springfield Community Church ("In Marge We Trust"), and donated to the local food drive ("Homer Defined").

Marge is inherently moderate in all things, from parenting and running the house to making fun of the size of Burns's genitalia during her "Brush with Greatness." She is not as stifling as Maude Flanders or Agnes Skinner, but not as permissive as Mrs. Muntz or the recently-divorced Luann Van Houten. Marge even preaches moderation to Homer, urging him to limit his pork intake to six servings per week in "Principal Charming." Thus, just as Aristotle understands the importance of seeking a ratio-

[7] *NE* 1120b8–10.

nal mean in a life of genuine virtue, Marge directs her actions toward a moral balance between vicious extremes.

Justifying the Life of Virtue

Though virtue can be elusive, Aristotle believes that there is a significant payoff for those who find it. This is because virtue is an essential component of successful living. As he argues at the beginning of the *Nicomachean Ethics,* the ultimate end of human life is happiness. There are many other things (such as fame, money, and pork chops) that we may desire, but we desire these things because we believe they will ultimately make us happy. We are sometimes wrong about this, of course, but the bottom line is that "Happiness more than anything else seems unconditionally complete, since we always [choose it, and also] choose it because of itself, never because of something else."[8]

Now, it is important to distinguish Aristotle's notion of happiness (the original Greek term is *eudaimonia*) from pleasure (mmm . . . pleasure), for Aristotle does not want to say that the goal of human life is the sort of mere physical gratification that Homer (not the Greek) spends so much of his life pursuing. Rather, he seems to have in mind here a more long-term happiness or general flourishing; Terence Irwin suggests that a better translation of "eudaimonia" might be "doing well."[9] With this sort of happiness established as the ultimate goal of human life, Aristotle argues that the virtues are desirable because they promote the long-term happiness of those who possess them. While living virtuously does not guarantee that we will fare well in life, traits like self-confidence, friendliness, and honesty do increase our chances of success. Thus, we can justify the virtuous life because the virtues promote the well-being of people who have them.

Many have mistaken Aristotle's justification of virtue for a mere egoistic appeal to our own selfish motives.[10] However,

[8] *NE* 1097b1–5.

[9] See Irwin's translation of the *NE*, p. 407.

[10] For Aristotle's response to this criticism, see *NE* 1097b3 and 1170b5 as well as p. xviii of Irwin's translation.

Aristotle understood that we are a very social species, and that our long-term happiness depends heavily upon our family and friends. We cannot achieve eudaimonia without the contributions of others, and so many of the virtues (generosity, friendliness, and honesty, for instance) are valuable to us precisely because they help to cultivate the strong bonds of family and friendship that are essential to successful living.

Marge's own happiness exemplifies this as well as anyone's. Besides her sisters Patty and Selma ("the gruesome twosome"), she has no close friends, and without a regular job or hobby to occupy her attention, her focus rarely wanders from Bart, Lisa, Maggie, and Homer. The most important thing to her is, clearly, the well-being of her spouse and children; indeed, this is something she values for its own sake. As she says, "The only thing I'm high on is love; love for my son and daughters. Yes, a little L-S-D is all I need" ("Home Sweet Home-Diddily-Dum-Doodily"). So it's through the happiness of her family that Marge achieves eudaimonia for herself. Simple household tasks like washing clothes, creating meatloaf men when "Mr. Lisa Goes to Washington," and knitting seatbelts for homemade cars in "The City of New York vs. Homer Simpson" are not undesirable chores to her. Rather, they bring her happiness because they contribute to the good of the family she cherishes so dearly.[11] In fact, Marge nearly loses her sense of purpose after Homer's new job with the Globex Corporation requires the family to move into an automated home that does most of the housework for her in "You Only Move Twice." No longer knowing how to contribute to the good of her family, Marge sinks into a depression and develops a drinking habit (though still a moderate one, not requiring David Crosby's intervention). Thus, by living her life in accordance with the Aristotelian virtues, Marge nurtures the kinds of strong social relationships that bring a deep and powerful happiness to her life.

[11] One might wonder whether these kinds of activities lead Marge to enjoy genuine eudaimonia or something more like mere physical pleasure; note, though, that she doesn't seem to do these things because of some selfish motivation, but because she sees the role such actions can play in nurturing strong familial relations. For more on the feminist response to, and criticism of, Marge, see Chapter 9 of this volume.

[12] *NE* 1103a15.

Cultivating Virtue

Given the important role the virtues play in promoting eudaimonia, we might wonder what we can do to make our own lives more virtuous, and thus more successful. According to Aristotle, "None of the virtues of character arises in us naturally."[12] Instead, he says, we have a natural ability to acquire virtue through habituation; "We become just by doing just actions, temperate by doing temperate actions, and brave by doing brave actions."[13]

> Refraining from pleasures makes us become temperate, and when we have become temperate we are most able to refrain from pleasures. And it is similar with bravery; habituation in disdaining what is fearful and in standing firm against it makes us become brave, and when we have become brave we shall be most able to stand firm. (*NE* 1104a25–b5)

Virtuous people can thus serve as important models in our moral development. By choosing to do the kinds of things that virtuous people themselves do, we can make ourselves more virtuous. Eventually, we might even learn to feel the proper, virtuous motivation of those who act virtuously just because they recognize the value of being virtuous.

Marge also knows how important her model can be to the moral development of her children. Her influence is strongest upon Lisa, and she takes advantage of any opportunity she finds to encourage the growth of her daughter's own sense of right and wrong. When Homer decides to steal services from the local cable television company in "Homer vs. Lisa and the Eighth Commandment," Marge encourages Lisa's protest with lemonade and the advice that "[W]hen you love somebody, you have to have faith that, in the end, they will do the right thing." In "The Old Man and the Lisa," Marge encourages Lisa to listen to her own conscience as she struggles with the moral dilemma brought on by a multi-million dollar windfall from the animal recycling plant that she inadvertently convinced Mr. Burns to build. "Lisa, you do whatever your conscience tells you," she says. The effect of Marge's moral influence on Lisa is

[13] *NE* 1104a30–35.

poignantly expressed in their aforementioned exchange in Moe's Tavern:

> MARGE: Lisa, here's all the money I have. Take it and bury it in the back yard.
>
> LISA: I love you, Mom. ("The Last Temptation of Krusty")

Marge's influence also has an effect on Bart's slower and somewhat more muddled moral development. For instance, she advises Bart to "listen to your heart, and not the voices in your head" as he grapples with the question of whether to testify in Freddy Quimby's assault trial and risk punishment for skipping school himself in "The Boy Who Knew Too Much."[14] Like Aristotle, then, Marge knows what needs to be done to cultivate the virtues in those still unable to fully appreciate their value.

Marge's Opposition to the Divine Command Theory

Many of us believe that ethical questions can be settled only by reference to religion. Thus, we often look to our ministers, priests, rabbis, and other religious leaders as if they were moral experts with special abilities to solve ethical problems. It's also typical for institutional and governmental ethics review boards to include representatives of the major religions. Furthermore, many people have suggested that promoting school prayer, publicly posting the Ten Commandments, or teaching religious creationism in our nation's science classrooms could help to eliminate social problems like substance abuse and school violence.

In Springfield, Ned Flanders exemplifies one way (if not the only way) of understanding the influence of religion upon ethics.[15] Ned seems to be what philosophers call a divine com-

[14] Unfortunately for Bart, though, things are not always so clear; his conscience actually convinces him to shoplift a copy of the videogame *Bonestorm* in "Marge Be Not Proud."

[15] For another interpretation of Flanders's moral philosophy, see Chapter 14 of this volume. The divine command theory is not the only religious theory of ethics; St. Thomas Aquinas's natural law theory, for instance, is a religious moral philosophy, but very different from the divine command theory.

mand theorist, since he thinks that morality is a simple function of God's divine command; to him, "morally right" means simply "commanded by God," and "morally wrong" means simply "forbidden by God."[16] Consequently, Ned consults with Reverend Lovejoy or prays directly to God Himself to resolve the moral dilemmas he faces. For instance, he asks the Reverend's permission to play "capture the flag" with Rod and Todd on the sabbath in "King of the Hill"; Lovejoy responds, "Oh, just play the damn game, Ned." Ned also makes a special telephone call to the model train room in Reverend Lovejoy's basement as he tries to decide whether to baptize his new foster children, Bart, Lisa, and Maggie, in "Home Sweet Home-Diddily-Dum-Doodily."[17] (This call prompts Lovejoy to ask, "Ned, have you thought about one of the other major religions? They're all pretty much the same.") And when a hurricane destroys his family's home but leaves the rest of Springfield unscathed in "Hurricane Neddy," Ned tries to procure an explanation from God by confessing, "I've done everything the Bible says; even the stuff that contradicts the other stuff!" Thus, Ned apparently believes he can find solutions to his moral problems not by thinking for himself, but by consulting the appropriate divine command. His faith is as blind as it is complete, and he floats through life on a moral cruise-control, with his ethical dilemmas effectively pre-resolved.

In this context, it seems that Marge's religious beliefs have relatively little influence on her moral decision-making. It's clear that she believes in God; she prays to prevent Springfield's apparently imminent destruction in "Bart's Comet" and "Lisa the Skeptic," and when Homer gives up church, she warns him, "Don't make me choose between my man and my God, because you just can't win" ("Homer the Heretic"). She even seeks out Reverend Lovejoy's help with her marriage on two non-consecutive occasions in "War of the Simpsons" and "Secrets of a Successful Marriage." Nonetheless, Marge's everyday moral decision-making is driven more by her own well-developed

[16] This presentation of the divine command theory comes from Rachels, *Elements*, pp. 55–59.

[17] He also calls with concerns about enhancing his meekness and coveting *his own* wife, as well as such non-moral questions as what to do when he swallows a toothpick ("In Marge We Trust").

conscience than by her religious faith, and she is comfortable rejecting the Church's official moral judgments in a way that Flanders never could be. For instance, instead of joining the Lovejoy and Flanders families to protest an exhibition of Michelangelo's nude statue of David, Marge defends the great work of art on Kent Brockman's Smartline news show ("Itchy & Scratchy & Marge"). She refuses to lead, or even support, the knee-jerk protest because she sees that nudity is not necessarily evil or immoral, while all Helen Lovejoy can do is shout her favorite canned phrase, "Won't someone please think of the children?" She also criticizes the Reverend's out-of-touch pastoral counseling, then sets up her own counseling service that receives rave reviews from the residents of Springfield:

> MOE: I've lost the will to live.
>
> MARGE: Oh, that's ridiculous, Moe. You've got lots to live for.
>
> MOE: Really? That's not what Reverend Lovejoy's been tellin' me. Wow, you're good. Thanks. ("In Marge We Trust")

Thus, Marge's ethical standards are independent of those taught by Springfield's most prominent religious authorities.

Many moral philosophers, even religious moral philosophers, share Marge's doubts about the divine command theory.[18] The great ancient Greek philosopher Plato (Aristotle's teacher at the Academy in Athens) has had an especially influential role to play in this tradition. In his classic dialogue *Euthyphro*, Plato points out that morality would become utterly arbitrary if the divine command theory were true.[19] God could then command us to do anything whatsoever, and His simply commanding it would make it morally right. However, this general line of argument goes, it seems absurd to suggest that God's mere command could make mass murder or rape acceptable, and so the divine command theory must be flawed. Moral philosophy

[18] Reverend Lovejoy himself even admits that Biblical teachings have their shortcomings; while counseling Marge in "Secrets of a Successful Marriage," he asks, "Y'ever sat down and read this thing? Technically, we're not allowed to go to the bathroom."

[19] See G.M.A. Grube's translation of the *Euthyphro* in the *Five Dialogues* collection (Indianapolis: Hackett, 1981).

begins not with the observation that God's command makes an action right, but with questions about which qualities make an action right, and thus (perhaps) worthy of divine favor. In any case, Plato's critique has led many moral philosophers to inquire more deeply into such ethical questions, and if these thinkers are correct, then morality can be investigated and understood independently of religion.

Conclusion: "Just do what I would do"

Is Marge the model Aristotelian? No. Like the rest of the cast of *The Simpsons*, Marge is never totally defined, always ready to do or say something to set up a gag for Homer or Bart, even if it seems completely out of character. Indeed, any *Simpsons* character sketch is riddled with contradictions by the very nature of the show; as Burns says in "Team Homer," "I've had one of my characteristic changes of heart." Nevertheless, Marge typically follows the Aristotelian recipe for a happy, moral life, and with great success. The good to which she looks in making her decisions (moral or otherwise) is the good of her family, and therefore herself. She makes these decisions not because she hopes that they will be reciprocated, but because they are reciprocated by their very nature; what is good for them is good for her. In Marge we see that Aristotle's moral virtues can be successfully applied not just in the abstract, ivory towers of academia, but in the real, workaday cartoon world. Her bravery, honesty, temperance, and other virtues cannot be denied, and neither can her resulting happiness. Marge enjoys being brave, honest, and temperate because those qualities help her to help her family. Her happiness justifies her life of Aristotelian virtue and proves that people (or cartoon people anyway) can live moral lives regardless of their religious convictions.

Like so many people today, then, Marge might best be described as a Christian-flavored Aristotelian. Such folks favor the underlying message of peace on earth and good will toward men, but disregard many of the Bible's rigid moral rules, sanitary guidelines, and dietary requirements. Instead of trying to follow "all the well-meaning rules that don't work out in real life" like Flanders, people like Marge can support capital punishment, vote pro-choice, and still sit comfortably in church on Sunday with the knowledge that their ethical decisions are

based on reason and conscience, not just blind faith. Indeed, Marge is much less concerned with being a good Christian than with being a good person.

5

Thus Spake Bart: On Nietzsche and the Virtues of Being Bad

MARK T. CONARD

For the present, the comedy of existence has not yet "become conscious" of itself. For the present, we still live in the age of tragedy, the age of moralities and religions.

—NIETZSCHE[1]

JESSICA LOVEJOY: You're *bad*, Bart Simpson.

BART: No I'm not! I'm really—

JL: Yes you are. You're bad . . . and I like it.

BART: I'm bad to the bone, honey.[2]

Good Girls and Bad Boys

You know the stories: he cut the head off the statue of Jebediah Springfield; he burned down the family Christmas tree; he shoplifted a copy of Bonestorm; he cheated on an IQ test and got himself placed in genius school; he fooled the town into thinking there was a little boy trapped down a well, etc., etc., etc. Bart Simpson isn't some loveable little scamp who always seems to find himself in trouble; he isn't a rebel with a heart of

[1] Friedrich Nietzsche, *The Gay Science,* trans. Walter Kaufmann (New York: Vintage, 1974), section 1, p. 74.

[2] "Bart's Girlfriend."

gold. He's a wise-cracking delinquent, a bad boy in bright blue pants, a spoiler, one of Satan's minions—if you believe in that sort of thing.

You probably think it's his sister, Lisa, who's the virtuous one. She's bright, talented, very logical, rational, sensitive. She has principles: she fights injustice as she sees it; she's a vegetarian because she believes in animal rights; she stands up against the greedy Mr. Burns's excesses; and she has love and compassion for her friends and family, and indeed for all those who are less fortunate. She's the little girl we love to love. You'd probably say she's the only admirable character on the show.

Well, let me tell you about another bad boy, the bad boy of philosophy (what—you didn't think philosophy *had* bad boys?). His name was Friedrich Nietzsche, and—*philosophically*—he's as bad as they come, honey. He too was a kind of wise-cracking philosophical delinquent. He bucked authority, he was a spoiler. And one of Satan's minions?—hell, he wrote a book called *The Antichrist!* He seemed to hate everything, every ideal that most people love and hold dear to themselves—more, he would tear down those ideals by cleverly showing how they were interconnected with things that those same people hate. He rebuked religion, he laughed at pity. He called Socrates a buffoon who got himself taken seriously. He called Kant a decadent, Descartes superficial, and John Stuart Mill a flathead! He infamously wrote in *Thus Spake Zarathustra*, if you're going to women, "Don't forget the whip!"[3]

Now, while Nietzsche rejected and even laughed at the traditional ideal, the so-called "good person," the compassionate, religiously virtuous person, he forged something of his own ideal: the free spirit; the person who rejects traditional morality, traditional virtues; the person who embraces the chaos of the world and gives style to his character.

Could it be that from a Nietzschean perspective we've been admiring the wrong character? Might Lisa Simpson be part of what Nietzsche calls world-slandering weariness, decadence,

[3] *Zarathustra* is a fictional work, and thus the line is said by a fictional character, namely, a little old woman who is advising the prophet Zarathustra. Consequently, it's not at all clear whether this represents Nietzsche's own thinking, though he was known for saying some ridiculously awful things about women. On the other hand, it's not even clear who the whip is for!

slave morality, resentment? Sure, it's fun to be bad, but might there be something healthy and life-affirming, something philosophically important about it? Could Bart Simpson be, in the end, the Nietzschean ideal?

The Birth of Comedy:
Appearance vs. Reality

In order to answer the above questions, we need to understand why Nietzsche was the philosopher's bad boy, and why he extolled the virtues of acting out (so to speak).

In his earliest works, Nietzsche was very much influenced by the philosopher Arthur Schopenhauer, who was a particularly unfunny man. As legend has it, for example, he once threw an old lady down a flight of stairs. Now, among other things, Schopenhauer held a version of the division between appearance and reality. He believed that the world as we experience it, as things, people, trees, dogs and Squishies, is only a kind of surface appearance or, in his words, a representation. Underneath or behind this appearance is the true nature of the world, which he called will. This will is a blind, ceaseless, driving force, the same force and will that we find in ourselves as the sex drive, for example, or as the instinct for Duff Beer. Because the will is an endless striving, desires are sated but arise over and over again. You drink a Duff (or ten), get drunk, and your desire is momentarily satisfied. But tomorrow the desire arises anew. Now, Schopenhauer believed that to desire and to have one's desires frustrated is to suffer, and thus since there is no ultimate end to the desire, no ultimate satisfaction, life is perpetual suffering.

In his first book, *The Birth of Tragedy*, Nietzsche clearly adopts this Schopenhauerian dualistic view of a distinction between appearance and reality, will and representation, but interestingly he personifies the word "will," treats it as if it were a conscious agent, and refers to it as "the primal unity."[4] Now, the word "aesthetics," which has to do with the study of art and beauty, is derived from the Greek word, "*aisthetikos*," which

[4] Friedrich Nietzsche, *The Birth of Tragedy*, trans. Walter Kaufmann (New York: Vintage, 1967), section 4, p. 45.

refers to the perceptive quality, or the appearance of things. Since the world as representation, the world we experience around us everyday, *is* an appearance, Nietzsche in this first work talks about this world as if it were a kind of artistic creation of this personified primal unity at the heart of things: "[W]e may assume that we are merely images and artistic projections for the true author, and that we have our highest dignity in our significance as works of art—for it is only as an *aesthetic phenomenon* that existence and the world are eternally *justified* . . ."[5] The "true author" is of course the primal unity, but—continuing the anthropomorphism—why does it project us and the rest of the world, why does it do art? Nietzsche says:

> . . . the truly existent primal unity, eternally suffering and contradictory . . . needs the rapturous vision, the pleasurable illusion, for its continuous redemption. And we, completely wrapped up in this illusion and composed of it, are compelled to consider this illusion as the truly nonexistent—i.e., as a perpetual becoming in time, space and causality—in other words, as empirical reality.[6]

The world as we know it, the everyday world, the world as representation, is a mere illusion, the "truly nonexistent." And at its heart, reality is so awful—a ceaseless, blind, driving, ultimately aimless and therefore unsatisfied and suffering will—that to see into this heart, to understand the true nature of existence, is debilitating. What's more, the curse of human beings is to be (able to be) aware of their situation, to realize the nature of the world and to want to put it right. But of course that's impossible. Nietzsche says: "Conscious of the truth he has once seen, man now sees everywhere only the horror or the absurdity of existence."[7]

According to Nietzsche, art, and only art, is our saving grace:

> Here, when the danger to his will is greatest, *art* approaches as a saving sorceress, expert at healing. She alone knows how to turn these nauseous thoughts about the horror or absurdity of existence into notions with which one can live: these are the *sublime* as the

[5] *Ibid.*, section 5, p. 52.
[6] *Ibid.*, section 4, p. 45.
[7] *Ibid.*, section 7, p. 60

artistic taming of the horrible, and the *comic* as the artistic dis-
charge of the nausea of absurdity.[8]

We and the primal unity alike, having grasped the meaningless
chaotic nature of things, both need the "rapturous vision" and
the "pleasurable illusion" for our "continuous redemption"; we
need it really just to survive.

The Birth of Tragedy concerns the way the ancient Greeks
dealt with the horror and the absurdity of existence: through art,
specifically Attic tragedy, they were able to overcome the horri-
ble truth, they were able to find redemption. According to
Nietzsche, this is the healthy, honest way to face chaotic, mean-
ingless existence. But there are unhealthy and dishonest ways as
well. These consist mainly in denying the meaninglessness, the
absurdity, the chaos, the horror, turning away from it, lying to
oneself and others about the nature of reality. In Ancient
Greece, this unhealthiness and dishonesty is embodied, accord-
ing to Nietzsche, in the person of Socrates. He says:

> . . . there is, to be sure, a profound *illusion* that first saw the light
> of the world in the person of Socrates: the unshakable faith that
> thought, using the thread of causality, can penetrate the deepest
> abysses of being, and that thought is capable not only of knowing
> being but even of *correcting* it.[9]

Instead of acknowledging the true character of the world and
learning to deal with the chaos, Socrates believed that thought
was capable of not only grasping and understanding the world,
but also of fixing it. Nietzsche goes on to say:

> Socrates is the prototype of the theoretical optimist who, with his
> faith that the nature of things can be fathomed, ascribes to knowl-
> edge and insight the power of a panacea, while understanding
> error as the evil *par excellence*.[10]

We all know Socrates to be the supremely rational person.
Reason is not only our guide to understanding the world, he

[8] *Ibid.*, section 7, p. 60
[9] *Ibid.*, section 15, p. 95
[10] *Ibid.*, section 15, p. 97

tells us, but it is the key to living well, and evil is only ignorance. For Nietzsche, in this earliest work, this is a grand mistake, a symptom of degeneration and weakness; it is a lie we tell ourselves because we're too weak to face reality.

It's clear that if our world is chaotic, meaningless and absurd, the Simpson universe is even more so. Think of the craziness that we witness from episode to episode. Jasper mistakes Friday's pills for Wednesday's and instantly turns into some kind of werewolf-like creature; Mr. Burns is simultaneously seventy-two and a hundred and four years old; Maggie manages to shoot Mr. Burns; Aunt Selma finds husband after husband; Marge and Chief Wiggum have the same color blue hair; and nobody ever gets any older.

The point I want to make here is that in Springfield, the town without a state, Lisa plays the role of Socrates, the theoretical optimist. Despite being confronted with the chaotic, absurd world around her, she persists in believing that reason can not only help her to understand that world but correct it. She tries to stand up for animal rights; she tries to cure Mr. Burns of his greediness and Homer of his ignorance. She tries to mold Bart's character, to teach him how to be virtuous. She uses flashcards to try and teach Maggie such words as "credenza," even though Maggie never speaks. Lisa struggles from week to week to penetrate the dark, abyssal clouds of absurdity and meaninglessness, vice and ignorance, with her razor-sharp intellect and her reason. But, alas, nothing ever really changes. Mr. Burns remains greedy, Homer ignorant, Bart vicious, and Springfield at large absurd. Consequently, from a Nietzschean point of view, the tables might be turned on Lisa. All the characteristics and virtues for which we admire and praise her might in fact be symptoms of a Socratic sickness, a hyper-rational weakness, a flight from reality into illusion and self-deception.

But even if this is true, even if this is the way we ought to view Lisa, that doesn't automatically mean that Bart, the rebel, the spoiler, the maker of fart noises, and the nightmare of Sunday school teachers and babysitters, is to be admired.

Life as Art, Or at Least as a Cartoon

Soon after *The Birth of Tragedy*, Nietzsche abandoned any form of dualism, he rejected the split between representation and

will, appearance and reality. In this later view, Nietzsche claims there is only the chaotic flux; flux is the only reality: "The reasons for which 'this' world has been characterized as 'apparent' are the very reasons which indicate its reality," Nietzsche says; in other words, the fact that it becomes, that it's in flux, means that it's real; "any other kind of reality is absolutely indemonstrable."[11]

So why did we ever believe there was something beyond what we experience, beyond "this" world, why did we ever think there was a distinction to be made between appearance and reality? One of the main reasons, Nietzsche says, is because of the structure of language. We see actions, deeds, being performed (that is, we experience phenomena in the chaotic world around us), and the only way we can make sense of these actions or phenomena, to grasp them, is to project behind them, by means of language, some stable subject which causes them. ("I" run; "you" yell; "Nelson" punches.) Because thinking and language cannot describe or represent a world in flux, it is necessary to speak as if there were stable things which have properties, and stable subjects which cause actions. This limitation of thought and language then gets projected into the world. We actually come to believe in unity, substance, identity, permanence (in other words, being). Nietzsche says:

> . . . the popular mind separates the lightning from its flash and takes the latter for an *action*, for the operation of a subject called lightning . . . But there is no such substratum; there is no "being" behind doing, effecting, becoming; "the doer" is merely a fiction added to the deed—the deed is everything. The popular mind in fact doubles the deed; when it sees the lightning flash, it is the deed of a deed: it posits the same event first as cause and then a second time as its effect. [12]

We say, "lightning flashes," but are there really two things, the lightning *and* the flash? No, of course not. But this seems to be the only way we're able to grasp and express things. We have to

[11] Friedrich Nietzsche, *Twilight of the Idols*, "Reason in Philosophy," from *The Portable Nietzsche* (New York: Penguin, 1954), section 6, p.484.
[12] Friedrich Nietzsche, *On the Genealogy of Morals*, "'Good and Evil', 'Good and Bad'" (New York: Vintage, 1967), section 13, p. 45.

use a subject, "lightning," and a verb, "flashes," in order to express what we've experienced. But in so doing, we trick ourselves into believing that there's some stable thing behind the action which in fact causes it. That is, because we have the subject/predicate distinction built into our language, we come to believe that this adequately mirrors the structure of reality. But this is a mistake. We say, "Homer eats," "Homer drinks," "Homer belches," when in reality there is nothing called "Homer" beyond the eating, drinking, and belching. There is no being behind the doing. Homer just is the sum of his actions, and no more.

This distinction between doer and deed petrified in our language is the beginning of the split between appearance and reality, Nietzsche tells us, and gets transformed by Plato, for example, into the forms/particulars dichotomy; by Schopenhauer into the will/representation distinction; and by Christians into the split between heaven and earth, God and man. "I am afraid we are not rid of God because we still have faith in grammar,"[13] Nietzsche says.

Before going on to talk about Nietzsche's reversal of the traditionally "good" and traditionally "bad," I want to point out that, though of course TV hadn't yet been invented when Nietzsche lived, and though animation was the farthest thing from his mind, a cartoon like *The Simpsons* may be the perfect embodiment of (or metaphor for) Nietzsche's insight about the fiction of the "doer" being projected behind the "deed." That is, in a show like *The Simpsons* there truly is no being behind the doing. What you see is what you get. Homer, Bart, Lisa, Marge, and Maggie are indeed no more than the sum of their actions. There is no substance, no ego, no being behind the phenomena, which then causes those actions. A cartoon is of course purely phenomenal, pure appearance; there aren't even actors on screen or on stage portraying the characters, who can, as it were, take off the mask and step away from the character. What more is there to Bart than his weekly misdeeds? The answer: nothing. There couldn't be anything more to him. He is purely the sum of what he does. Nietzsche's insight, again, is that this is not only the way cartoons work; this is the way the world is,

[13] Friedrich Nietzsche, *Twilight of the Idols*, "Reason in Philosophy," from *The Portable Nietzsche*, section 5, p.483.

the way reality is constructed. The world is a chaotic, meaning-less flux of becoming, and to be real, to be a part of the world, to be a part of the flux, *is* to appear. The appearance doesn't mask reality; the appearance is reality. Or, better: we can now do away with these concepts, appearance and reality, alto-gether. All we can really say is, there is the flux.

The Nietzschean Ideal

To repeat, in his earliest writings, Nietzsche held that the world was divided into appearance and reality, will and representa-tion, a view which he soon repudiated by claiming that there's nothing masking the chaos, there is no being behind doing. Now, here's the really interesting consequence of this shift in his position: As opposed to the earlier view, in which we were mere phenomena of the underlying will, artistic projections, art works for the primal unity which is the true artist and spectator, we are now both will and phenomenon, or rather, these are the same thing. Thus we ourselves become artist, spectator, and art-work all in one: "As an aesthetic phenomenon existence is still *bearable* for us, and art furnishes us with eyes and hands and above all the good conscience to be *able* to turn ourselves into such a phenomenon."[14] Nietzsche has obliterated the distinction between art and life. Consequently, since it is as an aesthetic phenomenon, as an artistic endeavor that existence is justified or redeemed, Nietzsche moves from talking about justification of the world to individual justification. It is as expressions of will, as will manifest, that we are artists and art works combined, and thus we justify ourselves, we provide meaning for our lives, by creating ourselves, through these expressions of will, through our actions.

What would it mean, though, to make an artwork of one's life? Recall that for Nietzsche, abandoning a reality hidden behind appearance means also abandoning any notion of a sta-ble, enduring ego or subject: "The 'subject' is not something given, it is something added and invented and projected behind what there is."[15] Part of what Nietzsche is after here, then, is to

[14] *The Gay Science*, section 107, p. 163.
[15] *The Will to Power*, section 481, p. 267.

construct a self for oneself out of one's various drives, instincts, wills, actions, etc. In his influential work, *Nietzsche: Life as Literature*, Alexander Nehamas tells us: "The unity of the self, which therefore also constitutes its identity, is not something given but something achieved, not a beginning but a goal."[16] In *The Gay Science,* Nietzsche hints at this ideal or project when he speaks of "giving style" to oneself:

> *One thing is needful.*—To "give style" to one's character—a great and rare art! It is practiced by those who survey all the strengths and weaknesses of their nature and then fit them into an artistic plan until every one of them appears as art and reason and even weaknesses delight the eye. . . In the end, when the work is finished, it becomes evident how the constraint of a single taste governed and formed everything large and small. Whether this taste was good or bad is less important than one might suppose, if only it was a single taste![17]

Since the ego is "only a conceptual synthesis,"[18] not something stable or given, it is a part of the flux, like everything else, the goal for Nietzsche becomes to perform this synthesis, to construct an identity for oneself, to create oneself, according to some kind of plan or schema, thus giving "style" to one's character.

This Nietzschean ideal culminates in the figure of the *Übermensch*, or overman, the being who has achieved this very difficult project of making an artwork out of his life, the self-creating being. Nehamas says: "*Thus Spoke Zarathustra* is constructed around the idea of creating one's own self or, what comes to the same thing, the *Übermensch.*"[19] And Richard Schacht says: ". . . the 'overman' is to be construed as a symbol of human life raised to the level of art. . ."[20]

[16] Alexander Nehamas, *Nietzsche: Life as Literature* (Cambridge: Harvard University Press), 1985, p. 182.

[17] *The Gay Science*, section 290, p. 232-3.

[18] *The Will to Power*, section 371, p. 200.

[19] Alexander Nehamas, *Nietzsche: Life as Literature*, p. 174.

[20] Richard Schacht, *Making Sense of Nietzsche*, "Making Life Worth Living: Nietzsche on Art in *The Birth of Tragedy*" (Urbana: University of Illinois Press), 1995, p. 133.

Sure, It's *Fun* To Be Bad, But Might It Also Be . . .

I discussed above "Socratic optimism," the belief that the universe is intelligible and meaningful, and how it is a means to avoid accepting and embracing the chaotic meaningless flux of existence. Throughout his life, Nietzsche never ceases to rail against those who he claims deny reality, those who aren't strong enough to affirm life the way that it is. These include most traditional philosophers and virtually all religions. What they tend to have in common, Nietzsche says, is that they posit a fictitious other world, something beyond, as the denial of the here and now, the flux, in an effort to comfort themselves. Plato, for example, believes in a realm of eternal and unchanging forms, beyond this world of transient and unstable particulars. Christians posit as their "other" God, heaven, and a soul, standing in opposition to human beings, the earth, and the body. In other words, this world is chaotic and meaningless and therefore unendurable; consequently, in order to make myself feel better, I'll believe that there is something which is the opposite, something which is eternal rather than transient, stable rather than chaotic, and meaningful rather than meaningless.

This would be all well and good, were it not for a couple of very dire consequences, Nietzsche says. First, in positing a world of infinite value, reality, the here and now, is divested of any possible value that it might have. Just because the world, as it is, is inherently meaningless, doesn't mean that nothing has value. Value is something that is generated by human beings, in the way we lead our lives, and through our relationships to things and to other people. Our lives and this world have value because we invest them with value. But when we create and believe in a beyond that is of infinite value, something that's eternal and unchanging, the here and now, reality, in comparison, is emptied of any possible value. What worth does the earth or my body have in comparison to heaven and my immortal soul? What value do the particulars in the world have, in comparison to Plato's eternal forms? None, of course! All worth, all value is transferred out of the world, out of this life to a nonexistent beyond, leaving us with a world worth nothing.

Second, this kind of thinking is not just a private consolation. Those who believe in a beyond traditionally have wanted to

force others, and indeed typically the rest of the world, to accept that belief too. In the first essay of *On the Genealogy of Morals*, "'Good and Evil,' 'Good and Bad'," Nietzsche tells the story of how moral valuations first came about. The judgment, "good," Nietzsche says, first arose when the strong, the healthy, the active, the noble, designated themselves and everything like them as "good":

> [I]t was "the good" themselves, that is to say, the noble, powerful, high-stationed and high-minded, who felt and established themselves and their actions as good, that is, of the first rank, in contradistinction to all the low, low-minded, common and plebian.[21]

The strong nobles, as an affirmation of themselves and everything that was like them, coined the word, "good," to designate themselves and their kind. In contrast, rather as an afterthought, they designated everything that was not like them, everything weak, sickly, ignoble, as "bad," not, mind you, as any kind of condemnation. These terms didn't yet have any kind of moral connotation attached to them. The nobles had no sense that things could or ought to be different, that a bad person was in any way responsible for being bad. This mode of valuation was simply a way of distinguishing themselves, and of designating those who were not like them.

Nietzsche refers to this mode of valuation as "master morality," and he doesn't pull any punches in describing these early "masters" or "nobles": Indeed, they were strong, healthy, and active, but they were also uneducated, lacking in self-reflection, and they were violent. They took what they wanted, robbed, raped, pillaged, all because they could, because they were strong enough to do so, and because they enjoyed it. Think of Nelson and his cronies. They beat up kids, take their lunch money, steal their cupcakes, all with seeming impunity. Why? Because they can, of course. No one is tough enough to stop them.

Now, the "bad," as designated by the nobles, the weak, the sickly, the ignoble and inactive, of course didn't like being

[21] *On the Genealogy of Morals*, "'Good and Evil', 'Good and Bad'," section 2, p. 26.

beaten up and having their cupcakes stolen. But there was nothing they could do about it. They weren't strong enough to stand up for themselves. Consequently, there developed in them a deep, festering, hateful resentment against the nobles. This festering resentment, then, is the origin of "slave morality":

> The slave revolt in morality begins when *ressentiment* itself becomes creative and gives birth to values: the *ressentiment* of natures that are denied the true reaction, that of deeds, and compensate themselves with an imaginary revenge. While every noble morality develops from a triumphant affirmation of itself, slave morality from the outset says No to what is "outside," what is "different," what is "not itself"; and *this* No is its creative deed. This inversion of the value-positing eye—this *need* to direct one's view outward instead of back to oneself—is of the essence of *ressentiment*: in order to exist, slave morality always first needs a hostile external world; it needs, physiologically speaking, external stimuli in order to act at all—its action is fundamentally reaction.[22]

Out of his resentment for being weak, sickly, for being maltreated and being unable to do anything about it, the "slave" *reacts*, he screams No at what is different, at the noble, at what he wishes he could be. He labels the noble, "evil," and as an afterthought calls himself, "good."

Nietzsche doesn't mean to say that these people were actually and literally slaves. He's using that term to designate the weak, sickly type of man whose morality springs from resentment. What this "slave," this weak man wants, more than anything, is to be strong, to be healthy and active, to take, to conquer, to rule; he wants to be like the noble. Unable to do this, he exacts his revenge upon the strong and healthy. First, Nietzsche says, the slave's weakness is transformed into "something meritorious"; his "impotence which does not requite [is changed] into 'goodness of heart'; anxious lowliness into 'humility'; subjection to those one hates into 'obedience'."[23] His inability to be strong, healthy and active is reinterpreted as a virtue,

[22] *Ibid.*, section 10, p. 36–37. Nietzsche likes to use the French word, "*ressentiment.*" For an explanation, see Walter Kaufmann's Introduction to the *Genealogy.*

[23] *Ibid.*, section 13, p. 47.

as something desirable, and of course the commanding strength and vitality of the "master" is, in contrast, redefined as something reprehensible. Then, in a crafty and underhanded move, the weak man devises his heaven as the kingdom where *he* will rule, and where the strong will be punished for their strength: "These weak people—some day or other *they* too intend to be the strong, there is no doubt of that, some day *their* 'kingdom' too shall come—they term it 'the kingdom of God,' of course . . ."[24] The meek shall inherit the earth, and the "evil" will be punished for eternity. Nietzsche says: "When the herd animal is irradiated by the glory of the purest virtue, the exceptional man must have been devaluated into evil."[25]

Slave morality triumphed, of course. The weak were able to convince the simple-minded nobles that weakness, humility, obedience, pity, etc., are virtues, and that strength, action, vitality, etc. are vices. According to Nietzsche, this was a calamity of unimaginable proportions. Strength, health, vitality, an ability to not only accept the chaos of the world, but to embrace it and to mold it into something beautiful—these are the very traits and characteristics necessary for the person who is capable of investing his life and this world with meaning, with value and worth, to actually do so. And not only have they been lied and vilified into something repugnant, but the earth and this life have been devalued. Consequently, we're left with a valueless, devalued existence and are powerless to reinvest it with meaning, with vitality, with worth.

This, then, is the root of Nietzsche's "bad boy" persona, why he bucks tradition and morality, why he reviles most things that the majority of us weaklings take to be the most important, but which, he claims, are really life-denying, life-slandering, and dangerous. Consequently, he counsels us to go "beyond good and evil," to move beyond the "slave morality," to stop transferring value and worth out of this world and out of this life, and to have the strength and courage to embrace the chaos of existence and our lives and to forge something meaningful out of it.

[24] *Ibid.*, section 15, p. 48.

[25] Friedrich Nietzsche, *Ecce Homo*, "Why I Am a Destiny" (New York: Vintage, 1967), section 5, p. 330.

Bart the *Übermensch?*

Okay, so Nietzsche is the philosopher's bad boy, and Bart Simpson is Springfield's bad boy. Certainly Bart bucks authority, and he has rejected (or perhaps never actually adopted) traditional morality. Trying to convince Mr. Burns to allow him to come along to retrieve the Flying Hellfish bonanza, for example, he says: "Can I go with you to get the treasure? I won't eat much and I don't know the difference between right and wrong."[26] But would Nietzsche have approved of Bart? Could Bart in some way be an exemplar of the Nietzschean (reverse) ideal? Alas, the answer is clearly no.

First—and many people make this mistake—even though Nietzsche condemns "slave morality," calling it world-slandering and life-denying, he is not at all advocating master morality. The masters were violent, unthinking brutes. Nietzsche is not holding them up as an ideal, saying we should be like them, that might makes right, etc. He's not counseling us to bully others, take their lunch money, and eat their cupcakes. So even if Bart were to adhere to a master morality ethic—and it seems that this characterization would fit Nelson and Jimbo better than him—that still wouldn't make him an exemplar of the Nietzschean ideal.

No, Nietzsche's ideal is more the artist, the self-overcoming, self-creating individual, who forges new values, who makes an artwork out of his life. And I think we'd be hard-pressed to describe Bart in this way. He does seem at times to have a sense of the chaos of the world and his existence. For example, hoping to play Fallout Boy in the new Radioactive Man film, he says: "If I get this role, I can finally come to terms with this funny little muddle called Bart."[27] He realizes that his life is chaotic, that he's a "funny little muddle," which needs to be given form. And indeed there does seem to be a consistent sort of style to his character, but the way he defines himself is largely *re*active, and this is of course something that Nietzsche would not condone at all. What I mean is that Bart largely defines himself and forges his identity, not as some kind of triumphant affirmation of his

26 "The Curse of the Flying Hellfish."
27 "Radioactive Man."

talents and abilities, not as a grand and creative weaving-together of the disparate elements of his self, but rather he defines himself in opposition to authority. For example, Bart accidentally gets Principal Skinner fired when he brings Santa's Little Helper to school for show-and-tell. Ned Flanders fills in as principal, eliminates detention, puts all the kids on the honor system, and serves peanut butter cups and Yoo-Hoo to whomever gets sent to his office. Bart and Skinner become friends, oddly enough, and then after Skinner re-enlists in the army, Bart realizes that he misses Skinner's authoritarian (as opposed to Flanders's very lax) rule. Lisa tells him why:

BART: It's weird, Lis: I miss him as a friend, but I miss him even more as an enemy.

LISA: I think you need Skinner, Bart. Everybody needs a nemesis. Sherlock Holmes had his Dr. Moriarty, Mountain Dew has its Mellow Yellow, even Maggie has that baby with the one eyebrow.[28]

Everyone may need a nemesis, but while Holmes had a distinct character all his own and thus used Dr. Moriarty simply to test his formidable skills, Bart actually seems to create or define himself precisely in opposition to authority, as the other to authority, and not as some identifiable character in his own right.

In one very telling episode, the entire town of Springfield is convinced by self-help guru Brad Goodman that they ought to act like Bart, and "do what they feel like." News anchorman Kent Brockman curses on live TV and sprays his mouth full of whipped cream; Reverend Lovejoy plays Marvin Hamlisch (very poorly) on the church organ in front of the congregation; Aunt Patty and Aunt Selma ride naked through town on horseback. Seeing that everyone is following his lead, Bart proclaims to his sister: "Lis, today I am a god."

But Bart soon finds that having everyone do as he does is not all ham and plaques. He wants to respond to Mrs. Krabappel's questions in class, but everybody is giving wise-cracking answers. He wants to do some of his "patented spitting off the overpass," only to find dozens of people already standing there

[28] "Sweet Seymour Skinner's Baadasssss Song."

hocking lugies. Bart is not happy, and again it is Lisa who provides the answer to why:

> BART: Lis, everyone in town is acting like me. So why does it suck?
>
> LISA: It's simple, Bart: you've defined yourself as a rebel, and in the absence of a repressive milieu your societal nature's been co-opted.
>
> BART: I see.
>
> LISA: Ever since that self-help guy came to town, you've lost your identity. You've fallen through the cracks of our quick-fix, one-hour photo, instant oatmeal society.
>
> BART: What's the answer?
>
> LISA: Well, this is your chance to develop a new and better identity. May I suggest . . . good-natured doormat?
>
> BART: Sounds good, sis. Just tell me what to do.[29]

Bart's whole identity is created around rebelling, bucking authority. Consequently, when the authority disappears, Bart loses his identity. He no longer knows who and what he is. Interestingly, Lisa, in all her wisdom, suggests to Bart that he forge a new identity, a good-natured doormat, presumably a Ned Flanders-like goody-goody, over whom people (like Homer) walk. Bart, not knowing how to go about such a thing, wants her to tell him what to do. In other words, again, far from being the Nietzschean self-overcoming, self-creating ideal, the being who actively gives style to his character and forges new values, Bart is still looking to identify himself reactively, in response to others, through the mediation of others (both through Lisa, who will instruct him what to do, and through others who, presumably, will be the ones to walk over him). In a "repressive milieu," Bart is the anti-authority, he does everything his parents and teachers forbid him to do—that's just who he is, and that's *all* he is. In the absence of that milieu, Bart flounders and grasps for someone to help define and create himself.

Bart may in fact represent the precariousness of our position in a post-Nietzschean world. That is, according to Nietzsche we

[29] "Bart's Inner Child."

must go "beyond good and evil," and leave all our metaphysical comforts behind: God, heaven, soul, a moral world order, and so on. But, in abandoning another world, a beyond, we're in great danger of slipping into nihilism: "The most extreme form of nihilism would be the view that *every* belief, every considering-something-true, is necessarily false because there simply is no *true world*."[30] He goes on to say: "One interpretation has collapsed; but because it was considered *the* interpretation it now seems as if there were no meaning in existence, as if everything were in vain."[31] In other words, once we abandon any notion of some eternal and perfect beyond, and are left with only the chaotic flux that is the world, we're in danger of falling into an anything-goes nihilism, an intellectual and moral free-for-all. While the possibility of such a thing terrified Nietzsche, it wasn't something he had to face. In his lifetime, the Western world was still a very religious and oppressively moral place. Consequently, it made very good sense—and indeed, it was an act of great courage and foresight—to act out the way he did, to buck tradition, to rebuke the church. The last thing Nietzsche wanted to do was create another religion, another eternal and absolute system, so, once he'd acted out, all he could do was counsel his readers to invest their lives with meaning, to embrace the chaos and make artworks out of their lives.

But what are *we* supposed to do, now that the dark blanket of nihilism has slipped over us (and if you're not aware of it, trust me it has)? There's a thin fuzzy line between continuing to act out, continuing to rebuke and destroy the old idols in an effort to forge a new path, new values, on the one hand; and on the other hand immersing ourselves in the nihilism, engaging in the intellectual and moral free-for-all, not taking anything seriously, believing that, since there are no absolute values, nothing is of any real value. Bart, the boy in the bright blue pants, may indeed represent this nihilistic danger. He has no (or few) virtues; he has no creative spirit; he has accepted the chaos of existence, but not in such a way as to form it and forge something beautiful out of it; he accepts and deals with it in a sort of spirit of resignation. Nothing really means anything, so why not

[30] *The Will to Power*, section 15, p. 14.
[31] *Ibid.*, section 55, p. 35.

act out, why not do what I feel like? He rejects, rebukes and reviles, not in an effort to destroy old, life-slandering, life-denying and hollow idols, but really out of a lack of a solid identity, a lack of any kind of complete self.

Comedy Becoming Conscious

Yes, sadly, in the end Bart may just be part and parcel of the decadence and nihilism that pervades our era. And in that respect we might look upon him as a kind of cautionary example: this is what Nietzsche was trying to warn us about. But, and to end on a happier note, even though Bart isn't our Nietzschean hero and may be an example of nihilistic decline, *The Simpsons* may as a whole be something more. Our lives and the world are no less chaotic and absurd than they were for the ancient Greeks, and if, as Nietzsche says, their comedy was a necessary "artistic discharge of the nausea of absurdity,"[32] then perhaps *The Simpsons* might serve that function for us as well. As a social satire, a commentary on contemporary society, the show often achieves stunning brilliance; it is often truly excellent, in the best Greek sense of the word. And it usually achieves this excellence by taking the disparate elements of our chaotic American lives and molding them together, giving them form, giving them style, forging them into something meaningful and sometimes even beautiful. Even if it is only a cartoon.

[32] *The Birth of Tragedy*, section 7, p. 60.

Simpsonian Themes

6

The Simpsons and Allusion: "Worst Essay Ever"

WILLIAM IRWIN and J.R. LOMBARDO

"A lot of talented writers work on the show, half of them Harvard geeks. And you know, when you study the semiotics of *Through the Looking Glass* or watch every episode of *Star Trek,* you've got to make it pay off, so you throw a lot of study references into whatever you do later in life."

— Matt Groening

"We're really writing a show that has some of the most eso-teric references on television. I mean really, really, really, strange, odd, short little moments that very few people get and understand. We're writing it for adults and intelligent adults at that."

— David Mirkin

"I hate quotations. Tell me what you know."

— Ralph Waldo Emerson

Matt Groening says: "*The Simpsons* is a show that rewards you for paying attention." Any fan can confirm the creator's asser-tion, and, in fact, most true fans of *The Simpsons* will tell you its episodes stand up to, and perhaps even demand, repeat view-ing. Thank God for reruns! Among the many reasons why fans continue to view and review *The Simpsons* is the show's rich and clever use of allusion. From the venerable name of "Homer" to Lisa's "Howl," to parodies of *The Raven, Cape Fear,* and *All*

in the Family, The Simpsons links itself to high culture and popular culture alike, weaving an intricate design, making the show fit for repeat viewing and worthy of close attention.

What Is an Allusion?

The Simpsons is rife with satire, sarcasm, irony, and caricature. Often these stylistic elements are linked to the use of allusion in *The Simpsons,* but, to be clear, they are not the same as allusion. The Kennedyesque Quimby and the stereotypical Scot, Willie, are not our direct concern here. Rather, we will train our focus on such references as the birds reminiscent of *The Birds* and the "yabba dabba doo's" that link Springfield to Bedrock. By definition, an allusion is an intended reference that calls for associations that go beyond mere substitution of a referent.[1] An ordinary reference allows us to easily substitute one term or phrase for another. For example, "the author of *Hamlet*" refers to Shakespeare. An allusion, however, calls for us to go beyond such substitution. For example, in "Lisa The Simpson," in which Homer tries to show Lisa that the "Simpson gene" has not caused all Simpsons to be dim-witted failures, one of Homer's relatives informs us that he runs an "unsuccessful shrimp company." This is clearly intended as an allusion to *Forrest Gump.* Notice, though, that we are not merely to substitute one term or phrase for another. Rather, to really get the allusion, we must make additional associations. Gump, though mentally challenged, runs the hugely successful *Bubba Gump Shrimp Company* ("It's a household name"). The allusion suggests that the Simpson relative is so doltish and unlucky that he cannot succeed in a business in which even the mentally challenged prosper.

The intent driving many allusions is for the audience to bring to mind certain things and to let other connections flow freely. For example, the episode titled "The Day the Violence Died" not only alludes to an allegorical and allusive Don Mclean dittie, but

[1] We cannot present a theoretical defense of this definition here, but for a fuller discussion and defense of this definition see William Irwin's article "What Is an Allusion?" *The Journal of Aesthetics and Art Criticism,* forthcoming 2001.

includes "Amendment To Be," a parody of "I'm Just a Bill." In this case, not only is it intended that we recognize that this cynical political commentary is poking fun at the sweet and sincere Schoolhouse Rock classic, but we are to recall the pleasant memories and sugared cereal highs of Saturday mornings long since gone. If there was any doubt about this at the beginning of "Amendment To Be," it is quickly erased when Lisa explains to Bart, "It's one of those crappy seventies throwbacks that appeals to Generation Xers."

Does an allusion have to be intended? Surely there are many connections that the careful viewer can make in watching *The Simpsons,* and not all of these could have been intended by the writers of the show. Such connections are not allusions, but rather "accidental associations." They are "accidental" not in any negative sense, but in accord with the etymology of 'accident'; they simply "happen" to be. The motivation for the distinction between allusions and accidental associations is that it is at best inaccurate, and at worst unethical, to attribute an association to a writer—even a cartoon writer—that he did not intend. While it is often difficult to know with certainty if an association was intended or not, clues such as context can make things clear. For example, when Homer sings "I'm gonna make it after all," celebrating his success at his new job in the bowling alley ("And Maggie Makes Three"), the writers intended the allusion to the "career girl" in *The Mary Tyler Moore Show.* Not only is this a line from the show's opening theme song, but Homer throws his bowling ball in the air, parodying the way Mary throws her hat in the air in the show's opening sequence.

One way in which we can be sure that we have an accidental association, rather than an allusion, is when it would be anachronistic to attribute a writer's intention to a certain association. For example, in viewing reruns one might be tempted to see Marge's short-lived career as real estate agent in "Realty Bites" as an allusion to Annette Benning's character, Carolyn Burnham, in *American Beauty.* This, however, would be impossible, given that the episode first aired in 1997 while the movie debuted in 1999. Obviously, one cannot intend a reference to what does not yet exist. (The title "Realty Bites" is, however, pretty clearly an allusion to the 1994 movie *Reality Bites,* and the episode also alludes to elements of the movie *GlenGarry Glen Ross.*) Whatever connections or associations may be drawn

between the episode and *American Beauty* are the viewer's own, and are not attributable to the writers. There may be intertextual elements (as they are fashionably called) which the writers did not actually intend, but which an ideal, or merely reasonable, viewer notices, such as the contrast in the real estate sales techniques of Marge and Carolyn. There is no harm in taking notice of these intertextual elements as long as we do not incorrectly attribute them to the writers' intentions. They are, properly speaking, our accidental associations. To take another example, the educated viewer cannot help but think of the epic poet of Ancient Greece when he or she hears the name Homer. As it turns out though, the character on *The Simpsons* is named after Matt Groening's father, just as the other Simpsons are named after other Groenings. Still, one cannot help but suspect that Groening intends for us to make the connection with the author of *The Odyssey*. After all, this connection is much clearer and actually less esoteric, and it's deliciously ironic. Mmmm . . . irony.

Consider another example. In watching reruns a viewer might mistakenly take Otto's humming "Iron Man" in "Blood Feud" as an allusion to the signature chant of *Beavis and Butthead*. Given that the episode originally aired in 1991 when *Beavis and Butthead* had not yet (dis)graced the airwaves, this is impossible. Otto's choice of tunes is intended to conjure up macabre images of the band who originally recorded the song, Black Sabbath, and its erstwhile lead singer Ozzy Osbourne. One might suggest instead that Mike Judge, the voice and creator of *Beavis and Butthead,* uses "Iron Man" to allude to Otto and *The Simpsons*. Given the timeline this is possible, though improbable. More likely, any connections the viewer makes between *The Simpsons* and *Beavis and Butthead* with regard to Otto's rendition of "Iron Man" are accidental associations, and we should recognize them as such rather than attribute them to the writers. The viewer has the right to be creative in his viewing, but he must yield somewhat to what the writers give us.

Aesthetics of Allusion

Aesthetics is the branch of philosophy that studies the nature of the beautiful and the pleasing, and includes the philosophical

study of art. Why do we find aesthetic pleasure in the allusions others make? Because, as audience members, we enjoy recognizing, understanding, and appreciating allusions in a rather special way. The comprehension of an allusion combines the pleasure we feel when we recognize something familiar, like a favorite childhood toy, with the pleasure we feel when we know the right answer to the big question on *Jeopardy* or *Who Wants to be a Millionaire?* We derive pleasure from understanding allusions in a way we do not from understanding straightforward statements. For example in the episode "Colonel Homer," in which Homer briefly manages the career of country singer Lurleen Lumpkin, a boy on a porch plays the banjo tune from *Deliverance*. This is a far more effective way of telling the audience that Homer has entered a backward, redneck area than any straightforward statement could achieve. The audience derives pleasure both from recognizing the significance of the banjo tune and from recalling a favorite movie, asking themselves: Will Homer end up squealing like a pig?

Audiences enjoy being involved in the creative process; they enjoy filling in the blanks for themselves rather than being told everything. For example, in "A Streetcar Named Marge," Maggie is placed in the "Ayn Rand School for Tots" where the proprietor, Ms. Sinclair, reads *The Fountainhead Diet*. To understand why pacifiers are taken away from Maggie and the other children one has to catch the allusion to the radical libertarian philosophy of Ayn Rand. Recognizing and understanding this allusion yields much more pleasure than would a straightforward explanation that Maggie has been placed in a daycare facility in which tots are trained to fend for themselves, not to depend on others, not even to depend on their pacifiers.

We also like allusions because of their game-like (ludic) quality. There is something playful in making an allusion, and we are, in a sense, being invited to play in considering an allusion. For example, in "Separate Vocations" Lisa becomes a troublemaker at school when a career test suggests that her ideal line of work is that of a homemaker.[2] When Principal Skinner asks her, "What are you rebelling against?" the audience anticipates her response, à la Brando in *The Wild One,* "Whattaya got?"

[2] For further discussion of this episode see Chapter 9 of this volume.

One of the most important aesthetic effects allusion can have is "the cultivation of intimacy" and the forging of community.[3] The clear advantage of making allusions that draw on information that not everyone possesses is that they strengthen the connection between the author and the audience. Author and audience become intimately connected; they become, in effect, members of a club who know the "secret handshake." Such is the case with the "Amendment to Be" allusion to Schoolhouse Rock. Similarly, the recurrent allusions in *The Simpsons* to Hitchcock films such as *The Birds, Rear Window, North by Northwest,* and *Vertigo* forge a bond between audience members (who recognize them) and the writers of the show. Any reader of Ginsberg with a sense of humor could not help but appreciate the writers' wit when they have Lisa utter, "I saw the best meals of my generation destroyed by the madness of my brother / My soul carved in slices by spikey-haired demons." Fans of classic television certainly find endearing the ubiquitous allusions to, and parodies of, memorable *Twilight Zone* episodes. Those who cannot resist watching *The Graduate* (any time they find it during a late night cable surf) feel a kinship and bring forth a chuckle when Grandpa breaks up Mrs. Bouvier's wedding to Mr. Burns by screaming from behind the glass of the church organist's booth ("Lady Bouvier's Lover").

In the case of *The Simpsons,* perhaps nothing does more to cultivate intimacy and forge community than allusions to past episodes. *The Simpsons* does not run a continuous story line from one episode to the next, nor is it particularly linear in its storytelling within a given TV season. Partly for this reason, the appearance of an object from a previous episode has a real effect on the viewer. In "Natural Born Kissers" for example, Homer finds a leaflet from the funeral of Frank Grimes in his sports jacket pocket. To the casual viewer this appears incidental, but to the careful and faithful watcher, the leaflet recalls a favorite episode featuring Homer's nemesis, Frank "Grimey" Grimes. The leaflet also comments on Homer's typical attire, suggesting that the Grimes funeral, nearly one year ago in terms of air dates, was probably the last time Homer wore that sports

[3] See Ted Cohen, *Jokes: Philosophical Thoughts on Joking Matters* (Chicago: University of Chicago Press, 1999), p. 29.

jacket. In "Mayored to the Mob" Benjamin, Doug, and Gary, Homer's study buddies from "Homer Goes to College," dress as Mr. Spock for the Science Fiction Convention. This choice of costume alludes to their nerdy tendencies, as revealed in the earlier episode, though the casual viewer would just assume they were typical (nerdy) attendees at the convention. In "Viva Ned Flanders" one of the Comic Book Guy's bumper stickers reads "Kang is My Co-pilot." This is what we might call a "double allusion." The bumper sticker alludes to the alien who routinely terrorizes the Simpson family in the "Treehouse of Horror" episodes, and *The Simpsons* alien alludes to the Klingon captain of the same name from an episode of the original *Star Trek* series.

There is, to be sure, a certain elitism and exclusion involved in the use of allusion. To cultivate intimacy with some is, sometimes, to exclude others. Not all *Simpsons* viewers will get the overt Ayn Rand allusions; fewer will get the more covert allusions to Ginsberg and Kerouac; very few indeed will realize that Bart's vision of hell allusively makes use of a Hieronymous Bosch painting ("Bart gets Hit by a Car"). Throughout the history of art and literature (and now TV) some have understood cultural allusions while others have not, but the growing numbers of those who do not understand is a problem we must face today. One reason for the current problem is the lack of a substantial shared body of common knowledge, what E.D. Hirsch, Jr. called "cultural literacy" in his acclaimed and defamed bestseller, *Cultural Literacy: What Every American Needs to Know*. Cultural literacy is essential for successful communication and comprehension, as is clear in considering allusions. The cultural literacy presupposed by *The Simpsons* is not always, or even often, highbrow, frequently relying on knowledge of earlier "classic" television shows. This has the effect of excluding younger viewers who are not familiar with the likes of *Yogi Bear, Casper the Friendly Ghost, The Twilight Zone, Knight Rider, Dallas, Twin Peaks, The Smurfs, I Love Lucy, Magilla Gorilla, That Girl, Bewitched,* yada yada yada. This is a point not lost on Homer Simpson, who bemoans the death of "pop-cultural literacy" as he berates Bart for not knowing who Fonzie is. "Who's Fonzie? Don't they teach you anything in school? He freed the squares"("Make Room for Lisa"). Ever the champion of pop-cultural lore from the '70s and '80s, Homer is taken aback by the

kid at the local record store when he tells Homer that Hullabalooza is the greatest rock festival of all time. Homer's response? There's only one great festival, The US Festival. It was sponsored by the guy from Apple Computer. The Kid's response? *What* computer? Hirsch readily admits that cultural literacy is an ever-changing phenomenon, and any list detailing it will be descriptive not prescriptive. Still, I don't think he'd go as far as Homer in adding "Fonzie" and the US Festival to the list of "What Every American Needs to Know," though perhaps Apple Computer still stands a chance.

One way in which *The Simpsons'* use of allusion is aesthetically successful is that it is generally not disruptive. The writers recognize that not everyone will catch all the allusions, and so they craft them in such a way that the allusions enhance our enjoyment if they are caught, but do not detract from the enjoyment of the show if they are missed. The finely blended texture of the allusions in *The Simpsons* allows both the old and young, sophisticated and naïve, educated and ignorant, to enjoy the same show. In fact, the true test of the comic and aesthetic success of *The Simpsons'* use of allusion is to watch the show alongside a child. If the child laughs at an obscure allusion, we know it's because of the humor and not because he has "gotten it." The blending has succeeded. For example in "Trash of the Titans" the band plays a brief flare from the *Sanford and Son* theme-song as Homer is ousted and Sanitation Commissioner Patterson is reinstated. If one does not recognize the musical allusion to *Sanford and Son,* one can still salvage an understanding. In fact, part of the beauty of the allusion is that it blends into the scene perfectly well; it can slide by without being understood, perhaps just taken as funny-sounding music, without causing the feeling that one has missed something. Similarly, in "Lisa's Wedding," an episode that looks into the future, a *Jetsons* motif comes into play. Homer wears a white shirt like that of the "futuristic" George Jetson, and *Jetsons* sound effects are sprinkled liberally throughout. Again, these allusions blend perfectly well, bringing pleasure to those who recognize them without drawing attention to themselves and raising questions for those who miss them. The same is true of allusions to high culture, such as the Pretzel Man's parody of Tom Joad's famous speech in *The Grapes of Wrath.* As the Pretzel Man tells Marge, "Wherever a young mother is ignorant of what to feed

her baby you'll be there. Wherever nacho penetration is less than total you'll be there. Whenever a Bavarian is not quite full, you will be there" ("The Twisted World of Marge Simpson"). Again, the allusion to Steinbeck's *The Grapes of Wrath* brings pleasure to those who recognize it, but goes unnoticed and causes no disruption to those unequipped to get it. Perhaps some astute viewers will realize, in this case or others, that an allusion is being made although they do not know to what it refers. Still, this does not have the effect of making the viewer feel lost. Rather the viewer may chuckle, realizing that something funny is going on even though he can't fully appreciate it. The same blended texture can be found in more comprehensive allusions, parodies that span an entire episode or segment, such as "The Shinning," "The Raven," and "Bart of Darkness" (the title of which plays on a Conrad novel while the plot of the episode parodies Hitchcock's *Rear Window*).

What's the Connection?

Allusions have a practical value in addition to, and beyond, their aesthetic value. The practical value of allusions is found in their ability to provide links to other works of art. Such links in turn provide a context and a tradition in which a work of art is to be interpreted. Whereas philosophers deal with their predecessors or contemporaries by criticizing their arguments and offering new, and hopefully better, arguments, artists tend to allude to their predecessors or contemporaries. Artists use allusions in this way to pay homage, parody,[4] mock, and surpass.

We would not ordinarily expect the writers of a cartoon to employ allusion for the purpose of linking their art and creating a context, but *The Simpsons* is no ordinary cartoon. What context and tradition do the writers of *The Simpsons* attempt to dictate through their use of allusion? Let's briefly consider the lists of artworks to which they allude.

The list of movies alluded to in *The Simpsons* includes, but is not limited to, the following: *101 Dalmatians, 2001: A Space Odyssey, Alien, The Amityville Horror, Apocalypse Now, Backdraft, Basic Instinct, Ben Hur, Big, The Birds, The*

[4] For further discussion of parody in particular see Chapter 7 of this volume.

*Bodyguard, Cape Fear, Chariots of Fire, Citizen Kane, Close
Encounters of the 3rd Kind, A Clockwork Orange, Cocktail, The
Deer Hunter, Deliverance, Dr. Strangelove, Dracula, E.T., The
Exorcist, Fear and Loathing in Las Vegas, The Fly, Forrest Gump,
Frankenstein, Full Metal Jacket, The Godfather, Godzilla, Gone
with the Wind, Goodfellas, The Graduate, It's a Wonderful Life,
Jaws, The Jazz Singer, Jumanji, Jurassic Park, King Kong,
Lawrence of Arabia, Mary Poppins, Midnight Express, Miracle
on 34th St., The Natural, Night of the Living Dead, A Nightmare
on Elm Street, North by Northwest, An Officer and a Gentleman,
One Flew over the Cuckoo's Nest, Patton, Pink Flamingoes,
Planet of the Apes, Pride of the Yankees, Psycho, Pulp Fiction,
Raiders of the Lost Ark, Rain Man, Rear Window, The Right Stuff,
Risky Business, Rocky, Rocky Horror Picture Show, Rudy, The
Shining, The Silence of the Lambs, Soylent Green, Speed, Star
Wars, Steamboat Willie, Terminator, Titanic, Treasure of the
Sierra Madre, Vertigo, Village of the Damned, Waterworld, The
Wild One,* and *The Wizard of Oz.*

The list of television shows alluded to in *The Simpsons*
includes, but is not limited to, the following: *All in the Family,
Batman, Beavis and Butthead, Bewitched, Bonanza, Casper the
Friendly Ghost, A Charlie Brown Christmas, Cheers, The Cosby
Show, Dallas, Davey and Goliath, Dennis the Menace, Doctor
Who, Fish, The Flintstones, The Fugitive, Futurama, Gilligan's
Island, Happy Days, Hekyll and Jekyll, Home Improvement,
Howdy Doody, I Love Lucy, In Search Of, The Jeffersons, The
Jetsons, Knight Rider, Lassie, Laverne and Shirley, The Little
Rascals, Mad about You, Magilla Gorilla, The Mary Tyler Moore
Show, Popeye, The Prisoner, Ren and Stimpy, Rhoda, The Ropers,
Schoolhouse Rock, The Smurfs, Star Trek, That Girl, That '70s
Show, Twin Peaks, The Twilight Zone, The Wonder Years, The X
Files, Xena, Warrior Princess,* and *Yogi Bear.*

The list of authors and works of literature alluded to in The
Simpsons includes, but is not limited to, the following: *The
Bible, Castañeda,* Dickens's *A Christmas Carol,* Ginsberg's
"Howl," Golding's *Lord of the Flies,* Hemingway's *The Old Man
and the Sea,* Homer's *Odyssey,* Kerouac, Melville's *Moby-Dick,*
Michener, Poe's *Telltale Heart, The Raven,* and *The Fall of the
House of Usher,* Ayn Rand's *The Fountainhead,* Shakespeare,
Steinbeck's *The Grapes of Wrath,* and Tennessee Williams's *A
Streetcar Named Desire.*

The first thing to notice about these lists is that the writers of *The Simpsons* do not limit their allusions to the genre of cartoons or even the medium of television. There are ample allusions to film and literature. Though less common, we could also note allusions to paintings such as "The Kentuckian" and musical happenings such as "USA for Africa." The second thing to notice is that the allusions are overwhelmingly, though not exclusively, to American art works, both cultural and pop-cultural. This seems fitting given that Springfield (the town without a state) is likely meant to represent America itself.

The allusions in *The Simpsons* are very "American" in one rather unflattering way, pointing to America as a fast-food society in which the masses don't like to "think too much." In many, though certainly not all, cases the allusions are very plainly stated or shown to the viewer. Songs such as "The End" or "Hot Blooded" are nods to other forms of popular art and do not demand any great effort or esoteric knowledge on the part of the viewer, who simply must acknowledge the allusion and register the thought. *The Simpsons* often uses real people or fictional characters, such as Ron Howard, Dennis the Menace, or The Red Hot Chili Peppers. Frequently the use of these people constitutes an allusion because of double layers; the viewer must know why the person or situation is funny in addition to the mere fact that they are in the scene. For example, David Crosby has given voice to his cartoon likeness in a number of episodes, most often in the context of some rehabilitative or self-help role, such as a 12-step meeting of an "anonymous" group. We're left with the questions: Do Americans like, or (worse) need, such "no-brainers"? Are all the pop-cultural allusions a sign of American decay? Do they represent the immolation of Hirsch's cultural literacy, with only a nihilistic pop-cultural literacy to rise from the ashes?

No, it's probably not meant to be all that grim. Consider that many baby boomers and Generation-Xers had their first exposure to classical music through Bugs Bunny cartoons, only to mature into a taste for Bach and Beethoven. The straightforward allusions and combination of pop-culture and high culture need not signal "the closing of the American mind." Such a death knell would only be sounded if a generation of Americans never moved beyond *The Simpsons* in their aesthetic appreciation. There is no "clear and present danger" of that. In fact, both *The*

Simpsons and this book serve their purpose best when they prompt their audience to consider cultural, aesthetic, and philosophical issues whose surface the show only scratches.

Getting the Joke

Perhaps you think we've made "much Apu about nothing" in this discussion of allusion. If so, you can count Homer on your side. "Oh Marge, cartoons don't have any deep meaning. They're just stupid drawings that give you a cheap laugh" ("Mr. Lisa Goes to Washington"). We prefer to side with Matt Groening, though, who says, "That's one of the great things about *The Simpsons*—if you have read a few books, you'll get more of the jokes."[5] In the end all we can ask is that you take this essay and this book as seriously as you would a *Simpsons* episode.[6]

[5] http://www.snpp.com/other/interviews/groeining99e.html

[6] We wish to thank the following folks for their help with this essay: Mark Conard, Raja Halwani, Megan Lloyd, Jennifer O'Neill, David Weberman, Sarah Worth, and Joe Zeccardi.

7

Popular Parody:
The Simpsons
Meets the Crime Film

DEBORAH KNIGHT

In this essay, rather than drawing on the corpus of episodes that make up *The Simpsons* to establish general philosophical points, I want to work in the other direction by looking at a particular episode of *The Simpsons*. My focus is on parody, in particular on the strategies of parody that characterize popular rather than "High Art" narratives.[1] The topic of parody has obvious affinities to allusion. Irwin and Lombardo make the pertinent observation that for something to be an allusion rather than an "accidental association," it must be intended by the makers of the fiction—usually, for the purposes of *The Simpsons*, allusions must be intended by the writers.[2] Parody operates the

[1] Contrasting so-called "high" and "popular" artforms is a convenient though problematic way of speaking. Cinema and more recently television are obvious examples of media which can pretty much collapse this distinction. Philosophers of art such as Stanley Cavell and Ted Cohen have long recognized that Hitchcock's *North By Northwest* is just as clearly an example of art as a Rembrandt self-portrait. Noël Carroll, in *A Philosophy of Mass Art* (Oxford: Clarendon Press, 1998), suggests that we are better off talking about "mass" art if what we are referring to is "popular art produced and distributed by a mass technology" (p. 3). I think it is beyond contention that *The Simpsons* qualifies as an example of this sort of mass or popular art. I do not assume that "high" art is necessarily superior to "popular" art: there are great popular artworks just as there are lousy "high" artworks.

[2] See Chapter 6 of this volume.

same way—unintended references are at best accidental. *The Simpsons* cites numerous American television series and films, and makes these citations in a variety of ways. What I'm particularly interested in is a specific way of citing and also using a recognizable narrative genre. My focus is the crime film and the episode in question is "Bart the Murderer." But my point is applicable to any episode of *The Simpsons* that uses the same strategies we find in "Bart the Murderer."

"Bart the Murderer"

You will remember how this episode goes. Bart wakes up singing and struts confidently downstairs, thinking he's in for a great day. But things go downhill quickly. First, Homer has stolen the police badge from Bart's box of cereal. Then Bart misses the school bus. Sunny weather turns to thunderstorms as he makes his way to school—only to clear up the minute he gets there. He has to fill out a tardy slip. And if all that weren't bad enough, he's forgotten his permission slip for the afternoon fieldtrip to the chocolate factory. He gets to watch his classmates pour themselves into the bus, and winds up licking PTA envelopes for Principal Skinner, who counsels Bart to "make a game of it" by counting how many envelopes he can lick in an hour and then try to beat that number the next hour. Bart calls it a "crappy game," and of course he's right. Gummy tongued, he skateboards home, again in a rainstorm. But things still haven't stopped going wrong: he falls off his skateboard and down a flight of stairs. "What now?" he despairs. That question is quickly answered as a dozen handguns are pointed at him.

Bad as Bart's luck has been all day, this is the unluckiest turn of all. He has landed outside a gangster hangout run by mob boss Fat Tony (Joe Mantegna) and his trigger-happy henchmen. But all is not lost. Fat Tony, who likes to bet on the ponies, sets Bart an initiation test. When asked which horse will win the third race, Bart replies, "Don't have a cow." Sure enough, Don't Have a Cow is first to the wire, and Fat Tony's bet pays off. Fat Tony starts to think that Bart might be lucky after all—rather than just plain mouthy. So Bart is set a second test. Seems the club is short its barkeep, and Fat Tony wants to know if Bart can mix a Manhattan. Nervously, Bart manages it, and this secures him entry into the mob "family." His career as a mob bartender seems

to be going well—if you overlook the fact that he turns his bedroom into a storehouse for a stolen truck's worth of cigarettes, begins to affect annoying mob mannerisms such as tucking money into people's pockets for favors he thinks they owe him, and starts to dress like a junior member of the Rat Pack after Fat Tony rewards him with a fancy suit. But when Principal Skinner keeps Bart after school for trying to bribe him, Bart is late for work at Fat Tony's club, and this is a problem, since Fat Tony has promised an antagonistic mob boss a superb Manhattan—only Bart isn't there to mix it. As the other mob boss leaves, he gives Fat Tony the "kiss of death" as only mob bosses can do ("Just what I need!" says Fat Tony). And this all because Bart was late for work. Bart finally arrives saying Principal Skinner kept him after school for detention, and Fat Tony takes it into his head to go and talk with Skinner. Skinner is soon confronted in his office by "tall men" who don't have an appointment. (Skinner wants to know how they got past the hall monitor.)

When Skinner unexpectedly goes missing, Bart is the focus of police attention. In fact, he is put on trial for Skinner's murder. At the trial, everyone turns on Bart: Homer confesses on the stand that the evidence points to Bart. Fat Tony insists that Bart is the real capo of the organization. Things would have been bleak indeed except for Skinner's miraculous reappearance. Skinner explains how he came to be trapped for days under a pile of newspapers in his garage—keeping his mind agile by playing with a basketball, counting the number of times he could bounce it in a day and then, the next day, looking to beat his own score. The case against Bart is dismissed. On the courthouse steps, Bart announces to Fat Tony what he has learned: that "crime doesn't pay." Tony agrees, before getting into the first of a fleet of limousines that take him and his henchmen away. The Simpson family is reunited.

Parody and Popular Narratives

As Thomas J. Roberts argues in *An Aesthetics of Junk Fiction*,[3] it is characteristic of popular fictions—junk fictions, as Roberts

[3] Thomas J. Roberts, *An Aesthetics of Junk Fiction* (Athens, GA: University of Georgia Press, 1990).

affectionately calls them—to be replete with references to their own contemporary culture. Popular fictions establish connections with their readers and viewers, Roberts argues, because of their frequent citations of familiar or at least recognizable *extratextual* people, events, and objects. For instance, popular fictions refer to makes of cars and guns, to songs, movies and television shows, to public figures such as movie or rock stars, sports stars and politicians, to clothes and makeup, to major news stories, to types of technology. These references can involve something as straightforward as naming or depicting, or they can be as subtle as some of the associative allusions Irwin and Lombardo describe. Given the speed at which cars, movies, stars, fashion, and technologies change—and recognizing how many of them simply drop out of memory—even a generation or two later the references a contemporary audience would have immediately recognized can become opaque. One notable thing that happens when a work of junk fiction changes status from popular to classic is that our attention shifts from immediate recognition of these extratextual references to other matters, for instance to such literary critical matters as form and theme. This shift actually naturalizes our own cultural forgetfulness. Let's just consider a few examples. Who remembers teen idols of the seventies such as Bobby Sherman and Leif Garrett? If asked about the Barracuda, would you think first of the make of automobile or the character on *Frasier*? One of the defining features of junk fiction is its constant referencing of what often turn out to be culturally (and technologically) transient entities. The likelihood of being able to recognize this sort of specific reference cannot be reliably predicted outside of the immediate temporal framework that indexes the reference's intended audience. Homer Simpson himself makes this point when he realizes that Bart doesn't know who The Fonz was, as Irwin and Lombardo remind us.

The Simpsons is of course chock full of these sorts of references to contemporary culture. To mention only one from the episode in question: at breakfast as Bart is hunting through his cereal box for the police badge, we see that Lisa's breakfast cereal is called "Jackie-Os." I probably don't have to spell out that this cereal exploits the name given to Jacqueline Kennedy

Onassis by the popular press—and even the popular press recognized Jackie O as a woman of distinctive beauty not to mention remarkable connections, power, and influence. Nor do I need to mention that Jackie-Os also allude to Cheerios, the cereal probably best known for its dependable focus on good health, and correlatively noteworthy for its announced lack of sugar, frosting, flavor or, for that matter, any sort of cereal pizzazz. One day not long from now we may well have to explain both who Jackie O was, and what Cheerios were. What needs emphasis here, however, is that there is no single attitude that *The Simpsons* adopts to the extratextual cultural references it cites. On the face of it, we can't isolate exactly what sort of attitude motivates the reference to Jackie O. Nor can we even be certain that the reference to Jackie O is intended as anything more than a fortuitous sound-alike for other breakfast cereals whose names end in "o."

There is, however, another sort of referencing that needs to be considered when thinking about, for instance, "Bart the Murderer." Many episodes of *The Simpsons* including "Bart the Murderer" refer to recognizable cinema and television genres. We can call this generic referencing. Not all of the references to cinema and television in *The Simpsons* are of the same order, and in particular not all suggest a single attitude toward the genres referenced. In another episode, Apu is trying to get Homer and his family to watch an Indian film on television. Apu is merely trying to share his culture with Homer and Marge, though as one might have anticipated he has little success. Homer can only see the visible differences between the conventions of this Indian film and the sorts of films he is used to, that is, American films. The best Homer can do is laugh himself silly because he thinks the Indian costumes are ridiculous. One of the wonderful references built into this scene as something of a throw-away line is Apu's assurance to Homer and Marge that this film made it into the "Top 400" list of Indian films.

One way to access this joke, although I think it is a wrong way, is to suppose that Indian cinema cannot make sensible discriminations between its films and thus overpraises all of them by including them in such an enormously long list. Another way to access the joke, again a wrong one, is to think that Apu's

remark is simply an exaggeration—here the humor would be found by thinking that there are only a few if any "Top" Indian films. The right way to access the joke, by contrast, involves knowing that the Indian cinema is one of the most productive and vibrant among the world cinemas. It has one of the highest outputs of any national cinema, outproducing by far the American cinema. This makes the idea of a "Top 400" more understandable, since the enormous pool of Indian films explains the shift from a more usual idea of a "Top 10" or a "Top 100" to something much larger, for instance, a "Top 400." Here the joke works for those viewers who know something about Indian cinema. To know something about Indian cinema would tend to align viewers with Apu, and if we share that affinity, then we will empathize with him and not with Homer's crude response. Of course, there is no way to ensure that this interpretation of the joke is the one viewers recognize. Here we have a familiar problem in the hermeneutics of narrative: to feel an affinity with Homer is certainly possible, but to do so really means that you are in the wrong hermeneutic circle.

I will call this reference to Indian cinema and others that work like it *extrinsic references*. They are extrinsic in the sense that the reference originates from and points back to something outside the narrative. It references but does not embody in the narrative aspects of the cinematic practices it alludes to. So the reference to the Indian cinema is comparable to the reference to Jackie Onassis in the cereal name. Both get their meaning because they are extratextual. "Bart the Murderer," by contrast, engages in *intrinsic reference*: it references by means of incorporating specific generic patterns into the very story that makes the allusion. The genre in question is the crime film. "Bart the Murderer" allows us to think about the more general contribution of *The Simpsons* to such things as generic development and transformation, parody, and homage. It also allows us to think about one of the central thematics of the crime film: the family. There are different sorts of crime films—and there are even different sorts of crime films that focus on the figure of the gangster. *Donnie Brasco* (Mike Newell, 1997), for example, follows an undercover cop (Johnny Depp) as he infiltrates a group of mobsters by befriending one of its weaker members (Al Pacino). But *Donnie Brasco* is best looked at as an undercover crime

thriller with a gang setting. By contrast, an important subgenre of the crime film running from the 1930s to the present focuses on the rise and fall of the gangster. A central dynamic of such gangster films is the contrast they draw between the ordinary American family and the crime family. This subgenre informs "Bart the Murderer." The thematic contrast between ordinary American family and crime family is made more arresting in this episode since it is the Simpsons themselves who fill the role of the "ordinary American family."

The Family and Popular Genres

Among popular Hollywood film genres, only two are primarily defined by their focus on the family. One, the family melodrama, is standardly thought of as a "woman's" genre—also known as "weepies" because of their ability to reduce audiences to tears. Family melodramas such as *Stella Dallas* (King Vidor, 1937), *Mildred Pierce* (Michael Curtiz, 1945) and *Imitation of Life* (Douglas Sirk, 1958) focus on an incomplete nuclear family, usually headed by a single mother who is seen to be in need of a husband. From the 1930s through the 1950s, in particular, a frequent theme of these films was the tension between being a mother and being the head of the household. The central characters of two of the three films just named pursue successful professional careers, and it is their success in the public sphere that threatens the stability of their families and causes problems in their relationships with men, whether husbands or lovers. The other family-centered Hollywood film genre is, ironically, the gangster film. Classics include *The Public Enemy* (William Wellman, 1931), *The Godfather* (Francis Ford Coppola, 1971, 1974, 1990), and *Goodfellas* (Martin Scorsese, 1990). In the women-centered family melodramas, the family is held up for the most part as the basic social unit, dependent upon both mother and father figures, good relationships between parents and their children, and the inculcation of social values. In family melodrama, loyalty is ideally centrifugal, moving outward from the couple to their family and from there to the community. The gangster film offers an inverse vision of the family, one in which women characters are marginalized, usually reduced to such roles as trophy wife or mistress. The value systems of gangster

films also invert those of the family melodramas. The gangsters' values never benefit the broader community but instead only support and preserve the criminal microcosm. In the crime film, loyalty is radically centripetal, turned in on the crime family and most importantly directed to the mob boss. As Robert DeNiro's character says in *Goodfellas*, in the mob there are two rules: don't tell anyone anything and always keep your mouth shut.

The generic referencing of "Bart the Murderer" turns our attention toward the gangster film, away from the family melodrama. What is the relationship, then, between *The Simpsons* and these two genres? Let's look first at *The Simpsons*. Clearly, it is closer in structure and format to the family sit-com than to either the family melodrama or the crime film. In fact, it is part of the tradition of critical family sit-coms focusing on the working-class rather than the middle-class, and featuring ongoing disputes between family members as a primary mechanism of plot construction. This puts *The Simpsons* in the line of television situation comedies running from *All in the Family* to *Roseanne*. And it distinguishes these three programs and related family sit-coms from family-centered television dramas, for instance *The Waltons, Little House on the Prairie,* and, paradigmatically, *Family*, all of which incline more toward the overtly melodramatic than the sit-coms do. Still, the family sit-com does have recognizable affinities with the family melodrama, since it is precisely the struggles of the family that are centermost in both cases. We might think of the family sit-com as a transformation of fifties-style family melodramas brought about through the new conventions and formats of sixties and post-sixties television.

We can say, then, that the connection between *The Simpsons* and the family melodrama is neither intrinsic nor extrinsic, but rather one of historical inheritance and variation on the thematics of the family. The relationship of "Bart the Murderer" to the crime film, however, is intrinsic rather than extrinsic, since in "Bart the Murderer," the crime film isn't simply extrinsicly referenced; it is incorporated as part of the narrative structure of the episode. "Bart the Murderer" can be thought of as a combination of parody and homage to the crime film, as in fact *The Simpsons* itself is a combination of parody and homage to the family sitcom. Which leads us to consider how parody operates here.

Art Parody and Popular Parody

We are considering parody in a popular context. How exactly does popular parody square with theories of parody? Let us look at Linda Hutcheon's theory. Art parody—which Hutcheon calls, simply, "parody"—is "a sophisticated genre in the demands it makes on its practitioners and its interpreters."[4] Parody describes a relationship between two texts: the parodic text itself and the parodied or target text. For Hutcheon, parody is a self-conscious, indeed a self-reflexive, practice, one that involves the intention of the artist or author in the encoding, and the interpretive activity of the audience in decoding. The intention of the artist is necessary because parody involves "repetition with difference"—repetition denoting the acknowledgement of historical precedents in the artworld, and difference marking the shifts, variations or ironic examination to which that historical precedent is subjected (p. 101). The interpretive activity of the audience is likewise necessary to recognize the target text and thus to work out the relationship between the parodic and the parodied.

Hutcheon wants to distinguish parody from a range of artistic and literary practices with which it has often been confused, among them "burlesque, travesty, pastiche, plagiarism, quotation, and allusion" (p. 43). Nevertheless, her account pertains primarily to modernist and postmodernist "High Art" practices. Perhaps her favorite example is Magritte's parody of Manet's parody of Goya's *Majas on a Balcony*. In fact, this example raises the question of just what counts as parody and when, and it actually doesn't provide an easy answer. What, we might ask, is the critical advantage of treating Manet's *Le Balcon* as a parody? Did it, perhaps, only become one after Magritte painted *Perspective: Le Balcon de Manet*? When not referring to the tradition of oil painting, Hutcheon focuses on the masterworks of the European novel such as Proust's allegedly parodic relationship to Flaubert. Film parodies do get a mention, for instance Brian DePalma's reworking of Hitchcock's *Psycho* (1960) in his *Dressed to Kill* (1980) and of Michelangelo Antonioni's *Blow-Up* (1966) in *Blow-Out* (1981). But little is said about just how much an audience needs to know about the target texts here in order

[4] Linda Hutcheon, *A Theory of Parody: The Teachings of Twentieth-Century Artforms* (New York: Methuen, 1985), p. 33.

to understand De Palma's films. Arguably, *Psycho* is such a classic of Hollywood cinema that it would be hard to imagine audiences not seeing the connection. But *Blow-Up*, also a masterpiece, is not nearly as popular as *Psycho*, and thus isn't as well-known, and it strikes me that knowledge of the target text in this case is only a distraction from the plot of *Blow-Out*, whose audiences are certainly more familiar with John Travolta's previous roles than with Antonioni's film.

While Hutcheon does periodically mention popular rather than canonical artworks, there are obvious problems with her account. For starters, a parodic text need not parody some particular canonical artwork. Indeed, it need not parody an artwork at all: it can just as easily parody the recognizable conventions of a narrative genre. Second, parodic texts need not refer to so-called "High" artworks—consider Roy Lichtenstein's parodies of cartoons. Nor need the parodic text itself qualify as "High" art: witness this and related episodes of *The Simpsons*. Hutcheon would probably agree with me about these latter two points, but it is worth emphasizing that even her selection of mass artworks (in this case, films) focuses on target texts which are recognized as masterpieces by admired auteurs.

Perhaps the most telling problem with Hutcheon's account, though, is her privileging of irony: "Ironic inversion is a characteristic of all parody" (p. 6). This move owes much to the centrality of irony among literary values which we find in most critical practices from the New Critics to the present. Irony grounds Hutcheon's notion that parody "marks the intersection of . . . invention and critique," since irony is understood to have an inherently critical function (101). But this takes irony for granted as a mark of literary seriousness, and anything that seeks out seriousness as a criterion of aesthetic merit can be traced back to "High Art" critical traditions. Not surprisingly, then, Hutcheon approvingly quotes Robert Burden's observation[5] that parody "is created to interrogate itself against significant precedents; *it is a serious mode*" (Hutcheon, p. 101; Burden, p. 136; emphasis added). Clearly, Hutcheon is right to insist that parody does not exhaust itself by merely mocking or ridiculing

[5] Robert Burden, "The Novel Interrogates Itself: Parody as Self-consciousness in Contemporary English Fiction," in Malcom Bradbury and David Palmer, eds., *The Contemporary English Novel* (London: Edward Arnold, 1979)

the target text. But she is too quick to dismiss Margaret Rose's notion that parody is "the critical quotation of a preformed literary language with comic effect" (p. 41). Understanding Rose to mean something like literary forms, conventions, narrative structures and so forth when she says "language," the acknowledgement of the comic rather than paradigmatically ironic effect achieved by parodic texts is an important corrective to Hutcheon's account.

In what sense, then, is "Bart the Murderer" an example of parody? Arguably it isn't art parody. The episode seems to exploit the comic rather than the ironic. It doesn't set itself the task of interrogating significant precedents. "Bart the Murderer" is simply not critical in the sense beloved by critical theorists. Does this mean that the intrinsic referencing we find in "Bart the Murderer" isn't parody after all? The answer, I suggest, is that this episode is an example of popular parody, and its primary attitude isn't one of criticism but rather one of homage. In parodic homage, the intention is to rework a loved and well-known text or narrative form. We can see this sort of homage at work, for instance, in *Clueless* (Amy Heckerling, 1995), among whose range of intrinsic references we cannot fail to note Jane Austen's *Emma*—a point that is not affected by the fact that much of the film's comedy depends on extrinsic references to fashion, the media, and popular culture. If *Clueless* ascends to the status of a classic, Cher's tendency to describe cute guys as Baldwins may need explanation if the Baldwin brothers are forgotten. One hopes that a similar reminder will not be necessary with respect to *Emma*. There are other parody-homages, of course. *Charade* (Stanley Donen, 1963) and other suspense-comedies of the sixties are parody-homages to the great Hitchcock suspense-comedies, notably *North By Northwest* (1959). Many Woody Allen films are parody-homages. De Palma's films also count. Whereas Hutcheon claims that art parody involves using irony to create a critical distance between the parodic text and its target, this objective seems largely absent in *Clueless* and *Charade*, just as it is largely absent from "Bart the Murderer."

Back to "Bart the Murderer"

The primary target of "Bart the Murderer" is Scorcese's brilliant *Goodfellas,* starring Ray Liotta, Robert De Niro, and Joe

Pesci.[6] But *Goodfellas* is an instance of the gangster genre, and as such the conventions that make the genre what it is, and the key films that make up the genre, are also targets. Viewers approach *Goodfellas* with some knowledge of the gangster genre, and this generic knowledge is what allows them to understand the situation and actions of the characters involved. There is a generic verisimilitude at work in any genre. This is what makes it reasonable for characters to break into song in musicals, action heros to survive when outnumbered a dozen to one by bad guys with far superior fire power, and everyone to realize that, after Wile E. Coyote falls (again!) to the bottom of the canyon, in the next scene he will be unboxing a package from Acme Inc. to help him catch the Roadrunner. Some of the features of the gangster film that contribute to its generic verisimilitude include the evident ethnicity of the gangsters (Irish Americans, Italian Americans, and so on), the principal settings in bars, casinos, and anywhere that promotes drinking, smoking, and gambling, the characteristic and illegal money-making enterprises, the tight-knit group of men who flaunt guns and serve their boss. It takes the episode of "Bart the Murderer" some time to arrive in the gangster world, but as soon as Bart falls into the hands of Fat Tony's men, we find all these features of the gangster film present.

A recurrent thematic feature of the gangster film, which we see in the figure of James Cagney in *The Public Enemy* as well as in Ray Liotta's character in *Goodfellas*, is the impressionable youth who is taken into the mob and slowly ascends to positions of greater trust and importance, adapting to the dynamics of the new mob family and turning against his own. The narrative trajectory of the gangster film is a paradoxical one: ascent within the power structure of the crime family corresponds to descent into the morally twisted mobsters' world. This peculiar

[6] The enormous popularity of Martin Scorsese should not be underestimated. For instance, he has been voted the most popular movie director by readers of the *Time-Out Film Guides*—more popular even than Hitchcock—and in their 2000 edition *Goodfellas* ranks 11th on the list of most popular films, between *It's A Wonderful Life* and *North By Northwest*. Of the top thirty most popular films on that list, only two—*Pulp Fiction* (13th) and *Schindler's List* (20th)—were made more recently than *Goodfellas*.

conjunction of ascent and descent makes sense, of course, because the gangster isn't a hero but rather an anti-hero. And the values that dominate the mobsters' world are themselves an inversion of those usually associated with the American Dream. If the American Dream is the myth that everyone can make it in America by hard work and the right connections, then the mobsters' world is exactly that myth inflected by corruption, excess, violence, and an out-of-balance ethic of masculinity as brute power and greed. The basic story structure featuring an anti-hero or villain involves a series of increasing successes—here understood as the gangster's slow but steady rise in power, position, wealth, and material accessories—that nevertheless bring about a precipitating event which "makes inevitable a failure followed by punishment."[7] Thus *The Public Enemy* ends with Cagney's death—fitting punishment for his life of crime. The ending of *Goodfellas* is rather different. Henry Hill's fate is sealed when he turns state's evidence. But unlike Cagney, he doesn't die. His punishment is worse than death; in fact, he sees it as a living death. Hill is forced to return to anonymous middle-class life in anonymous middle America. No more big money, no more flashy clothes or fast cars or hanging with the rich and powerful in casinos and night clubs, no more easy women, no more influence: just a normal suburban house in an average suburban neighborhood. Punishment indeed.

Bart follows the path of ascent in the mob world as evidenced by his job, the cash he keeps receiving, the fancy suit, and the way the other mobsters, especially Fat Tony, come to rely on him. This series of successes leads to the inevitable failure—his arrest in the alleged murder of Principal Skinner. But "Bart the Murderer" is a selective parody of the gangster genre, which is pretty much what we ought to expect from a cartoon comedy. What is most obviously missing is the excess of violence which is a hallmark of the genre targets and embodied by all gangster protagonists from Cagney to Liotta. Also missing is the sense of corruption of values. Yes, Bart gets a bit above himself when he calls Principal Skinner, "My man," and stuffs cash into his pocket. Still, this sort of cheekiness is not atypical of Bart. A more important contrast is that, unlike *The Public Enemy*

[7] Algis Budry, quoted in Roberts, p. 90.

and *Goodfellas*, there is no epic timeframe. The classic gangster films develop over years, charting the "good life" which our anti-hero enjoys before his downfall. Since no one ever ages in *The Simpsons,* this option is plainly unavailable.

Although the parody is selective, "Bart the Murderer" does exploit the idea of punishment we found in *Goodfellas.* Just as Liotta's character, Henry Hill, has to go back to the very way of life he had tried to escape, so too does Bart wind up having to return to his normal life. That means returning from the mob family to his own.

The gangster as anti-hero has always longed at best to be able to do a better job of providing for the family than his father was able to do, or at worst to get away from his natural family, neighborhood, and class altogether. In gangster films, the protagonist's family is either naive or uninterested. Either way, they don't fully understand just what sort of company their son has gotten himself involved with. Marge's and Homer's reactions to Bart's new situation are in this sense classic. Although Marge frets about Bart's changes in behavior, both Marge and Homer agree that it's good for a boy to have a part-time job. Marge's anxieties aren't wholly allayed, however, and she persuades Homer to go check out Bart's place of work. Homer, oblivious to all the signs, is allowed to win at poker and concludes that everything is fine. In short, Homer and Marge exert very little positive influence over Bart during his brief career in the mob.

What does it mean for Bart to return to his family after charges against him are dismissed? There are two ways of answering this question, and which you choose depends upon whether or not you think that the conclusion of "Bart the Murderer" is ironic. If you don't think that irony is involved, then the selectivity of the parody just means that, since nothing fundamental ever changes in cartoon comedies such as *The Simpsons,* it's simply inevitable that the end of the episode returns Bart to the situation in which he started out. If you think that irony is involved, then despite the selectivity of the parody, this conclusion is a critical observation about the limits of the family structure in which Bart finds himself. If Ray Liotta's punishment is to return to "normal"—that is, "average"—American life, we might want to think about Bart's return to his family as an irony at the expense of the very notion of American family life. Which, of course, is one of the most striking and persistent

themes of *The Simpsons*.

Conclusion

What conclusions can we draw about popular parody as opposed to art parody? First, that it tends to focus on the comic rather than the ironic. This does not mean that irony is necessarily absent; merely that the primary mechanisms are comic, with irony subordinate to comic intentions. Furthermore, popular parody is often undertaken out of fondness for the target texts rather than an attitude of aesthetic self-consciouness or self-reflexivity. Popular parody, unlike art parody, is not primarily critical of its target texts—at least, it is not critical in the sense of "interrogating" its precedents. Homage rather than criticism is a significant and recurring parodic strategy found in popular art. Certainly popular parody can ridicule and lampoon its target text. But lampooning is usually based on extrinsic rather than intrinsic references. "Bart the Murderer" exploits intrinsic references by employing some of the most central narrative themes and structures from the gangster genre. But as we have seen, the parody here is selective: not all the defining thematics are explicitly present. Is "Bart the Murderer" itself part of the genre of gangster films? It is hardly a paradigm example of the genre, especially given the absence of extreme violence. Still, it is a good mixed example. What *The Simpsons* tells us about the family in the 1990s thanks to the other primary generic component of the mix, the cartoonized version of the family sit-com, is expertly analysed by Paul A. Cantor in this volume.[8] And that turns out to be something even *Goodfellas* could not tell us.[9]

[8] See Chapter 11.

[9] Thanks to George McKnight, Bill Irwin, and Carl Matheson for comments and suggestions.

8

The Simpsons, Hyper-Irony, and the Meaning of Life

CARL MATHESON

> DISAFFECTED YOUTH #1: Here comes that cannonball guy. He's cool.
> DISAFFECTED YOUTH #2: Are you being sarcastic, dude?
> DISAFFECTED YOUTH #1: I don't even know anymore.
>
> — "Homerpalooza," Season 7

What separates the comedies that were shown on television fifty, forty, or even twenty-five years ago from those of today? First, we may notice technological differences, the difference between black-and-white and color, the difference between film stock (or even kinescope) and video. Then there are the numerous social differences. For instance, the myth of the universal traditional two-parent family is not as secure as it was in the 1950s and 1960s, and the comedies of the different eras reflect changes in its status—although even early comedies of the widow/widower happy fifties, sixties, and seventies were full of non-traditional families, such as are found in *The Partridge Family, The Ghost and Mrs. Muir, Julia, The Jerry van Dyke Show, Family Affair, The Courtship of Eddie's Father, The Andy Griffith Show, The Brady Bunch, Bachelor Father*, and *My Little Margie*. Also, one may note the ways in which issues such as race have received different treatments over the decades.

But I would like to concentrate on a deeper transformation: today's comedies, at least most of them, are funny in different ways from those of decades past. In both texture and substance the comedy of *The Simpsons* and *Seinfeld* is worlds apart from

the comedy of *Leave it to Beaver* and *The Jack Benny Show,* and is even vastly different from much more recent comedies, such as *MASH* and *Maude.* First, today's comedies tend to be highly *quotational*: many of today's comedies essentially depend on the device of referring to or quoting other works of popular culture. Second, they are *hyper-ironic*: the flavor of humor offered by today's comedies is colder, based less on a shared sense of humanity than on a sense of world-weary cleverer-than-thou-ness. In this essay I would like to explore the way in which *The Simpsons* uses both quotationalism and hyper-ironism and relate these devices to currents in the contemporary history of ideas.

Quotationalism

Television comedy has never completely foregone the pleasure of using pop culture as a straight man. However, early instances of quotation tended to be opportunistic; they did not comprise the substance of the genre. Hence, in sketch comedy, one would find occasional references to popular culture in *Wayne and Shuster* and *Johnny Carson,* but these references were really treated as just one more source of material. The roots of quotationalism as a main source of material can be found in the early seventies with the two visionary comedies, *Mary Hartman Mary Hartman,* which lampooned soap operas by being an ongoing soap opera, and *Fernwood 2Night,* which, as a small-budget talk show, took on small-budget talk shows. Quotationalism then came much more to the attention of the general public between the mid-seventies and early eighties through *Saturday Night Live, Late Night with David Letterman,* and *SCTV.* Given the mimical abilities of its cast and its need for weekly material, the chief comedic device of *SNL* was parody—of genres (the nightly news, television debates), of particular television shows *(I Love Lucy, Star Trek)* and of movies *(Star Wars).* The type of quotationalism employed by Letterman was more abstract and less based on particular shows. Influenced by the much earlier absurdism of such hosts as Dave Garroway, Letterman immediately took the formulas of television and cinema beyond their logical conclusions *(The Equalizer Guy,* chimp cam, and spokesperson Larry "Bud" Melman).

However, it was *SCTV* that gathered together the various strains of quotationalism and synthesized them into a deeper,

more complex, and more mysterious whole. Like *Mary Hartman,* and unlike *SNL*, it was an ongoing series with recurring characters such as Johnny Larue, Lola Heatherton and Bobby Bittman. However, unlike *Mary Hartman,* the ongoing series was about the workings of a television station. *SCTV* was a television show about the process of television. Through the years, the models upon which characters like Heatherton and Bittman were based vanished somewhat into the background, as Heatherton and Bittman started to breathe on their own, and therefore, came to occupy a shadowy space between real (fictional) characters and simulacra. Furthermore, *SCTV*'s world came to intersect the real world as some of the archetypes portrayed (such as Jerry Lewis) were people in real life. Thus, *SCTV* eventually produced and depended upon patterns of inter-textuality and cross-referencing that were much more thorougoing and subtle than those of any program that preceded it.

The Simpsons was born, therefore, just as the use of quotationalism was maturing. However, *The Simpsons* was not the same sort of show as *SNL* and *SCTV*. One major difference of course, was that *The Simpsons* was animated while the others were (largely) not, but this difference does not greatly affect the relevant potential for quotationalism—although it may be easier to draw the bridge of the U.S.S. Enterprise than to rebuild it and re-enlist the entire original cast of *Star Trek*. The main difference is that as an ostensibly ongoing family comedy, *The Simpsons* was both plot and character driven, where the other shows, even those that contained ongoing characters were largely sketch driven. Furthermore, unlike *Mary Hartman Mary Hartman,* which existed to parody soap operas, The Simpsons did not have the *raison d'être* of parodying the family-based comedies of which it was an instance. The problem then was this: how does one transform an essentially non-quotational format into an essentially quotational show?

The answer to the above question lies in the form of quotationalism employed by *The Simpsons*. By way of contrast, let me outline what it was definitely not. Take, for instance, a *Wayne and Shuster* parody of Wilde's *The Picture of Dorian Gray*. In the parody, instead of Gray's sins being reflected in an artwork, while he remains pure and young in appearance, the effects of Gray's overeating are reflected in the artwork, while he remains thin. The situation's permissions and combinations are squeezed

and coaxed to produce the relevant gags and ensuing yuks. End of story. Here the quotationalism is very direct; it is the source both of the story line and of the supposedly humorous contrast between the skit and the original novel. Now, compare this linear and one-dimensional use of quotation for the purposes of parody with the pattern of quotation used in a very short passage from an episode from *The Simpsons* entitled "A Streetcar Named Marge." In the episode, Marge is playing Blanche Dubois opposite Ned Flanders's Stanley in *Streetcar!*, her community theatre's musical version of the Tennessee Williams play. In need of day care for little Maggie, she sends Maggie to the Ayn Rand School for Tots, which is run by the director's sister. Headmistress Sinclair, a strict disciplinarian and believer in infant self-reliance, confiscates all of the tots' pacifiers which causes an enraged Maggie to lead her classmates in a highly organized reclamation mission, during which the theme from *The Great Escape* plays in the background. Having re-acquired the pacifiers the group sits, arrayed in rows, making little sucking sounds, so that when Homer arrives to pick up Maggie, he is confronted with a scene from Hitchcock's *The Birds*.

The first thing that one can say about these quotations is that they are very funny. However, I don't want to play the doomed game of saying why they're funny, because any crinkly-eyed chuckler who tries to analyze sources of humor ends up seeming about as funny as Emil Jannings in *Blue Angel* (and not in the really funny part where he is cuckolded by a circus strongman, forced to do a grief-stricken and impotent imitation of a rooster in front of his jeering students, and sent off to die a broken man, but in the less funny parts before that). To see that these quotations are funny just watch the show again. Second, we note that these quotations are not used for the purpose of parody.[1] Rather, they are allusions, designed to provide unspoken metaphorical elaboration and commentary about what is going on in the scene. The allusion to Ayn Rand underscores the ideology and personal rigidity of Headmistress Sinclair. The

[1] I don't mean to say that *The Simpsons* does not make use of parody. The episode currently under discussion contains a brilliant parody of Broadway adaptations, from its title to the show-stopping tune "A Stranger is Just a Friend You Haven't Met!"

theme music from *The Great Escape* stresses the determination of Maggie and her cohort. The allusion to *The Birds* communicates the threat of the hive-mind posed by many small beings working as one. By going outside of the text via these nearly instantaneous references, *The Simpsons* manages to convey a great deal of extra information extremely economically. Third, the most impressive feature of this pattern of allusion is its pace and density, where this feature has grown more common as the series has matured. Early episodes, for instance the one in which Bart saws the head off the town's statue of Jebediah Springfield, are surprisingly free of quotation. Later episodes derive much of their manic comic energy from their rapid-fire sequence of allusions. This density of allusion is perhaps what sets *The Simpsons* most apart from any show that has preceded it.[2]

However, the extent to which *The Simpsons* depends on other elements of pop culture is not without cost. Just as those readers who are unfamiliar with Frazer's *Golden Bough* will be hindered in their attempt to understand Eliot's "The Waste Land," and just as many modern day readers will be baffled by many of the Biblical and classical allusions that play important roles in the history of literature, many of today's viewers won't fully understand much of what goes on in *The Simpsons* due to an unfamiliarity with the popular culture that forms the basis for the show's references. Having missed the references, these people may interpret *The Simpsons* as nothing more than a slightly off-base family comedy populated with characters who are neither very bright nor very interesting. From these propositions they will probably derive the theorem that the show is neither substantial nor funny, and also the lemma that the people who like the show are deficient in taste, intelligence, or standards of personal mental hygiene. However, not only do the detractors of the show miss a great deal of its humor, they also fail to realize that its pattern of quotations is an absolutely essential vehicle for developing character and for setting a tone. And, since these people are usually not huge fans of popular culture to begin with, they will be reluctant to admit that they are missing something significant. Oh well. It is difficult to explain color to

[2] For more on allusion in *The Simpsons,* see Chapter 6 of this volume.

a blind man, especially if he won't listen. On the other hand, those who enjoy connecting the quotational dots will enjoy their task all the more for its exclusivity. There is no joke like an in-joke: the fact that many people don't get *The Simpsons* might very well make the show both funnier and better to those who do.

Hyper-Ironism and The Moral Agenda

Without the smart-ass, comedy itself would be impossible. Whether one subscribes, as I do, to the thesis that all comedy is fundamentally cruel, or merely to the relatively spineless position that only the vast majority of comedy is fundamentally cruel, one has to admit that comedy has always relied upon the joys to be derived from making fun of others. However, usually the cruelty has been employed for a positive social purpose. In the sanctimonious *MASH,* Hawkeye and the gang were simply joking to "dull the pain of a world gone mad," and the butts of their jokes, such as Major Frank Burns, symbolized threats to the liberal values that the show perpetually attempted to reinforce in the souls of its late twentieth-century viewers. In *Leave it To Beaver,* the link between humor and the instillation of family values is didactically obvious. A very few shows, most notably *Seinfeld*, totally eschewed a moral agenda.[3] *Seinfeld*'s ability to maintain a devoted audience in spite of a cast of shallow and petty characters engaged in equally petty and shallow acts is miraculous. So, as I approach *The Simpsons*, I would like to resolve the following questions. Does *The Simpsons* use its humor to promote a moral agenda? Does it use its humor to promote the claim that there is no justifiable moral agenda? Or, does it stay out of the moral agenda game altogether?

These are tricky questions, because data can be found to affirm each of them. To support the claim that *The Simpsons* promotes a moral agenda, one usually need look no further than Lisa and Marge. Just consider Lisa's speeches in favor of integrity, freedom from censorship, or any variety of touchy-

[3] For a different view, see Robert A. Epperson, "Seinfeld and the Moral Life," in William Irwin, ed., *Seinfeld and Philosophy: A Book about Everything and Nothing* (Chicago: Open Court, 2000), pp. 163–174.

feely social causes, and you will come away with the opinion that *The Simpsons* is just another liberal show underneath a somewhat thin but tasty crust of nastiness. One can even expect Bart to show humanity when it counts, as when, at military school, he defies sexist peer-pressure to cheer Lisa on in her attempt to complete an obstacle course. The show also seems to engage in self-righteous condemnation of various institutional soft targets. The political system of Springfield is corrupt, its police chief lazy and self-serving, and its Reverend Lovejoy ineffectual at best. Property developers stage a fake religious miracle in order to promote the opening of a mall. Mr. Burns tries to increase business at the power plant by blocking out the sun. Taken together, these examples seem to advocate a moral position of caring at the level of the individual, one which favors the family over any institution.[4]

However, one can find examples from the show that seem to be denied accommodation within any plausible moral stance. In one episode, Frank Grimes (who hates being called "Grimey") is a constantly unappreciated model worker, while Homer is a much beloved careless slacker. Eventually, Grimes breaks down and decides to act just like Homer Simpson. While "acting like Homer" Grimes touches a transformer and is killed instantly. During the funeral oration by Reverend Lovejoy (for "Gri-yuh-mee, as he liked to be called") a snoozing Homer shouts out "Change the channel, Marge!" The rest of the service breaks into spontaneous and appreciative laughter, with Lenny saying "That's our Homer!" End of episode. In another episode, Homer is unintentionally responsible for the death of Maude Flanders, Ned's wife. In the crowd at a football game, Homer is eager to catch a T-shirt being shot from little launchers on the field. Just as one is shot his way, he bends over to pick up a peanut. The T-shirt sails over him and hits the devout Maude, knocking her out of the stands to her death. These episodes are difficult to locate on a moral map; they certainly do not conform to the standard trajectory of virtue rewarded.

Given that we have various data, some of which lead us towards and others away from the claim that *The Simpsons* is

[4] For a defense of the thesis that *The Simpsons* defends family values, see Chapter 11 of this volume.

committed to caring, liberal family values, what should we conclude? Before attempting to reach a conclusion, I would like to go beyond details from various episodes of the show to introduce another form of possibly relevant evidence. Perhaps, we can better resolve the issue of *The Simpsons'* moral commitments by examining the way it relates to current intellectual trends. The reader should be warned that, although I think that my comments on the current state of the history of ideas are more or less accurate, they are greatly oversimplified. In particular, the positions that I will outline are by no means unanimously accepted.

Let's start with painting. The influential critic, Clement Greenberg, held that the goal of all painting was to work with flatness as the nature of its medium and he reconstructed the history of painting so that it was seen to culminate in the dissolution of pictorial three-dimensional space and the acceptance of total flatness by the painters of the mid-twentieth century. Painters were taken to be like scientific researchers whose work furthered the progress of their medium, where the idea of artistic progress was to be taken as literally as that of scientific progress. Because they were fundamentally unjustifiable and because they put painters into a straitjacket, Greenberg's positions gradually lost their hold, and no other well-supported candidates for the essence of painting could be found to take their place. As a result painting (and the other arts) entered a phase that the philosopher of art, Arthur Danto, has called "the end of art." By this Danto did not mean that art could no longer be produced, but rather that art could no longer be subsumed under a history of progress towards some given end.[5] By the end of the 1970s, many painters had turned to earlier, more representational styles, and their paintings were as much commentaries on movements from the past, like expressionism, and about the current vacuum in the history of art, as they were about their subject matter. Instead of being about the essence of painting, much of painting came to be about the history of painting. Similar events unfolded in the other artistic media as

[5] See Arthur Danto, *After the End of Art* (Princeton: Princeton University Press, 1996).

architects, film-makers, and writers returned to the history of their disciplines.

However, painting was not the only area in which long-held convictions concerning the nature and inevitability of progress were aggressively challenged. Science, the very icon of pro-gressiveness, was under attack from a number of quarters. Kuhn held (depending on which interpreter of him you agree with) either that there was no such thing as scientific progress, or that if there was, there were no rules for determining what progress and scientific rationality were. Feyerabend argued that people who held substantially different theories couldn't even understand what each other was saying, and hence that there was no hope of a rational consensus; instead he extolled the anarchistic virtues of "anything goes." Early sociological work-ers in the field of science studies tried to show that, instead of being an inspirational narrative of the disinterested pursuit of truth, the history of science was essentially a story of office-pol-itics writ large, because every transition in the history of science could be explained by appeal to the personal interests and alle-giances of the participants.[6] And, of course, the idea of philo-sophical progress has continued to be challenged. Writing on Derrida, the American philosopher Richard Rorty argues that anything like *the* philosophical truth is either unattainable, non-existent, or uninteresting, that philosophy itself is a literary genre, and that philosophers should reconstrue themselves as writers who elaborate and re-interpret the writings of other philosophers. In other words, Rorty's version of Derrida rec-ommends that philosophers view themselves as historically aware participants in a conversation, as opposed to quasi-sci-entific researchers.[7] Derrida himself favored a method known as deconstruction, which was popular several years ago, and which consisted of a highly technical method for undercutting

[6] Thomas Kuhn, *The Structure of Scientific Revolutions,* second edition (Chicago: University of Chicago Press, 1970). Paul Feyerabend, *Against Method* (London: NLB, 1975). For a lively debate on the limits of the sociology of knowledge, see James Robert Brown (ed.), *Scientific Rationality: The Sociological Turn* (Dordrecht: Reidel, 1984).

[7] Richard Rorty, "Philosophy as a Kind of Writing," pp. 90–109 in *Conse-quences of Pragmatism* (Minneapolis: University of Minnesota Press, 1982).

texts by revealing hidden contradictions and unconscious ulterior motives. Rorty questions whether, given Derrida's take on the possibility of philosophical progress, deconstruction could be used only for negative purposes, that is, whether it could be used for anything more than making philosophical fun of other writings.

Let me repeat that these claims about the nature of art, science, and philosophy are highly controversial. However, all that I need for my purposes is the relatively uncontroversial claim that views such as these are now in circulation to an unprecedented extent. We are surrounded by a pervasive crisis of authority, be it artistic, scientific or philosophical, religious or moral, in a way that previous generations weren't. Now, as we slowly come back to earth and *The Simpsons,* we should ask this: if the crisis I described were as pervasive as I believe it to be, how might it be reflected generally in popular culture, and specifically in comedy?

We have already discussed one phenomenon that may be viewed as a consequence of the crisis of authority. When faced with the death of the idea of progress in their field, thinkers and artists have often turned to a reconsideration of the history of their discipline. Hence artists turn to art history, architects to the history of design, and so on. The motivation for this turn is natural; once one has given up on the idea that the past is merely the inferior pathway to a better today and a still better tomorrow, one may try to approach the past on its own terms as an equal partner. Additionally, if the topic of progress is off the list of things to talk about, an awareness of history may be one of the few things left to fill the disciplinary conversational void. Hence, one may think that quotationalism is a natural offshoot of the crisis of authority, and that the prevalence of quotationalism in *The Simpsons* results from that crisis.

The idea that quotationalism in *The Simpsons* is the result of "something in the air" is confirmed by the stunning everpresence of historical appropriation throughout popular culture. Cars like the new Volkswagen Beetle and the PT Cruiser quote bygone days, and factories simply can't make enough of them. In architecture, New Urbanist housing developments try to recreate the feel of small towns of decades ago, and they have proven so popular that only the very wealthy can buy homes in

them. The musical world is a hodgepodge of quotations of styles, where often the original music being quoted is simply sampled and re-processed.

To be fair, not every instance of historical quotationalism should be seen as the result of some widespread crisis of authority. For instance, the New Urbanist movement in architecture was a direct response to a perceived erosion of community caused by the deadening combination of economically segregated suburbs and faceless shopping malls; the movement used history in order to make the world a better place for people to live with other people. Hence the degree of quotationalism in *The Simpsons* could point towards a crisis in authority, but it could also stem from a strategy for making the world better, like the New Urbanism, or it could merely be a fashion accessory, like retro-Khaki at The Gap.

No, if we want to plumb the depths of *The Simpsons'* connection with the crisis in authority we will have to look to something else, and it is at this point that I return to the original question of this section: does *The Simpsons* use its humor to promote a moral agenda? My answer is this: *The Simpsons* does not promote anything, because its humor works by putting forward positions only in order to undercut them. Furthermore, this process of undercutting runs so deeply that we cannot regard the show as merely cynical; it manages to undercut its cynicism too. This constant process of under-cutting is what I mean by "hyper-ironism."

To see what I mean, consider "Scenes from the Class Struggle in Springfield," an episode from the show's seventh season. In this episode Marge buys a Coco Chanel suit for $90 at the Outlet Mall. While wearing the suit, she runs into an old high-school classmate. Seeing the designer suit and taking Marge to be one of her kind, the classmate invites Marge to the posh Springfield Glen Country Club. Awed by the gentility at the Club, and in spite of sniping from club members that she always wears the same suit, Marge becomes bent on social climbing. Initially alienated, Homer and Lisa fall in love with the club for its golf-course and stables. However, just as they are about to be inducted into the club, Marge realizes that her newfound obsession with social standing has taken precedence over her family. Thinking that the club also probably doesn't want them anyway, she and the family walk away. However, unbeknownst to the

Simpsons, the club has prepared a lavish welcome party for them, and is terribly put out that they haven't arrived—Mr. Burns even "pickled the figs for the cake" himself.

At first glance, this episode may seem like another case of the show's reaffirmation of family values: after all, Marge chooses family over status. Furthermore, what could be more hollow than status among a bunch of shallow inhuman snobs? However, the people in the club turn out to be inclusive and fairly affectionate, from golfer Tom Kite who gives Homer advice on his swing despite that fact that Homer has stolen his golf clubs—and shoes—to Mr. Burns, who thanks Homer for exposing his dishonesty at golf. The jaded cynicism that seems to pervade the club is gradually shown to be a mere conversational trope; the club is prepared to welcome the working-class Simpsons with open arms—or has it realized yet that they are working class?[8] Further complicating matters are Marge's reasons for walking away. First, there is the false dilemma between caring for her family and being welcomed by the club. Why should one choice exclude the other? Second is her belief that the Simpsons just don't belong to such a club. This belief seems to be based on a classism that the club itself doesn't have. This episode leaves no stable ground upon which the viewer can rest. It feints at the sanctity of family values and swerves closely to class determinism, but it doesn't stay anywhere. Furthermore, upon reflection, none of the "solutions" that it momentarily holds is satisfactory. In its own way, this episode is as cruel and cold-blooded as the Grimey episode. However, where the Grimey episode wears its heartlessness upon its sleeve, this episode conjures up illusions of satisfactory heart-warming resolution only to undercut them immediately. In my view, it stands as a paradigm of the real *Simpsons*.

I think that, given a crisis of authority, hyper-ironism is the most suitable form of comedy. Recall that many painters and architects turned to a consideration of the history of painting and architecture once they gave up on the idea of fundamental trans-historical goal for their media. Recall also that once Rorty's version of Derrida became convinced of the non-existence of transcendent philosophical truth, he reconstructed philosophy

[8] For further discussion of the working class see Chapter 16 of this volume.

as an historically aware conversation which largely consisted of the deconstruction of past works. One way of looking at all of these transitions is that, with the abandonment of *knowledge* came the cult of *knowingness*. That is, even if there is no ultimate truth (or method for arriving at it) I can still show that I understand the intellectual rules by which you operate better than you do. I can show my superiority over you by demonstrating my awareness of what makes you tick. In the end, none of our positions is ultimately superior, but I can at least show myself to be in a superior position for now on the shifting sands of the game we are currently playing. Hyper-irony is the comedic instantiation of the cult of knowingness. Given the crisis of authority, there are no higher purposes to which comedy can be put, such as moral instruction, theological revelation, or showing how the world is. However, comedy can be used to attack anybody at all who thinks that he or she has any sort of handle on the answer to any major question, not to replace the object of the attack with a better way of looking at things, but merely for the pleasure of the attack, or perhaps for the sense of momentary superiority mentioned earlier. *The Simpsons* revels in the attack. It treats nearly everything as a target, every stereotypical character, every foible, and every institution. It plays games of one-upmanship with its audience members by challenging them to identify the avalanche of allusions it throws down to them. And, as "Scenes from the Class Struggle in Springfield" illustrates, it refrains from taking a position of its own.

It would be quite right to point out that many other episodes are far less bleak or narratively unstable than the Frank Grimes and the country club episodes. Most of the early shows, such as the episode in which Bart decapitates the town statue, possess simple family-oriented resolutions. Later shows contain some cosmetic undercutting. Early in "Deep Space Homer," from season five, Bart writes "Insert Brain Here" in felt marker on the back of Homer's head. Later, after Homer the astronaut saves his space capsule, Bart writes "Hero" on the back of Homer's head. Here, the illusion of undercutting serves merely to bitter-coat an otherwise unpalatably sugary pill. Or does it? After all, Homer saved the space mission by mistake: he unintentionally repaired a damaged air hatch while trying to kill another astronaut with a carbon rod. The air hatch in question had been shaken loose

during an attempt to evacuate some experimental ants which Homer had accidentally released. In addition, the world—and *Time* magazine—recognized the "inanimate carbon rod" for saving the space-craft, not Homer. Therefore, it would be fair to say that the moment between Homer and Bart was somewhat contaminated by previous events.

However, to be fair to those who believe *The Simpsons* takes a stable moral stance, there are episodes which seem not to undercut themselves at all. Consider, for instance the previously mentioned episode in which Bart helps Lisa at military school. In that episode, many things are ridiculed, but the fundamental goodness of the relationship between Bart and Lisa is left unquestioned. In another episode, when Lisa discovers that Jebediah Springfield, the legendary town founder, was a sham, she refrains from announcing her finding to the town when she notices the social value of the myth of Jebediah Springfield.[9] And, of course, we must mention the episode in which jazzman Bleeding Gums Murphy dies, which truly deserves the Simpsonian epithet "worst episode ever." This episode combines an uncritical sentimentality with a naive adoration of art-making, and tops everything off with some unintentionally horrible pseudo-jazz which would serve better as the theme music for a cable-access talk show. Lisa's song "Jazzman" simultaneously embodies all three of these faults, and must count as the worst moment of the worst episode ever. Given these episodes and others like them, which occur too frequently to be dismissed as blips, we are still left with the conflicting data with which we started the section. Is *The Simpsons* hyper-ironic or not? One could argue that the hyper-ironism is a trendy fashion accessory, irony from The Gap, which does not reflect the ethos of the show. Another critically well-received program, *Buffy the Vampire Slayer* is as strongly committed to a black and white distinction between right and wrong as only teenagers can be. Its dependence on wisecracks and subversive irony is only skin deep. Underneath the surface, one will find angst-ridden teens fighting a solemn battle against evil demons who want to destroy the world. Perhaps, one could argue, beneath the sur-

[9] Was Lisa being hypocritical? For discussion of justifiable hypocrisy see Chapter 12 of this volume.

face irony of *The Simpsons* one will find a strong commitment to family values.

I would like to argue that *Simpsonian* hyper-ironism is not a mask for an underlying moral commitment. Here are three reasons, the first two of which are plausible but probably insufficient. First, *The Simpsons* does not consist of a single episode, but of over two hundred episodes spread out over more than ten seasons. There is good reason to think that apparent resolutions in one episode are usually undercut by others.[10] In other words, we are cued to respond ironically to one episode, given the cues provided by many other episodes. However, one could argue, that this inter-episodic undercutting is itself undercut by the show's frequent use of happy family endings.

Second, as a self-consciously hip show, *The Simpsons* can be taken to be aware of and to embrace what is current. Family values are hardly trendy, so there is little reason to believe that *The Simpsons* would adopt them whole-heartedly. However, this is weak confirmation at best. As a trendy show, *The Simpsons* could merely flirt with hyper-irony without fully adopting it. After all, it is hardly hyper-ironic to pledge allegiance to any flag, including the flag of hyper-ironism. Also, in addition to being a self-consciously hip show, it is also a show that must live within the constraints of prime-time American network television. One could argue that these constraints would force *The Simpsons* towards a commitment to some sort of palatable moral stance. Therefore, we cannot infer that the show is hyper-ironic from the lone premise that it is self-consciously hip.

The third and strongest reason for a pervasive hyper-ironism and against the claim that *The Simpsons* takes a stand in favor of family values is based on the perception that the comedic energy of the show dips significantly whenever moral closure or didacticism rise above the surface (as in the Bleeding Gums Murphy episodes). Unlike *Buffy the Vampire Slayer*, *The Simpsons* is fundamentally a comedy. *Buffy* can get away with dropping its ironic stance, because it is an adventure focussed on the timeless battle between good and evil. *The Simpsons* has nowhere else to go when it stops being funny. Thus, it's very

[10] Thanks to my colleague and co-contributor, Jason Holt, for first suggesting this to me.

funny when it celebrates physical cruelty in any given *Itchy and Scratchy Show*. It's very funny when it ridicules Krusty and the marketing geniuses who broadcast *Itchy and Scratchy*. It's banal, flat, and not funny when it tries to deal seriously with the issue of censorship arising from *Itchy and Scratchy*. The lifeblood of *The Simpsons,* and its astonishing achievement, is the pace of cruelty and ridicule that it has managed to sustain for over a decade. The prevalence of quotationalism helps to sustain this pace, because the show can look beyond itself for a constant stream of targets. When the target-shooting slows down for a wholesome message or a heart-warming family moment, the program slows to an embarrassing crawl with nary a quiver from the laugh-meter.

I don't mean to argue that the makers of *The Simpsons* intended the show primarily as a theater of cruelty, although I imagine that they did. Rather, I want to argue that, as a comedy, its goal is to be funny, and we should read it in a way that maximizes its capability to be funny. When we interpret it as a wacky but earnest endorsement of family values, we read it in a way that hamstrings its comedic potential. When we read it as a show built upon the twin pillars of misanthropic humor and oh-so-clever intellectual one-upmanship, we maximize its comedic potential by paying attention to the features of the show that make us laugh. We also provide a vital function for the degree of quotationalism in the show, and as a bonus, we tie the show into a dominant trend of thought in the twentieth century.

But, if the heart-warming family moments don't contribute to the show's comedic potential, why are they there at all? One possible explanation is that they are simply mistakes; they were meant to be funny but they aren't. This hypothesis is implausible. Another is that the show is not exclusively a comedy, but rather a family comedy—something wholesome and not very funny that the whole family can pretend to enjoy. This is equally implausible. Alternatively, we can try to look for a function for the heart-warming moments. I think there is such a function. For the sake of argument, suppose that the engine driving *The Simpsons* is fuelled by cruelty and one-upmanship. Its viewers, although appreciative of its humor, might not want to come back week after week to such a bleak message, especially if the message is centered on a family with children. *Seinfeld* never

really offered any hope; its heart was as cold as ice. However, *Seinfeld* was about disaffected adults. A similarly bleak show containing children would resemble the parody of a sit-com in Oliver Stone's *Natural Born Killers,* in which Rodney Dangerfield plays an alcoholic child-abuser. Over the years, such a series would lose a grip on its viewers, to say the least. I think that the thirty seconds or so of apparent redemption in each episode of *The Simpsons* is there mainly to allow us to soldier on for twenty-one and a half minutes of maniacal cruelty at the beginning of the next episode. In other words, the heart-warming family moments help *The Simpsons* to live on as a series. The comedy does not exist for the sake of a message; the occasional illusion of a positive message exists to enable us to tolerate more comedy. Philosophers and critics have often talked of the paradox of horror and the paradox of tragedy. Why do we eagerly seek out art forms that arouse unpleasant emotions in us like pity, sadness, and fear? I think that, for at least certain forms of comedy, there is an equally important paradox of comedy. Why do we seek out art that makes us laugh at the plight of unfortunate people in a world without redemption? The laughter here seems to come at a high price. *The Simpsons'* use of heart-warming family endings should be seen as its attempt to paper over the paradox of comedy that it exemplifies so well.

I hope to have shown that quotationalism and hyper-ironism are prevalent, inter-dependent, and jointly responsible for the way in which the humor in *The Simpsons* works. The picture I have painted of *The Simpsons* is a bleak one, because I have characterized its humor as negative, a humor of cruelty and condescension—but really funny cruelty and condescension.[11] I

[11] Although I have shown that the humor of *The Simpsons* is frequently cruel, I have not shown that it is always cruel. Indeed it isn't. Some very funny moments are based on harmless sight gags, such as when Sideshow Bob hides behind an intricately shaped statue of an aircraft that exactly matches the outlines of his hair. Furthermore, I have only stated rather than argued that the show stops being funny when it moves away from cruelty for long. Part of my reason for this claim is my belief that all of comedy (as opposed to every instance of humor) is based on cruelty. However, this claim is extremely controversial and there isn't enough space to argue for it here. To assess the centrality of cruelty as the mainspring of *The Simpsons'* humor, we would have to

have left out a very important part of the picture however. *The Simpsons*, consisting of a not-as-bright version of the Freudian id for a father, a sociopathic son, a prissy daughter, and a fairly dull but innocuous mother, is a family whose members love each other. And, we love them. Despite the fact that the show strips away any semblance of value, despite the fact that week after week it offers us little comfort, it still manages to convey the raw power of the irrational (or nonrational) love of human beings for other human beings, and it makes us play along by loving these flickering bits of paint on celluloid who live in a flickering hollow world. Now *that's* comedy entertainment.[12]

look at many supposedly funny examples from the show. What I fear is simply that different people would disagree over what was funny. Since, at this point, matters become philosophically interesting but also extremely messy, I must admit that any sort of universal claim about the role of cruelty within the show is controversial and in need of additional support.

[12] This paper has benefited greatly from discussions I have had with Heidi Rees, Jason Holt, Adam Muller, Emily Muller, George Toles, Steve Snyder, and Guy Maddin. Thanks also to William Irwin for his supportive editorship and to *The Simpsons* Archive (www.snpp.com) for very helpful episode listings.

9

Simpsonian Sexual Politcs

DALE E. SNOW and JAMES J. SNOW

What *The Simpsons* does best is question television pieties rang-
ing from the fifties bromide that "Father knows best" to the
burning question of the quality of present-day Fox program-
ming. Yet it continues and extends a conservative sexual politics
in three ways: the depiction of Springfield as having an over-
whelmingly male population; the fact that a large majority of the
episodes are focused on Bart or Homer; and the characterization
given of both Marge and Lisa.

It's a Male, Male, Male, Male World

REP. ARNOLD: You must be Lisa Simpson.

LISA: Hello, sir.

REP. ARNOLD: Lisa, you're a doer. And who knows, maybe
someday you'll be a congressman or senator. We have
quite a few women senators, you know.

LISA: Only two. I checked.

REP. ARNOLD: [*chuckles*] You're a sharp one. ("Mr. Lisa goes to
Washington")

One of the unfailing visual delights of almost every Simpsons
episode is the richness and detail of the backgrounds, especially
crowd scenes. Bugs Bunny may have played baseball before a

stadium of indistinct oval squiggles, and we find similar empty faces in *Doug* or *Ren and Stimpy* (to name two rather different recent cartoons), but Springfield is alive with real and recognizable people in every crowd scene. It is easy to understand why each episode takes six months to animate, given the care lavished on signage, background landscapes both urban and rural, and the creation of dozens of instantly recognizable Springfield residents.

The regular viewer is not surprised to see Moe, Otto, Mr. Burns, Smithers, and Jasper in the audience at school functions, for example, despite the fact that (we presume) they do not have school age children at Springfield Elementary. Similarly, Principal Skinner, Groundskeeper Willy, and Edna Krabappel are familiar faces in the crowds listening to hucksters, attending the circus, or demonstrating outside Town Hall. The regular viewer feels that he or she knows the town, as numerous critics have pointed out. Indeed, Springfield is a vital element in *The Simpsons'* success:

> By bringing life to such a "wonderfully congested cosmos," Groening manages to leave the main plot line undetermined for a relatively long period of time The series setting and basic composition contribute to and are preconditions for an exceptional variety of plot lines, opening up the whole infinite universe of storytelling the genre of animation is capable of; that is, portraying both reality and the surreal in an artistic as well as dramatic manner which is otherwise particular to literature only and can rarely be found in modern film.[1]

Therefore it's hardly a minor matter to point out that in terms of gender distribution, the town of Springfield is, if anything, slightly *more* conservative than the universe of shows it often satirizes. Julia Wood describes the television norm:

> White males make up two-thirds of the population. The women are less in number, perhaps because fewer than ten percent live beyond 35. Those who do, like their younger and male counterparts, are nearly all white and heterosexual. In addition to being

[1] Gerd Steiger, "The Simpsons: Just Funny or More?" *The Simpsons* Archive, http://www.snpp.com/other/papers/gs.paper.html.

young, the majority of women are beautiful, very thin, passive, and primarily concerned with relationships There are a few bad, bitchy women, and they are not so pretty, not so subordinate, and not so caring as the good women. Most of the bad ones work outside of the home, which is probably why they are hardened and undesirable. [2]

To the best of our knowledge, Census 2000 has not visited Springfield, so we will rely on three sources in an effort to establish the distribution of the sexes. "Who's Who? in Springfield," a web site which describes itself as "an exhaustive list of literary, political, historical, television, military, movie, musical, commercial, and cartoon allusions to supporting characters in *The Simpsons*"[3] contains a sub-section called "Recurring Characters," which purports to include every character to have appeared in more than one episode, from Bleeding Gums Murphy to Rainer Wolfcastle. In addition to the five immediate Simpson family members, it lists 45 male characters, as well as "Radioactive Man" (Bart's favorite comic book character), and eleven female characters, along with "Malibu Stacy," Lisa's doll. Even if Itchy and Scratchy are regarded as beyond gender, this is a 4:1 ratio.

Another source of information is *The Simpsons: A Complete Guide to Our Favorite Family*[4] and *Simpsons Forever: A Complete Guide to Our Favorite Family Continued*.[5] *The Complete Guide*'s "Who Does the Voice?" section lists 59 male characters, to which we would add Lionel Hutz, Troy McClure, Sideshow Bob and Sideshow Mel, for a total of 63, and 16 female characters.[6] *The Simpsons Forever* adds five male characters (Database, Dr. Loren J. Pryor, Mr. Bouvier, Gavin, and Billy) and one female one, sort of (the voice of Malibu Stacy); but it also drops

[2] *Gendered Lives: Communication, Gender, and Culture* (Belmont, CA: Wadsworth, 1994), p. 232. Donald M. Davis finds a similar pattern in prime-time television: men are 65.4 percent of all prime-time television characters, women 34.6 percent ("Portrayals of Women in Prime-Time Network Television: Some Demographic Characteristics," *Sex Roles* 23: 325–332).

[3] "Who's Who? In Springfield" http://snpp.com/guides/whoiswho.html.

[4] Matt Groening, Ray Richmond, ed., New York: Harperperennial Library, 1997.

[5] Matt Groening, Scott M. Gimple, ed., New York: Harperperennial Library), 1999.

[6] *A Complete Guide*, pp. 178–79.

Jacqueline Bouvier and Aunt Gladys, presumably because they are dead, in which case Maude Flanders should also be dropped.[7]

Finally, we have done our own head count. We would add Agnes Skinner, (Mrs.) Helen Lovejoy, (Mrs.) Luanne Van Houten, Manjula (Apu's fiancée/wife), and Janey Powell to the "Who's Who" list, which brings the total of recurring female characters to fifteen. The roster is still far from inspiring: of the fifteen, six appear exclusively as wives or mothers of much more fully developed male characters: Mrs. Bouvier, Maude Flanders, Mrs. Lovejoy, Mrs. Van Houten, Agnes Skinner, and Manjula. Five are truly minor characters who seldom speak: Sherri and Terri, the purple-haired twins, Janey Powell, Lunchlady Doris, and Miss Hoover (Lisa's teacher). That leaves Selma and Patty, along with Edna Krabappel, to represent working women (and since a defining characteristic of all three is incessant chain-smoking, they do seem to be presented as "hardened and undesirable," as Wood puts it). Only Ruth Powers, the Simpsons' divorced neighbor, is an unattached adult female with a mind of her own (and she has had speaking parts in only two episodes: "New Kid on the Block" and "Marge on the Lam").

Thus it comes as something of a shock (and here we merely choose one of many critics who have expressed similar sentiments) to read, in James Poniewozik's essay for *Time* magazine, "The Best TV Show Ever," that one of *The Simpsons'* strengths is:

> It has TV's greatest cast. No other series has developed as numerous and fully fleshed a supporting cast as the population of Springfield. The writers of "The Simpsons" opened worlds within worlds, investing seemingly minor characters with full back stories and lives. Any character who showed up for a few seconds in one episode might carry entire episodes later on: Apu, Smithers, Barney the drunk. To look at one of these B-listers, Krusty the Clown, is to understand the endless fertility of "The Simpsons." Beginning as a prop for Bart and Lisa to watch on the family TV, Krusty developed a story of ethnic identity (born Herschel Krustofsky, he rebelled against his rabbi father) and became a satiric stand-in for the entire entertainment industry.[8]

[7] *Simpsons Forever*, pp. 86–87.

[8] http://www.time.com/time/daily/special/simpsons.html

If "TV's greatest cast" is at least three quarters male, what does this say about the mirror of reality TV holds up to us, the viewers? And it is no help to point out that *The Simpsons* is a fun-house mirror, for in this instance, Springfield's majority male population is not an ironic commentary on television as usual, but rather an unquestioning extension of the norm.

That the population of Springfield skews so heavily male might in and of itself seem to be a minor matter, but it takes on an added significance when the content and focus of the episodes themselves are considered. Of the 248 episodes broadcast through the first eleven seasons, "The Lisa File"[9] lists 28 "Lisa Episodes," to which we would add eight more titles.[10] "The Marge File"[11] has an obviously incomplete list of episodes which might be claimed to focus on Marge; we put the total at 21, even including those episodes which "flash back" to Homer and Marge's courtship days. We have gone into some detail in order to provide evidence for our claim that there is approximately the same ratio in episode content that was to be found in the population of Springfield (that is, between four and five times as many episodes are focused on Bart, Homer, or another male character as episodes devoted to Lisa, Marge, or another female character[12]). Those fond of conspiracy theories will be entertained to note that, according to *The Simpsons* Archive article "Simpsons Guest Stars," there have been exactly 160 male guest stars (not counting multiple appearances of Phil Hartman, Albert Brooks, Jon Lovitz, etc.) and 40 female guest stars.[13] In the large majority of cases these guest stars were playing themselves, so the skewed male-female ratio extends even to the guest list.

[9] *The Simpsons* Archive, "The Lisa File," created by Dave Hall, maintained by Dale G. Abersold, http://www.snpp.com/guides/lisa.file.html.

[10] *"Round Springfield," "Make Room For Lisa," "They Saved Lisa's Brain," "Desperately Xeeking Xena" from Treehouse of Horror X, "Little Big Mom," "Bart to the Future," "Last Tap Dance in Springfield,"* and *"Lisa Gets an A."*

[11] http://www.snpp.com/guides/marge.file.html

[12] Only Patty and Selma, in "Homer vs. Patty and Selma," "A Fish Called Selma," "Selma's Choice" and "Black Widower" and Mrs. Simpson, in "Mother Simpson" seem to have received this honor; "Lady Bouvier's Mother" is clearly devoted to Grandpa.

[13] http://www.snpp.com/guides/gueststars.html

The Content of Their Character

Marge is directly descended from a long line of saintly and long-suffering TV wives and mothers whose main dramatic function is to understand, love, and clean up after her man. Of course this lovely creature pre-existed television; Virginia Woolf described her with taxonomic precision in her essay "Professions for Women" by the name "The Angel in the House":

> You who come of a younger and happier generation may not have heard of her—you may not know what I mean by The Angel in the House. I will describe her as shortly as I can. She was intensely sympathetic. She was immensely charming. She was utterly unselfish. She excelled in the difficult arts of family life. She sacrificed herself daily. If there was chicken, she took the leg; if there was a draught, she sat in it—in short she was so constituted that she never had a mind or wish or her own, but preferred to sympathize always with the minds and wishes of others.[14]

Marge is not quite so angelic a character, perhaps, but her small-screen foremothers are easy to identify: Alice Kramden bore with her irascible Ralph, Edith Bunker with Archie's unpredictable outbursts, and Marion Cunningham with her entire wacky family in much the same all-forgiving spirit that Marge uses with Homer. Patricia Mellencamp, discussing the archetypal fifties sitcom, *Father Knows Best,* points out that a staple of domestic situation comedy is a portrayal of the "comic containment of women" in traditional domestic roles.[15] An attempt to break out of the traditional female role is obviously funny, and a large number of Marge episodes trade on precisely this kind of humor. The other main aspect of the "comic containment of women" is on display in the efforts of the traditional wife to uphold etiquette, moral, or legal standards; this transforms her into the familiar "nag" which makes her the butt of much male humor, and here too, Marge more than fits the mold.

[14] William Smart (ed.), *Eight Modern Essayists,* 4th edition (New York: St. Martin's Press, 1985), p. 9.

[15] Cited in June M. Frazer and Timothy C. Frazer, "'Father Knows Best' and 'The Cosby Show': Nostalgia and the Sitcom Tradition," *Journal of Popular Culture,* 13, p. 167.

At first blush, Marge is insurgent as a television mom. Her blue well-coiffed hair and yellow skin make her visually startling. On closer inspection, however, she remains well within the boundaries of television-motherhood in the late 1950s and early 1960s. The well-coiffed hair recalls mothers from Harriet Nelson to June Cleaver. Her pearl necklace recalls Margaret Anderson *(Father Knows Best)*, June Cleaver, Donna Stone *(The Donna Reed Show)*, and even Wilma Flintstone. Whether in the house or in public, Marge wears the conventional dress of her late 1950s and early 1960s predecessors. The dress of the television mom was only briefly subverted by Morticia Addams and Lily Munster between 1964 and 1966. And like many of her lineage, motherhood has made her relatively asexual, yet all the while, traditionally feminine.

Recall that the first sexualized T.V. moms—Morticia Addams and Lily Munster—were, quite simply, freaks of nature (Lily and Herman Munster were the first TV couple to share a bed).[16] The first truly sexually defined television mother, Peg Bundy, gained her sexuality by a kind of grudging non-participation in the traditionally female familial roles; although she did not work outside the home, she did not do housework, either, and she certainly did not mother. The first TV mom to completely subvert all traditional maternal roles is *South Park*'s Mrs. Cartman. Mrs. Cartman challenges traditional maternal roles insofar as she is a calamitous contradiction. She recognizes motherhood as a role, even a facade (and she is not very good at it), as she drinks, smokes crack, and is sexually promiscuous. If we indulge ourselves for a moment and construct a continuum of television mothers from say, Harriet Nelson to Mrs. Cartman, we see that Marge remains firmly within the tradition of television motherhood of the 1950s and 1960s.

There is yet another way in which Marge remains deeply traditional as a television mother; not only is she in terms of tem-

[16] Ray Richmond observes, "Until *The Munsters,* married folk on the air were required to sleep in separate twin beds, which had to have made it awfully difficult to conceive the children who always kept popping out. But Lily and Herman snuggled under the same sheets in a queen-size bed, the thinking evidently being that they were kind of like cartoon characters, anyway, so it didn't really count. But it did." *TV Moms: An Illustrated Guide* (New York: TV Books, 2000), p. 52.

perament mostly Virginia Woolf's "Angel," but like so many of her predecessors, she remains "in the house." Recall that Harriet Nelson never left the house, nor did June Cleaver, Donna Stone, Morticia Addams, Lily Munster, Samantha Stevens, and others. Many traditional television moms who did work outside the home (such as Elyse Keaton or Clair Huxtable) did their work largely off camera to insure that it would not interfere with mothering. So too the case with Marge Simpson; married women do not work in the world of *The Simpsons,* so the drama of her life usually unfolds within the confines of the house on Evergreen Terrace.

The house on Evergreen Terrace is a bastion of domestic harmony and moral serenity. Springfield, representative of the public sphere, is marked by moral decay, whether it be the gluttonous capitalism of Mr. Burns or the drunkenness at Moe's. This is not to suggest that the Simpson home itself is never morally challenged, but it is morally challenged when the private sphere is threatened with subversion by the public. Often Groening and the writers will allow evil to invade the house through television (Krusty the Clown and especially Itchy and Scratchy, but also slightly more subtly, in Kent Brockman's obviously biased newscasts, or Troy McClure's unctuous infomercials). But the home remains ultimately impervious to moral disintegration; the family remains intact and morally functional.

Marge is often the only adult defender of moral and aesthetic values, and as such recalls "The Angel in the House" and her legendary purity. She takes on violence in cartoons ("Itchy and Scratchy and Marge") and wasteful public projects ("Marge vs. the Monorail"), and defends the artistic merit of Michelangelo's David. She is even able to get Homer to quit drinking, at least for a month ("Duffless"). The flashbacks to Homer and Marge's courtship reveal a completely conventional story of Homer pursuing Marge by arranging to be tutored by her in French; when she discovers that he is not even taking French, it is too late—they are in love, and Marge is firmly on course for life with a man who would try the patience of a saint. We are not surprised to hear the litany of quite reasonable complaints she makes during her first visit to a marriage counselor:

> He's so self-centered. He forgets birthdays, anniversaries, holidays—both religious and secular—he chews with his mouth open,

he gambles, he hangs out in a seedy bar with bums and lowlifes. He blows his nose on the towels and puts them back in the middle. He drinks out of the carton. He never changes the baby. When he goes to sleep, he makes chewing noises. When he wakes up, he makes honking noises. Oh, oh, and he scratches himself with his keys. I guess that's it. ("The War of the Simpsons")

Although Marge does occasionally take jobs ("Marge Gets a Job," "Marge in Chains," "Springfield Connection," "Realty Bites," "The Twisted World of Marge"), or even snaps from the strain of her daily life and takes off for a break at Rancho Relaxo ("Homer Alone"), she is always back (or unemployed) by the end of the episode. Far more usual are the scenarios which require her to bail out Homer or play along with some wild scheme of his, often for no very obvious reason, as when he begs her to pretend to be Apu's wife in order to fool Apu's mother into believing that he is already married, which involves (among other things), putting Apu's mother up at their house, while Homer basks in irresponsibility out at the Springfield Retirement Castle.[17] This is tantamount to asking Marge to participate in two marriages, when her marriage to Homer obviously provides all the burdens one woman can possibly be expected to bear. This is wifehood above and beyond the call of duty, or even what fifties and sixties sitcom moms were expected to handle, and as such makes Marge the undisputed champion of the genre.

Lisa's crisis in "Separate Vocations," when the school aptitude test (Career Aptitude Normalizing Test or CANT) has predicted that her future career will be "homemaker," is especially revealing with respect to Marge's role. First we see Lisa at her desk, writing "Dear log: This will be my last entry, for you were a journal of my hopes and dreams. And now, I have none." The next morning, when she comes down to breakfast, grumbling, Marge attempts to convince her of the creativity of homemaking by pointing proudly to the smiley faces she has created on Bart and Homer's plates with bacon, eggs and toast.

[17] Homer reflects on living in a retirement home: "It's like being a baby, only you're old enough to appreciate it" ("The Two Mrs. Nahasapeemapetilons").

LISA: What's the point? They'll never notice.

MARGE: You'll be surprised.

Of course, Bart and Homer come to the table and obliviously wolf down their food without a word to Marge.

Angel that she is, Marge only allows herself the smallest murmur of disappointment; it's Lisa who is truly aghast at the unsentimental truth about the thanklessness of housework, even though she had predicted Bart and Homer's reaction (or lack thereof) accurately moments before. So Marge is, in an important sense, even worse off than her predecessors. Although their sacrifices may have been largely invisible and unappreciated, at least in the terms that matter most on television: screen time, lines, and plots devoted to their characters, they were at least respected. Marge's whole way of life is openly despised by Lisa, and this, too, is something Marge resignedly accepts.

It must be admitted that Homer is conscious of needing her, as his immortal lines from the episode "Marge in Chains" proves. As Marge is being hauled off to jail to serve her sentence for shoplifting from the Kwik-E-Mart, Homer moans: "Marge, I'm going to miss you so much. And it's not just the sex. It's also the food preparation." Marge does have one enormous advantage over her counterparts in non-animated shows: even after many years of marriage and three children, she has a satisfying sex life. From the twin beds of Rob and Laura Petrie on *The Dick Van Dyke Show* to the constant marital sniping of Peg and Ted Bundy on *Married with Children,* television writers have both implicitly and explicitly depicted marriage as the death of sex (at least between husband and wife). *The Simpsons'* departure from the television norm in this respect may partially explain Marge's curiously anachronistic personality: she has to be the ultimate loving and accepting wife in order for viewers to embrace Homer as the inimitable boob that he is. No matter what mad stunt he pulls, from joining the Movementarians sect to climbing Mount Springfield, no matter how much his shenanigans cost in property damages, legal fees, or self-respect, we know Marge will rescue him and take him back.

If Marge is in some respects a throwback to the loving, giving, and self-effacing TV wives and mothers of TV's golden age, and this explains her limited role, the same kind of explanation

will not work for Lisa, who is if anything ahead of her time. In the brief shorts on *The Tracey Ullman Show* which introduced the Simpson family as characters, Lisa was little more than Bart's partner in crime, and there are still episodes in recent seasons in which Bart and Lisa are an effective team, although the goals of their activities tend to be higher-minded now. This is seen in the exposure of voter fraud in "Sideshow Bob Roberts," or trying to effect Krusty's reconciliation with his estranged father in "Like Father, Like Clown."

Lisa has become a complex character and the writers do a good job of allowing the different sides of her personality to emerge, without ever entirely abandoning the fiction that the speaker of their words is supposed to be an eight-year-old, albeit a highly intelligent one. Lisa has a crush on a substitute teacher, begs her father for a pony, is upset by an unflattering caricature, is jealous of other (smart) girls, and fights with her brother. Yet she also suffers existential despair, plays the sax like a Marsalis, wins essay contests, displays rare mathematical and scientific ability, and joins Mensa. So why is this dynamic and intelligent character not more of a presence on the show?

One possibility might lie in the supposed unpopularity of her views: some critics have pigeonholed Lisa as little more than a precocious feminist, based on her rejection of Marge's limited life and her penchant for crusades, such as her campaign to reform the entire doll industry in "Lisa versus Malibu Stacy," which seems to appear on almost every "best episodes" list. Lisa objects to the silly and sexist things her new talking Malibu Stacy doll has been programmed to say, and in her usual take-charge manner goes straight to the top to confront Malibu Stacy's creator. An interview with the actress who does Lisa's voice, Yeardley Smith, reveals that she felt that the writers were trying to strike an elusive balance on a difficult subject in the Malibu Stacy episode: "I'm always proud of Lisa when she stands up on principle and does that stuff, but I get a little worried when she gets too principled and doesn't act enough like an eight-year-old."[18]

[18] "Yeardley's Top Ten Episodes" in "*The Simpsons* Folder: Writings" at http://springfield.simplenet.com/folder/yardley.html

Sometimes the crusade is moral, as in "Homer vs. Lisa and the 8th Commandment," when Lisa tries to convince her family and especially Homer that it is wrong to steal cable; even law-abiding Marge vacillates, and Lisa needs the entire episode to prevail. Vegetarianism is another of Lisa's moral causes, but in this instance she does not succeed in persuading the other Simpsons, although it might be argued that the most important moral lesson of "Lisa the Vegetarian" comes at the end, when Lisa the vegetarian learns tolerance from Apu the vegan. Some writers identify Marge and Lisa in this respect, but the comparison usually redounds to Lisa's credit:

> Like her mother, she possesses strong ethical virtues. Although Marge has accepted the lesser sins as a part of society, Lisa advocates morality in any situation. . . . With her honest principles, Lisa is disillusioned by corruption in society, often making her "the saddest kid in grade number two."[19]

It is Lisa the intellectual[20]—the overachiever to Bart's underachiever—who gets the most attention, at least from critics. One typical description reduces her to nothing more than this:

> Lisa Simpson, like Homer, is governed by one trait. She is the site of rationality. Lisa acts as the voice of reason, questioning with a critical eye the motives and behavior of other characters. Her intelligence, however, only makes her an outcast. The family usually ignores her advice and she has few friends at school. She is often at odds with the entire community, suggesting the dismissal of reason in American culture.[21]

From her God-like powers in the "Treehouse of Horror VII" episode, "The Genesis Tub," in which she creates an entire race of tiny people, to her mathematical abilities in "Lisa the Greek,"

[19] John Sohn, "Simpson Ethics." *The Simpsons* Archive, http://www.snpp.com/other/papers/js. paper.html.

[20] For a more complete analysis of Lisa's role in the portrayal of the intellectual, see Aeon J. Skoble's essay, "Lisa and American Anti-Intellectualism," in this volume.

[21] Sam Tingleff, "*The Simpsons* as a Critique of Consumer Culture," http://www.snpp.com/other papers/st.paper.html.

to her hard-headed insistence on a scientific explanation for the angel-shaped fossil she found at the ground-breaking for the new mall in "Lisa the Skeptic," we are given a quirky but clearly recognizable portrait of a nerd. And the "smart kid," male or female, has always been a relatively minor character, at least on television.

We think that the main reason why only around 15 percent of the episodes are focused on Lisa is not just her feminism or intellectual gifts. Indeed, the variations on the oft-cited idea that Lisa is somehow Bart's opposite confuse rather than explain the issue, for if they are genuinely opposites, we might reasonably expect them to receive approximately equal time. Jeff MacGregor, in *The New York Times*, defends one of the most articulate versions of this view when he observes:

> Bart and Lisa, the scapegrace and overachiever, the delinquent yin and bookish yang, id and superego of American children every-where, are characters far richer and more fully evoked than the one-dimensional little wisenheimers so often seen dissing their par-ents on other sitcoms. Their fears and neuroses prevent these two from becoming simple punch-line delivery platforms in the manner of the Olsen twins.[22]

What MacGregor perhaps has seen is that for most people (and arguably American culture in general), there is far more psychic energy invested in the id (Bart) than in the superego (Lisa). *The Simpsons* needs Lisa for psychic balance, but in a very real sense it does not need too much of her. She is not the yang to Bart's yin, for this image assumes complementarity if not equality of influence, which we have abundantly proven not to be the case.

A related aspect of the unusually philosophical dimensions of Lisa's personality emerges most clearly in "They Saved Lisa's Brain," the episode in which Lisa is secretly invited to join the Springfield chapter of Mensa. Even in comparison with her fel-low Mensa members, she quickly shows herself to be a utopian

[22] "More Than Sight Gags and Subversive Satire," *New York Times* (20 June, 1999); also in *The Simpsons* Archive, http://www.snpp.com/other/articles/morethan.html.

and an idealist. After Mayor Quimby abdicates and the Mensa members have become the new government of Springfield, Lisa is astonished at how quickly even very smart people can become narrowly partisan and argumentative. Even Steven Hawking cannot quite convince her that her dream of the common good is an unrealizable mirage. Since most societies have been able to tolerate at most one idealist or reformer without martyring him or her, the Simpson family should probably be given high marks for the degree to which they embrace theirs.

Good Girls and Dumb Guys

It must, of course, be recognized that episodes of *The Simpsons* often provide a rich parody of television, family, and a host of other cultural institutions and conventions. Therefore, an all-too-serious deconstruction of the text risks effacing the humor and scathing social commentary that have sustained it through eleven seasons to a demographically diverse audience. Still, the series demands analysis within the very genre of the television situation comedy it so often, and so perceptively, parodies.

The demographics of Springfield, as we have seen, precisely mirror the demographics of the television world writ large. In Springfield (and in most of television), it is a man's world, even if the men (and boys) are in large measure bumbling idiots. The male characters in *The Simpsons,* like the characters in most of mainstream television comedy over the last half-century, (dys)function in a public world of work and commerce, of public recreation and entertainment. And the public world in which these men (dys)function is all too often a bitter world of moral challenge, a truly postmodern arena devoid of meaningful social structure and lacking a moral center. And it is to the credit of Groening and the writers that this public world is so wittily examined, disentangled, and sometimes turned upside down. It is equally ironic, then, that Homer and Bart, like so many in television land before them, are able to come home to the house on Evergreen Terrace that despite all its eccentricities, remains an asylum in a postmodern world. The home on Evergreen Terrace remains a place not unlike the home of the Nelsons, the Cleavers, and the Munsters, a place where the center does hold, and where things (ultimately) do not fall apart, and where Marge Simpson faithfully waits, the "Angel in the House."

Might one respond to our observations by complaining that we have missed the point, that *The Simpsons* is intended as parody of "the normal American family in all its beauty and horror."[23] We think not: the ideal of the family does not come in for anything like the skewering bestowed on other targets. Take the case of capitalism: Mr. Burns is to a great degree capitalism personified. Most often, Mr. Burns is presented as an exaggerated characterization of the Friedmanesque free-wheeling capitalist whose telos is profit, whose *raison d'être* is greed. In the character of Mr. Burns we have an effective caricature of the relentless capitalist. Like all effective satirists, Groening is able to offer up some biting criticisms of the capitalist world-view by exaggerating or magnifying that view. Put another way, Mr. Burns shows us the logical conclusion of the capitalist world-view when it is unchecked by other fundamental moral or social commitments. Still, Mr. Burns is not merely the personification of capitalist greed, but a character in his own right, insofar as he has occasional moments of angst, if not existential despair, as a direct result of his unwavering capitalist machinations. In a similar vein, it might well be argued that the character of Marge (like Mr. Burns) is a parody of the culturally constructed ideal of wife and mother, an exaggerated spoof meant only to reveal the ultimately vacuous nature of her roles. There is, no doubt, some merit to this view.

However, if we read the character of Marge as largely satirical in nature, problems emerge. First, satire, by its nature, requires that we take an all-too-familiar cultural convention (capitalism, religion, motherhood . . .) and exaggerate its most salient characteristics to a very great degree, thereby revealing absurdities latent within the cultural convention itself, but then revealed through the satiric exaggeration of that convention or idea. The character of Marge does not exaggerate motherhood, wifehood, or femininity nearly to the extent that the character of Burns exaggerates and lampoons capitalism, or the Reverend Lovejoy satirizes postmodern religion. Burns takes capitalism to its logical conclusion and reveals it to be a barren way of life. Marge, by contrast, does not take the conventions she embod-

[23] Description of the Simpson family attributed to series executive producer James L. Brooks in "*The Simpsons*: Just Funny or More?", by Gerd Steiger, *The Simpsons* Archive, http://www.snpp.com/other/papers/gs/.paper.html.

ies to their logical conclusions, she does not exaggerate them grossly, and she certainly does not reveal them to be vacuous or superficial. Secondly, parody (at its best) reveals to us an aspect of something heretofore not seen or appreciated. It jars us from our complacencies by showing us where a convention or idea may end up if unfettered by other ideas or conventions. In the case of Mr. Burns and capitalism we are reminded of the lineaments of unfettered capitalist pursuits (environmental destruction, exploitation of workers, self-loathing, and loneliness). Not so with Marge: not only does she not seem a grossly exaggerated portrayal of wifehood or motherhood, her character is continuous with the virtues we know so well from her predecssors. Marge presents the viewer with a valorized and largely affectionate view of a woman who rules as wife and mom.

Groening and company are to be saluted for their originality in expanding the moral center with the character of Lisa as "the Idealist in the House" (with apologies to Virginia Woolf). Not merely the voice of reason, Lisa emerges as fully human, giggling at *Itchy and Scratchy* cartoons, gleefully participating in the grease fight which interrupts a school dance, and risking her life to rescue precious airline tickets for her family. In the fullness of time, she has even succeeded in changing Bart's behavior for the better, at least to some extent. An early example can be found in the second season's "Bart Gets an F"; after Bart has prayed for one more day to study for a test, and received it in the form of a freak snowstorm, he is tempted to forget studying and play in the snow. It is Lisa who reminds him: "I heard you last night, Bart. You prayed for this. Now your prayers have been answered. I'm not a theologian. I don't know who or what God is exactly. All I know is He's a force more powerful than Mom and Dad put together and you owe him big." Bart studies (and passes).

In the fourth season, Lisa and Bart work together to expose the horrible conditions at "Kamp Krusty," the cruelty to animals of "Whacking Day," and help Krusty revitalize his image in "Krusty gets Kancelled." Season Six features Lisa and Bart pitted against one another as athletic rivals in pee-wee hockey, egged on by most of adult Springfield, including Homer. As the game comes down to a final penalty shot, Bart and Lisa take off their equipment and embrace; the game ends in a tie ("Lisa on Ice"). It is one thing to rise above the inanity of the ethos of winning

at any cost, especially for boys, but the true measure of Lisa's influence on Bart can be seen in "The Secret War of Lisa Simpson." As the lone female cadet at Rommelwood Military Academy, Lisa's faith in her ability to cope with the hazing and demanding physical tests begins to flag as she becomes increasingly isolated. At first Bart will only help her train in secret, but at the crucial moment during the dreaded rope test, he risks ostracism from the other boys by shouting words of encouragement. Lisa finishes successfully.

A kind of symmetry has been achieved: Bart the underachiever has grown sufficiently (by the end of the eighth season) to put the private value of family loyalty ahead of even male solidarity in a public setting. Moral truths that only Lisa could see in earlier seasons (keep your promises, protect the vulnerable, even if they are snakes, stand by your friends) have been adopted by Bart to the extent that he actually acts nobly on his own, without prompting from Marge or Lisa (this interpretation conveniently ignores the fact that Bart did give Lisa the silent treatment at the beginning of the episode).

The real acid test for the influence of Lisa's moral idealism is not, of course, Bart, but Homer. The time frame here is of necessity even longer—in fact, Homer's only explicit recognition of Lisa's worth comes in the flash-forward episode "Lisa's Wedding." Now 23, Lisa has met and fallen in love with Hugh Parkfield, an upper-class Englishman who shares her interest in the environment, high opinion of the art of Jim Carrey, and typically humorless vegetarianism. When she returns to Springfield for the wedding, Homer is overcome with emotion:

HOMER: Little Lisa, Lisa Simpson. You know, I always felt you were the best thing that my name has ever been attached to. Since the time you learned to pin your own diapers, you've been smarter than me.

LISA: Oh, Dad—

HOMER: No, no, let me finish. I just want you to know that I've always been proud of you. You're my greatest accomplishment and you did it all yourself. You've helped me understand my own wife better and taught me to be a better person, but you're also my daughter, and I don't think anyone could have a better daughter than you.

LISA: Dad, you're babbling.

HOMER: See? You're still helping me.

Despite a valiant effort, Hugh is somewhat put off and alarmed by Lisa's family, and when he offhandedly remarks that it will be a relief to get back to England and not have to deal with them, she calls off the wedding. This is a vital moment in the development of Lisa's character. Despite the broad hint given in "Lisa the Simpson," in which Lisa discovers stupidity to be a sex-linked trait appearing in all male Simpsons (which seems to imply that her talents and intelligence may yet take her far from Springfield and her family), Lisa's reaction to criticism of her family shows that her love for them will perhaps, as it were, outweigh the promise of her intelligence. One episode does not define Lisa's character, and one can even hope that love for family can be maintained along with the promise of intelligence, but Lisa's choice to remain in the quagmire of Simpson family life suggests that her promise is yet to be realized. In an interview in *Loaded Magazine* Groening himself addresses this concern with the character of Lisa. "The men have no self-awareness at all in *The Simpsons* and the women are on the verge of gaining some. I think that Lisa might escape Springfield eventually so there's hope for her."[24] Lisa's promise is yet to be fulfilled.

Marge is the guardian of the home and the refuge to which Homer and Bart return every episode, and we know that she is too important in that role to ever be more than temporarily released from it. In any case, she is too good to succeed in the harsh and corrupt public sphere. After all, she failed to sell a single house during her brief employment at Lionel Hutz's Red Blazer Realty, not because she was a woman but because she was unable to lie to her clients. Lisa, too, will never really grow up or leave home because she is too important as moral exemplar. Marge reassures her boys that she loves them just the way they are; Lisa makes them want to be better, and guides them in the direction of that possibility. These are wonderful and

24 "And on the Seventh Day Matt Created Bart," *The Simpsons* Archive, http://www.snpp.com/other/interviews/groening96.html.

dramatically significant roles, and seem to attribute the best human qualities exclusively to the female of the species. Yet to be an inspiration to dumb guys everywhere (as well as those in your own family) is to still leave unquestioned the position of those dumb guys squarely at the center of life's stage.

Part III

I Didn't
Do It:
Ethics
and *The*
Simpsons

10

The Moral World of the Simpson Family: A Kantian Perspective

JAMES LAWLER

In a review of *Harry Potter and the Goblet of Fire,* by J.K. Rowling, science fiction author Spider Robinson writes: "Okay, Harry himself is a bit of a goody-goody . . . in fact, let's admit it: Harry is the AntiBart. But do you really want your own kids to have no better role model than a Simpson?" (*The Globe and Mail,* 15 July 15 2000, p. D14).

As a role model for children, we don't have to choose between a goody-goody Harry Potter and a hellion Bart Simpson. There is also, for example, Lisa Simpson. *The Simpsons* is not reducible to any one of its parts but comes in the totality of its perspectives. Failure to recognize the unique moral perspective of Lisa Simpson, and the representation of the moral role model in the form of the "goody-goody" individual, suggests a narrow view of moral goodness.

What is moral goodness? A central feature of the moral point of view, according to Immanuel Kant, is a commitment to the performance of "duty." The term "duty" implies the presence of two opposing forces. On the one hand, there are our spontaneous desires, feelings and interests—including our fears and hatreds, our jealousies and insecurities. On the other hand, there is what one believes one ought to do and the kind of person one ought to be. The term "duty" suggests that these two forces frequently come into conflict, and consequently doing what one ought to do or trying to be what one ought to be can be difficult or painful, involving sacrifices of various kinds. The indi-

vidual who is committed to maintaining a moral point of view—
the ideal moral role model—is one who resolves to subordinate,
and to sacrifice if need be, personal desires, feelings and inter-
ests to duty—for the sake of doing the right thing or becoming
the right kind of person.

Episodes of *The Simpsons* frequently highlight the conflict
between personal desire, feelings, or interests, on the one hand,
and the sense of moral duty, on the other. Each member of the
Simpson family, including baby Maggie, contributes to the cre-
ation of a complex moral atmosphere, in which morality stands
out in its significance as duty precisely because the contrary
exists as well—the passionate desires, feelings, and interests of
strong personalities. We will look briefly at the way these
themes are played out in the characters of Homer, Bart, and
Marge, before focusing on the primary instance of the dutiful
moral person, in the character of Lisa. In this exposition it will
become clear that it is the entire Simpson family that ultimately
resolves and surmounts the contradictions of duty and desire.

Homer Between Moe and Flanders

Sometimes this conflict is underscored by a caricature of the
sense of duty. Homer Simpson exhibits a great ability to ratio-
nalize his desires and interests as constituting moral duty itself,
so that no difficult conflict arises for him. In "Dumbell
Indemnity," Moe wants Homer to destroy Moe's automobile so
that Moe can collect on his insurance policy. Homer feels
intense pressure from the generally egotistical or me-first char-
acter Moe. He is intimidated by the threat of Moe's sharp tongue
and so wants to yield to his friend's insistent demand. Moe as a
rule puts his own personal desires and interest first and has lit-
tle or no concern for any conflicting moral duty. By contrast,
Homer has a moment of doubt in which he wonders whether or
not he is doing the right thing. He consults his "conscience,"
which takes the form of a mental picture of his wife Marge talk-
ing to him. Laughably, "Marge" tells him quite definitively: his
duty consists in destroying Moe's car so that Moe can collect on
the insurance. His "conscience" thereby satisfied, Homer pro-
ceeds with characteristic energy to perform the "dutiful" action.

Though in a satirical manner, the episode clearly raises the
moral perspective of duty. Rather than providing a positive role

model, Homer Simpson here shows us how *not* to act. We laugh at this caricature of the moral situation, but at the same time we ask ourselves whether or not our conceptions of moral obligation are not frequently determined by a similar procedure.

Homer's moral dilemmas emerge in largely concrete ways, as when he must weigh his love for Marge, and his duty to her as her husband, against his love for fishing and other personal pursuits. Homer truly wants to be a good father and husband, but the appeal of personal pleasures continually drives such dutiful thoughts out of his head. In "War of the Simpsons," after a particularly flagrant demonstration of Homer's thoughtlessness, Marge persuades Homer to attend a weekend marriage counseling session at Catfish Lake, led by the Reverend Lovejoy. Although he recognizes the marital problem he has created, Homer is mainly motivated by the possibility of catching the legendary giant catfish, "General Sherman," "five hundred pounds of bottom-dwelling fury."

Early their first morning, Marge catches Homer, in full fishing regalia, trying to sneak out of their cabin. How can he possibly think about fishing when their marriage is at stake? Sincerely ashamed, Homer renounces his plan and takes a walk along the lakeside instead. Seeing that someone has apparently left a fishing pole behind, Homer conscientiously picks up the pole to return it to its owner. At that instant, General Sherman takes the bait with a force that hurls Homer into a rowboat and drags him out to the middle of the lake.

There ensues an epic battle of will and strength between man and beast, a lonely and heroic struggle out of Ernest Hemingway's *Old Man and the Sea*. Homer, finally victorious, returns to shore with great expectations of lasting fame as history's greatest fisherman, only to find a furious Marge charging him with utter selfishness. Face to face with the choice between selfish desire and moral duty, Homer renounces fame for family and returns the gasping General Sherman to the watery depths. In surmounting such powerful impulses of personal desire, Homer transmutes his physical exploit into a truly great feat of moral heroism. Homer recognizes his dutiful sacrifice: "I gave up fame and breakfast for our marriage."

The "goody-goody" Flanders is also at the counseling session with his wife. What is the problem with their marriage, if such a question is thinkable? Ned's wife sometimes underlines in his

copy of the Bible! Flanders is an important figure in the moral universe of *The Simpsons,* as he represents morality gone over-board, morality which no longer involves a conflict with per-sonal desires and interests because Flanders no longer apparently *has* personal desires and interests.[1] In this respect, Flanders is the opposite of Moe. For there to be a real sense of moral duty, there must be two forces, not just one: an aware-ness of moral duty and a healthy sense of individual desire, pleasure, and interest. The two tendencies contain the possibil-ity of conflict. Whereas Moe is decidedly out for himself, Flanders, in his caricature of Christian morality, has no personal life whatsoever.

This point is humorously brought home in "Viva Ned Flanders," when the rather youthful looking Flanders confesses that he is actually sixty years old. The reason for his youthful appearance, Homer tells him, is that he hardly has a life of his own. Regretfully accepting this analysis, he appoints Homer as his instructor on how to live.[2] The outcome, of course, is disas-trous, involving a drunken double wedding in Las Vegas. Homer's passion for immediate personal gratification is the inverse of Flanders's moralistic failure to "have a life." Neither has much of a sense of the limits to their respective approaches to life.

Even Bart Knows That's Wrong

Bart Simpson has a lot of his father in him. His is the devil-may-care attitude of the fun-loving, trouble-seeking boy. In "Bart's Girlfriend," Bart develops a compulsive infatuation with Reverend Lovejoy's daughter, Jessica. At first Bart thinks he has to convert to Sunday school piety in order to win Jessica's affec-tions. But Jessica only becomes interested in him when she thinks she recognizes a possible partner in crime. This episode illustrates the possibilities for moral hypocrisy[3] when morality is identified with conformity to an external code of behavior. As

[1] For a discussion of Ned's morality see Chapter 14 of this volume.

[2] For a discussion of Homer's admirable "love of life," despite his moral short-comings, see Chapter 1 of this volume.

[3] For a detailed examination of hypocrisy see Chapter 12 of this volume.

the minister's daughter, Jessica plays the role of the "goody-goody" child for all that it is worth. She hypocritically plays on morality to secure her selfish desires. But with Bart there are limits, a sense that enough is enough. As Jessica steals from the collection basket in Church, Bart does his best to oppose the theft: "Stealing from the collection basket is really wrong!" Bart tells her. "Even I know that." When Bart gets blamed for the theft, he asks Jessica why he should protect her. She replies: "Because, if you tell, no one will believe you. Remember I'm the sweet, perfect minister's daughter, and you're just yellow trash."

Because of his usual devilishness, Bart's periodic acknowledgements of duty may more effectively underline certain moral issues than would be the case with a conventionally well-behaved child. In "Bart the Mother," Bart experiences a moving crisis of conscience when his thoughtless antics lead to the death of a mother bird. Bart decides to devote himself entirely to the raising of the parentless eggs, uncharacteristically sacrificing his usual pleasures for the sake of his demanding charges. Life has its way of turning the best of intentions, perhaps especially when grounded in emotional impulse, into the path to hell. When it turns out that the eggs contain bird-eating reptiles, banned by federal law, Bart stands by his charges. He tells his mother, "Everyone thinks they're monsters. But I raised them, and I love them! I know that's hard to understand." Marge replies: "Not as hard as you think."

In the end, Bart's lizards decimate the pesky pigeon population of Springfield and Bart is celebrated as a town hero. Bart allows fame to smother whatever moral principle underlay his original actions. "I don't get it, Bart," says sister Lisa. "You got all upset when you killed one bird, but now you've killed tens of thousands, and it doesn't bother you at all." But Bart has returned to his usual non-moral mode and can hardly focus his mind on Lisa's ecologically relevant paradox.

Marge Stands Up for Herself

Marge is characteristically submerged in her role as the conventional wife and mother without a life of her own.[4] She becomes

4 For a feminist critique of Marge see Chapter 9 of this volume.

the focus of a high level of moral awareness when she challenges and rises above her conventional upbringing. We have duties to ourselves as well as to others, Kant insists. We have an obligation to develop the talents within us to the best of our ability. The path to independent self-development can, under certain circumstances, be a painful moral duty. It takes courage to stand up for your own personal development when social pressures and upbringing insist on service, and subservience, to others. Thus the great moral case of feminism is often put forward by Marge, otherwise the traditional housewife.

In the episode, "Realty Bites," borrowing from the film *Glengarry Glen Ross*, Marge takes a job as a real estate agent. She has had enough of having her selfless services taken for granted by her family. She too is a person, with a right to a life of her own. Marge wants a career in which she can prove her value and abilities to herself, to her family, and to the larger society of Springfield. As she is introduced to her colleagues in the business, we see that she's getting into a cut-throat, dog-eat-dog world. One agent venomously defends her rights to the West Side, while an older man, looking like a broken Jack Lemmon, is on the verge of complete personal demolition. Marge is unconscious of this environment at first, as she enthusiastically and proudly dons the spiffy red jacket of her company.

The trouble is that Marge sincerely wants to help her customers and is prepared to sacrifice her own interests for the sake of her perceived duty.[5] Trusting Marge, friends and neighbors defer to her opinion. Responding to that trust, Marge cannot help telling them what she actually thinks about the houses they are interested in buying. Marge is nothing if not honest with her customers, with whom she feels the ties of friendship in this tightly connected community, and as a result she doesn't make the sales that ensure her a continued place in the company. She fails to be "a closer."

Marge defends her approach to the suave manager, Lionel Hutz: "Well, like we say, 'The right house for the right person!'" Lionel replies: "Listen, it's time I let you in on a little secret, Marge. The right house is the house that's for sale. The right per-

[5] For a discussion of Marge being virtuous, as opposed to dutiful, see Chapter 4 of this volume.

son is anyone." "But all I did was tell the truth!" says Marge. "Of course you did," says Hutz. "But there's the truth" (here he frowns and shakes his head negatively) "and the truth" (here he looks cheerful and shakes his head positively). A sale could be made if she would only put her product in the right light: call a tiny, cramped house "cozy," describe a ramshackle, falling-down dump "a handy-man's dream," and so forth.

Marge is unconvinced, but eventually she must face the option: either fail at her job, or do some shading of the truth. In the conflict between personal interest and moral duty, we see how, because of underlying structures of competitive social organization, she is pressured into choosing personal interest. Changing her approach, then, Marge makes a big sale while concealing from the naively trusting Flanders family the fact that there was a brutal murder in the house they are buying. She tries to find pleasure in the possession of Flanders's check, the sign of her success in her chosen career, the tribute to her worth as a person. But she feels guilty for what she believes is a betrayal of duty. Her sense of duty ultimately triumphs over desire and self-interest. She decides to risk sacrificing everything she has aspired to, and goes back to her customers with the whole story. It turns out that her expectation of the Flanders's response had been quite wrong. They are delighted with the adventure of living in a house with such an interesting, gruesome history. Paradoxically, in this case complete honesty would have been, from the very beginning, the best policy.

After some initial fluctuation, Marge finally does her duty for the sake of duty, and still achieves her personal goals. Isn't this the way life should always work? Why should doing the right thing result in personal sacrifice? This brings us to a second major feature of moral consciousness: If you do the right thing, somehow you ought to be rewarded. This second feature of morality seems to contradict the first—the tension and possible conflict between duty and desire. But this tension is only momentary, Kant argues. Ultimately, in the long run, moral duty and personal happiness ought to be reconciled. The "highest good" and supreme moral duty is to create a world in which happiness arises out of the performance of moral duty. People who do their duty ought to be rewarded; self-centered people who pursue their goals at the expense of others ought to be punished.

Just as we are led to adopt this comfortable and consoling moral conclusion, Homer, on a parallel escapade involving a struggle over a car, crashes his automobile into the newly sold house. Emerging from the resulting rubble, Flanders turns to Marge and asks, "Do you still have that check?" Marge resignedly hands it over and he tears it up. The lesson? Do what you ought to do whatever the consequences.

Success in a career is not the most important thing in life. Marge returns to the bosom of her family amidst cheers and, finally, respect. By her ultimate commitment to moral principle she achieves an even higher reward than a big sale—the happiness that comes from experiencing the love and respect of her family. We periodically catch glimpses of the "highest good," the unity of duty and happiness, in such luminous moments of the Simpson household.

Lisa Stands Up for Principle

Dutiful moral consciousness is most graphically depicted in the character of second-grader Lisa Simpson. Lisa has an acute sense of moral duty. Hers is not, however, the self-assured, institutionally-based morality of Flanders, confident in the authority of his Bible and Church. Lisa's morality arises out of precocious personal reflection on the great themes of moral life: truthfulness, helping others in need, a commitment to human equality, and justice. Lisa shows us how difficult it sometimes is to live up to such principles in the face of thoughtless conventional compromises with the status quo. This points to another central characteristic of morality, according to Kant. Morality is essentially inner-determined. It arises out of personal reflection rather than from external social conventions or authoritative religious teachings. It involves clarity and consistency in the principles by which a person lives her life.

In "Lisa the Iconoclast," Lisa discovers that the legendary and supposedly heroic founder of Springfield was actually a vicious pirate who tried to kill George Washington. Lisa receives an "F" for her essay, "Jebediah Springfield: Superfraud." Her teacher explains: "This is nothing but dead white male bashing by a P.C. thug. It's women like you who keep the rest of us from landing a husband." Lisa is merely trying to tell the truth, as she has discovered it. This is not the varnished truth of the selling profes-

sion, but objective, historical, scientific truth, to be defended as an inherent value, no matter what the consequences and no matter what the sacrifices.

Some truths about founders, however, need to be upheld against contemporary practices. In "Mr. Lisa Goes to Washington," Lisa discovers that a certain politician is on the payroll of private moneymakers. Lisa attempts to expose this perversion of the founding ideals of American democracy. She takes her case to Thomas Jefferson himself. As usual, Lisa takes a stand for principle and suffers for it. The easier path is to go along with the crowd, not make waves, and turn a blind eye. Lisa fights City Hall.

Committed to fulfilling her duty as determined by consistent principles, Lisa continually raises difficult questions. Is it right to eat meat, and so cause suffering to innocent animals? In "Lisa the Vegetarian," Lisa identifies the lamb chop on her plate with the sweet, defenseless lamb in the children's zoo. She generalizes from this experience and militantly adopts vegetarianism. In standing up for consistent principles, she exemplifies a central aspect of Kant's moral theory, which requires that we thoughtfully examine the principles of our actions and eliminate contradictions between them. If it is wrong to harm a helpless animal in a zoo, how can it be right to condone the slaughter of a similar animal for our eating pleasure? This is one way to understand Kant's formulation of his Categorical Imperative: "Act only on that maxim through which you can at the same time will that it should become a universal law."

In fighting for her principles, Lisa ruins Homer's barbecue party. Homer is angry and Lisa feels ostracized from her family and the general community, until she finds refuge on the roof garden of the vegetarian Hindu storeowner, Apu. There she finds a new community with vegetarians Paul and Linda McCartney, where she finally feels that her ideas will be respected. "When will all those fools learn that you can be perfectly healthy simply eating vegetables, fruits, grains, and cheese?" But the mild Apu replies, "Oh, cheese!" Lisa recognizes the arrogance of her sense of moral superiority on discovering that others have higher standards. Apu, who will not even eat cheese, advises tolerance. Lisa develops a more subtle moral understanding as a result of this experience: "I guess I have been pretty hard on a lot of people. Especially my dad. Thank you, guys."

Lisa's Isolation

Lisa focuses attention on inescapable moral principles and makes people uneasy with the conventional compromises. Hence she is typically isolated and suffers intensely from her isolation. She yearns for respect and friendship. She too wants to be popular and to be liked. Because she is a Simpson she is not a goody-goody. She is not someone who finds happiness simply in doing what is acknowledged by all to be good. Like her brother, Lisa is adventuresome, but her adventures are on the moral rather than on the physical plane. Because of this, moral values are most sharply highlighted in the Lisa episodes—positively, not negatively as in many of the Homer episodes, with principled consistency rather than through the role-reversals of her mother.

In "The Secret War of Lisa Simpson," Lisa's moral isolation is graphically illustrated in her encounter with the military academy. Bart is being sent to a military academy on the theory that strict military discipline will control his wayward impulses. We understand in Bart's successful adaptation to the school that this can hardly be the right way to restrain possible tendencies to delinquency. "My killing teacher says I'm a natural," Bart boasts. Such moral reflections on conventional social values frequently shout at the viewer of *The Simpsons*. Is the objection really that there is not enough morality in this program, or that there is too much morality—too much of a critical perspective on our society, too much of the Lisa Simpson outlook?

The episode focuses, however, not on Bart but on Lisa, who insists that she be enrolled as well. Lisa is looking for the challenge that she can't find in the dumbed-down curriculum of her school. She's also standing up for her right as a woman to equal treatment with men. Her introduction as the first girl in the academy involves moving all the boys out of their sleeping quarters—hardly a good way to gain the acceptance Lisa is anxious to achieve. Alone and facing a hostile male-chauvinist environment, Lisa consoles herself with thoughts of Emily Dickinson. She too was lonely and yet was able to write beautiful poetry, she reflects. And then, Lisa recalls, she went crazy as a loon!

Publicly, Bart goes along with the ostracism, afraid to acknowledge his sister. Privately he apologizes: "Sorry I froze you out Lis. I, I just didn't want the guys to think I'd gone soft

on the girl issue." However, Bart secretly helps Lisa train at night on "The Eliminator," a rope-crossing exercise at a vertiginous height, "with a blister factor of twelve." Ultimately, Lisa conquers the obstacle, despite shouts of "drop, drop, drop" from the boys. Bart finally stands up to the bullies, a sole but effective voice of encouragement. Even Bart knows it's wrong to abandon a sister. I wonder if such a point could be made as effectively by Harry Potter.

Lisa's Sorrow and the Saxophone

What makes Lisa more than a goody-goody kid is the fact that she is an acutely sensitive person with a great desire for personal happiness. The conflictual nature of moral duty, with its tendency to require personal sacrifice, is accordingly represented here in all its poignancy. Hers is all the suffering that a commitment to self-determined principle creates in a precocious, sensitive child. Her deep love of life and beauty, played out against a no less profound commitment to truth and goodness, issues in the frustrations and sorrows that she expresses in the woeful, yearning sounds of the jazz saxophone. Kant holds that beauty and art bring into sensuous presence the possibilities of a higher moral life. When actual life seems to pay little or no attention to such possibilities, the doleful cry of Lisa's soul finds an outlet in the wail of a saxophone. In the character of Lisa, the comedy of *The Simpsons* does not allow us to forget a depth of tragedy.

In the episode "Moaning Lisa" Lisa has trouble going along with conventional patriotism. In a music class, instead of playing the simple notes of "My Country 'Tis of Thee," Lisa improvises a soulful jazz solo on her saxophone. "There's no crazy bebop in 'My Country 'Tis of Thee,'" says the teacher. "But that's what my country's all about," Lisa momentously declaims. "I'm wailing out for the homeless man living out of his car, the Iowa farmer whose land has been taken away by unfeeling bureaucrats, the West Virginia coal miner, caught . . ." "That's all well and good," says the teacher, "but, Lisa, none of those unpleasant people are going to be at the recital next week."

A letter is sent home from school, critical for a change of Lisa, not Bart: "Lisa won't play dodge ball because she is sad." The game of dodge ball seems particularly expressive of Lisa's

situation. One person is singled out for attack by all the others. Lisa just allows herself to be bombarded, refusing to enter the spirit of the game by defending herself. We should remember that this episode was made well before the onslaught of "Reality TV" with its glorification of the Darwinian struggle for survival.

The main problem is that there seems to be no one with whom Lisa can communicate the reasons that she feels are at the root of her melancholy. Bart and Homer are engrossed in ferocious videogame slugfests. How can they understand her issues? Lisa tries to explain: "I'm just wondering, what's the point? Would it make any difference at all if I never existed? How can we sleep at night when there's so much suffering in the world?" Homer tries to cheer her up by bouncing her on his knees. Perhaps it's an underwear thing, he later surmises when Marge remarks on her difficult age. Homer has his heart, at least, in the right place.

Lisa's gloomy mood first begins to lift when she hears the plaintive notes of fellow saxophonist, Bleeding Gums Murphy, playing into the night on a lonely bridge in a haunting moon-illuminated cityscape. Murphy's gums bleed because he has never been to the dentist. "I have enough pain in my life," he says. Lisa tells about her own pain. "I can't help you with that," he says, "but we can jam together."

Lisa and Bleeding Gums jam together—"I'm so lonely, since my baby left me . . ." And Lisa responds:

> I got this bratty brother,
> He bugs me every day,
> And this morning my own mother
> Gave my last cupcake away.
> My dad acts like
> He belongs in a zoo.
> I'm the saddest kid
> In grade number two.

Marge interrupts the session and commandeers Lisa. "Nothing personal," Marge says to Bleeding Gums. "I just fear the unfamiliar."

Marge, in her persona as the conventional mother, advises Lisa to smile. That was her own mother's advice to her: "Put your happy face on," her mother tells a young Marge in a flash-

back, "because people know how good a mom you have by the size of your smile." Lisa says she doesn't feel like smiling. Marge is firm: "Now Lisa, listen to me. This is important. I want you to smile today. It doesn't matter what you feel inside, you know. It's what shows up on the surface that counts. That's what my mother taught me. Take all your bad feelings and push them down, all the way down, past your knees until you're almost walking on them. And then you'll fit in, and boys will like you, and you'll be invited to parties, and happiness will follow."

Lisa, perhaps desperate by now for some relief, follows her mother's advice. And it works! "Hey," says one boy, "nice smile." Another tells the first boy, "What're you talking to her for? She'll only say something weird." Lisa just continues to smile. "I used to think you were some kind of braniac," says one of the boys, "but I guess you're OK." "Why don't you come over to my house," says the other boy. "You can do my homework." "OK," says Lisa. The teacher appears and says he hopes Lisa won't have "another outburst of unbridled creativity." "No sir," Lisa answers, widely smiling.

Watching this scene, Marge recognizes the error of the traditional teaching, and sweeps Lisa away with squealing tires. "So that's where she gets it," says the teacher, revealing the deeper truth of the relation between Lisa and her mother. Marge apologizes to Lisa. "I was wrong. I take it all back. Always be yourself. You want to be sad, honey, be sad. We'll ride it out with you. And when you get finished feeling sad, we'll still be there. From now on, I'll do the smiling for both of us."

Hearing this affirmation of her own feelings, Lisa genuinely smiles for the first time. At Lisa's suggestion, the entire family goes to the club where Bleeding Gums pays homage to "one of the great little ladies of jazz" and plays Lisa's song. In the company of her happy and supportive family—including baby Maggie sucking rhythmically on her pacifier—Lisa is beaming. The free, independent, dutiful individual deserves to be happy.

11

The Simpsons:
Atomistic Politics
and the Nuclear Family

PAUL A. CANTOR

When Senator Charles Schumer (D-N.Y.) visited a high school in upstate New York in May 1999, he received an unexpected civics lesson and from an unexpected source. Speaking on the timely subject of school violence, Senator Schumer praised the Brady Bill, which he helped sponsor, for its role in preventing crime. Rising to question the effectiveness of this effort at gun control, a student named Kevin Davis cited an example no doubt familiar to his classmates but unknown to the Senator from New York: "It reminds me of a *Simpsons* episode. Homer wanted to get a gun but he had been in jail twice and in a mental institution. They label him as 'potentially dangerous.' So Homer asks what that means and the gun dealer says: 'It just means you need an extra week before you can get the gun.'"[1] Without going into the pros and cons of gun control legislation, one can recognize in this incident how the Fox Network's cartoon series *The Simpsons* shapes the way Americans think, particularly the younger generation. It may therefore be worthwhile taking a look at the television program to see what sort of political lessons it is teaching. *The Simpsons* may seem like mindless entertainment to many, but in fact it offers some of the most sophisticated comedy and satire ever to appear on American

[1] As reported in Ed Henry's "Heard on the Hill" column in *Roll Call*, 44, no. 81 (13 May 1999). His source was the *Albany Times-Union*.

television. Over the years, the show has taken on many serious issues: nuclear power safety, environmentalism, immigration, gay rights, women in the military, and so on. Paradoxically it is the farcical nature of the show that allows it to be serious in ways that many other television shows are not.

I will not, however, dwell on the question of the show's politics in the narrowly partisan sense. *The Simpsons* satirizes both Republicans and Democrats. The local politician who appears most frequently in the show, Mayor Quimby, speaks with a heavy Kennedy accent[2] and generally acts like a Democratic urban machine politician. By the same token, the most sinister political force in the series, the cabal that seems to run the town of Springfield from behind the scenes, is invariably portrayed as Republican. On balance, it is fair to say that *The Simpsons,* like most of what comes out of Hollywood, is pro-Democrat and anti-Republican. One whole episode was a gratuitously vicious portrait of ex-President Bush,[3] whereas the show has been surprisingly slow to satirize President Clinton.[4] Nevertheless perhaps the single funniest political line in the history of *The Simpsons* came at the expense of the Democrats. When Grandpa Abraham Simpson receives money in the mail really meant for his grandchildren, Bart asks him: "Didn't you wonder why you were getting checks for absolutely nothing?" Abe replies: "I figured 'cause the Democrats were in power again."[5] Unwilling to

[2] The identification is made complete when Quimby says: "Ich bin ein Springfielder" in the episode "Burns Verkaufen der Kraftwerk." I cite all *Simpsons* episodes by title, using the information supplied in the invaluable reference work *The Simpsons: A Complete Guide to Our Favorite Family,* edited by Ray Richmond and Antonia Coffman (New York: HarperCollins, 1997).

[3] "Two Bad Neighbors."

[4] With respect to the show's reluctance to go after Clinton, see the rather tame satire of the 1996 presidential campaign in the "Citizen Kang" segment of the Halloween episode, "Treehouse of Horror VII." Finally in the 1998–99 season, faced with the mounting scandals in the Clinton administration, the creators of *The Simpsons* decided to take off the kid gloves in their treatment of the President, especially in "Homer to the Max" (in which Homer legally changes his name to Max Power). Hustled by Clinton at a party, Marge Simpson is forced to ask: "Are you sure it's a federal law that I have to dance with you?" Reassuring Marge that she is good enough for a man of his stature, Clinton tells her: "Hell, I've done it with pigs—real no foolin' pigs."

[5] "The Front."

forego any opportunity for humor, the show's creators have been generally evenhanded over the years in making fun of both parties, and of both the right and the left.[6]

Setting aside the surface issue of political partisanship, I am interested in the deep politics of *The Simpsons,* what the show most fundamentally suggests about political life in the United States. The show broaches the question of politics through the question of the family, and this in itself is a political statement. By dealing centrally with the family, *The Simpsons* takes up real human issues everybody can recognize and thus ends up in many respects less "cartooonish" than other television programs. Its cartoon characters are more human, more fully rounded, than the supposedly real human beings in many situation comedies. Above all, the show has created a believable human community: Springfield, USA. *The Simpsons* shows the family as part of a larger community, and in effect affirms the kind of community that can sustain the family. That is at one and the same time the secret of the show's popularity with the American public and the most interesting political statement it has to make.

The Simpsons indeed offers one of the most important images of the family in contemporary American culture, and in particular an image of the nuclear family. With the names taken from creator Matt Groening's own childhood home, *The Simpsons* portrays the average American family: father (Homer), mother (Marge), and 2.3 children (Bart, Lisa, and little Maggie). Many commentators have lamented the fact that *The Simpsons* now serves as one of the representative images of American family life, claiming that the show provides horrible role models for parents and children. The popularity of the show is often cited as evidence of the decline of family values in the United States.

[6] An amusing debate developed in *The Wall Street Journal* over the politics of *The Simpsons.* It began with an op-ed piece by Benjamin Stein entitled "TV Land: From Mao to Dow" (5 February 1997), in which he argued that the show has no politics. This piece was answered by a letter from John McGrew given the title "*The Simpsons* Bash Familiar Values" (19 March 1997), in which he argued that the show is political and consistently left-wing. On 12 March 1997, letters by Deroy Murdock and H.B. Johnson Jr. argued that the show attacks left-wing targets as well and often supports traditional values. Johnson's conclusion that the show is "politically ambiguous" and thus appeals "to conservatives as well as to liberals" is supported by the evidence of this debate itself.

But critics of *The Simpsons* need to take a closer look at the show and view it in the context of television history. For all its slapstick nature and its mocking of certain aspects of family life, *The Simpsons* has an affirmative side and ends up celebrating the nuclear family as an institution. For television, this is no minor achievement. For decades American television has tended to downplay the importance of the nuclear family and offer various one-parent families or other non-traditional arrangements as alternatives to it. The one-parent situation comedy actually dates back almost to the beginning of network television, at least as early as *My Little Margie* (1952–55). But the classic one-parent situation comedies, like *The Andy Griffith Show* (1960–68) or *My Three Sons* (1960–72), generally found ways to reconstitute the nuclear family in one form or another (often through the presence of an aunt or uncle) and thus still presented it as the norm (sometimes the story line actually moved in the direction of the widower getting remarried, as happened to Steve Douglas, the Fred MacMurray character, in *My Three Sons*).

But starting with shows in the 1970s like *Alice* (1976–85), American television genuinely began to move away from the nuclear family as the norm and suggest that other patterns of child rearing might be equally valid or perhaps even superior. Television in the 1980s and 1990s experimented with all sorts of permutations on the theme of the non-nuclear family, in shows such as *Love, Sidney* (1981–83), *Punky Brewster* (1984–86), and *My Two Dads* (1987–90). This development partly resulted from the standard Hollywood procedure of generating new series by simply varying successful formulas.[7] But the trend toward nonnuclear families also expressed the ideological bent of Hollywood and its impulse to call traditional family values into question. Above all, though television shows usually traced the absence of one or more parents to deaths in the family, the trend away from the nuclear family obviously reflected the real-

[7] Perhaps the most famous example is the creation of *Green Acres* (1965–71) by inverting *The Beverly Hillbillies* (1962–71). If a family of hicks moving from the country to the city was funny, television executives concluded that a couple of sophisticates moving from the city to the country should be a hit as well. And it was.

ity of divorce in American life (and especially in Hollywood). Wanting to be progressive, television producers set out to endorse contemporary social trends away from the stable, traditional, nuclear family. With the typical momentum of the entertainment industry, Hollywood eventually took this development to its logical conclusion: the no-parent family. Another popular Fox program, *Party of Five* (1994–2000), shows a family of children gallantly raising themselves after both their parents have been killed in an automobile accident.

Party of Five cleverly conveys a message some television producers evidently think their contemporary audience wants to hear—that children can do quite well without one parent and preferably without both. The children in the audience want to hear this message, because it flatters their sense of independence. The parents want to hear this message, because it soothes their sense of guilt, either about abandoning their children completely (as sometimes happens in cases of divorce) or just not devoting enough "quality time" to them. Absent or negligent parents can console themselves with the thought that their children really are better off without them, "just like those cool—and incredibly good-looking—kids on *Party of Five*." In short, for roughly the past two decades, much of American television has been suggesting that the breakdown of the American family does not constitute a social crisis or even a serious problem. In fact it should be regarded as a form of liberation from an image of the family that may have been good enough for the 1950s but is no longer valid in the 1990s. It's against this historical background that the statement *The Simpsons* has to make about the nuclear family has to be appreciated.

Of course television never completely abandoned the nuclear family, even in the 1980s, as shown by the success of such shows as *All in the Family* (1971–1983), *Family Ties* (1982–89), and *The Cosby Show* (1984–92). And when *The Simpsons* debuted as a regular series in 1989, it was by no means unique in its reaffirmation of the value of the nuclear family. Several other shows took the same path in the 1990s, reflecting larger social and political trends in society, in particular the reassertion of family values that has by now been adopted as a program by both political parties in the United States. Fox's own *Married with Children* (1987–1998) preceded *The Simpsons* in portraying an amusingly dysfunctional nuclear

family. Another interesting portrayal of the nuclear family can be found in ABC's *Home Improvement* (1991–99), which tries to recuperate traditional family values and even gender roles within a postmodern television context. But *The Simpsons* is in many respects the most interesting example of this return to the nuclear family. Though it strikes many people as trying to subvert the American family or to undermine its authority, in fact, it reminds us that anti-authoritarianism is itself an American tradition, and that family authority has always been problematic in democratic America. What makes *The Simpsons* so interesting is the way it combines traditionalism with anti-traditionalism. It continually makes fun of the traditional American family. But it continually offers an enduring image of the nuclear family in the very act of satirizing it. Many of the traditional values of the American family survive this satire, above all the value of the nuclear family itself.

As I have suggested, one can understand this point partly in terms of television history. *The Simpsons* is a hip, postmodern, self-aware show.[8] But its self-awareness focuses on the traditional representation of the American family on television. It therefore presents the paradox of an untraditional show that is deeply rooted in television tradition. *The Simpsons* can be traced back to earlier television cartoons that dealt with families, such as *The Flintstones* or *The Jetsons*. But these cartoons must themselves be traced back to the famous nuclear family sitcoms of the 1950s: *I Love Lucy, The Adventures of Ozzie and Harriet, Father Knows Best, Leave it to Beaver. The Simpsons* is a postmodern recreation of the first generation of family sitcoms on television. Looking back on those shows, we easily see the transformations and discontinuities *The Simpsons* has brought about. In *The Simpsons* father emphatically does not know best. And it clearly is more dangerous to leave it to Bart than to Beaver. Obviously *The Simpsons* does not offer a simple return to the family shows of the 1950s. But even in the act of recreation and transformation, the show provides elements of continuity that make *The Simpsons* more traditional than may at first appear.

[8] On the self-reflexive character of *The Simpsons*, see my essay "The Greatest TV Show Ever," *The American Enterprise*, Vol. 8, No. 5 (September–October 1997), pp. 34–37.

The Simpsons has indeed found its own odd way to defend the nuclear family. In effect the shows says: "Take the worst-case scenario—the Simpsons—and even that family is better than no family." In fact, the Simpson family is not all that bad. Some people are appalled at the idea of young boys imitating Bart, in particular his disrespect for authority and especially his teachers. These critics of *The Simpsons* forget that Bart's rebelliousness conforms to a venerable American archetype and that this country was founded on disrespect for authority and on an act of rebellion. Bart is an American icon, an updated version of Tom Sawyer and Huck Finn rolled into one. For all his trouble-making—precisely because of his trouble-making—Bart behaves just the way a young boy is supposed to in American mythology, from *Dennis the Menace* comics to the *Our Gang* comedies.[9]

As for the mother and daughter in *The Simpsons*, Marge and Lisa are not bad role models at all. Marge Simpson is very much the devoted mother and housekeeper; she also often displays a feminist streak, particularly in the episode in which she goes off on a jaunt à la *Thelma and Louise*.[10] Indeed she's very modern in her attempts to combine certain feminist impulses with the traditional role of a mother. Lisa is in many ways the ideal child in contemporary terms. She is an overachiever in school, and, as a feminist, a vegetarian, and an environmentalist, she is politically correct across the spectrum.

The real issue, then, is Homer. Many people have criticized *The Simpsons* for its portrayal of the father as dumb, uneducated, weak in character, and morally unprincipled. Homer is all those things, but at least he is there. He fulfills the bare minimum of a father: he is present for his wife and above all his children. To be sure, he lacks many of the qualities we would like to see in the ideal father. He is selfish, often putting his own interest above that of his family. As we learn in one of the

[9] Oddly enough, Bart's creator, Matt Groening, has now joined the chorus condemning the Simpson boy. In 1999 a wire service report quoted Groening as saying to those who call Bart a bad role model: "I now have a seven-year-old boy and a nine-year-old boy so all I can say is I apologize. Now I know what you were talking about."
10 "Marge on the Lam."

Halloween episodes, Homer would sell his soul to the devil for a donut (though fortunately it turns out that Marge already owned his soul and therefore it was not Homer's to sell).[11] Homer is undeniably crass, vulgar, and incapable of appreciating the finer things in life. He has a hard time sharing interests with Lisa, except when she develops a remarkable knack for predicting the outcome of pro football games and allows her father to become a big winner in the betting pool at Moe's Tavern.[12] Moreover, Homer gets angry easily and takes his anger out on his children, as his many attempts to strangle Bart attest.

In all these respects, Homer fails as a father. But upon reflection, it is surprising to realize how many decent qualities he has. First and foremost, he is attached to his own—he loves his family because it is *his*. His motto basically is: "My family, right or wrong." This is hardly a philosophic position, but it may well provide the bedrock of the family as an institution, which is why Plato's *Republic* must subvert the power of the family. Homer Simpson is the opposite of a philosopher-king; he is devoted not to what is best but to what is his own. That position has its problems, but it does help explain how the seemingly dysfunctional Simpson family manages to function.

For example, Homer is willing to work to support his family, even in the dangerous job of nuclear power plant safety supervisor, a job made all the more dangerous by the fact that he is the one doing it. In the episode in which Lisa comes to want a pony desperately, Homer even takes a second job working for Apu Nahasapeemapetilon at the Kwik-E-Mart to earn the money for the pony's upkeep and nearly kills himself in the process.[13] In such actions, Homer manifests his genuine concern for his family, and as he repeatedly proves, he will defend them if necessary, sometimes at great personal risk. Often Homer is not effective in such actions, but that makes his devotion to his family in some ways all the more touching. Homer is the distillation of pure fatherhood. Take away all the qualities that make for a genuinely good father—wisdom, compassion, even temper, selflessness—and what you have left is Homer Simpson with his

[11] "The Devil and Homer Simpson" in "Treehouse of Horror IV."
[12] "Lisa the Greek."
[13] "Lisa's Pony."

pure, mindless, dogged devotion to his family. That is why for all his stupidity, bigotry, and self-centered quality, we cannot hate Homer. He continually fails at being a good father, but he never gives up trying, and in some basic and important sense that makes him a good father.

The most effective defense of the family in the series comes in the episode in which the Simpsons are actually broken up as a unit.[14] This episode pointedly begins with an image of Marge as a good mother, preparing breakfast and school lunches simultaneously for her children. She even gives Bart and Lisa careful instructions about their sandwiches: "Keep the lettuce separate until 11:30." But after this promising parental beginning, a series of mishaps occurs. Homer and Marge go off to the Mingled Waters Health Spa for a well-deserved afternoon of relaxation. In their haste, they leave their house dirty, especially a pile of unwashed dishes in the kitchen sink. Meanwhile, things are unfortunately not going well for the children at school. Bart has accidentally picked up lice from the monkey of his best friend Milhouse, prompting Principal Skinner to ask: "What kind of parents would permit such a lapse in scalpal hygiene?" The evidence against the Simpson parents mounts when Skinner sends for Bart's sister. With her prescription shoes stolen by her classmates and her feet accordingly covered with mud, Lisa looks like some street urchin straight out of Dickens.

Faced with all this evidence of parental neglect, the horrified principal alerts the Child Welfare Board, who are themselves shocked when they take Bart and Lisa home and explore the premises. The officials completely misinterpret the situation. Confronted by a pile of old newspapers, they assume that Marge is a bad housekeeper, when in fact she had assembled the documents to help Lisa with a history project. Jumping to conclusions, the bureaucrats decide that Marge and Homer are unfit parents, and lodge specific charges that the Simpson household is a "squalid hellhole and the toilet paper is hung in improper overhand fashion." The authorities determine that the Simpson children must be given to foster parents. Bart, Lisa, and Maggie are accordingly handed over to the family next door, presided over by the patriarchal Ned Flanders. Throughout the series, the

[14] "Home Sweet Homediddly-Dum-Doodily."

Flanders family serves as the *Doppelgänger* of the Simpsons. Flanders and his brood are in fact the perfect family according to oldstyle morality and religion. In marked contrast to Bart, the Flanders boys, Rod and Todd, are well-behaved and obedient. Above all, the Flanders family is pious, devoted to activities like Bible reading, more zealous than even the local Reverend Lovejoy. When Ned offers to play "bombardment" with Bart and Lisa, what he has in mind is bombardment with questions about the Bible. The Flanders family are shocked to learn that their neighbors do not know of the serpent of Rehoboam, not to mention the Well of Zahassadar or the bridal feast of Beth Chadruharazzeb.

Exploring the question of whether the Simpson family really is dysfunctional, the foster parent episode offers two alternatives to it: on the one hand, the oldstyle moral-religious family; on the other, the therapeutic state, what is often now called the nanny state. Who is best able to raise the Simpson children? The civil authorities intervene, claiming that Homer and Marge are unfit as parents. They must be re-educated and are sent off to "family skills class," based on the premise that experts know better how to raise children. Child rearing is a matter of a certain kind of expertise, which can be taught. This is the modern answer: the family is inadequate as an institution and hence the state must intervene to make it function. At the same time, the episode offers the oldstyle moral-religious answer: what children need is godfearing parents in order to make them godfearing themselves. Indeed Ned Flanders does everything he can to get Bart and Lisa to reform and behave with the piety of his own children.

But the answer the show offers is that the Simpson children are better off with their real parents—not because they are more intelligent or learned in child rearing, and not because they are superior in morality or piety, but simply because Homer and Marge are the people most genuinely attached to Bart, Lisa, and Maggie, since the children are their own offspring. The episode works particularly well to show the horror of the supposedly omniscient and omnicompetent state intruding into every aspect of family life. When Homer desperately tries to call up Bart and Lisa, he hears the official message: "The number you have dialed can no longer be reached from this phone, you negligent monster."

At the same time we see the defects of the oldstyle religion. The Flanders may be righteous as parents but they are also self-righteous. Mrs. Flanders says: "I don't judge Homer and Marge; that's for a vengeful God to do." Ned's piety is so extreme that he eventually exasperates even Reverend Lovejoy, who at one point asks him: "Have you thought of one of the other major religions? They're all pretty much the same."

In the end, Bart, Lisa, and Maggie are joyously reunited with Homer and Marge. Despite charges of being dysfunctional, the Simpson family functions quite well, because the children are attached to their parents and the parents are attached to their children. The premise of those who tried to take the Simpson children away is that there is a principle external to the family by which it can be judged dysfunctional, whether the principle of contemporary child-rearing theories or that of the oldstyle religion. The foster parent episode suggests the contrary—that the family contains its own principle of legitimacy. The family knows best. This episode thus illustrates the strange combination of traditionalism and anti-traditionalism in *The Simpsons*. Even as the show rejects the idea of a simple return to the traditional moral-religious idea of the family, it refuses to accept contemporary statist attempts to subvert the family completely and reasserts the enduring value of the family as an institution.

As the importance of Ned Flanders in this episode reminds us, another way in which the show is unusual is that religion plays a significant role in *The Simpsons*. Religion is a regular part of the life of the Simpson family. Several episodes revolve around churchgoing, including one in which God even speaks directly to Homer.[15] Moreover, religion is a regular part of life in general in Springfield. In addition to Ned Flanders, the Reverend Lovejoy is featured in several episodes, including one in which no less than Meryl Streep provided the voice for his daughter.[16]

This attention to religion is atypical of American television in the 1990s. Indeed, judging by most television programs today, one would never guess that Americans are by and large a religious and even a churchgoing people. Television generally acts

[15] "Homer the Heretic."
[16] "Bart's Girlfriend."

as if religion played little or no role in the daily lives of Americans, even though the evidence points to exactly the opposite conclusion. Many reasons have been offered to explain why television generally avoids the subject of religion. Producers are afraid that if they raise religious issues, they will offend orthodox viewers and soon be embroiled in controversy; television executives are particularly worried about having the sponsors of their shows boycotted by powerful religious groups. Moreover, the television community itself is largely secular in its outlook and thus generally uninterested in religious questions. Indeed, much of Hollywood is often outright anti-religious, and especially opposed to anything labeled religious fundamentalism (and it tends to label anything to the right of Unitarianism as "religious fundamentalism").

Religion has, however, been making a comeback on television in the past decade, in part because producers have discovered that an audience niche exists for shows like *Touched By An Angel* (1994–).[17] Still, the entertainment community has a hard time understanding what religion really means to the American public, and it especially cannot deal with the idea that religion could be an everyday, normal part of American life. Religious figures in both movies and television tend to be miraculously good and pure or monstrously evil and hypocritical. While there are exceptions to this rule,[18] generally for Hollywood religious figures must be either saints or sinners, either laboring against all odds and all reason for good, or religious fanatics, full of bigotry, warped by sexual repression, laboring to destroy innocent lives in one way or another.[19]

But *The Simpsons* accepts religion as a normal part of life in Springfield, USA. If the show makes fun of piety in the person of Ned Flanders, in Homer Simpson it also suggests that one can go to church and not be either a religious fanatic or a saint. One episode devoted to Reverend Lovejoy deals realistically and

[17] I would like to comment on this show, but it is scheduled at the same time as *The Simpsons* and I have never seen it.

[18] Consider, for example, the minister played by Tom Skerrit in Robert Redford's film of Norman Maclean's *A River Runs through It*.

[19] A good example of this stereotyping can be found in the film *Contact*, with its contrasting religious figures played by Matthew McConaughey (good) and Jake Busey (evil).

rather sympathetically with the problem of pastoral burnout.[20]
The overburdened minister has just listened to too many prob-
lems from his parishioners and has to turn the job over to Marge
Simpson as the "listen lady." The treatment of religion in *The
Simpsons* is parallel to and connected with its treatment of the
family. *The Simpsons* is not pro-religion—it is too hip, cynical,
and iconoclastic for that. Indeed, on the surface, the show
appears to be anti-religious, with a good deal of its satire
directed against Ned Flanders and other pious characters. But
once again we see the principle at work that when *The
Simpsons* satirizes something, it acknowledges its importance.
Even when it seems to be ridiculing religion, it recognizes, as
few other television shows do, the genuine role that religion
plays in American life.

It is here that the treatment of the family in *The Simpsons*
links up with its treatment of politics. Although the show
focuses on the nuclear family, it relates the family to larger insti-
tutions in American life, like the church, the school, and even
political institutions themselves, like city government. In all
these cases, *The Simpsons* satirizes these institutions, making
them look laughable and often even hollow. But at the same
time, the show acknowledges their importance and especially
their importance for the family. Over the past few decades, tele-
vision has increasingly tended to isolate the family—to show it
largely removed from any larger institutional framework or con-
text. This is another trend to which *The Simpsons* runs counter,
partly as a result of its being a postmodern recreation of 1950s
sitcoms. Shows like *Father Knows Best* or *Leave it to Beaver*
tended to be set in small-town America, with all the intricate
web of institutions into which family life was woven. In recre-
ating this world, even while mocking it, *The Simpsons* cannot
help recreating its ambience and even at times its ethos.

Springfield is decidedly an American small town. In several
episodes, it is contrasted with Capital City, a metropolis the
Simpsons approach with fear and trepidation. Obviously the
show makes fun of small-town life—it makes fun of every-
thing—but it simultaneously celebrates the virtues of the tradi-
tional American small town. One of the principal reasons why
the dysfunctional Simpsons family functions as well as it does is

[20] "In Marge We Trust."

that they live in a traditional American small town. The institutions that govern their lives are not remote from them or alien to them. The Simpson children go to a neighborhood school (though they are bussed to it by the ex-hippie driver Otto). Their friends in school are largely the same as their friends in their neighborhood. The Simpsons are not confronted by an elaborate, unapproachable, and uncaring educational bureaucracy. Principal Skinner and Mrs. Krabappel may not be perfect educators, but when Homer and Marge need to talk to them, they are readily accessible. The same is true of the Springfield police force. Chief Wiggum is not a great crime-fighter, but he is well-known to the citizens of Springfield, as they are to him. The police in Springfield still have neighborhood beats and have even been known to share a donut or two with Homer.

Similarly, politics in Springfield is largely a local matter, including town meetings in which the citizens of Springfield get to influence decisions on important matters of local concern, such as whether gambling should be legalized or a monorail built. As his Kennedy accent suggests, Mayor Quimby is a demagogue, but at least he is Springfield's own demagogue. When he buys votes, he buys them directly from the citizens of Springfield. If Quimby wants Grandpa Simpson to support a freeway he wishes to build through town, he must name the road after Abe's favorite television character, Matlock. Everywhere one looks in Springfield, one sees a surprising degree of local control and autonomy. The nuclear power plant is a source of pollution and constant danger, but at least it is locally owned by Springfield's own slave-driving industrial tyrant and tycoon, Montgomery Burns, and not by some remote multinational corporation (indeed in an exception that proves the rule, when the plant is sold to German investors, Burns soon buys it back to restore his ego).[21]

In sum, for all its postmodern hipness, *The Simpsons* is profoundly anachronistic in the way it harks back to an earlier age, when Americans felt more in contact with their governing institutions and family life was solidly anchored in a larger but still local community. The federal government rarely makes its presence felt in *The Simpsons,* and when it does it generally takes a quirky form like former President Bush moving next door to

[21] "Burns Verkaufen der Kraftwerk."

Homer, an arrangement that does not work out. The long tentacles of the IRS have occasionally crept their way into Springfield, but its stranglehold on America is of course all-pervasive and inescapable.[22] Generally speaking, government is much more likely to take local forms in the show. When sinister forces from the Republican Party conspire to unseat Mayor Quimby by running ex-convict Sideshow Bob against him, it is *local* sinister forces who do the conspiring, led by Mr. Burns, and including Rainer Wolfcastle (the Arnold Schwarzenneger lookalike who plays McBain in the movies) and a Rush Limbaugh lookalike named Burch Barlow.[23]

Here is one respect in which the portrayal of the local community in *The Simpsons* is unrealistic. In Springfield, even the media forces are local. There is of course nothing strange about having a local television station in Springfield. It is perfectly plausible that the Simpsons get their news from a man, Kent Brockman, who actually lives in their midst. It is also quite believable that the kiddie show on Springfield television is local, and that its host, Krusty the Klown, not only lives in town but also is available for local functions like supermarket openings and birthday parties. But what are authentic movie stars like Rainer Wolfcastle doing living in Springfield? And what about the fact that the world-famous *Itchy & Scratchy* cartoons are produced in Springfield? Indeed the entire *Itchy & Scratchy* empire is apparently headquartered in Springfield. This is not a trivial fact. It means that when Marge campaigns against cartoon violence, she can picket *Itchy & Scratchy* headquarters without leaving her hometown.[24] The citizens of Springfield are fortunate to be able to have a direct impact on the forces that shape their lives and especially their family lives. In short, *The Simpsons* takes the phenomenon that has in fact done more than anything else to subvert the power of the local in American politics and American life in general—namely the media—and in effect brings it within the orbit of Springfield, thereby placing the force at least partially under local control.[25]

[22] See, for example, "Bart the Fink."

[23] "Sideshow Bob Roberts."

[24] "Itchy & Scratchy & Marge."

[25] The episode called "Radioactive Man" provides an amusing reversal of the usual relationship between the big-time media and small-town life. A

The unrealistic portrayal of the media as local helps highlight the overall tendency of *The Simpsons*—to present Springfield as a kind of classical polis; it is just about as self-contained and autonomous as a community can be in the modern world. This once again reflects the postmodern nostalgia of *The Simpsons;* with its self-conscious recreation of the 1950s sitcom, it ends up weirdly celebrating the old ideal of small-town America.[26] Again, I do not mean to deny that the first impulse of *The Simpsons* is to make fun of small-town life. But in that very process, it reminds us of what the old ideal was and what was so attractive about it, above all the fact that average Americans somehow felt in touch with the forces that influenced their lives and maybe even in control of them. In a presentation before the American Society of Newspaper Editors on April 12th, 1991 (broadcast on C-SPAN), Matt Groening said that the subtext of *The Simpsons* is: "The people in power don't always have your best interests in mind."[27] This is a view of politics that cuts across the normal distinctions between left and right and explains why the show can be relatively evenhanded in its treatment of both political parties and has something to offer to both liberals and conservatives. *The Simpsons* is based on distrust of power, and especially of power remote from ordinary people. The show celebrates genuine community, a community in which everybody more or less knows everybody else (even if they do not necessarily like each other). By recreating this older sense of community, the show manages to generate a kind of warmth out of its postmodern coolness, a warmth that is largely responsible for its success with the American public. This view of community may

Hollywood film company comes to Springfield to make a movie featuring the comic book hero, Radioactive Man. The Springfield locals take advantage of the naive moviemakers, raising prices all over town and imposing all sorts of new taxes on the film crew. Forced to return to California penniless, the moviemakers are greeted like small-town heroes by their caring neighbors in the Hollywood community.

[26] In his review of *The Simpsons: A Complete Guide to Our Favorite Family,* Michael Dirda aptly characterizes the show as "a wickedly funny yet oddly affectionate satire of American life at the end of the 20th century. Imagine the unholy offspring of *Mad* magazine, Mel Brooks's movies, and 'Our Town'." See *The Washington Post,* Book World (11 January 1998), p. 5.

[27] Oddly enough, this theme is also at the heart of Fox's other great television series, *The X-Files.*

be the most profound comment *The Simpsons* has to make on family life in particular and politics in general in America today. No matter how dysfunctional it may seem, the nuclear family is an institution worth preserving. And the way to preserve it is not by the offices of a distant, supposedly expert, therapeutic state, but by restoring its links to a series of local institutions, which reflect and foster the same principle that makes the Simpson family itself work—the attachment to one's own, the principle that we best care for something when it belongs to us.

The celebration of the local in *The Simpsons* was confirmed in "They Saved Lisa's Brain," which for once explores in detail the possibility of a utopian alternative to politics as usual in Springfield. The episode begins with Lisa disgusted by a gross-out contest sponsored by a local radio station, which, among other things, results in the burning of a travelling Van Gogh exhibition. With the indignation typical of youth, Lisa fires off an angry letter to the Springfield newspaper, charging: "Today our town lost what remained of its fragile civility." Outraged by the cultural limitations of Springfield, Lisa complains: "We have eight malls, but no symphony; thirty-two bars but no alternative theater." Lisa's spirited outburst catches the attention of the local chapter of Mensa, and the few high-IQ citizens of Springfield (including Dr. Hibbert, Principal Skinner, the Comic Book Guy, and Professor Frink) invite her to join the organization (once they have determined that she has brought a pie and not a quiche to their meeting). Inspired by Lisa's courageous speaking out against the cultural parochialism of Springfield, Dr. Hibbert challenges the city's way of life: "Why do we live in a town where the smartest have no power and the stupidest run everything?" Forming "a council of learned citizens," or what reporter Kent Brockman later refers to as an "intellectual junta," the Mensa members set out to create the cartoon equivalent of Plato's *Republic* in Springfield. Naturally, they begin by ousting Mayor Quimby, who in fact leaves town rather abruptly once the little matter of some missing lottery funds comes up.

Taking advantage of an obscure provision in the Springfield charter, the Mensa members step into the power vacuum created by Quimby's sudden abdication. Lisa sees no limit to what the Platonic rule of the wise might accomplish: "With our superior intellects, we could rebuild this city on a foundation of rea-

son and enlightenment; we could turn Springfield into a utopia."
Principal Skinner holds out hope for "a new Athens," while
another Mensa member thinks in terms of B.F. Skinner's
"Walden II." The new rulers immediately set out to bring their
utopia into existence, redesigning traffic patterns and abolishing
all sports that involve violence. But in a variant of the dialectic
of enlightenment, the abstract rationality and benevolent uni-
versalism of the intellectual junta soon prove to be a fraud. The
Mensa members begin to disagree among themselves and it
becomes evident that their claim to represent the public interest
masks a number of private agendas. At the climax of the
episode, the Comic Book Guy comes forward to proclaim:
"Inspired by the most logical race in the galaxy, the Vulcans,
breeding will be permitted once every seven years; for many of
you this will mean much less breeding; for me, much much
more." This reference to *Star Trek* appropriately elicits from
Groundskeeper Willie a response in his native accent that calls
to mind the *Enterprise's* Chief Engineer Scotty: "You cannot do
that, sir, you don't have the power." The Mensa regime's self-
interested attempt to imitate the *Republic* by regulating breeding
in the city is just too much for the ordinary citizens of Springfield
to bear.

With the Platonic revolution in Springfield degenerating into
petty squabbling and violence, a *deus ex machina* arrives in the
form of physicist Stephen Hawking, proclaimed as "the world's
smartest man." When Hawking voices his disappointment with
the Mensa regime, he ends up in a fight with Principal Skinner.
Seizing the opportunity created by the division among the intel-
ligentsia, Homer leads a counterrevolution of the stupid with the
rallying cry: "C'mon you idiots, we're taking back this town."
Thus the attempt to bring about a rule of philosopher-kings in
Springfield ends ignominiously, leaving Hawking to pronounce
its epitaph: "Sometimes the smartest of us can be the most child-
ish." Theory fails when translated into practice in this episode of
The Simpsons and must be relegated once more to the confines
of the contemplative life. The episode ends with Hawking and
Homer drinking beer together in Moe's Tavern and discussing
Homer's theory of a donut-shaped universe.

The utopia episode offers an epitome of what *The Simpsons*
does so well. It can be enjoyed on two levels—as both broad
farce and intellectual satire. The episode contains some of the

grossest humor in the long history of *The Simpsons* (I have not even mentioned the subplot concerning Homer's encounter with a pornographic photographer). But at the same time, it is filled with subtle cultural allusions; for example, the Mensa members convene in what is obviously a Frank Lloyd Wright prairie house. In the end, then, the utopia episode embodies the strange mixture of intellectualism and anti-intellectualism characteristic of *The Simpsons*. In Lisa's challenge to Springfield, the show calls attention to the cultural limitations of small-town America, but it also reminds us that intellectual disdain for the common man can be carried too far and that theory can all too easily lose touch with common sense. Ultimately *The Simpsons* seems to offer a kind of intellectual defense of the common man against intellectuals, which helps explain its popularity and broad appeal. Very few people have found *The Critique of Pure Reason* funny, but in *The Gay Science* Nietzsche felt that he had put his finger on Kant's joke:

> Kant wanted to prove in a way that would puzzle all the world that all the world was right—that was the private joke of this soul. He wrote against the learned on behalf of the prejudice of the common people, but for the learned and not for the common people.[28]

In Nietzsche's terms, *The Simpsons* goes *The Critique of Pure Reason* one better: it defends the common man against the intellectual, but in a way that both the common man and the intellectual can understand and enjoy.[29]

[28] See *Die fröhliche Wissenschaft,* sect. 193 (my translation) in Friedrich Nietzsche, *Sämtliche Werke: Kritische Studienausgabe,* ed. Giorgio Colli and Mazzino Montinari (Berlin: de Gruyter, 1967–77), Vol. 3, p. 504.

[29] This essay is a substantial revision of a paper originally delivered at the Annual Meeting of the American Political Science Association in Boston, September 1998. It was originally published in *Political Theory* 27 (1999), pp. 734–749, and is reprinted here with the permission of the author and Sage Publications, Inc.

12

Springfield Hypocrisy

JASON HOLT

> You talk the talk, Quimby, but do you walk the walk?
> — Chief Wiggum

From the Ayn Rand School for Tots to Zen Buddhism, *The Simpsons* runs a gamut of philosophically interesting subject-matter. One can hardly forget Bart's answer to the koan: What is the sound of one hand clapping? (He quickly closes the fingers of one hand, making a slapping noise that approximates applause.) William James would have been proud. The show is not intended to be "philosophical" in the way that, say, existentialist literature is. And that's okay. Regardless of the writers' or producers' intentions, *The Simpsons* provides much animated grist for the philosopher's mill, often in the form of illustrative examples. The result is not only reliably entertaining, it is also, on occasion, illuminating.

The Simpsons satirizes contemporary culture deftly, with Wilde precision and at Swift extremes. An important recurring theme is the role of morality, or the lack thereof, in the lives of Springfield citizens. In this respect, *The Simpsons* is rather like existentialist literature, both of which diagnose, in different ways, but arguably with equal aplomb, the moral crisis of the present age. What is the crisis? Well, that's a long story, and a lot depends on who you ask. Suffice it to say, many people take values less seriously than they should. With so many different value systems to choose from, it is easy to miss the point of

values, and tough to tell which system, if any, is correct. By what values should one live if morality has no discernible foundation?

This is a big question, of course, and I do not propose to answer it, much less by appeal to *The Simpsons*. But it is worth observing, as the existentialists did, that even if there is no objective morality, we can still talk in a meaningful way about values. More precisely, whatever one's values happen to be, one can be judged in a morally significant way by how those values relate to one's actions. According to some existentialists, we can be praiseworthy for being true to the principles or values we accept, whatever the values are and on whatever basis we accept them. Likewise, we can be blameworthy for being false to those principles or values. We can distinguish, in other words, moral *content*—that is, specific moral principles—from *formal* moral properties, in particular being true to oneself, and practicing what one preaches. Where these smack of consistency, or integrity, betraying oneself, and failing to practice what one preaches, smack of inconsistency, of hypocrisy.

Hypocrisy is what I want to talk about, because *The Simpsons* not only illustrates many important features of this moral vice, it also reveals how certain things philosophers have said about it are false. It may seem odd that an animated sitcom could reveal what experts have missed, but the view from the ivory tower is not the same as the view from elsewhere, and different views afford different advantages. Still, the ordinary concept is in need of refinement. What I will do, first, is discuss illustrative examples from *The Simpsons*. For my chief philosophical point, I will use Wiggum as a test-case for a view that gives the hypocrite too much credit. Although hypocrisy is usually an egregious moral flaw, I will then show how there can be sympathetic, even praiseworthy cases of it. Where appropriate, I will juxtapose Springfield cases with classic literary examples, the goal being to sharpen the ordinary concept, as needed, while respecting as much as possible the view it constitutes.

First, let's get the ordinary concept straight. Hypocrisy is "not practicing what one preaches." That is, one affirms certain principles or values—words to live by—then acts in violation of those principles or values. If I say that one should abstain from beans, as a certain group of ancient philosophers did—It's true, I swear!—and then I go ahead and eat beans, I am a hypocrite.

If I abstain from beans, as I say one ought to, I am not a hypocrite. This only works with statements of value, which do not say how the world *is*, but how it *ought* to be. They do not describe facts, they prescribe actions. If I say that the cat is on the mat but behave as if the cat is *not* on the mat, or as if there is no cat, I am not a hypocrite but a liar, a joker, or perhaps I have a very bad memory, or some other cognitive dysfunction. In hypocrisy, one's actions violate one's own affirmation of values, moral, aesthetic, professional, rational, or otherwise. The fault is a moral one even if the values in question are not in the moral sphere.

Now this might sound a touch too academic, but the importance of formal virtues and vices in everyday life is obvious. We are right to value things like integrity, and to despise things like hypocrisy, in ourselves as well as in others. In one's own case, integrity gives a sense of pride, of a strong, self-determined, resolute life, and this sense of pride is appropriate. Where values clash, as they do in many areas of human interaction, one can legitimately respect or criticize others for whether they act in accordance with the values they espouse.

It might seem inapt to use Springfield as a philosophical springboard, but in addition to my earlier claim that *The Simpsons* gives a fresh perspective on the matter at hand—a four-digit hand, naturally—there is a further fact to consider. Though philosophers have discussed hypocrisy to some extent, they have, on the whole, ignored it. Any useful means of redressing this is warranted. Using *The Simpsons,* my aim is not only to illustrate important features of hypocrisy, and to help get a better understanding of it, but also to redress its relative neglect.

Li'l Lisa Goes to Washington

There are so many examples of clear and borderline hypocrisy in *The Simpsons* that it would be pointless to cover the bulk of them. But certain examples are to the purpose, especially as we associate hypocrisy most readily with corruption in politics, business, and religion. Accordingly, in this section I will focus on Mayor Quimby, Mr. Burns, and Reverend Lovejoy. Not all these cases are as clearcut as they might be, but together they serve to illustrate a number of basic points.

In "Mr. Lisa Goes to Washington," Lisa witnesses Congressman Bob Arnold taking a bribe. She is rightly upset, for Congressman Arnold acts in deliberate violation of his oath of office. And it is this that makes him a hypocrite. Mayor Quimby is a similar but more complex case. Notice the twofold hypocrisy in the following exchange.

WIGGUM: But she broke the law.

QUIMBY: Thanks for the civics lesson. Now listen to me. If Marge Simpson goes to jail, I can kiss the chick vote goodbye. ("Homer Alone")

Now Quimby is not just a hypocrite: he's a liar, a cheat, weak-willed, prejudiced, sexist, gullible, base, and, despite a modicum of political savvy, rather dense. It is important to distinguish his hypocrisy from these other moral, character, and intellectual flaws. Here Quimby not only decides against upholding the law, he intimates and violates a publicly presented concern with women's issues.

One might think that hypocrisy is inevitable in politics, and that Mayor Quimby, as a politician, does not deserve much blame. This is a cynical view. As I will discuss later, there are certain kinds of forgivable and even praiseworthy hypocrisy. But these are comparatively rare, and in such cases the objectives are either sympathetic or morally praiseworthy. Quimby's hypocrisy, on the other hand, like that of many politicians, is not to serve his constituents, but to use his power for personal gain. His purpose is neither sympathetic nor praiseworthy. Next to Sideshow Bob, he is the better Mayoral Candidate, but his hypocrisy is no less egregious for that.

Political hypocrites do not walk the walk they talk in taking oaths of office or, more narrowly, in toeing party lines. But this does not limit hypocrisy to cases where the values in question are explicitly affirmed. One can toe the party line without explicitly endorsing it. In other words, one can be a hypocrite by violating principles one *implicitly* affirms, either by toeing party lines in silence, holding a job where values are involved but no oath-taking is required, or, in a more calculated way, by presenting false public images that speak to such values. Think of Principal Skinner and Mrs. Krabappel, who as educators are

implicitly committed to certain education-related values, which they often violate and sometimes flout with abandon.

Another complex case is that of Mr. Burns, who displays a variety of moral turpitude, often in pursuit of profit. There is nothing wrong with, and indeed much to laud in, the profit motive and many of its consequences. But not hypocritical public relations, which Burns illustrates with a will as strong as his body is weak, in particular by presenting himself, on more than one occasion, as an environmentalist, which he decidedly is not. This is good PR of course, but Burns's hypocrisy is all too evident.

> I figured if one six-pack holder will catch one fish, a million sewn together will catch a million fish. . . . I call it the Burns Omni-net. It sweeps the sea clean. . . . I call our product: Li'l Lisa's Patented Animal Slurry. It's a high-protein feed for farm animals, insulation for low-income housing, and a top-notch engine-coolant. And best of all, it's made from 100-percent recycled animals. ("The Old Man and the Lisa")

The case of Li'l Lisa's Patented Animal Slurry might seem the best example, though here Burns fails to grasp the meaning of his own false front, in stark contrast to his calculated PR in other episodes. At a company litter cleanup, Burns poses for press cameras in full cleanup gear, which he casts off disgustedly as soon as the shutters stop ("Mother Simpson"). At a company retreat, he gives a speech on the value of teamwork and spirited competition ("Mountain of Madness"), while his track-record is not "teamly" but the worst sort of elitism, his efforts at competition not spirited but conniving, his play not fair but a cheat at every turn.

From a literary perspective, perhaps the most prominent kind of hypocrite is the religious hypocrite. A well-known example is Molière's Tartuffe, who uses a pretense of great piety to insinuate himself into a well-off family. Affirming the value of poverty, he lives with the family free of charge, and eventually finagles control of all the family's possessions. Secure in his new power, he acts in clear violation of his presented values, and is undone. *Tartuffe* is a classic play, well worth the read. *The Simpsons* is a different sort of classic in its own right, well worth the watch. Lovejoy, though, is no Tartuffe. Not that there's anything wrong with that, for despite Lovejoy's understandable world-weariness,

and somewhat resigned faith, there are certain indications that he may be a hypocrite. These include having his dog do its "dirty, sinful business" on the Flanders's lawn ("22 Short Films About Springfield"), downplaying the importance of Christian tenets ("Bart's Girlfriend"), and denying Lisa access to the Good Book ("Whacking Day"). Priesthood of all believers? Hardly. One might think Lovejoy a clear hypocrite, what with his ardent, judgmental moments. But we might interpret him more charitably as simply overinfluenced by the Old Testament.

Although Lovejoy is no Tartuffe, he might be something of a Don Manuel. In Miguel de Unamuno's *St. Manuel the Good, Martyr,* Don Manuel loses his faith, but continues to play the believing priest his parishioners take him to be, a role he deems necessary for the good of his flock. He doubts the religious basis of what he preaches, and so is disingenuous to be sure, but he is not a hypocrite, since he continues to practice accordingly. The difference is, his motivation is not religious but pragmatic. The actions prescribed are the same. Although his true values belie those presented to his flock, his actions do not violate either set. Lovejoy may, to a certain extent, be telling a similar noble lie. His role in the community is far less crucial than that of Don Manuel, but his position is still one of social benefit. Think of how much he does for the Flanderses, especially Ned, burdensome as the benefit is. Still, Lovejoy betrays a shallow indifference to his flock ("In Marge We Trust"), which seems to rule him out as even a diluted sort of Don Manuel.

So far a number of important features of hypocrisy have been illustrated by Springfield and other cases. In hypocrisy, one acts deliberately in violation of espoused principles. Or, one affirms principles *à la* Mr. Burns, in knowing violation of past or planned actions, the purpose being to minimize evident or conceal secret behavior. Inconsistency is the key. It is interesting that, with few exceptions, none of the Simpson family is much of a hypocrite. Bart? Yes, but only by coercion, and rarely at that. Homer? Not at all. He acts in full—if unreflective—accord with the hedonistic values he affirms, except when faced with a severe moral test, in which case he not only does the right thing, he does it under the auspices of consistent values.[1]

[1] For more on the idea that there is something admirable about Homer see Raja Halwani, "Homer and Aristotle," in this volume.

The Wiggum Case

Many philosophers understand hypocrisy in a way that strays too far from the ordinary concept. This misconception is understandable, even natural, but it is a misconception, and the humorous case of Chief Wiggum shows us why.

The misconception is that hypocrisy is essentially deceptive, that one can be a hypocrite only by some sort of pretense or misdirection.[2] On this view, hypocrisy is a kind of lying. One presents a false front, a normative veil, or a mask of good intentions. This serves a dual purpose. It makes known bad actions seem less egregious, and diverts attention from what might arouse suspicion, or lead to the discovery, of secret bad behavior. The hypocrite may, by such means, even deceive *himself* as to his own moral standing.

While I agree that many hypocrites fit this profile, and that the *purpose* of hypocrisy is often deceptive or exculpatory, I deny that this captures the essence of hypocrisy. Sometimes we do not consciously know what our intentions are, and sometimes we forget, or fail to understand, the values we present to others. If we can fall into hypocrisy unawares, then hypocrisy is not a matter of conscious deceit. Alternatively, say I present false values to others but, because I am too timid to act on my true values, I always act in accordance with those I present. This is not hypocrisy, for in such a case I *do* walk the walk. I fail to believe the talk, is all. Similarly, as Don Manuel illustrates, it is possible to satisfy, at the same time, and by the same actions, one's personal values and those one presents falsely to others. This is not hypocrisy either. Deceiving others as to one's values

[2] Variations on this theme are found in Gilbert Ryle, *The Concept of Mind* (London: Hutchinson, 1949), p. 173, Jonathan Robinson, *Duty and Hypocrisy in Hegel's Phenomenology of Mind* (Toronto: University of Toronto Press, 1977), p. 116, Béla Szabados, "Hypocrisy," *Canadian Journal of Philosophy* 9 (1979), p. 197, Eva Kittay, "On Hypocrisy," *Metaphilosophy* 13 (1982), p. 278, Judith Shklar, *Ordinary Vices* (1984), p. 47, Jay Newman, *Fanatics and Hypocrites* (Buffalo: Prometheus Books, 1986), p. 109, Christine McKinnon, "Hypocrisy, With a Note on Integrity," *American Philosophical Quarterly* 28 (1991), p. 321, Ruth Grant, *Hypocrisy and Integrity* (Chicago: University of Chicago Press, 1997), p. 67, and Béla Szabados and Eldon Soifer, "Hypocrisy After Aristotle," *Dialogue* 37 (1998), p. 563. This is a representative sample, not an exhaustive list.

or intentions is not essentially hypocritical. True enough, it is a form of deception. But it is not at the heart of hypocrisy.

How could a number of thinkers have gotten this wrong, even, as I said, in an understandable, natural way? Here is my diagnosis. Originally, in ancient Greece, hypocrisy was understood to be not a moral flaw but a dramatic stage technique—wearing a mask. Later, in Medieval times, this metaphor was applied to those who presented false values. Such misrepresentation was viewed as a serious moral fault. It still is. But this is markedly different from the modern conception. Misrepresentation of inner values is deceptive, and it may be a benchmark of hypocrisy, but that's about all. The modern conception does not even require that hypocrites have inner values to belie in presentation. So the idea that hypocrisy is inherently deceptive is anachronistic, a throwback to an outmoded sense of the term. Ignoring present language use altogether is an unwarranted departure from common sense.

Another reason is that the outmoded sense is superficially supported by certain prominent historical and literary examples. Sticking with literary cases for a moment, one thinks of Tartuffe from Molière's *Tartuffe*, Julien Sorel from Stendahl's *Scarlet and Black*, and Uriah Heep from Dickens's *David Copperfield*. What makes hypocrisy interesting and rich for literary exploration is to have the hypocrite be intelligent or at least clever. A clash of moral and intellectual virtues is a delight. But most hypocrisy is duller, more banal. To take exceptional cases as representing all cases is simply a mistake. In this case, it amounts to giving the hypocrite too much credit. Most are not so intelligent, and though many use hypocrisy as a smokescreen, one need not deceive in order to be a hypocrite.

If the point of hypocrisy is deception, then we should expect *pointless* hypocrisy to be non-deceptive. What we need in defense of the ordinary concept is an example where intelligence is absent and the usual deceptive purposes are not in play. *The Simpsons* provides an ideal example in the rotund figure of Chief Wiggum, whose actions violate the principles he presents as one of Springfield's finest. We have to be careful, though, because being a dirty cop is not the same as being a bad cop, and Wiggum is both.

This is Papa Bear. Put out an APB for a male suspect, driving a . . . car of some sort, heading in the direction of, uh, you know, that place that sells chili. Suspect is hatless. Repeat, hatless. ("Homer's Triple Bypass")

We think we're dealing with a supernatural being, most likely a mummy. As a precaution, I've ordered the Egyptian wing of the Springfield Museum destroyed. ("Treehouse of Horror IV")

I'm sorry, kids. I don't think you're ever gonna get back those greyhounds. Maybe Mr. Burns will sell you one of the twenty-five he got last night. ("Two Dozen and One Greyhounds")

Here we see Wiggum's professional incompetence. It is unfortunate, but morally neutral. To serve and protect? Minimally. This owes not only to his incompetence, however. It owes also to the motivation behind his competent, but morally suspect, duty-doing.

LOU: There's a couple of guys fighting at the aquarium, Chief.
WIGGUM: They still sell those frozen bananas?
LOU: I think so.
WIGGUM: Let's roll. ("Brother from the Same Planet")

LOU: That sounded like an explosion at the old Simpson place.
WIGGUM: Forget it. That's two blocks away.
LOU: Looks like beer coming out of the chimney.
WIGGUM: I am proceeding on foot. Call in a code eight.
LOU: *(into radio)* We need pretzels. Repeat, pretzels. ("So It's Come to This: A Simpsons Clip Show")

Wiggum is not incompetent here. Nor is he a hypocrite. He answers the call, though not for the right reasons. His hypocrisy, by contrast, lies in taking bribes, using drugs, hiring prostitutes, his dereliction of duty, and his abuse of power.

You have the right to remain silent. Anything you say blah blah blah blah blah blah. ("Krusty Gets Busted")

I'll tear up this ticket, but I'm still going to have to ask you for a bribe. ("A Fish Called Selma")

Aw, can't anybody in this town take the law into their own hands? ("The Secret War of Lisa Simpson")

All right. Come out with your hands up, two cups of coffee, an auto freshener that says 'Capricorn', and something with coconut on it. ("Marge in Chains")

Do not be alarmed. Continue swimming naked. Aww, c'mon, continue! Come on! Awww. . . . Alright, Lou, open fire. ("Duffless")

Here we see Wiggum's hypocrisy, large and amorphous as the Chief himself. It is self-serving, of course, as is most hypocrisy. But it is not deceptive. Think of "The Springfield Connection," in which Wiggum, Lou and Eddy, and other members of the force, take evidence against a counterfeit jeans operation—the jeans—for themselves, with the result that there is insufficient evidence for an arrest. The inconsistency is there for all to see as the police zip up and the Chief delivers his classic closer: "Lookin' good, boys!" Why is there no deception? Two reasons. There's no need, for one. And besides, Wiggum's mind is not really up to it.

Wiggum's stripped-down hypocrisy shows that the vice comports much better with ordinary understanding than more sophisticated cases make it seem. Defenders of the view I criticize might insist that Wiggum is not a hypocrite, precisely because his practices are not at all deceptive. But although it is in the philosopher's purview to tailor concepts for theoretical purposes, this cannot be done arbitrarily, or in unexamined contradiction to cases which support a more commonsense view. The concept of hypocrisy does need sharpening, but such refinement must respect the Wiggum case, if not Wiggum himself. What makes Springfield hypocrisy so funny is that it is, in contrast to more sophisticated examples, pointless. This is less an elaboration of contemporary culture than many would admit. Harsh medicine. But one hardly notices the taste for the laughter.

Shh!

Even in its most humorous forms, hypocrisy is typically one of the most reprehensible moral vices. I say "typically" because sometimes it is excusable, sympathetic, sometimes even praiseworthy. Look, for laudable cases, to literary characters like Huckleberry Finn and historical figures like Oscar Schindler. In *The Adventures of Huckleberry Finn,* Huck abets the escape of a slave, and although his actions are praiseworthy, he describes them as immoral. On a grander scale, in World War II Schindler presented himself as a Nazi, saving, by this deceit and other machinations, the lives of many Jews. Hypocrisy is praiseworthy when it is a necessary means to a worthwhile moral end, as in the Finn and Schindler cases. It is excusable when coerced, and sympathetic when the coercion is unfair. Take Bart's writing "I WILL NOT WASTE CHALK" repeatedly on the blackboard ("Bart the Genius"), which might seem to be a case of excusable, if not sympathetic, hypocrisy. It is detention, after all, and there is clear inconsistency in wasting chalk for the purpose of learning not to waste chalk. But it is not clear that Bart is making a value claim, even an implicit one, in writing "I WILL NOT WASTE CHALK." If there is hypocrisy here, it belongs to whoever assigned him the task. Be it Skinner or Krabappel, they ought to know better.

To my knowledge, there are no examples of praiseworthy hypocrisy in *The Simpsons.* But there are sympathetic cases. First off, Apu. Facing unfair deportation, he presents a false front of "American" values to hide his illegal status, and we are right to feel sympathy for him and to consider his hypocrisy excusable. When the false front becomes too much to maintain, Apu's cheerful lip-service falls to incredulity, then angry despair, in the span of a single sentence.

> What is the infinite compassion of Ganesha next to Tom Cruise and Nicole Kidman staring at me with their *dead eyes*? ("Much Apu about Nothing")

Second, Lisa. Finding herself isolated, punished for her virtues, she decides to win friends by disavowing, and even violating, the values she normally and honestly affirms.

LISA: My goony brother's always going to libraries. I usually hang out in front.

ERIN: Oh, you like hangin' out, too?

LISA: Well, it beats *doin'* stuff.

ERIN: Yeah. Stuff sucks. ("Summer of 4 ft. 2")

The coercion here is milder, a form of psychological duress. But Lisa's predicament is still a sympathetic one. Her hypocrisy is guided by an intelligent selfishness. It is pretty much harmless, unlike the crude selfishness of other Springfield hypocrites and most in real life.[3]

I have left a lot of meaty philosophical issues, pace Homer, untouched. Just the same, I want to make a few niggling remarks. Is one a hypocrite by falling short of an espoused ideal? No, because the idea is to practice what you preach. Where practice is needed, there is not yet perfection. What happens if values conflict? Order them hierarchically and act in accordance with the dominant value. Otherwise hypocrisy is unavoidable. Is hypocrisy always bad? Yes, provided it is not coerced, or a necessary means to moral action. Is integrity the opposite of hypocrisy? No. Integrity is acting in accordance with one's true values, not one's presented values. This means it is possible, oddly enough, to have integrity as a hypocrite.[4] What is hypocrisy again? A formal vice, intended or unintended inconsistency between deliberate actions and values espoused tacitly or explicitly. Mmm. . . meaty.[5]

[3] Two borderline cases worth mentioning here are Lisa's decision not to reveal the truth about Jebediah Springfield ("Lisa the Iconoclast"), and Marge's attempt to become a member of the Springfield Glen Country Club ("Scenes from the Class Struggle in Springfield"). If Lisa's silence is hypocritical, then it is arguably, contrary to my earlier claim, a case of praiseworthy hypocrisy. Marge's attempt to join the country club is somewhat sympathetic, although, like Lisa's silence, it is not obviously hypocritical. For reminding me of these examples I thank William Irwin and Adam Muller respectively.

[4] For more on the idea that integrity is not always a good thing see Robert A. Epperson, "Seinfeld and the Moral Life," in William Irwin, ed., *Seinfeld and Philosophy: A Book About Everything and Nothing* (La Salle: Open Court, 2000), pp. 165–66.

[5] Thanks to Rhonda Martens and the editors for comments on an earlier draft. Thanks also to Carl Matheson and Adam Muller for spirited discussion, and for the infiltration of Bar Italia, long overdue.

13

Enjoying the So-called "Iced Cream": Mr. Burns, Satan, and Happiness

DANIEL BARWICK

What true *Simpsons* fan has never rubbed his hands together and said in a slow, breathy voice: "Excellent . . ."? Monty Burns's expression of joy is familiar to all who watch *The Simpsons,* and it's regarded by *Simpsons* fans as the ultimate indication that all is well with the world. But despite the frequency with which he uses the expression, Mr. Burns finds little in the world to be pleased about. He is not a happy man, and the source of his unhappiness is none of the more familiar features of his character. Burns's unhappiness lies not in his advanced age, his decrepit physical condition, his long list of diseases, his support of slavery, his slaughter of thousands of animals (for sport or for wardrobe), his maltreatment of his employees, nor his rejection by the townspeople in general and women in particular. Rather, his unhappiness lies in a particular way of looking at the world, a way that cripples him emotionally and is echoed increasingly in the way we interact with our own world. We have a lot to learn from Mr. Burns about how not to spend a life; but this cautionary essay is *not* about kindness or greed, or wealth or power. Instead, it is about enjoying the cool smoothness of ice cream and the happiness it brings.

How could it be that Mr. Burns is unhappy? He has his own Xanadu (who wouldn't like his or her own Xanadu, complete with hounds to be loosed on Girl Scouts and other visitors?), a nuclear power plant that he runs with an iron fist, a chauffeur-driven Rolls-Royce, control of the local Republican Party, an

extensive wardrobe made from hard-to-find materials, an assistant who dotes on him, and sixteen prize-winning greyhounds. Monty is the owner of Burns Construction Company, the Burns Slant-Drilling Company, the owner and founder of "Lil' Lisa's Patented Animal Slurry" Plant, and the inventor of Burns's Omni-net. He owns King Arthur's "Excalibur," the only existing nude photo of Mark Twain, and that rare first draft of the Constitution with the word "suckers" in it. He was even reunited with his precious teddy bear, Bobo. What, then, might the problem be?

Mr. Burns has three problems that stand in the way of his happiness. I shall focus on the third, but the first two bear mentioning because they are an integral part of understanding his psyche. First, he is a creature of gross excess. Everything about him is big: his house, his fortune, his power (and abuse of that power), his ambition, his robotic Richard Simmons. As Springfield's richest man, he is "free to wallow in his own crapulence," as Mr. Burns gleefully admits. Although there is a rich tradition in philosophy that condemns such excess and advocates a life of moderation, surely the reader does not need the philosophic canon to see that none of Mr. Burns's excesses bring him much happiness. Despite being surrounded by people, he is alone. Despite his vast wealth, he wants ever more.

Second, because he sees everything in abstract terms, because he sees everything as a symbol of something else, he attaches unnecessary importance to everything around him and does not enjoy things for what they are. In "Team Homer," winning a worthless bowling trophy is much more important to him than the sweet, albeit momentary, pleasure of a group of jocular friends enjoying a game, bonding as a team, and drinking Duff Beer. Instead, winning the trophy becomes a singular achievement, and the problem with this approach is that when everything matters, nothing gets a chance to really matter. Mr. Burns sees everything in a symbolic fashion. He sees everything in an important symbolic way. As such, everything has the same level of importance, and so in the end everything bores him.

But this problem is common. We are all guilty, to a greater or lesser extent, of attaching ridiculous importance to the events in our own lives. It is often amazing to become aware of the unimportant things about which we become angry or glad, and equally amazing to recognize the truly important things to which

we are indifferent. But Burns's problems are parasitic upon a third, more fundamental problem. This problem is the symbolism that he attaches to everything; the result is that the original thing that is symbolized ceases to exist, at least in any pleasurable way. Unfortunately for Mr. Burns, it is the original thing that he truly needs for happiness. Allow me to explain.

Scene One: HELL[1]

Scorned by a woman, Satan took council with his chief tempters in Pandemonium. "What," he asked the assembled Principalities and Powers, "are we doing to hasten the dehumanization of man?"

One by one, they reported. Formidable Senior Vice-Presidents in charge of Envy, Pride, and Avarice gave glowing accounts; the Chiefs of the Bureaus of Lust and Sloth read lengthy bills of particulars. Lawyers lectured on loopholes. Satan, however, was not pleased. Even the brilliant report from the Head of the War Department failed to satisfy him. He listened restively to the long treatise on nuclear proliferation; he fiddled with pencils during the section on the philosophy of guerilla warfare.

Finally, Satan's wrath overcame him. He swept his notes from the table and leapt to his feet. "Self-serving declarations!" he roared. "Am I doomed to sit forever listening to idiots try to hide incompetence behind verbiage? Has no one anything new? Are we to spend the rest of eternity minding the store as we have for a thousand years?"

At that point, the youngest tempter rose. "With your permission, my lord," he said, "I have a program." And as Satan sat down again, the demon launched into his proposal for an interdepartmental Bureau of Desubstantialization. He claimed that the dehumanization of man was going so slowly because their infernal strategy had failed to cut man off from one of the chief bulwarks of his humanity. In concentrating on offenses against God and neighbor, it had failed to corrupt his relationship to things. Things, the tempter declared, by their provision of unique delights and individual astonishments, constituted a

[1] This story is borrowed, strangely enough, from a cookbook: Robert Farrar Capon's *The Supper of the Lamb* (New York: Doubleday, 1969), pp. 106–107.

continuous refreshment of the very capacities Hell was at pains to abolish. As long as man dealt with real substances, he would himself tend to remain substantial. What was needed, therefore, was a program to deprive man of *things*.

Satan took evident interest. "But," he objected, "how shall we proceed? In an affluent modern society man has more 'things' than ever. Are you saying that in the midst of such abundance and possessed by such materialism he simply will not notice so obvious and so bizarre a plot?" "Not quite, my lord," said the tempter. "I do not mean to take anything from him physically. Instead, we shall encourage him *mentally* to alienate himself from reality. I propose that we contrive a systematic substitution of abstractions, diagrams, and spiritualizations for actual things, actual beings. Man must be taught to see things as symbols— must be trained to use them for *effect*, and never for themselves. Above all, the door to delight must remain firmly closed.

"It will not," he continued, "be as difficult as it seems. Men are so firmly convinced that they are materialists that they will believe anything before they suspect us of contriving their destruction by spiritualization. By way of a little insurance, how- ever, I have taken the liberty of arranging for an army of tele- vangelists who will continue, as in the past, to thunder against them for being materialists. Humanity will be so busy feeling delightfully wicked that nobody will notice the day when we finally cut them loose from their reality altogether."

And at that, Satan smiled, sat back and folded his hands. "Excellent . . . ," he said. "Let the work go forward."

I could stop the essay there, because we find immediate con- firmation of my hypothesis (or at the very least a very credible hint) in the episode "Rosebud" in which the *Springfield Shopper* headline reads:

BURNS BIRTHDAY TODAY
CREDITS LONG LIFE TO SATAN

But consider:

Scene Two: The Bowling Alley

BURNS: [*walking in*] Look at them, Smithers, enjoying their embezzlement.

SMITHERS: [*dramatic*] I have a much uglier word for it, Sir: *misappropriation.* Simpson! [*Homer sees them and tosses his ball away; someone screams*]

BURNS: [*menacing*] Listen here. . . . I want to join your team.

HOMER: You want to join my *what?*

SMITHERS: You want to *what* his team?

BURNS: I've had one of my unpredictable changes of heart. Seeing these fine young athletes, reveling in the humiliation of a vanquished foe . . . mmm, I haven't felt this energized since my last . . . er . . . bowling.

[*Later, after winning the championship*]

HOMER: Woo hoo! We won! We won! [*Homer, Apu, and Moe dance while the Pimple-Face Kid gets the trophy from the case. Homer holds it, but Burns snatches it away*]

BURNS: You mean, *I* won.

APU: But we were a team, sir.

BURNS: Oh, I'm afraid I've had one of my trademark changes of heart. You see, teamwork will only take you so far. Then, the truly evolved person makes that extra grab for personal glory. Now, I must discard my teammates, much like the boxer must shed roll after roll of sweaty, useless, disgusting flab before he can win the title. Ta! [*He leaves.*] ("Team Homer")

First, Burns sees inclusion on the bowling team as *not* what it is first and foremost: a recreational activity with "friends" and lots of beer. He does not see these things at all. Rather, he sees only "these fine young athletes, reveling in the humiliation of a vanquished foe." Winning the trophy causes Homer, Apu, and Moe to dance with the joy of the moment, but for Mr. Burns there is no moment to enjoy. He has none of Homer's "in your face humanity" or "lust for life."[2] Instead, he thinks not about the win, but about his relationship to his teammates, discarding them like the flab around the waist of Wiggum. What Burns calls one of his "trademark changes of heart" is not a change of heart

[2] See Chapter 1 of this volume.

at all. He is merely following his heart: seeing each event, person, and thing as nothing but a sign for something else. We see this throughout *The Simpsons*. Some examples:

What does his son mean to him?

> Well, son, delighted to have met you. It's good to know that . . . there's another kidney out there for me. ("Burns, Baby Burns")

On his similarities to Holocaust hero Oscar Schindler:

> Schindler and I are like peas in a pod: we're both factory owners, we both made shells for the Nazis, but mine worked, dammit!" ("A Star is Burns")

On his public image:

> SMITHERS: I'm afraid we have a bad image, sir. Market research shows people see you as something of an ogre.
>
> BURNS: I ought to club them and eat their bones! ("Two Cars in Every Garage and Three Eyes on Every Fish")

On our sun:

> No, not while my greatest nemesis still provides our customers with free light, heat, and energy. I call this enemy . . . the sun." ("Who shot Mr. Burns? Part One")

On our feathered and four-legged friends:

> I call it Li'l Lisa's patented animal slurry. It's a high-protein feed for farm animals, insulation for low-income housing, a powerful explosive, and a top-notch engine coolant. And best of all, it's made from one hundred percent recycled animals! ("The Old Man and the Lisa")

On pieces of fine art:

> Let's just take them. We'll all be rich, rich as Nazis! ("The Curse of the Flying Hellfish")

Is my thesis merely that Mr. Burns has lost his inner child? Perhaps. But when we give some thought to the way children

see the world, we find that they too engage in a great deal of symbolism, or at least representationalism. When a child plays a game, say toy soldiers, he envisions the toy soldiers as standing for real soldiers and the battle as being much more important than it really is. When a little girl plays dress-up, she envisions herself or the dolls she is dressing as attending some important social function, much more important than the game which the girl is playing.

So I am not merely suggesting that Mr. Burns is no longer a child or no longer behaves like a child. In fact, it is Mr. Burns's exclusive use of symbolism that, in the end, fails him in his quest for happiness. Why? There is a widely held conception of happiness that explains happiness has two components. The first (the component we won't discuss) is the occurrence of a certain set of emotions experienced during, following, or in anticipation of a markedly favorable set of circumstances. The second is dispositional: in order to be happy it is necessary that one like, or be satisfied with, those parts of one's total life pattern and circumstances that one thinks are important, without which one would would be substantially different.[3]

But of course we all know that Mr. Burns wishes that his life were substantially different. He is permanently in search of a new life for himself, whether it be as an athlete, a governor, an innocent child, or whatever. Whenever Burns has an idea to improve his life, it is always to *become* something; or, more accurately, to become a certain *type* of thing. Nothing is enjoyable or funny or desirable to him unless it can be seen as standing for or representing something else, something bigger and more important.

Why can't such representationalism lead to happiness? If we leave aside for a moment the speculation that Mr. Burns's representationalism is the product of Satan's attempt to cut him off from his humanity, we find some more interesting philosophical grounding for my claim. There is a distinction, familiar to most undergraduate philosophy majors, between intrinsic goodness

[3] This account and others like it can be found in many accounts of happiness. See K. Duncker, "On Pleasure, Emotion, and Striving." *Philosophy and Phenomenological Research,* Vol. 1 (1941), pp. 391–430. The most concise formulation may be found in Richard B. Brandt's article on happiness in the *Encyclopedia of Philosophy,* p. 414.

and instrumental goodness. Things which are instrumentally good are good only insofar that they lead to, or are in some way related to, other things which are good. Those things which they lead to are either also instrumentally good, or intrinsically good. (Instrumental goodness is sometimes referred to as extrinsic goodness.) Intrinsically good things are things which are good in themselves; not because they lead to something good, but because they themselves are valuable; not because they produce any result, or lead to something good, or lead to something pleasurable, or perhaps have any results at all. Rather they are good because of the kind of thing they are. They need no further justification for their goodness other than what they are.

Consider pleasure. We find that pleasure may be instrumentally good or intrinsically good. For example, instrumentally good pleasure might be the pleasure my dog feels when I praise him for doing a trick—the reason I say it's instrumentally good is that the pleasure my dog feels makes it more likely that he will perform that trick later when I ask him to do so. But the pleasure he feels may also be intrinsically good, that is, it seems almost odd to ask "Well, what's good about pleasure?" Explaining the intrinsic goodness of pleasure will mostly just be explaining what pleasure is. Now notice, of course, pleasure can be instrumentally bad while being intrinsically good. For example, let's say I decide to shoot heroin. The pleasure I experience may itself be intrinsically good while at the same time being instrumentally bad, since the pleasure I derive from taking that drug may lead to problems—health problems, psychological problems, financial problems, and so forth.

But the interesting question is: Can there be such a thing as instrumental goodness without there also being intrinsic goodness? Can we have instrumental goodness, that is, something we recognize as good, while being mindful of something else good that the thing will bring, while at the same time believing there is no such thing as intrinsic goodness? No, this would be impossible. Goodness is a bit like a check one writes to pay off a debt. If Homer writes a check and has the money to cover the check, then the check is actually worth the money. But if Homer writes a check and the check is only good if Barney's check clears in Homer's account, then it seems that Homer's check is only good if Barney has the money. What if Barney only has the money if Moe's check clears in Barney's account? Each person is depen-

dent on someone else to close the loop, so to speak. Isn't it obvious that no one has any money? That is, if everybody is always dependent on someone else coming up with money, isn't it true that no one has any money? Instrumental goodness is the same, in the sense that something that is instrumentally good is only good if it leads to something else that involves goodness. Instrumental goodness is problematic in the sense that it seems as if we can never talk about, for example, money being intrinsically good in virtue of its bringing about, for example, a Squishie, without some appeal to intrinsic goodness. If we only had instrumental goodness, it would seem that money is only good if it brings about the instrumentally good Squishie and a Squishie is only good if it brings about the instrumentally good sugar high, . . . and so on. It has to go on forever since instrumental goodness is always goodness in relation to something that is being produced or something that has some relationship to another thing. This seems to generate an infinite regress in which it is not clear that the goodness is ever grounded, that there is ever any foundation to the claim that money, for example, is a good thing. So in Mr. Burns's world, when everything is a representation of something else, when everything serves as a symbol of something else, and everything only takes on meaning in light of something else, it would seem as if nothing would have any meaning. It would seem as if nothing would have any real power, nothing would stand for anything real. If everything is what it is only in virtue of its relationship to something else, for example winning the bowling trophy is what it is only in virtue of its relationship to being a spectacular victory, then this generates a problem similar to intrinsic vs. instrumental goodness.

You have noticed, of course, that if everything is what it is in relationship to something else, as it appears to be in Mr. Burns's world, then the spectacular victory that underpins the act of winning the bowling trophy must have itself some sort of underpinning . . . and all these underpinnings are required for the act to have real meaning. Unless we arrive at something that has meaning in itself, something which in a sense is simple and foundational, not symbolic, not representational. Nothing in Mr. Burns's world can have any meaning, and it isn't a very big leap from there to say that, in the end, without anything meaningful in Mr. Burns's life he cannot be particularly happy. One of the

hallmarks of the unhappy life is meaninglessness, and one of the hallmarks of the happy life is its meaningfulness.

There is a related problem with Mr. Burns's way of seeking happiness. Mr. Burns never enjoys anything beyond what that thing represents, and what that thing represents often lies in the past or in the future. Such representationalism guarantees that Mr. Burns loses the value of the moment in favor of a *method* for finding happiness. The method he prefers is looking beyond the objects of the moment for the happiness those things will bring. But this method has never yielded happiness. There is a saying of Eastern origin: "There is no way to happiness. Happiness is the way." Mr. Burns's representationalism, although habitual by now, is an activity designed to bring him happiness. It exemplifies Mr. Burns's belief that happiness must be sought deliberately. But people who are happy (and not merely momentarily happy) do not seek happiness or a way to happiness; they did not arrive at being happy after a series of steps or as a result of some deliberate action. This is because happiness in the classic sense is not merely an emotional after-effect; rather, it is a dispositional state.

What are Mr. Burns's prospects for finding happiness? There is no logical impossibility involved in old Monty finding happiness. Indeed, we see him finding momentary happiness throughout the series, hence the title of this essay. When Mr. Burns is tasting ice cream at the local festival and says to Mr. Smithers, "I'm really enjoying this so-called 'iced cream'," we see the seed of happiness in Mr. Burns; we see him enjoying something merely for what it is; enjoying the physical pleasure of the cold clean ice cream ("Bart's Inner Child"). This is Mr. Burns at his best (although not of course at his most entertaining); for a moment he is not mean. At this moment he is displaying his ignorance of things common and blue-collar, that in which man takes pleasure. The scene is significant in that it shows that Mr. Burns is indeed capable of engaging in ordinary pleasure without attaching to it a high degree of symbolism and representationalism. So Mr. Burns can in fact experience happiness.

But this isn't saying very much. There are very few people, even unhappy people, who don't experience moments of happiness, moments where in the case of Mr. Burns he simply forgets to be himself. He forgets to engage in the symbolizing habit he has engaged in all of his life. But does this mean that he can

be happy in the long term? Can he evolve from a person who finds no real meaning in his life into a person who can feel real pleasure, real happiness, who can enjoy the so-called iced cream on a permanent basis? The answer to this is, of course, no—not likely. Although stories such as Dickens's *A Christmas Carol* may go a long way toward convincing us that mean old people can change their ways, the fact is that is highly doubtful that a 104-year-old man,[4] steeped in malice, hatred, regret, anger, revenge, desire for money, lust for power, and with a nasty habit of casting away the immediacy of experience, will be able to change (even if the producers would let him).

[4] Monty Burns was a member of Yale's class of 1914. Assuming that he graduated at the usual age of around 22, Mr. Burns would have been born in 1892. That would confirm his age as 104 in 1996, when this episode aired. (Although an earlier show pegs his age at 72, the writers must have realized that no 72-year olds are as decrepit as Mr. Burns.)

14

Hey-diddily-ho, Neighboreenos: Ned Flanders and Neighborly Love

DAVID VESSEY

"Love your neighbor as yourself" (Matthew19:19) is the center-piece of Christian ethics. Yet what it means and what it requires—like many good moral principles—is ambiguous. Among all Ned Flanders's acts that exemplify "love your neigh-bor," the one most philosophically interesting occurs in the episode "Home Sweet Homediddly-Dum-Doodily." In this episode the Flanderses are acting as a foster family for Bart, Lisa, and Maggie. During a Bible study game, Ned discovers from Lisa that the Simpson children haven't been baptized and immedi-ately rushes to perform the sacrament. The reason to have them baptized is obvious: Flanders believes that without baptism they cannot be saved. Oddly, his sense of obligation does not seem to extend beyond the household. He has never before tried to have Bart, Lisa, or Maggie baptized (perhaps because he hasn't known), nor does he continue afterwards. Nor does his sense of obligation ever seem to extend to the clearly non-Christian char-acters. So the philosophical question raised is: To what extent is "loving your neighbor" consistent with tolerating your neigh-bors' beliefs and practices when you think that holding those beliefs will cause them eternal suffering? How can you properly love others without acting to prevent them from meeting such a fate? This becomes even more complicated when we consider the full principle "love your neighbor as yourself." After all, a clear feature of self-love is that you act to prevent your own

eternal suffering when possible. So if you are required to love your neighbor as yourself, and a consequence of loving yourself is that you work to avoid suffering (including eternal suffering), then it would seem you are required to work to prevent the eternal suffering of others. And that requirement would include working to baptize them. But Ned does not try to do that except when it concerns children in his care. So our task here is to provide a possible justification for Ned's actions given his beliefs.

Philosophy and Fictional Characters

Now it should be acknowledged at the outset that this is an odd project. What does it mean to talk about the beliefs, or possible beliefs, of a fictional character? Ned Flanders is only that which Matt Groening and his staff make him to be. It doesn't really make a whole lot of sense to say "Ned should have said or done x, or should believe y," or even "these arguments justify Ned's actions" because, quite obviously, Ned has no beliefs and does not actually act. So how are we to understand the project in front of us?

One way would be to hypothesize Ned as an actual person. Our claims would then be of the form, "If Ned were real, and Ned acted this way, how might he philosophically justify his actions?" This doesn't work either. We are not seeking hypothetical "If Ned were real" conclusions, but a genuine understanding of the possible justification of certain actions. And this justification should hold regardless of whether the actions are performed by a real-life person, or simply depicted by the character Ned. Really, in the end it's the actions we want to focus on—not Ned the character or even Ned as potentially real—and thus we should think of the character as representing certain kinds of actions: actions that can be reflected upon independently of their enactment. To do so will make our investigations more philosophical, as opposed to belonging more to cultural or literary analysis.

We must also clarify that we are not out to explain the actions, but to provide a possible justification for the actions. What is the difference? The only thing that really explains Ned's "actions" is the fact that he was written that way. Though it makes some sense to say that Ned did something because he believed it was necessary, and so forth, as we have seen, strictly

speaking, Ned has no beliefs. Explaining actions is a compli-cated and sometimes futile undertaking. For example, what explains the shooting death of an innocent man? The question is horribly indeterminate because what counts as an explanation is horribly indeterminate. There are many possible legitimate answers: society, madness, mistaken identity, pulling the trigger of a loaded gun aimed at the victim, the bullet, the hole, the lack of oxygen to the victim's brain, or, of course, the ubiqui-tous explanation: God's will. So which really explains the action? It's not clear there is a single answer to that question. At any rate, notice that the answers tend towards psychological, sociological, and biological (and even theological!) explana-tions. Our issue here is what *justifies* an action. What kind of reasons could we provide that would make these actions and these beliefs consistent?

The Responsibility to Save Lives

So we're concerned with a set of actions represented by Ned Flanders in "Home Sweet Homediddly-Dum-Doodily." What actions? Not Ned's attempt to baptize the Simpson children when they were under his care. That action does not raise a par-ticularly difficult philosophical question. Providing a possible justification is fairly simple. You should always act in the best interest of those in your care. For what could it mean to care for others if not to enable them to pursue their best interests? And when others are in your care, as children are in parents' care— and as the Simpson children are in their foster parents', the Flanderses, care—this means not only helping them achieve their goals, but helping them to acquire the proper goals as the guardian or parent sees them. Even though Bart and Lisa didn't think being baptized was in their best interest, it is the respon-sibility of the guardians to act in the children's interest regard-less of their beliefs.

The issue we need to confront is this: given the belief that without baptism eternal life is unattainable, and the belief that you should love your neighbor as yourself, why wouldn't Ned always be working to baptize the unbaptized as an act of love? To love someone would seem to require you to act to save his or her *earthly* life—or at least to try to save his or her life. Indeed many would think this requirement is not limited to

those you love; you should try to save someone's life even if you have no connection to that person. It would seem, then, that you are even more morally bound to try if you love that person. But if you are morally required to save someone's earthly life when you believe it is endangered, then it would follow that you are morally required to save his or her eternal life if you think it is endangered. That is, if you hold the beliefs represented by Ned Flanders, then you are morally required to work for the baptism of all persons at least as hard as you would to save someone's life. But, Ned clearly doesn't. And, in fact, most people who hold these beliefs don't. Are they simply inconsistent? To put our question in more general terms, could you be justified in not working to save someone's eternal life if you thought it was endangered? That is the action (or lack of action) that requires justification. Clearly it is a much more difficult question than whether the Flanderses were justified in trying to baptize the Simpson children. Let us spell the argument out in more detail, deriving it from the central principle of "Love your neighbor as yourself." Notice that the obligation always focuses on *trying* to save someone's life, not necessarily succeeding (as this may be impossible).

1. You should love your neighbor as yourself.
2. Loving someone requires trying to save his or her life.
3. If you are morally required to try to save someone's life, you are morally required to try to save someone's eternal life.
4. If you are morally required to try to save someone's eternal life, you are morally required to try to provide what is necessary for him or her to receive eternal life.
5. Baptism is necessary for eternal life.
6. Therefore, you are morally required to try to baptize everyone out of love, for the sake of saving their eternal life.

Premises 1 and 5 are taken as given, and surely they are beliefs represented by Ned Flanders. Premise 2 seems trivially true, but we will have to see if there are cases when you would, out of love, not try to save someone's life. Premise 3 also seems trivially true. Line 6 is the conclusion, and follows from the other premises. Premise 4 is something we haven't discussed yet, and needs our attention.

Are there cases in which you are required to act for an end, but not required to bring about the means to that end? It would seem unlikely, but let's consider two scenarios. First, you have a moral obligation to save somebody, but it would be physically impossible for you to save that person (perhaps because that person is on the other side of the world from you). Now since you are not morally obligated to do something physically impossible, you have a situation where you are obligated to an end, but not the necessary means. In this case, the error is in thinking that you can still perform an action even if you physically cannot perform the necessary means to that action. You can only perform an action if the conditions necessary for the action are in place. As you are not morally obligated to perform impossible acts, you are not morally obligated to perform the end. So in fact you are only obligated if you can realize the means.[1] In the second scenario, you have a moral obligation to save somebody, but in order to do it, you need to act immorally. Since you cannot be morally required to act immorally, again we have a case where the end is required, but not the means. The question here is what happens if the means are themselves immoral. If it's the case that it might be immoral to baptize someone under certain circumstances, then the proof would fall apart. But what might those circumstances be? Certainly there may be ways of getting someone baptized which are recognizably immoral. Two examples would be tricking someone into being baptized (somehow) or forcing someone to be baptized against his or her will. But all we need conclude from this scenario is that some ways of baptizing someone are more moral than others. This is not a surprising conclusion and not one which really jeopardizes the argument.[2] A greater concern is that, since baptism provides

[1] When we consider our example, the problem dissolves even more. According to most interpretations, only God can really provide eternal life. So the end is not in your power. What is in your power is trying to provide some of the necessary means to salvation, in this case baptism. So in this case it is really the means that you are required to try to provide, not the end itself.

[2] There is also the issue of baptizing infants before they can have a choice in the matter. We addressed this briefly above when we argued that guardians have a moral responsibility to act as they see would be in the best interest of the children in their care. Moreover, especially in the case of infants, baptism is not forcing the children to adopt any particular religious beliefs. They are free to renounce their parents' beliefs as they grow older.

for the possibility of eternal life, the ends justify the means. The immorality of the means is overshadowed by the possible good that can come from the action. Perhaps so, but we'll not solve this problem until we understand under what conditions you could morally refrain from trying to facilitate someone's salvation through having him or her baptized. What we will find is that the solution to the original problem also addresses the challenge that the end may justify the means. For the time being, let's accept premise 4 and turn directly to the possibility of justifiably not trying to save someone's eternal life, in the name of love.

Understanding the Command to Love Your Neighbor as Yourself

First, I think we need to look closely at the basic moral principle at work here: "Love your neighbor as yourself." Let's take "neighbor" to mean, as it is commonly understood, all human beings, and not simply those living next door (though of course the narrow reading would still apply to the Flanderses and the Simpsons).[3] This principle shares a feature with the Golden Rule ("Do unto others as you would have them do unto you"): both commands derive the appropriate action from your own relation to. yourself. As you love yourself, so should you love others; as you want done to you, so should you do to others. The concern following all such theories is that they open up what we will call "The masochist problem." In the case of the Golden Rule, what if what the person wants done to him- or herself is to have pain inflicted for the sake of sexual arousal? Is he or she morally required to inflict pain on others in order to sexually arouse himself or herself? This is a problem for some versions, but interestingly it is less a problem for the "Love your neighbor" principle. We are to love our neighbors as we love ourselves. Since the obligation turns on a projection of our self-love to love of others, we are restricted from the start. Willing is much broader than loving, and not everything willed upon oneself is consistent with loving oneself. One could easily argue that masochism

[3] Needless to say, "love" here is not meant as a feeling, as if the feeling of being in love could be obligated, but as a way of relating to others.

can't be consistent with proper self-love, but of course this raises the question of the distinction between proper and improper self-love. Consider one particular form of self-love: narcissistic self-love (excessive pride, which the Medievals thought the worst of all vices and the source of the rest). This form of self-love is not the self-love of the principle of "love your neighbor as yourself." We know this from simply looking at the form of the principle. The principle calls on us to treat others as we treat ourselves, but narcissistic self-love precludes precisely this other attentiveness. If we are narcissistically self-loving, we are incapable of loving others, much less loving them as ourselves. Clearly this is a morally improper form of self-love. Self-love of this sort can't be universalized to apply to others, therefore if the principle is going to avoid self-contradiction, it must call for a form of self-love other than narcissistic self-love.

What, then, are we to make of the notion of self-love? At the very least self-love requires this: that we aim to provide the means necessary for advancing the nobler aspects of our selves. Of course it will involve much more than this—for example, striving for self-realization has to be balanced with self-acceptance—but at the very least, to love oneself is to work to perfect oneself as a person. That never involves simply following one's immediate wants and desires. Rather it always involves evaluating those desires and integrating those desires into a complete and fulfilling life. Thus to love others as yourself is, at the very least, to work to promote the perfection of others as human beings—to promote others' development of their nobler aspects. And note well that these nobler aspects may not only be independent of self-interest, they may be antithetical to it. One of the noblest traits we recognize in people is their willingness to act on principle above and beyond their personal, selfish desires. Indeed, we praise those who not only act against their selfish desires, but who sacrifice themselves for the sake of acting morally. Loving others, then, involves encouraging them to act on principles which may not be connected to their desires. Notice this is appropriate given our discussion of the principle "Love your neighbor as yourself." That very principle requires us to act on principles like it. That is, the commands of the principle to love others as yourself preserve the idea of acting on principle rather than on narcissistic self-love.

At this point we can return to something we saw earlier. Recall that premise 2 in the argument was "Loving someone requires trying to save his or her life." We can now see there are cases where, out of love, we should refrain from trying to save someone's life. If we allow that love for others requires us to encourage others to act on principles more noble than merely following their wants and desires, then we realize there may be cases where a person is willing to risk death for one of these principles. If we are privileging some principles over interests, then we should privilege them over the ultimate interest: self-preservation. It would seem then that the principle "Love your neighbor as yourself" may, in fact, lead us into a situation where the appropriate action is not to act to save someone's life. That is, in cases where people are acting on a principle which, when realized, advances nobler aspects of themselves and perfects them as persons, and the following of which jeopardizes their lives, then you should not intervene. A clear example would be if someone—recognizing it might mean his or her death—refuses on principle to follow orders to kill innocent civilians.

Now an obvious objection is that no one on *The Simpsons* is represented as holding such principles. Not even the most principled character, Lisa, could be said to belong to that category, so the argument is moot. But again, we are not concerned with Ned and the characters per se, but only with them as representatives of a certain set of actions, and we are inquiring as to how those actions could be justified. On first glance, it would seem that they are rarely, if ever, justified. Still, we have arrived at a sketch of a solution to the problem, but only a sketch. Those familiar with the history of philosophy will have recognized by now that our conclusions approach those arrived at independently and for different reasons by Immanuel Kant. Let's look at his account of autonomy as a guide for fleshing out the view that is emerging.

Kantian Autonomy

At this point our view has two elements: acting on principle, and acting independently of interests. Kant held both of these factors to be crucial for an action to be moral.[4] The first he considered trivial. Every action, he claims, whether we know it or

not, has some principle behind it: a maxim. The moral worth of an action, then, depends on the nature of the maxim guiding it. Some maxims reflect personal interests ("Act in such a way as to maximize your pleasure" is a common one), while others do not. We've seen that "Love your neighbor as yourself" is an example of a maxim which does not reflect personal interests. According to Kant, an action will be moral only if the motivation for the action is simply morality itself. We do it because it's the right thing to do. The same movements might be done for different reasons, but they are only fully moral if they are done for moral reasons. This is not to say the actions can't also fulfill our interests, just that our self-interests can't be the motivation of the action if the action is to be considered a moral action.

But when aren't actions done from self-interest? Kant acknowledges that it is difficult to tell. In fact he says it's impossible to tell when you are genuinely acting morally, but the key here is that it is possible to act morally. You can act on principles independent of your interests. In addition to merely acting on the principles, however, you must be aware of what you are doing for the action to be a properly moral action. At least you need to be aware that you are trying to act according to the principle you've chosen. To act morally, then, you yourself need to make the moral principle your principle. Certainly it is praiseworthy when someone acts benevolently out of instinct, but to fully act morally means to decide to make the moral guiding principle the principle to be followed. You give yourself the

[4] Kant, surprisingly, rarely discusses at length the command to love your neighbor as yourself. Here's what he does say in Part II of *The Metaphysics of Morals*. "The saying 'you ought to love your neighbor as yourself' does not mean that you ought immediately (first) to love him and (afterwards) by means of this love do him good. It means, rather, do good to your fellow human beings, and your beneficence will produce love of them in you (as an aptitude of the inclination to beneficence in general)" (Immanuel Kant, *Practical Philosophy*, Cambridge: Cambridge University Press, 1996. p. 531). Later in the same work he writes, "The duty of love for one's neighbor can, accordingly, be also expressed as the duty to make others' ends my own (provided only that these are not immoral). . . . In accordance with the ethical law of perfection 'love your neighbor as yourself,' the maxim of benevolence (practical love of human beings) is a duty of all human beings toward one another, whether or not one finds them worthy of love" (*Practical Philosophy*, pp. 569–570).

principle, you determine for yourself how you should act, and you act on that principle. Only then have you freed yourself from merely imitating others and according to Kant, only then are you genuinely free.[5] Kant refers to this genuine freedom as *autonomy*, and it is different from what we will call metaphysical freedom. Metaphysical freedom is the ability to initiate new causal chains: the ability to, say, move your arm at will without it being moved by something external to you. Autonomy, however, is the ability to legislate your own actions by choosing the principle of your actions. It is taking responsibility for the maxim of your action.

Consider this feature of Kantian autonomy in the context of our guiding question. We have been developing a possible moral justification for 1. believing you should love your neighbor and 2. believing that without being baptized your neighbor will suffer eternally, and 3. still not acting to baptize your neighbor. And a picture of the conditions of such an action to be legitimate have started to emerge. If someone is acting on principle—a principle that perfects him or her—and that principle leads him or her to jeopardize his or her life (including his or her eternal life), you might be required to refrain from interfering on the basis of loving your neighbor. But surely if it's possible to be acting on principle without really adopting that principle consciously, then we are given pause. If someone has not consciously adopted the principle of his or her action and made it his or her own, then it would seem that there is an obligation to intervene "on his or her behalf" (so to speak). If self-love requires you to pursue principles of action that perfect yourself, then loving others means enabling them to do the same. But this must mean enabling them to choose these principles for themselves, and only in such conditions might "love your neighbor" obligate you to respect their decision. So the central feature of Kant's theory of autonomy, self-legislation

[5] But note that simply making the principle your own doesn't make it a moral principle, it must be the right kind of principle. That is, the morality of the principle is independent of your willing the principle. We will see more of this as Kant's views unfolds. Of course we could not come close to presenting Kant's moral theory in all its complexity here. For a good presentation of Kant's ethics see Allan Wood's *Kant's Ethical Thought* (Cambridge: Cambridge University Press, 1999).

of moral principles, seems to be required for our account as well.

Yet how do we come across these principles and make them our own? How do we distance ourselves from our inclinations enough to make this possible? Kant's answer is reason. Consider our three criteria for a moral action: 1. acting on a principle, 2. which is independent of our interests and 3. which we have given to ourselves. Reason is necessary for all three. Reason is what lets us step back from our immediate desires and inclinations, and it is reason which allows us to think through the principles and decide if the action we are going to make is being done for moral reasons (or selfish reasons). More importantly for our case, it is reason that ultimately allows us to judge that a person is risking his or her eternal life on the basis of what the person takes to be a more noble principle. For Kant, reason becomes the key to understanding how to formulate the ultimately proper moral principle. Reason abstracts us from our particular interests and, in doing so, universalizes our judgment. This universalization is the key to what Kant calls the categorical imperative—a principle which will tell us when our maxims are moral. Act only on the maxims which can be willed to be universal laws.[6] We don't need to follow Kant to this extreme formalism, but we have already seen his concerns for universality at play in our interpretation of the meaning of self-love. At the very least we should agree with Kant that a condition of autonomy is rationally standing back from your desires in order to reflectively embrace a principle of action. Promoting your reasoned stance towards your desires is perfecting the nobler aspects of yourself. At least, the principle of "Love your neighbor" requires you to perfect your ability to use reason in this way.

So our conception of autonomy is complete. Loving your neighbor does not require you to try to save someone's eternal

[6] Kant gives a couple of versions of the categorical imperative. Perhaps the most relevant version for our emphasis on autonomy (moral self-legislation) is the principle to act "on the idea of the will of every rational being as a will giving universal law" (*Practical Philosophy*, p. 81). Which is to say, treat all as capable of being autonomous agents. In effect, this and the principle of benevolence (help others perfect themselves) is the content we've given to the "love your neighbor" principle. We should recognize all as capable of autonomy and help them achieve that end.

life when he or she is acting autonomously. Autonomous agency, we've concluded with Kant's help, has four parts. You must be acting on principles that are independent from your interests and that you have consciously given to yourself. The principles must aim to perfect yourself and must be the result of rational reflection about how to act. In such a case Ned's actions would be justified. Under these conditions, premise 2 from our earlier argument—"Loving someone requires trying to save his or her life"—turns out to be sometimes false and the argument no longer holds.[7]

Conclusion: Autonomy vs. Choice

Still, doesn't this simply boil down to the commonsense reaction that you should not interfere in the choices of others? Where does the argument differ? Although it is true that if a person has consciously chosen his or her ends, the person meets one of the criteria, there is still the concern for choosing principles which function independently of desires. If a person is acting out of his or her interests rather than on principles independent of his or her interests, then there is never a case where the preservation of life is sacrificed to higher interests. Well, unless of course that interest is the interest in eternal life, but this is precisely the point. If people act out of interest rather than out of principle, then helping them attain eternal life is consistent with their aims, whether they realize it or not. So it is not the case that choices are tolerated simply because a person made them. Only some choices people make—rational, principled choices that are independent of interests—free someone like Ned Flanders

[7] Although we've moved away from the question of the Simpson children, there is a concern about how this reasoning would apply to all children, not just those in your care. Kant thought everyone was capable of acting autonomously, however not everyone realized this capacity. Children rarely act autonomously; so the argument may still hold that one should try to baptize all children in your care or otherwise. There isn't room to develop a fuller response to this concern, but I think one of two tracks (or both) would be successful. One might argue that you should respect the judgments autonomous people make for those in their care; or one might argue that the conclusion is that loving your neighbor requires you to work for your neighbor's salvation or to work for your neighbor's realization of his or her autonomy.

15

The Function of Fiction: The Heuristic Value of Homer

JENNIFER L. MCMAHON

Though people might expect a philosophic argument concerning the heuristic function of fiction to allude to the works of Homer, renowned epic poet of ancient Greece, it's likely that references to Homer Simpson in such a context would come as a surprise. While not a conventional choice, the popular television show *The Simpsons* illustrates some general claims made by philosophical writers about fiction. It's well-suited to illustrate these claims because of the accessibility of its characters and scenes, the pertinence of its subject matter amidst its levity, the unique nature of its medium, and its mass appeal. Because I am interested in determining how fiction instructs, I shall focus more on why *The Simpsons* can educate than on what it teaches. While I shall offer examples, it is not my intention to articulate precisely what *The Simpsons* has to convey.

In a number of the other chapters of this book, my co-authors discuss some of the pertinent benefits of viewing *The Simpsons*. Among other things, they suggest it can cultivate cultural literacy and inform us about American values. However, because we could not enumerate every insight that *The Simpsons* has to offer, we hope simply to inspire people to look with greater seriousness at a show that seems to be more about entertainment than education.

Most Americans are familiar with Matt Groening's *The Simpsons*. Indeed, given that the show is televised in a host of foreign countries, so are many non-Americans. Whether one

likes *The Simpsons* or not, the show's popularity and longevity
have made it a part of contemporary culture. Avid viewers tune
in weekly to watch the latest fiasco in the lives of Homer, Marge,
Bart, Lisa, and little Maggie. They watch latenight re-runs, culti-
vating a mental index of favorite lines and scenes. For better or
worse, famous phrases from the show have even become part
of colloquial English. Stationed in Springfield—the city without
a state—the Simpson family parodies the stereotypical American
one. It entertains us with its hysterical situations, its combination
of comic dialogue and physical humor, as well as its skillful allu-
sion to other popular comedies like *The Three Stooges, The
Honeymooners,* and *The Flintstones.*[1] The question is, however,
how does it help us learn?

 While most people would find the proposition that we can
learn from art uncontroversial, philosophers do not. Indeed,
since Plato offered his critique of art in the fifth century B.C.,
philosophers have debated whether art can educate. Today, the
philosophical debate continues. A focus of that debate is the
heuristic function of fiction. While people have used stories as
a means of instruction for centuries, philosophers have tradi-
tionally been suspicious of the educational value of literature.
Recently however, many philosophers have come to laud its
instructive ability. Arguably, Martha Nussbaum is the most well-
known advocate of this claim.[2] In *Love's Knowledge,* Nussbaum
offers the bold assertion that certain truths can be conveyed
adequately only in art. While her insights have broad implica-
tions, Nussbaum focuses on literature's inimitable ability to dis-
close moral truths. Using Nussbaum's work as a point of
departure, I shall further explore the instructive capacity of fic-
tion. Specifically, I shall examine how engaging with fiction

[1] See Chapter 6 of this volume for a thorough account of the role and effects
of allusion in *The Simpsons.*

[2] While she is the most well-known, Nussbaum is not the only philosopher
making claims regarding the heuristic function of fiction. Other authors who
discuss this topic include Wayne Booth in *The Company We Keep: An Ethics of
Fiction* (Berkeley: University of California Press, 1988), Susan Feagin in
Reading with Feeling (Ithaca: Cornell University Press, 1996), David Novitz in
Knowledge, Fiction, and Imagination (Philadelphia: Temple University Press,
1987), and Jenefer Robinson in her article titled "L'Education Sentimentale" in
the *Australasian Journal of Philosophy* 73:2 (1995).

prompts greater reflection on the part of the individual, reflection that can compel not only the development of a keener understanding, but also moral improvement. I shall use the popular television show *The Simpsons* to illustrate my claims regarding the function of fiction. While these same features might first be thought to compromise its heuristic function, I shall demonstrate that *The Simpsons* is well suited to illustrate my claims because of the caricatured ordinariness of its characters and setting, its levity, its animated medium, and its mass appeal.

Laying the Foundation for Fiction

Before offering my views regarding fiction generally and *The Simpsons* in particular, it is necessary to discuss their foundation, namely Nussbaum's position and the skeptical argument to which Nussbaum responds. Typically, those who deny that literature can instruct ground their skepticism in doubts about fiction's capacity to represent reality, as well as in concerns regarding the power of artful words to undermine rational thought. They claim that stories about characters and events that are not real cannot offer us worthwhile information about the real world. They propose that the feelings literature typically elicits frustrate, rather than facilitate, clear thought. In *Love's Knowledge,* Nussbaum responds to both of these concerns.

Contrary to the assertion that fictions do not depict reality and thus cannot serve as vehicles for truth, Nussbaum contends that "certain truths about human life can only be fittingly and accurately stated in the language and forms characteristic of the narrative artist."[3] Nussbaum elevates the language and forms of the narrative artist because she believes that "the world's surprising variety, its complexity and mysteriousness, its flawed and imperfect beauty . . . [can only] be fully and adequately stated . . . in a language and in forms themselves more complex, more allusive, more attentive to particulars" (*LK*, 3). Concerning the assertion that literature arouses emotions that impair our ability to think clearly, Nussbaum asserts that emotions are essential to good judgment. She states, "emotions are not simply

[3] Martha Nussbaum, *Love's Knowledge* (Oxford: Oxford University Press, 1990), p. 5. Subsequent references to this work will be indicated in parentheses accompanied by *LK* and a page number.

blind surges of affect . . . they are discriminating responses [that are] closely connected with beliefs about how things are and what is important" (*LK*, 41).

Nussbaum begins her case for literature with a critique of conventional philosophic prose. While philosophers have tended to view literary narrative as an inadequate tool for the conveyance of truth, they have seen their medium of expression as ideally suited to the task of describing the true nature of things. Nussbaum gives us cause to question this assumption. She contends that conventional philosophic prose is limited because of its tendency toward abstraction and its privileging of reason at the expense of emotion.

As Nussbaum explains, when a style that is abstract and cleansed of emotion is employed to describe a reality that is concrete, complex, and infused with feeling, problems inevitably result. She asserts, "only the style of a certain sort of narrative artist (and not, for example, the style associated with the abstract theoretical treatise) can adequately state certain important truths about the world, embodying them in its shape and setting up in the reader the activities that are appropriate for grasping them" (*LK*, 6). In particular, Nussbaum contends that conventional philosophic prose is stylistically unsuitable for the expression of our moral situation. She maintains that this style misrepresents our situation and encourages misunderstanding regarding how we ought to live in it. She concludes that conventional philosophic prose is not sufficient to disclose the nature of our situation in a way that could educate us morally. She claims that literature is an essential supplement to conventional philosophic works when it comes to the study of moral philosophy and moral education generally.

Nussbaum continues her case for literature by enumerating the features of the narrative style that make it conducive to the articulation of our moral situation. She contends that literature is more capable of expressing the nature of our moral situation because it prioritizes particulars (for example, acknowledging the inherent worth and incommensurability of individuals) and recognizes the significance of emotion. These features are important because they are stylistically consistent with the depiction of a reality that is inherently variegated and replete with emotion. In Nussbaum's view, our moral situation is extraordinarily complex and painfully ambiguous. While we

may want it to be simple, it is anything but simple. In order to offer an accurate depiction of our moral situation, one needs to use a style that is attentive to detail, appreciative of complexity, and committed to the articulation not only of the facts, but also of our feelings. She argues that the absence of any of these features will result in an incomplete rendering of our moral terrain.

In addition to affording a more accurate representation of our moral situation, Nussbaum asserts that reading literature has other benefits. In order for a person to be moral, an individual must not only be aware of the significance of individuals and emotion, she must also possess certain habits and sensitivities. Nussbaum believes that reading literature cultivates such morally relevant habits and sensitivities. Where abstract styles direct our attention away from the concrete, literature's characteristic emphasis on particular people and events conditions readers to develop a corresponding appreciation of the inherent worth and inescapable uniqueness of individuals and situations. Likewise, literature's careful depiction of the diversity and influence of emotion encourages readers to appreciate the role that emotions play in our lives as well as the intellectual and ethical consequences of the presence and absence of specific emotions. Finally, literature's solicitation of emotion contributes to what Nussbaum calls the "shaping of sympathy" (*LK*, 44). She believes that the ability to feel for fictional characters is a morally relevant capacity that engenders feeling for others in our ordinary lives.

Ultimately, Nussbaum sees literature as unique in its heuristic ability because it both embodies in its style, and encourages in its readers, an attentiveness to the particular that is a condition for being moral. With her critique of conventional philosophic prose, Nussbaum draws her readers' attention to the deleterious effects of a style of writing that has been celebrated as the medium of truth. Nussbaum maintains that this style is unsuitable for representations of our moral situation because it promotes a simplistic understanding of our moral experience as well as an undesirable degree of emotional detachment. She feels literary works are more capable of generating moral understanding and improvement because they offer a more accurate depiction of our moral situation and encourage greater sensitivity in their readers.

Continuing the Case for Fiction

While the previous section summarizes Nussbaum's argument for literature, Nussbaum's work is not the intended focus of this chapter. Rather, the objective of this piece is to utilize Nussbaum's work as a basis for my own argument regarding the heuristic relevance of *The Simpsons*. As I depart from Nussbaum in some respects, it is important to make explicit what I draw from her argument as well as what I see as its shortcomings. Like Nussbaum, I believe that literature possesses unique heuristic properties. Like Nussbaum, I believe that literature is uniquely able to convey certain information and that it can compel important cognitive and affective responses. I share Nussbaum's opinion that literature often provides a more accurate depiction of our moral situation than conventional philosophic prose. I agree that reading literature can help encourage the basic attention to, and concern for, individuals that is a prerequisite for being a moral person. Finally, I share the belief that literary works should be incorporated into the study of moral philosophy and moral education generally.

While I am in agreement with most of her major points, Nussbaum's argument has several shortcomings. Several of these are relevant to our subsequent consideration of *The Simpsons*. First, in her argument for literature, Nussbaum alludes almost exclusively to classic novels and plays from the Western canon. While she does not exclude the possibility that other varieties of fiction can instruct, her clear preference for canonical authors and forms serves to promote the elitist—and erroneous—assumption that only such elevated works have educational value. This assumption must be dispensed with if one is to appreciate the heuristic value of works that fall outside of the literary canon, including popular fictions like *The Simpsons*.

Second, while it is perhaps a result of her unqualified enthusiasm for what literature can provide, Nussbaum seems insufficiently attentive to the potential that fiction has to distort our understanding and foster disturbing sensitivities. While literature can influence us positively, it also can exert a negative effect. It can compel ignorance and morally repugnant attitudes as easily as understanding and moral improvement. It can have these effects because individuals do not encounter literature generally; they encounter individual works of literature. These individual

works may paint erroneous pictures of the world. They may foster disturbing attitudes and allegiances.[4] While fiction's potential to distort our understanding and compel moral corruption led Plato to advocate wide-ranging censorship, the benefits it can provide make censorship an unacceptable option. However, it seems both insufficiently critical and somewhat irresponsible to fail to address the possible untoward effects of indiscriminate exposure to fiction. Such effects are especially pertinent when one recognizes that popular fictions like *The Simpsons* have the potential to affect large audiences.

Third and finally, Nussbaum grounds her argument regarding the laudatory effects of fiction exclusively in literature's capacity to offer accurate representations of reality and cultivate sympathy. Though these features certainly contribute to its heuristic function, there is more going on in our relationship with fiction than astute representation and the promotion of sympathy. We learn from fiction not only because it offers accurate representations of individuals and promotes feelings for those individuals, but also because it promotes identification. Such identification clearly occurs with characters like Homer and Marge Simpson whose lives bear similarity—albeit caricatured—to those of many viewers.

Ultimately, the heuristic function of fiction is rooted in the unique opportunities it provides. Fiction's distinctive emphasis on particulars not only makes it more capable of depicting reality accurately, it also positively affects readers' or viewers' patterns of attention by encouraging them to become more attentive to individual people and circumstances. Likewise, fiction's unparalleled emphasis on emotion makes it capable of

[4] For further discussion of how fiction can promote problematic attitudes and allegiances, see Cynthia Freeland's *Realist Horror in Philosophy and Film* (New York: Routledge, 1995). Here, the author examines the effects of the eroticization and glamorization of the villain that occurs in many realist horror films. In films like *Silence of the Lambs* and Freeland's example, *Henry*, viewers are encouraged to sympathize with serial killers. As Freeland explains, the cultivation of such sympathy is not necessarily negative. Indeed, if a viewer is cognizant of her sympathy and the problematic nature of it, the cultivation of such sympathies can prompt reflection and heightened understanding. However, the generation of such allegiances in uncritical and highly suggestible viewers may not result in such a positive outcome.

soliciting feeling in ways that educate peoples' emotions.[5] Fiction's heuristic success also issues from the activity of identi- fication that it encourages. As most individuals who read or view fiction attest, one of the most engaging properties of fiction is the way that it prompts identification. When we read or watch good fictions, we become absorbed. We become absorbed largely because these fictions compel us to slip into the situa- tions they represent. Unlike other literary forms, works of fiction are structured in ways that encourage readers or viewers to pro- ject themselves imaginatively into the text. Fictions transport us into the worlds they create, encouraging us not only to feel as if we are present to the actions taking place, but also to identify with individual characters. This involvement yields unique heuristic effects.

First, fiction offers readers or viewers a fuller understanding of the reality represented by getting them inside it. Our imagi- native involvement with fiction makes the situations depicted "available as it were from within, on the most intimate footing."[6] By prompting our imaginative identification, fictions afford us "a sense of what it is like to feel, see, and live in a certain way" (*TCS*, 84). This imaginative identification provides a more inti- mate understanding than we would achieve without it. Susan Feagin agrees, asserting that fiction promotes simulation, a process that provides a fuller understanding than the memo- rization of propositional information. She argues that when we engage imaginatively with a fiction we intellectually and affec-

[5] An example from *The Simpsons* that illustrates fiction's ability to educate our emotions occurs in the episode titled, "The Raging Abe Simpson and his Grumbling Grandson." At the end of this episode, viewers' hearts are warmed when Bart hugs his grandfather publicly. Though Grandpa Simpson thinks Bart will be too embarrassed to hug him in public and Bart does become self- conscious during the hug, initially Bart doesn't have any reservations about showing his affection in this way. Indeed, Bart declares that he doesn't care who knows he loves his grandpa. While we often temper our behavior in order to achieve a certain appearance, our satisfaction with Bart's action reminds us that concerns about appearances should take a backseat to earnest expressions of feeling.

[6] Flint Schier, "Tragedy and the Community of Sentiment in Philosophy and Fiction" (Aberdeen: Aberbeen University Press, 1983), p. 84. Subsequent ref- erences to this work will be indicated in parentheses accompanied by *TCS* and a page number.

tively simulate what it would be like to be in the situation represented. Because it forces the individual to shed her conventional orientation and try on another, Feagin contends that simulation "enriches and deepens [one's] understanding of the represented situation and makes one better able to deal with a situation that bears similarity to it."[7] Simulation educates by disclosing to the individual who practices it "what it is like to be such a person or to be in a certain situation" (*RF*, 112). It supplements the more superficial outsider's perspective obtained from being told a story with the more in-depth insider's one obtained through identification.[8]

The process of identification that fiction encourages has a second benefit. It gives us access to experiences that would not be available under normal empirical conditions. Through our identification with fictional characters, we can experience situations and perspectives that we could not access otherwise. By encouraging us to slip into the characters and worlds it represents, fiction helps us glean an understanding of what it would be like to live in other times and places, hold different beliefs, have different values, and be different people. As Nussbaum states, "our experience is, without fiction, too confined and too parochial. Literature extends it, making us reflect and feel about what might otherwise be too distant for feeling" (*LK*, 47). Wayne Booth agrees, stating, "in a month of reading, I can try out more lives than I could test in a lifetime."[9] By encouraging imaginative identification, fiction gives individuals the opportunity to explore a greater range of experiences than are actually avail-

[7] Susan Feagin, *Reading with Feeling* (Ithaca: Cornell University Press, 1996), p. 98. Subsequent references to this work will be made in parentheses accompanied by *RF* and a page number.

[8] The benefit of fiction lies in its ability to provide readers or viewers with both the insider's and outsider's perspective. We all know from our own experience that the insider's view is not necessarily the clearest. Sometimes we're too close to things to see them objectively. At the same time however, the outsider's or observer's perspective is not always sufficient. Fiction gives individuals a luxury that they do not tend to have in life, namely the luxury of having access to both the insider's and the observer's point of view.

[9] Wayne Booth, *The Company We Keep: An Ethics of Fiction* (Berkeley: University of California Press, 1988), p. 485. Subsequent references to this work will be indicated in parentheses accompanied by *CWK* and a page number.

able. These vicarious experiences are instructive insofar as they shift people out of their conventional perspective, compelling a more genuine appreciation of alternative outlooks, contexts, and ways of being.

The vicarious experiences we have in relation to fiction are also instructive in that they offer a medium with which people can more adequately assess alternative attitudes, courses of action, and the consequences of each. While not without risk, this opportunity to test out outlooks and actions is of unique cognitive value because it is relatively safe. Through identification with fictional characters we can find out what it is like to do or believe certain things without actually doing or believing them. In this way, fictions can help inform our decision-making by giving us an experiential sense of the effects of particular choices before we actually make those choices and experience those effects.[10]

Lastly, our identification with fictional characters educates us emotionally. One of the things our identification with fictional characters does is elicit emotion. Gregory Currie describes our relationship to fictional characters as an "empathetic re-enactment"[11] wherein readers or viewers simulate the emotional and intellectual states of particular characters. In addition to giving people the positive opportunity to vent emotions,[12] this re-enactment also educates individuals about themselves and others. It can increase an individual's degree of self-knowledge by disclosing sensitivities or opinions that she was unaware of having.[13] Though not always pleasant, such knowledge is essential

[10] Admittedly, the perception gleaned is virtual not actual. Thus, its accuracy cannot be guaranteed. However, having the opportunity to evaluate an action or situation in fiction that bears similarity to an action or situation one is entertaining seems preferable to not having that opportunity.

[11] Gregory Currie, "The Moral Psychology of Fiction," *Australasian Journal of Philosophy,* 73:2 (1995), p. 256. Subsequent references to this work will be made in parentheses accompanied by *MPF* and a page number.

[12] Here, I am referring in more common terminology to the process of *katharsis,* or purgation of negative emotion, that fiction can prompt. Figures like Aristotle stress that the kathartic venting of emotion that fiction often encourages is one of its most positive effects because it provides a safe venue for the expression of disagreeable or destructive emotions.

[13] For example, while reading a novel or watching a film I might have a powerful reaction to a character, a reaction I find surprising because I did not

to self-understanding and informed agency. Identification also contributes to the generation of genuine understanding of, and compassion for, others. Only by slipping imaginatively into the shoes of others do we become truly appreciative of the agony of their conflicts, the depth of their joys, and the weight of their losses. By encouraging individuals to identify with characters, fictions encourage not only the admirable activity of sympathy, but also the morally relevant ability to empathize.

Philosophers have been reluctant to admit that fictions can educate because of the paradox associated with them (e.g., how could one obtain information of real worth from works that are, by definition, about things that are not real?). However, learning from fiction only generates a paradox if one draws a radical line of demarcation between fiction and reality. If one sees fiction as a creative endeavor that is grounded in the real and draws all its material from it, the idea that fiction can educate is unproblematic. Fictions sketch hypotheticals. Their illustrations can inform us because the places and problems of which they speak resemble our own.

While it may not be paradoxical that we learn from fiction, there is something paradoxical about our relationship to it. Indeed, I contend that fiction's heuristic ability issues largely from the paradoxical nature of our engagement to it. One has to reflect only momentarily to recognize the paradox. As much as fiction draws us in, it keeps us out. Though fictions encourage us to identify with particular characters and project ourselves imaginatively into their worlds, we can never be those characters or enter those worlds. Likewise, while our engagement with fiction arouses real emotions, we cannot do the same things with the emotional responses we have to fiction that we do with the ones we have in response to real people and situations. Because they are not real, the relationships we have to the characters and situations represented in fiction are qualitatively different from the ones we have with real people and events. The fact that the characters and situations in fiction are not real at once facilitates and frustrates our engagement with them.

expect to feel so strongly. The solicitation of this strong feeling can serve as a catalyst for reflection. Specifically, in an effort to discern the basis for my reaction, I reflect carefully upon the fictional circumstances that generated it, perhaps uncovering a belief or feeling I did not know I had.

The fact that characters and contexts depicted in fictions are not real facilitates readers or viewers imaginative involvement because it gives them a sense of safety. When we project ourselves imaginatively into fictions we can operate without consequence and be intimate without risk. We enter worlds we can abandon if the going gets tough. Without requiring us to move off the couch, our engagements with fiction allow us to explore different worlds and adopt different personas. We slip into fictions easily because they do not have the weight of being real. Though we know they can affect us, we relish letting ourselves go with fictions because we know that the characters and events they depict aren't real, our immersion in their virtual worlds is not permanent,[14] and our identification with their characters is not complete. Because of the safety the form affords us, we allow ourselves to experience things in fiction that we could not, or would not, in actuality. Fiction thus expands our knowledge base by letting us learn from experiences we would not have in real life.

At the same time that fiction invites our involvement, the fictionality of the characters and events it represents frustrates our habitual modes of response. For example, even if we sense something is amiss in a fictional situation, we know we cannot change it. Similarly, if the picture of the world offered by a fiction does not correspond to our own, we are not at liberty to alter it. While we enter fictions imaginatively, we cannot change them. We can stop reading or watching but we cannot adjust a work to suit our wants. Likewise, when we respond emotionally to fictions, the fictionality of the characters and events prevents us from acting upon our emotions the way we do normally. The fictionality of the characters and events frustrates my habitual responses, forcing me to examine why I am so affected by something that is not real.

The inalterability of the characters and contexts of fiction, the fact that we can become immersed in them but not alter them, prompts us to reflect. The way fiction frustrates our engagement with it is central to its heuristic function. It is central because it

[14] What is horrifying—or "harsh"—about the virtual worlds depicted in works like *The Matrix* and *Harsh Realm* is that characters either cannot, or typically do not, escape from them.

is this thwarting of habitual response that prompts readers or viewers to reflect on the fiction, assess the fictional world and its characters critically, and compare a particular fictional rendition to other fictional or actual ones. It prompts readers or viewers to contemplate the message of the representation. It prompts them to ponder their affective responses and the fictional circumstances that generated them. Such reflective activities can yield greater general understanding as well as moral improvement.

Ultimately, fiction has the unique ability to let us inside the characters and situations it represents without ever letting us forget our separateness from them. It generates what can be called frustrated identification. Our identification with fictional characters is instructive because it lets us experience a wealth of different periods, perspectives, and situations vicariously. Our assimilation of the information our identification provides is then facilitated by our differentiation from characters. Specifically, insofar as we know we are not the fictional characters with whom we identify, they remain objects to be analyzed, objects from which we have a critical distance, objects we are likely to view with less bias than we do ourselves. It is fiction's simultaneous promotion of identification and dissociation, of intimacy and difference, that allows it to educate us so well. Where we are often too close to ourselves and our situation to see clearly, our ever-present knowledge that the characters and situations represented in fiction are separate from us allows us to view them with greater impartiality. However, because the process of identification helps reveal how characters are like us, it can increase our self-understanding by prompting us to recognize that our situation, general attitudes, or habitual reactions are comparable to that of a specific fictional character.

Enough *&!#?@ Already!
What About Homer?

Ultimately, *The Simpsons* operates like other fictions in the way it draws our attention to individuals and both depicts and solicits emotion. Interestingly however, it is *The Simpsons'* combination of several other features, features that may incline some people against the show, that augment its educational effect.

The first feature is the ordinariness of the characters and set-
ting of the show. While extremely caricatured, the characters and
context of *The Simpsons* are undeniably average. Homer is the
somewhat dim but endearing working class father. He's not the
idealized figure of *Father Knows Best* or *Leave It to Beaver.*
Instead, he's the dysfunctional dad who drinks cheap beer and
burps intermittently and unapologetically while complaining
about work. Marge is the exasperated housewife who runs inter-
ference between Homer and the kids, admonishes family mem-
bers for their frequent scrapes, and consoles Homer unfailingly
despite his sometimes absurd behavior. Homer's and Marge's chil-
dren, Bart, Lisa, and Maggie, each exemplify the individuality,
ingenuity, and egoism of your average kid. Moreover, their rela-
tionships with one another illustrate all the conflict, conniving,
and competition that occurs in normal sibling relations. Finally,
the setting of Springfield and the Simpson family home are alike
in their innocuous averageness. It's not a scene out of *Lifestyles of
the Rich and Famous,* or the pampered setting of *Beverly Hills
90210.* Instead, *The Simpsons* presents us with the station wagon
in the driveway, dirty dishes in the sink, middle-class suburban
environment with which so many of us are familiar.

Though familiar to most, the commonplace quality of *The
Simpsons'* characters and setting may lead some to conclude that
the show has little to offer educationally speaking. People may
question whether important truths could issue from such a
pedestrian context. Of course, if truths cannot be ordinary, then
The Simpsons might not offer much. However, it seems that
oftentimes it is the ordinary truths that elude us.[15] Though it
exaggerates things in order to achieve its satirous effect, *The
Simpsons* isn't far off the mark in its rendering of contemporary
suburban life.[16] The bickering between Homer and Marge, Bart's
mantra, "I didn't do it!," Lisa's know-it-allness, the petty conflicts
between neighbors, Homer's perpetual disenchantment with his

[15] In *Being and Time* (New York: Harper and Row, 1962), German philoso-
pher Martin Heidegger demonstrates that what is the most immediate is not
always the best understood. Heidegger reveals that we are often the most con-
fused about what is closest to us, including who and how we are.

[16] Arguably, the effect of satire cannot be accomplished without such accu-
racy. People must recognize what is being satirized in order for the effect to
be achieved.

job, the characters' predictability coupled with their capacity to surprise, these all ring true. While these truths aren't particularly elevated, they resonate with viewers, reminding them of ubiquitous nature of such phenomena.

Ultimately, viewers' recognition of the omnipresence of certain aspects of ordinary life is facilitated by the commonplace quality of the characters and contexts of *The Simpsons*. The show's characters and setting are ones with which most viewers can easily identify. For example, though we might not act like him, we can empathize with Homer's irascibility and imprudence. Likewise, most viewers can relate to Marge's practicality and maternal forbearance as well as her tendency to remain passive until a situation escalates to a point where it positively demands her intervention. Rather than representing people with whom we have little in common, individuals whose experience may seem too foreign to be relevant, *The Simpsons* presents us with caricatures of ourselves. It depicts individuals who—like us—possess both serious flaws and admirable qualities. We can learn from these farcical figures because our ready identification with them, coupled with our recognition of their qualities, encourages us to admit that we possess some of the same tendencies that they do. Moreover, things like identifying vicariously with Homer's escapades afford both a safe indulgence of our impetuous and often vengeful desires, and an object lesson in the dangers of such caprice.[17]

The second feature of *The Simpsons* that contributes to its heuristic value is its humor. You don't have to watch *The Simpsons* for very long to appreciate its levity. It combines slapstick comedy seamlessly with sophisticated humor, creating a complex comic fabric that appeals to a diverse audience. While the genre of comedy may be unrivaled in its capacity to entertain, people have doubted its ability to instruct more than any other literary form. Perhaps because it isn't serious, comedy hasn't been taken as seriously as other genres when it comes to the question of education. This is unfortunate. While there is always

[17] While we may relish Homer's indignant attitude and absolute lack of concern for consequence when he does things like throw his boss out a window, given that Homer's schemes usually back-fire and leave him looking stupid, Homer typically illustrates what not to do in a similar situation.

a place for seriousness, comedy is a tremendous pedagogical tool. Indeed, by displacing certain anxieties and disabling habitual resistances, comedy can bring to light things that might otherwise be too uncomfortable to acknowledge. For example, not many of us like to admit that we suffer from paranoia or the fits of idiocy that it can prompt. However, we find Homer funny in large part because he manifests these tendencies so unabashedly. We laugh at Homer because we see some of ourselves in him. In laughing at him, we learn a little more about ourselves.

Comedy is also beneficial because it allows for the examination of serious—but often disconcerting—subjects in a more comfortable forum. Among other things, *The Simpsons* has addressed pertinent subjects like racism, gender relations, public policy, and environmentalism. Unfortunately, formal discussions of these topics often end up in shouting matches or soap-boxing. Most people aren't especially interested in hearing either one. Comedy is a useful way to broach such difficult subjects because it diffuses some of the tension that surrounds them. In most cases, comedy can direct people's attention to a topic, and even offer opinions about it, without inciting too much antagonism or appearing too heavy-handed.[18] Where people might tune out other mediums, their openness to comedy and the pleasures it provides allows it to prompt their consideration of subjects they might otherwise resist. Whether it be legalized gambling ("$pringfield,"), allowing women to enroll in military academies ("The Secret War of Lisa Simpson"), or animal rights ("Lisa the Vegetarian"), *The Simpsons* has certainly compelled many Americans to think more deeply about such topics.

A third feature of *The Simpsons* that aids its ability to instruct is its animated medium. Like the genre of comedy, the medium of animation has not been taken as seriously as mediums like film and verse. Perhaps because it reminds us of our childhood and Saturday mornings in front of the TV, we tend to see the medium of animation as unsophisticated. These associations

[18] Though there are exceptions, comedy tends not to seem too heavy-handed because it's comedy. By its nature, it lacks the sobriety of other mediums. Even when it is deadly serious, its style lightens the load, allowing it to convey content that might otherwise be met with opposition.

may lead us to dismiss animated works from the class of fictions we think can provide heuristic benefits. This would be a mistake. While not all cartoons are equal (or educational), the form itself is instructive. Ultimately, the form of animation offers an explicit reminder to the reader or viewer of the fictionality of the characters and situations it depicts. One simply isn't going to mistake a cartoon character for a real one. Through their form, animated works offer us a powerful reminder that we are not the characters with whom we identify. As a result, such works are more decisive in encouraging our reflection about the characters they describe, the situations they depict, and the feelings and thoughts they elicit.

The final feature of *The Simpsons* that needs to be addressed is its mass appeal. Like the previous attributes, the broad appeal of *The Simpsons* might lead some to doubt its heuristic value. This doubt is grounded in the widespread assumption that popular works cannot educate. Conveniently forgetting that literary icons like Shakespeare and Dickens were popular authors, intellectuals often attempt to secure the ivory tower by claiming that popular works are didactically vacuous and derive their popularity solely from their appeal to the vulgar tastes of the masses. While this criticism may apply to a variety of popular works, the wholesale dismissal of a class of fiction is not only inadvisable, it is illogical.[19]

The mass appeal of *The Simpsons* should not lead us to deny its heuristic significance, it should compel us to consider it more carefully. Unlike more elite—and typically more revered—forms of fiction, *The Simpsons* influences an extraordinarily large and diverse audience. Not only can it convey important truths and prompt the consideration of salient issues, it can offer these truths to, and compel increased reflection in, a huge number of people. While *The Simpsons* may not be heuristically superior to Tolstoy, its heuristic effects ought to be considered due to its wide appeal.[20]

[19] Just as it is illogical to conclude that all people love chocolate because some people do, one cannot conclude that all popular fictions are vacuous because some of them are.

[20] Also important is the consideration of negative effects that might result from exposure to *The Simpsons* and other popular fictions. Because of their range of influence, we must seriously consider the potential that popular fictions

Ultimately, a wise person is one who recognizes that she can learn something from virtually every experience. Unfortunately, we are not always very wise. Rather than open ourselves to what individual experiences can offer, we often inhibit the learning process by prejudging certain experiences as cognitively irrelevant. While we take things from these experiences nonetheless,[21] we do not let ourselves learn much as we might from experiences we do not regard as educational. With this essay, I have tried to show that opportunities for learning exist in the largely unforeseen context of popular fiction. Specifically, I have suggested that we can learn from *The Simpsons*. In drawing attention to *The Simpsons* I do not mean to suggest that this fiction is formally or functionally superior to classic works like those of Shakespeare or Sophocles. I do not believe it is. I simply want to draw readers' attention to an opportunity they have to learn from a Homer they might have overlooked.[22]

have to generate negative effects. Individuals should be made aware of the effects that reading or viewing fiction can have so that they can be discriminating in their selection, and critical in their appropriation, of such works. Presently, the assumption, "It's just fiction!" thwarts most concern about fiction's influence. However, we could make better use of what fiction has to offer and be less vulnerable to untoward effects if we recognize the actual influence it exerts.

[21] As discussed previously, fiction affects us whether we know it or not. For example, the process of reading fiction encourages shifts in our patterns of attention whether or not we recognize that these shifts have taken place. It instructs us to be more attentive to details. This increased attention can certainly be beneficial. However, this is not the only positive effect fiction can have. Other effects require greater receptiveness on the part of the individual. For example, if one chooses to view the story about the hare and the tortoise as just an entertaining tale about animals, it is likely that this is all that it will be. However, if one is open to the idea that the story can both entertain and instruct—as children are—it serves both functions. Here, I am simply trying to draw attention to how our attitudes can inhibit our acquisition of knowledge.

[22] Special thanks to B. Steve Csaki for his help in the preparation of this essay as well as to Dr. Carolyn Korsmeyer, Dr. James Lawler, Dr. Kah-Kyung Cho, and Dr. Kenneth Inada for their help in the preparation of my dissertation, the work from which much of this essay derives.

The Simpsons and the Philosophers

16

A (Karl, not Groucho) Marxist in Springfield

JAMES M. WALLACE

"Humor," E.B. White warned, "can be dissected, as a frog can, but the thing dies in the process and the innards are discouraging to any but the pure scientific mind."[1] A Marxist dissection, performed by the dour scientific socialist, is almost certain to kill the humor in any joke as it lays bare the ugly entrails of ideology in the body of bourgeois comedy. "Reds are such glum, serious people," Tommy Crickshaw (Bill Murray) remarks in *Cradle Will Rock*. He's probably right.

It's not that Marxists don't enjoy a good joke; Marx himself tried his hand at writing comedy, most notably a novel in the style of *Tristram Shandy*. But humor presents a difficult challenge for anyone concerned with justice and equity: what's so funny, after all, in a country where five percent of the people control ninety-five percent of the wealth? Is it a betrayal of Marxist principles to know that 20 workers are murdered and 18,000 assaulted each week at their jobs in the United States and to laugh anyway when Apu, the bullet-scarred convenience store owner, tells Homer, "I won't lie to you. On this job you will be shot at"? Perhaps *The Simpsons'* Rabbi Krustofsky is right: "Life is not fun; life is serious."

[1] E.B. White, "Some Remarks on Humor." In *The Second Tree from the Corner* (New York: Harper, 1954), p. 174.

But *The Simpsons* is fun, and the comedy pulls in so many different directions—the "something for everyone" phenomenon—that it may be impossible to watch and not laugh despite your political or economic point of view. And given that the show is often touted as "subversive," we might expect it especially to appeal to anyone critical of prevailing ideologies and interested in how art might be used to shake the foundations of social power. Recognizing that humor can be very subjective and that an analysis will dampen the comedy just a bit, let's consider how *The Simpsons* accomplishes the comic subversion for which it is so well known.

Thoughtful Laughter

The show could be used in a comedy seminar to define one of the most fundamental notions of what makes something funny—incongruity. We tend to laugh hardest at the linking together of ordinarily incompatible elements, the yoking of ideas, images, feelings, and beliefs that we normally keep separate in our minds, the disruption of what we consider usual and conventional, and the thwarting of expectations, or, in Kant's words, "a strained expectation being suddenly reduced to nothing":[2]

> HOMER: "Oh, my God. Space aliens! Don't eat me! I have a wife and kids. Eat them!" ("Treehouse of Horror VII")

> HOMER: "Oh my God. I got so swept up in the scapegoating and fun of Proposition 24 [to deport illegal immigrants from Springfield], I never stopped to think it might affect someone I cared about. You know what, Apu? I am really, really gonna miss you." ("Much Apu About Nothing")

In both of these examples, the comedy derives from the difference between what we would expect someone to say in similar situations and what actually gets said. Our expectations depend, of course, on our being familiar with the conventions of behav-

[2] Immanuel Kant, *The Critique of Judgement,* trans. James Creed Meredith (New York: Oxford University Press, 1952), p. 199.

ior among fathers and friends. A father using his family to plead
for his life would normally, we assume, assert that his family
depends on him, not that they could substitute for him. When
the situation is reversed and the family is in danger, the father,
according to the conventional behavior of brave and noble
fathers, says "Take me instead." The usual and expected self-
lessness of a father is in one mental flash both linked to and
contradicted by Homer's selfish, but hilarious remark. The com-
edy depends, of course, on the "unreality" of art; a father who
literally sacrifices his children for his own survival is hardly
funny. To be sure, it might be said that a father betraying a son
in any context is not comical either, but in the realm of an art
that depends on comic incongruity and "shock," our assump-
tions and conventions are brought into relief with the result that
we are, perhaps for the first time, made conscious of them if we
pause momentarily to consider why we laughed. Subversion is
possible only after recognition, and *The Simpsons,* like all com-
edy based on incongruity, asks us to at least think about how
we normally see the world. In our "normal" view of the world,
fathers should be selfless, loyal providers committed at all costs
to the preservation of their families.

In the second example, Homer's epiphany is completely dis-
solved when he tells Apu he will "really, really miss" him. In
fact, his emphasis makes the line all the more comical since it
suggests that Homer really, really misses the contradiction
between, on the one hand, the sudden realization that he is
partly responsible for his friend's deportation and, on the other,
the kind gesture of telling Apu he'll miss him. In Homer's mind,
of course, there is no contradiction between these two senti-
ments: he's merely saying "I didn't realize you'd be leaving;
goodbye." But for viewers, brought up learning the conventions
of friendship and expecting the usual introspection and perhaps
apology that comes from someone who has just recognized his
complicity in a wrongful act, the line surprises. The joke would
not be funny in a society with values greatly different from our
own.

While the humor of the passage depends on our awareness
of conventional behavior and attitudes, the passage is funny on
another level as well since it points to some of the shortcomings
of "conventional" thought and behavior, which includes scape-

goating and stereotyping, forgetting that abstract political views have consequences for individuals, and failing to see the contradictions between our personal and public lives, all of which Homer is guilty of. In other words, Homer's complicated statement contains several insightful comments on social behavior and relationships, which we understand to be satirical comments since we recognize that a more perfect world would contain neither stereotyping, scapegoating, inconsistent behavior, and so forth. When Homer says, "I got so swept up in the scapegoating and fun . . .," we see it as comical because the conventional or common now clashes with the ideal, and we're surprised at the truth in Homer's comment. After all, people seldom so cavalierly admit to unethical behavior or illogical thinking. Homer's casual reference to a common practice that no one should be proud of is comical. As in all satire, an attack against the vice or shortcomings of humankind presupposes a better world where humans act according to the author's notions of what is right and proper. In this case, the incongruity serves to draw our attention to common human behavior (including, perhaps, our own) and to raise doubts about the appropriateness of that behavior. Such satire often challenges us to question "ordinary" practices, habits and perspectives and to reflect on how the world might be improved, in this case to eliminate stereotyping and scapegoating.

Because satire operates at a more intellectual level than, say, slapstick, it requires more from viewers who are expected, first, to understand what's being ridiculed and, second, to know what the ideal world is supposed to look like. Anyone familiar with Swift's "A Modest Proposal", one of the most ingenious satires ever written, knows the pitfalls of missing the satire and assuming that, in this case, Swift was honestly advocating eating Irish children rather than calling attention to how the English landlords had, metaphorically, "devoured" the Irish citizenry and land. The reader or viewer has to "get it," or the satire fails to make its point. All comedy makes demands of the reader, and satire perhaps more than any other form. George Meredith, Marx's contemporary and a leading novelist of the late Victorian age, believed with many writers of the period that literature, especially drama, should provide lessons regarding the social order and that comedies which evoked "thoughtful laughter"

could draw attention to humanity's foibles and contribute finally to the amelioration of social ills.[3] Aside from "A Modest Proposal" we might also consider from an earlier age Jonson's *Volpone* and "Vanity of Human Wishes," as well as, later, Byron's *Don Juan,* in a long list of memorable satires in this vein. While many modern theorists no longer believe that literature can or should correct society's problems, most comedies—even those on television—still follow the pattern of either reconstructing society according to a more humane blueprint, or, in the case of satire, pointing out the habits, vices, illusions, rituals, and arbitrary laws that impede movement toward a better world.

In the tradition of comedy, then, a subversive satire such as *The Simpsons* would aim—and apparently does aim—to expose the hypocrisy, pretense, excessive commercialism, gratuitous violence, and so forth that characterize modern society and to suggest that something better lies beyond. In Marxian terms, then, satirical comedy like *The Simpsons,* it might be argued, distances us momentarily from the prevailing *ideology* of capitalist America. The term *ideology,* as Michael Ryan defines it, "describes the beliefs, attitudes, and habits of feeling which a society inculcates in order to generate an automatic reproduction of its structuring premises. Ideology is what preserves social power in the absence of direct coercion."[4] In other words, the selflessness and loyalty we expect of fathers and the humility and contrition that we expect will follow from hurting our friends are part of ideology, as are the attitudes that lead to stereotyping and scapegoating and the values that support our current social relationships or economic conditions. The truly subversive satire, and especially one that, like *The Simpsons,* contains so much misdirection and incongruity, asks us to distance ourselves momentarily from ideology either to objectify the elements of that ideology (loyalty, humility, contrition) or to "laugh thoughtfully" at the beliefs, attitudes and habits of feeling that characterize modern society. Primarily, however, laughter— which requires intelligence, recognition and distance—would,

[3] George Meredith, *An Essay on Comedy and the Uses of the Comic Spirit* (New York: Scribners, 1897), p. 141.

[4] Michael Ryan, "Political Criticism," *Contemporary Literary Theory,* eds. Douglas Atkins and Laurie Morrow (Amherst: University of Massachusetts Press, 1989), p. 203.

for a Marxist, help an audience resist the inculcation of an ide-
ology intended "to generate an automatic reproduction of its
structuring premises" and "to preserve social power." The habits
of competition and of measuring the worth of individuals by
appearances, for example, ingrained in the capitalistic value sys-
tem, lead to stereotyping. The comic writer can draw our atten-
tion to these habits as habits, not as natural ways of acting and
believing, thereby encouraging us to resist them. *The Simpsons'*
many stereotypes could be seen, therefore, not as a malicious
depiction of ethnic groups, but as a caution against our ten-
dency to stereotype.

Unlike more traditional and "realistic" shows that reflect and
propagate ideology, *The Simpsons* offers us a chance to liberate
ourselves from it and from the "structuring premises"—such as
competition, consumerism, blind patriotism, excessive individu-
alism, and other assumptions—upon which capitalism is built.
In fact, because *The Simpsons* is a cartoon, its writers can do
things that producers of realistic television cannot do, which
allows them even more room to shatter the illusions of reality
and rattle viewers' belief that capitalism provides the only and
natural way of life. Shows that "imitate" life too closely give the
impression that the reality depicted is inescapable and natural.
It may not be too great a stretch, therefore, to suggest that *The
Simpsons* is a sort of Brechtian television show. Much in the
same way that Bertolt Brecht rejected the artificial elements of
drama—the unified plot, sympathetic characters, universal
themes—for techniques that "alienated" or distanced the audi-
ence, *The Simpsons* scrambles reality, keeping us on our intel-
lectual toes so that we avoid the stultifying habit of identifying
with characters and continue to assess the ideological content of
what we are seeing. The Marxist critic Pierre Macherey might
find in *The Simpsons* a prime example of "de-centered" art,
which scatters and disperses ideological content, effectively
revealing the limits of that ideology.

As just one example of *The Simpsons'* subversive challenges
to capitalist dogma, which is accomplished through incongruity,
the following exchange, which may be too good to sully with
analysis, is among the best in the series:

> LISA: If we don't get to the convention soon, all the good
> comics will be gone!

BART: Ah, what do you care about good comics? All you every buy is Casper the Wimpy Ghost.

LISA: I think it's sad that you equate friendliness with wimpiness, and I hope it'll keep you from ever achieving true popularity.

BART: [*showing comics of Casper and Richie Rich*] Well, you know what I think? I think Casper is the ghost of Richie Rich.

LISA: Hey, they do look alike!

BART: Wonder how Richie died.

LISA: Perhaps he realized how hollow the pursuit of money really is and took his own life.

MARGE: Kids, could you lighten up a little? ("Three Men and a Comic Book")

In a radical satire, especially one that contains an exchange like that or the unrelenting, biting portrayal of the evil Mr. Burns, one might expect a consistent undercutting and exposure of bourgeois ideology, a long line of barriers against the inculcation of repressive values. Unfortunately, it doesn't happen.

De Haut en Bas

Because political and social satire in a society built on capitalist values would almost by definition question those values, a Marxist should feel right at home on Evergreen Terrace. But that's apparently not the case. In fact, if in the public mind Marxism is synonymous with Communism (and obviously there is good reason to relate the two), many fans of *The Simpsons* will know that Marxists are not welcomed in Springfield. When *Itchy and Scratchy* moves to another show, Krusty is forced to substitute a cartoon featuring "Eastern Europe's favorite cat-and-mouse team, Worker and Parasite," a gloomy and boring look at the exploitation of the working class that immediately clears Krusty's television studio. In "Brother From the Same Planet," a recruiter from the Springfield Communist Party addressees the crowd before the start of a football game. Unfortunately for the decrepit old recruiter, it's "Tomato Day," and the crowd pelts the recruiter with their free tomatoes. In "Homer the Great," Grampa

Abe Simpson searches his wallet for proof that he's a member of the fraternal organization, The Stonecutters:

> ABE: Oh, sure. Let's see . . . [*going through his wallet*] . . . I'm an Elk, a Mason, a Communist. I'm the president of the Gay and Lesbian Alliance for some reason. Ah, here it is— The Stonecutters.

Apparently the Communist Party has hoodwinked another confused old man into signing up, or perhaps the point is that Communism is an old and feeble system, the demise of which everyone, including the members of Spinal Tap, celebrates:

> DEREK: I can't think of anyone who's benefited more from the death of Communism than us.
>
> NIGEL: Oh, maybe the people who actually live in the Communist countries.
>
> DEREK: Oh yeah, I hadn't thought of that. ("The Otto Show")

While that spoilsport Karl Marx may not be welcomed in Springfield, Groucho Marx has been spotted in several episodes, either in person (in the crowd around Dr. Hibbert in "Boy Scoutz 'N the Hood") or in paraphrase in—of all episodes!— "Scenes from the Class Struggle in Springfield." Marge, finally realizing that she has alienated her family in her attempt to be accepted as a member at the local country club, rejects the country club set with a version of Groucho's famous line. "I wouldn't want to join any club that would have *this* me as a member," Marge declares. The allusion is certainly warranted since the Marx brothers made a living exposing the pretensions and hypocrisy of high society. But the *paraphrase* is truly brilliant. While Groucho was sarcastically renouncing organizations with standards low enough to admit him, Marge is rejecting one whose standards allow only "this" Marge, the one who has spent her savings on an impressive dress, parked the car out of sight, and aggressively ordered her family to suspend their normal behaviors and to "just be good." It's not a version of Marge she's comfortable with, and she renounces an ideology that would force her to sacrifice her true identity, her true essence. Groucho, no stranger to subversion but certainly no Marxist,

supplies the inspiration for Marge's triumphant renunciation of the snobbish country clubbers; and, even though Karl's ilk are banned from town, she shows a true Marxist sensibility when she asserts her freedom from a repressive ideology.

But for a Marxist reader there is something disturbing about the final scene in "The Class Struggle in Springfield." While the upper class has been soundly lampooned, the episode ends with the Simpson brood back in their place, the more familiar surroundings of the Krusty Burger:

> PIMPLE-FACED KID: [*mopping the floor*] Hey, did you guys just come from the prom?
>
> BART: Sort of.
>
> MARGE: But, you know, we realized we're more comfortable in a place like this.
>
> PIMPLE-FACED KID: Man, you're crazy. This place is a dump!

While the family wisely turned its back on the cruel and insincere members of the country club ("I hope she didn't take my attempt to destroy her too seriously," one of them says of Marge), the Simpson family's defiance against the propertied and golfing class seems impotent and ineffectual. In fact, the infirmity of their protest had been foreshadowed earlier in the episode when Lisa, seeing Kent Brockman's daughter huff at a waiter who brings her a baloney sandwich rather than abalone (which she insists she asked for), is incensed but immediately becomes distracted at the sight of a man riding a pony, her favorite animal. Later she is seen riding a pony; "Look, Mom," she yells, "I found something more fun than complaining."

If Lisa's tirade against insolence and the mistreatment of employees is nothing more than "complaining" and if she can be silenced by a pony, what are we to make of her superb comment later in the episode when she approaches the initiation dinner at the club ("I'm going to ask people if they know their servants' last names, or in the case of butlers, their first") or her astounding Richie Rich comment or any of the ideology-pricking comments she's made over the years? Certainly, as a little girl, Lisa can be easily distracted by a favorite animal, so perhaps we shouldn't make too much of her vacillation. But the episode is indicative of the show's constant undercutting of what comes

precariously close at times to a left-leaning worldview, or to any political stance for that matter, as if the writers were careful at every step to avoid what could be seen as a consistent political or social statement. What might have been at least a thorough skewering of the moneyed class becomes a defeat for the Simpson family's class, the "upper-lower-middle class," as Homer describes it ("The Springfield Connection")—that group of people who, though they may not be the factory workers and miners of the proletariat, must worry about where the money comes from and how it gets spent. At the end of "The Class Struggle in Springfield," order is restored at the expense of the Simpsons, who return to their proper place, the "dump" where they have learned to live "comfortably." It's not clear at the end who, exactly, is the target of the satire or what better world lies outside the context of the struggle between one class and another. With the writers' attitude toward Marxism, perhaps the whole notion of class struggle is being ridiculed. In any case, despite the occasional jab, usually from Lisa, at capitalism's destructive tendencies, it's Marge's own bourgeois ideology that accounts for her being "comfortable" in a dump like the Krusty Burger. She came close to a revolutionary moment, but she's fallen back to a conditioned and quiet acceptance of things as they are.

The show's subversive label has started to fade, unless of course we are meant to sympathize with the Simpsons in the final scene. Engels himself noted in an often-cited letter to a young writer that an author "does not have to serve the reader on a platter the future historical resolution of the social conflicts which he describes."[5] Readers—or in this case, viewers—can do some of the work themselves. But the writers of *The Simpsons* seem to have taken pains to avoid earning our sympathy for the family or for anyone who suffers or endures. In their apparent refusal to pick a side, ridicule is equally distributed among the powerful and the helpless. While Groucho's banana peels were placed squarely under the heels of the affluent, the pretentious academics, the corrupt politicians, *The Simpsons'* are placed there *and* everywhere else, so that immigrants, women, the

[5] Frederick Engels, Letter to Minna Kautsky. In *Marx and Engels on Literature and Art* (Moscow: Progress Publishers, 1976), p. 88.

elderly, Southerners, homosexuals, the overweight, the studious, the politically committed, and every other marginalized or maligned group take as hard a tumble as the evil captains of industry. No one seems safe from derision or ridicule.

Take the portrait of workers, for example. Lisa's comment aside, we might expect those writers who lampooned the golf crowd to then side with the workers, not an unreasonable assumption given the dismissal of the former group. Throughout *The Simpsons,* no such sympathy or empathy is extended; indeed the portrait of workers suggests that for the writers and producers of this show, subversion does not include rebelling against unfair labor practices or struggling to improve the condition of the working class. In "Last Exit to Springfield," the union (the "Brotherhood of Jazz Dancers, Pastry Chefs, and Nuclear Technicians"), led by workers Lenny and Carl (Lenin and Marx?) don't give a moment's thought before trading their union's dental plan for the promise of a keg of beer at every union meeting. A strike ensues, and although the union wins back the plan by the show's end, it does so only through the stupidity of both Mr. Burns *and* union president Homer. In another show about striking employees, teachers carry picket signs reading "A is for Apple, B is for Raise," and "Gimme, Gimme, Gimme." The theme of the Springfield Auto Show is "We salute the American worker—now 61 percent drug free." Many of the characters are defined and identified by their occupations, and it's hard to think of any, beside Frank Grimes (and he was dispatched in short order), who isn't a bungler, a loser, inept, crooked, lazy, sycophantic, uneducated, unethical, criminal, or just plain dumb, Homer, of course, being the obvious example. In one memorable episode, Homer saves the Shelbyville Nuclear Power Plant from meltdown by choosing the correct button in a game of eenie-meenie.

It's almost impossible with such a free-floating, top-to-bottom attack to know precisely what *The Simpsons* is intended to satirize. It's as if Jonathan Swift, having shamed the English for devouring the Irish poor, had turned his contempt on the poor themselves. Because the target is so ill-defined or so all-encompassing, viewers have in individual episodes apparently missed the intended point. When the Catholic Church took offense to a parody of Super Bowl commercials, the show's executive producer revised a key line in re-runs of the episode. The pressure

to rewrite hints at the corporate control over even supposedly subversive shows, but it also points to the fact that in a satire with no vision of what the world should be, *re*vision is easily accomplished. The show has targeted pretty much anything its sponsors and its audience will let it get away with. Everything is fair game.

Without some core value, some vision of what a better world might look like, *The Simpsons* does little more than string together isolated and transitory comical moments that in the aggregate add up to no discernible, consistent political point of view, let alone a subversive one. In fact, because episodes like "The Class Struggle in Springfield" end with a restoration of the social order, with the country club set happily in their place and Marge's family content in their dump, the show subverts its own subversion and merely propagates rather than tears down the very institutions and social relationships it supposedly attacks. Class antagonisms, exploited for the humor, are merely propped back up. While the jokes, taken individually, can be exceptionally funny—incongruous, surprising, challenging— taken together in the totality of *The Simpsons,* they add up only to a view that is at once nihilistic (everything is a target) and conservative (the traditional social order endures). The satire collapses in a shower of individual jokes, and we are left with what we had to start with—a world of exploitation and struggle. The emphasis is clearly on *the joke,* on the one-liner, the comical juxtaposition, the occasional shocking truism in the mouth of a child. But the greater concerns, such as a consistent political or social philosophy, are ignored. When Homer utters one of the most memorable lines in the entire series during a quarrel between his daughter and an Albanian exchange student—

> Please, please, kids, stop fighting. Maybe Lisa's right about America being the land of opportunity and maybe Adil has a point about the machinery of capitalism being oiled with the blood of workers. ("Crepes of Wrath")

we're left wondering how we should respond. Can we take anything Homer says seriously, or is this just another witty remark in a show filled with witty remarks? Does Homer's insight have the same weight as some of his other comments?

Aw, Dad, you've done a lot of great things, but you're a very old man, and old people are useless. ("Homer the Vigilant")

"Lisa, if you don't like your job, you don't strike. You just go in every day and do it really half-assed. That's the American way." ("The PTA Disbands")

Most viewers would know that a wise, sensitive and dialectically minded character might voice the first sentiment as a mark of universal understanding, but the same character could not utter the second and third. The inconsistency in Homer's character makes him nothing more than a conduit for the writers' lines. Each joke is funny in its own small context, but taken together, the individual jokes amount to very little either in terms of a vision for improvement or in terms of art that accurately reflects the truth of how people live and act. Certainly *The Simpsons* is not realistic television, but an audience has no way of identifying with a character who, to save a good line for the writers, becomes even less human and more chameleon. In this case, the writers' sole claim to subversion is to subvert characterization. Only the joke survives. Nothing is really all that important. The kids have lightened up. To paraphrase Marx, all that is solid melts into laughter.

It Gets Worse

While *The Simpsons*—unlike traditional satire—hints at no concept of a better world, it can perhaps be viewed from a Marxist perspective as an accurate reflection of life in America at the turn of the millennium. Rather than challenge the prevailing ideology, *The Simpsons,* like all cultural products, develops from and *reflects* the material and historical conditions of the age in which it was created; reflects, in other words, the ideology of capitalism in late twentieth-century America. That the series in its entirety ultimately embodies an ideology rather than disrupts it is especially supported by the fact that this television series is produced not by a single individual writer, although one person does most of the writing for each episode, but by a team of at least sixteen writers and many other workers. Because consistency and continuity are difficult for even a single writer working on a single text, it's surprising that *The Simpsons* is as

uniform as it is. But with so many minds at work on the show, it can be assumed that the series reveals not the genius and vision of one person, but the labor of a collective body creating a show in accordance with the viewpoint of one person (Matt Groening) and intended for mass consumption by a public attuned to staccato images, disjointed themes and fragments of meaning.

In fact, as the high water mark of postmodern television, this stew of literary references, cultural allusions, self-reflexive parody, shotgun humor, and absurdly ironic situations is the inevitable result and perfect depiction of the fragmented, disjointed, contradictory world of capitalism, where wholeness and consistency are replaced by increasing disparity not just between the "haves" and "have nots," but between the social and the individual, the public and private, family and work, the general and the particular, the ideal and the concrete, word and deed; and where "rebellion" and "revolution" are used to sell Dodge trucks, promote the Oprah Winfrey show or drum up membership in the Republican Party. In *The Simpsons,* as under capitalism, all opposition is absorbed, and criticism is co-opted. Janis Joplin now *sells* Mercedes Benz, and the Comic Book Guy writes to the producers of *Itchy and Scratchy* in mockery of Internet users who critique *The Simpsons*. In *The Simpsons* everything is up for laughs; under capitalism everything is up for sale.

If the show is seen to manifest capitalist ideology, then, the vacillating attitude toward workers in *The Simpsons* might reflect the ambiguous attitude toward workers under capitalism, which professes to respect the individuality of every human being but strips workers of their individuality through alienating work. Perhaps the objectifying of characters who become stereotypes and mouthpieces for jokes can be seen as a reflection of capitalism's tendency to reduce social relations to the quality of objects. Although some Marxist critics such as Georg Lukács, and perhaps even Marx and Engels themselves, might reject *The Simpsons* for the unrealistic nature of its characters who are little more than abstract impersonation of real beings, it might be argued that the show is a more accurate depiction of the capitalist ideology, in which human beings matter less for their individual qualities than what they can be used for.

For a Marxist in a good mood, then, *The Simpsons* could be seen as the creative embodiment of a particular ideology, so that laughing at the show would be a way of laughing at the contradictions of capitalism. But, of course, that's not why people are laughing. Such an interpretation requires an audience attuned to Marxist criticism and predisposed to see capitalism as a flawed and alienating system. In fact the opposite appears to be true. *The Simpsons* is most often praised in such places as *Time, The Christian Science Monitor, The New York Times, National Review,* and *The American Enterprise* as a show that celebrates the American family, "who stick with one another through thick and thin"[6] or "love one another, no matter what,"[7] or that presents characters who, in their bungling attempts to endure, are ones we can all identify with, or that extols American values such as rebellion. It's tempting to suggest that these writers have missed the point of *The Simpsons,* or to say that of course the family endures else there's no show next week, or that Bart's rebellion is the kind of safe pestering that the ruling class tolerates as a safety valve to prevent more serious rebellion. But these writers are actually on the mark: *The Simpsons*—despite its barbs at commercialism and corporations—not only reflects, but conserves and propagates a traditional bourgeois ideology. And its success must be considered at least partly responsible for the trend in television sitcoms and cartoons toward focusing less on character development and satire and more on one-liners and often mean-spirited humor that includes no hope for progress.

The popularity of *The Simpsons* and its acceptance by conservative critics, finally, proves just how content we are with the ideology of modern America. When Monty Burns says,

> Listen, Spielbergo, [Oskar] Schindler and I are like peas in a pod: we're both factory owners, we both made shells for the Nazis, but mine worked, dammit! ("A Star is Burns")

[6] Richard Corliss, "Simpsons Forever," *Time* (2 May 1994), p. 77.
[7] M.S. Mason, "Simpsons Creator on Poking Fun," *Christian Science Monitor* (17 April 1998), p. B7.

we laugh, probably because we are shocked at his blindness to what he is admitting. But knowing this about him, viewers can continue to laugh at him only because in the broader context, the late twentieth and early twenty-first centuries, we're content and satisfied with the state of affairs. Auden helps to make the point:

> Satire flourishes in a homogenous society with a common conception of the moral law, for satirist and audience must agree as to how normal people can be expected to behave, and in times of relative stability and contentment, for satire cannot deal with serious evil and suffering. In an age like our own [the 1940s and 1950s] it cannot flourish except in private circles and as an expression of private feuds; in public life, the serious evils are so importunate the satire seems trivial and the only suitable kind of attack prophetic denunciation.[8]

For Auden, satire cannot flourish in times of evil and suffering. *The Simpsons* flourishes because suffering is not taken seriously. In other words, we can laugh at Mr. Burns only because we're not terribly bothered by the damage done by the class he represents. In the world that created *The Simpsons,* there is no better world and nothing, really, to worry about. Homelessness, racism, arms sales, political corruption, police brutality, an ineffective educational system can all be grist for the comedy mill, with the apparent message that current conditions are simply to be endured, not changed. Of course, we laugh at things in a cartoon that we wouldn't find funny in "real life," but our willingness to find *The Simpsons* funny demonstrates, a Marxist might contend, that if we truly recognized the violence done to workers, the human costs of stereotyping and scapegoating, the devastation sanctioned in the pursuit of profit, we couldn't possibly find *The Simpsons* comical. In fact, *The Simpsons* would have to be considered the worst kind of bourgeois satire since it not only fails to suggest the possibility of a better world, but teases us away from serious reflection on or criticism of prevailing practices, and, finally, encourages us to believe that the current system, flawed and comical as it sometimes is, is the best one

[8] W.H. Auden, "Notes on the Comic," *Thought* 27 (1952), pp. 68–69.

possible. A Marxist, even if he or she laughs, has to be disheartened.

The Simpsons is funny. It catches us off guard, setting us up for foiled expectations, taking us for a joy ride down a fast, straight road and cutting sharply right (sometimes left) without warning. Often the show challenges and provokes, keeps us alert and attentive, questions established authority, and exposes the emptiness of many bourgeois values. But for all its wonderful moments of incongruity and misdirection and its skewering of isolated sacred cows, the show offers no consistent satire against prevailing ideology, no hope of progress toward a more just and fair world where the best rather than the lowest possibilities of humankind are realized. Its contradictions and inconsistencies reflect a world opposite the integrated, harmonious world Marx envisioned. In the end the show promotes the interests of the class that maintains economic power over the masses, selling them T-shirts, key chains, lunch boxes, and video games. Its lack of vision and its equitable distribution of antagonism make it static and immune to criticism; it can absorb and co-opt any dialectical challenge and defend itself by appealing, with a wink and a nudge, to the supremacy of *the joke*. The jokes may be funny, but in *The Simpsons,* where no one grows up and lives never improve, laughter is not a catalyst for change; it is an opiate.[9]

[9] I am grateful to Louis Rader for his many suggestions on the numerous drafts of this essay.

17

"And the Rest Writes Itself": Roland Barthes Watches *The Simpsons*

DAVID L.G. ARNOLD

In 1978 the publication of Fiske and Hartley's *Reading Television* solidified the fledgling field of television studies, using as its foundation the concept of semiotics, the methodological examination of signs and sign systems. In making this connection Fiske and Hartley were trying to suggest not only that television shared some of the properties of language and was thus analyzable using some of the same tools, but also that it was worth studying at all, that the close analysis of the things television was showing us was worthwhile, even important. In their introductory chapter they state:

> We shall try to show how the television message, as an extension of our spoken language, is itself subject to many of the rules that have been shown to apply to language. We shall introduce some of the terms, originally developed in linguistics and semiotics, that can help us successfully decode the sequence of encoded signs that constitutes any television programme. The medium itself is both familiar and entertaining, but this should not blind us to its singularity. . . . In other words, we should not mistake an oral medium for an illiterate one.[1]

[1] John Fiske and John Hartley, *Reading Television* (London: Methuen, 1978), pp. 16–17.

In the twenty-two years since this seminal work appeared, the field of television studies has matured considerably, though it still faces, surprisingly, a great deal of resistance from mainstream scholars who consider it lowbrow and beneath the dignity of analysis or even thought. On the other hand, a large part of the serious work currently being done on television still takes as its starting point a generally structuralist approach. Ellen Seiter, in "Semiotics, Structuralism, and Television," suggests that the vocabulary of semiotics allows us to "identify and describe what makes TV distinctive as a communication medium, as well as how it relies on other sign systems to communicate."[2] She goes on to suggest that "By addressing the symbolic and communicative capacity of humans in general, semiotics and structuralism help us see connections between fields of study that are normally divided among different academic departments in the university. Thus they are specially suited to the study of television."[3] The versatility that Seiter describes makes semiotics and structuralism especially useful in the analysis of a complex text like a television cartoon, despite the limitations now generally recognized in the structuralist approach.

In this essay I want to examine the insights semiotic analysis can provide into a complex "text" like *The Simpsons*. This show, like most contemporary TV shows, confronts us with a dizzyingly rapid series of messages, and by breaking down these messages into a simple, repeatable sequence of codes we can begin to see how the show makes meaning. The art of *The Simpsons*, though, lies somewhat beyond what structuralism or semiotics alone can describe, in the way it seems to disrupt the stable, easily-interpretable diet of images and ideas that television viewers generally expect, and that the medium tends to encourage. Part of the show's ability to do this lies in the mechanics of the cartoon itself, a medium that at once suggests and confutes the impression of verisimilitude. Because it frees the writers from the physical and representational constraints involved in the use of live actors, the cartoon encourages both

[2] Ellen Seiter, "Semiotics, Structuralism, and Television" in Robert C. Allen, ed., *Channels of Discourse Reassembled: Television and Contemporary Criticism* (Chapel Hill: University of North Carolina Press, 1987), p. 31.

[3] Ibid., p. 32.

creative and interpretive play. Further, because viewers rightly or wrongly associate cartoons with childish, harmless, intellectually empty entertainment, the medium is well-situated to deliver what Douglas Rushkoff calls a "media virus," a subversive or even revolutionary message conveyed in an apparently innocent, neutral package.[4]

Semiotics—Images—Television

Structuralism emerged in France in the 1950s in the works of thinkers such as anthropologist Claude Lévi-Strauss and philosopher-critic Roland Barthes. Early proponents of structuralism sought to move beyond the subjectivity and impressionism of earlier schools of criticism by insisting that we see texts as a complex intersection of social, political, and textual "structures," often expressed as two-sided or binary oppositions like *high/low, self/other,* or *nature/culture.* These structures, they argue, arise from our way of perceiving reality, and some more radical structuralists suggest that they are in fact responsible for how we perceive. The bottom line of this method of analysis is its suggestion that meaning is not inherent in objects themselves but resides outside, in their relationships to other structures.

We can find an early sustained application of these ideas in Roland Barthes's 1950 work *Mythologies.*[5] In this slender book Barthes lays out the principles of semiotics in an essay called "Myth Today" and applies them to various phenomena of French popular culture like professional wrestling, wine, the new Citroen, and gladiator movies. The central concept of semiotics is the relationship of signs to the objects or ideas they represent, and the combination of signs into systems called codes. The key to Barthes's method of analysis is the division of every sign (and, by extension, every message or act of communication) into components: the "signifier" and the "signified." The signifier is the element that makes the statement or delivers the message (a word on a page; a note of music; a photograph), and the signified is the content or idea delivered. Although we can

[4] Douglas Rushkoff, *Media Virus: Hidden Agendas in Popular Culture* (New York: Ballantine, 1994).
[5] Roland Barthes, *Mythologies,* trans. Annette Lavers (London: Paladin, 1973).

separate these two elements for analysis, we normally experience them simultaneously as the "sign." For example, when we go to cross the street we pull up short at the red flashing outline of the hand. The picture itself is the signifier, a vehicle or delivery system for a message. We understand the message itself, the signified, because of previous experience with this symbol. "STOP!" or "Don't cross now!" are the messages the flashing hand delivers to us, though the words themselves aren't used. The picture (and also its red color and insistent flashing) is the signifier, and the message we understand is the signified, but when we come to the crosswalk we don't normally play out this little act of analysis: signifier and signified act on us simultaneously as what Barthes calls the sign.

This formulation draws on the work of Swiss linguist Ferdinand de Saussure, whose 1915 *Course on General Linguistics* is a model for much structuralist thought. Saussure developed this method of analysis to study language, making the point that the signifier in a system like language is generally arbitrary or "unmotivated"; that is, unlike the flashing red hand, the words we speak or write have no organic relationship to the concepts they denote and function only when the users of the system recognize the codes being deployed. It is our familiarity with these conventions or codes that allows the sign to have meaning for us. Certain signifiers, like photographs or realistic portraits, bear or seem to bear a more direct relationship to their signifieds. These signs are called "iconic" or "motivated" signs; no special knowledge on our part (knowledge of a certain language, or of the conventions of portraiture) is required to understand them. But when making sense of a sign requires an understanding of conventions or codes, the culturally specific aspect of sign systems starts to move to the fore. Saussure used the term *langue* to denote the reservoir of codes in a given system, for instance, the vocabulary of a given language. Each individual use of the codes from this reservoir is called *parole*. Thus for speakers of French the French language represents *langue*, and a discreet work drawing from that reservoir, such as a novel by Hugo or Dumas, is an example of *parole*. These utterances make sense only to people who are familiar with the codes that make up the French language. Because the signifier in a language system has little or no organic relationship with the concept it signifies (except in special cases like onomatopoeia),

meaning depends wholly upon convention, upon recognizing the codes that comprise the act of signification.

As suggested above, applying this method to more complex signifiers like photographs or teleplays involves deciphering the ways such images become "encoded" or loaded with meaning. Barthes addresses this question in his 1964 essay "The Rhetoric of the Image." In this essay he examines a print advertisement for a particular brand of pasta to show the ways an image functions on both "denotative" and "connotative" levels. Part of the problem with "reading" images, according to Barthes, is that they function by apparent analogy rather than by the combination of phonemes (as in written language). In other words, they appear to be motivated or iconic signifiers. We understand what a picture "means" partly because we recognize that it looks like something. This is its denotative meaning. However, he contends that "we never encounter (at least in advertising) a literal image in the pure state."[6] No drawing or photograph in this context comes to us except as part of a message, part of someone's attempt to communicate something. This is the image's connotative meaning, a culturally specific message superimposed on the image's already-present denotative meaning. To decipher this message one must first determine how it has been "encoded," that is, the degree to which what is otherwise a sign in its own right (a photograph of a bag of pasta) has been pressed into service to suggest things beyond its denotative value (the qualities of the pasta that the advertiser wants to highlight as desirable). Barthes mentions the color scheme of the ad and the presence of green peppers, fresh tomatoes, and garlic, which he reads as denotation of "Italianicity," an important quality, we suppose, in choosing which brand of pasta to buy. He also suggests that the apparent randomness and casualness with which these staples are seen to spill out of their string-mesh shopping bag suggests a kind of profusion and abundance, designed to remind the shopper of happy, prosperous homes and well-stocked tables. These features are part of the constructedness of this photograph, choices made by the advertiser and the photographer that enhance this "natural" image's power to suggest and persuade.

[6] Roland Barthes, *Image-Music-Text*, trans. Stephen Heath (New York: Noonday, 1977), p. 42.

Thus the photographic image gives rise to a kind of paradox, since as Barthes says, "the photograph . . . by virtue of its absolutely analogical nature, seems to constitute *a message without a code*. . . . for of all the kinds of image only the photograph is able to transmit the (literal) information without forming it by means of discontinuous signs and rules of transformation."[7] Written language works because we know that the letters represent sounds and that the sounds, when combined according to certain rules, denote certain concepts. The photograph, on the other hand, *appears to be* a natural, unmediated kind of signifier, a straightforward, unaltered representation of the object or concept it signifies. "In the photograph" Barthes continues,

> the relationship of signifieds to signifiers is not one of 'transformation' [as it is in written language] but of 'recording', and the absence of a code clearly reinforces the myth of photographic 'naturalness': the scene *is there,* is captured mechanically, not humanly (the mechanical here is a guarantee of objectivity). Man's interventions in the photograph (framing, distance, lighting, focus, speed) all effectively belong to the plane of connotation.[8]

Thus only when we focus on the way a photograph is in fact a product of human actions and decisions does its coding, its connotative aspect, begin to become clear. And for Barthes, the unique quality of the photographic message is its ability to *silence* its own coding, to make us forget that it has been constructed to bear a message:

> to the extent that it does not imply any code . . . the denoted image naturalizes the symbolic message, it innocents the semantic artifice of connotation. . . . Although the *Panzani* poster [the photograph advertising pasta] is full of 'symbols', there nonetheless remains in the photograph . . . a kind of natural *being-there* of objects: nature seems spontaneously to produce the scene represented. A pseudo-truth is surreptitiously substituted for the simple validity of openly semantic systems; the absence of code disintellectualizes the message because it seems to found in nature the signs of culture.[9]

[7] Ibid., pp. 42-43, my emphasis.
[8] Ibid. p. 44.
[9] Ibid., p. 45.

The photograph confronts us with a message whose ob-
vious constructedness we somehow (perhaps willfully) fail to
recognize. The result is a signifying system, a way of making
meaning, that seems to us to spring from nature and there-
fore to represent truth, as opposed to rhetoric or "semantic
systems."

Barthes's purpose in this essay is to reveal the constructed-
ness of what at first glance seems natural, and to suggest how a
constructed image, much like a word or a sentence, can become
encoded or charged with meaning. These ideas apply equally to
the images we see on television, images that are substantially
manipulated, constructed, fabricated, and distorted, but which
we tend to receive very passively, as reliable indices of nature
and reality.[10]

Semiotics and *The Simpsons*

Most television images qualify as indexical signs, as apparently
natural representations of something that has actually happened.
The fact remains, though, that such images are almost always
dictated by convention and are susceptible to extensive modifi-
cation by their producers. The original physical object may or
may not have been photographed, but through sophisticated
manipulation viewers can be convinced that it was. According
to Barthes cinematic (and by extension televisual) drama func-

[10] Barthes makes the comment that applying these ideas about the rhetoric of
a photograph to cinema, which is after all just a rapid sequence of pho-
tographs, can be more difficult because of the exaggerated sense of immedi-
acy, of "a *being-there* of the thing." We experience cinema (and television
moreso, I suggest) as more immediate, more directly involving. Barthes sug-
gests that "the photograph must be related to a pure spectatorial conscious-
ness and not to the more projective, more 'magical' fictional consciousness on
which film by and large depends." Although Barthes suggests that this
imposes a "radical opposition" between film and photographic images, we
can still, I believe, productively apply his ideas about the meaning-power of
images to a discussion of animated television shows, perhaps more so
because the television cartoon, unlike the large-screen movie drama, in cer-
tain tantalizing ways works against the "projective," "magical" suspension of
disbelief upon which cinema depends (Ibid., p. 45).

tions less like an indexical sign than photographs because the function of narrative, of storytelling, tends to stylize and regularize the images we see; they become less motivated, less "natural," and more mediated by conventions.

This is where our discussion of the signifying aspects of a narrative cartoon like *The Simpsons* begins. Animated television narratives still function to some small degree as indexical signs, but the representations are extensively mediated, fully conventionalized. Nonetheless, a sign system like a cartoon can't work without at least a nod toward verisimilitude. Indeed, *The Simpsons* gets its energy precisely from the conflict between our recognition of the signifiers as highly mediated, as un-realistic, and our understanding that they nonethelsss resemble a reality we recognize. The show's satiric power, indeed its very coherence, depends on this sometimes-tenuous resemblance.

This aspect of the television cartoon, and specifically of *The Simpsons,* will come out in our discussion, but I would like to begin our analysis of an episode of the show with a more traditional structuralist approach and demonstrate both what this can reveal about televisual narratives, and what its limitations might be.

As I suggested earlier, the structuralist tends to see in narratives or texts a series of generalized binary oppositions, larger structures of which the individual signs are manifestations, and to make inferences from this about a specific culture's worldview and habits of perception. In the *Simpsons* episode titled "The Front" a number of these binarisms suggest themselves immediately. In this episode Bart and Lisa decide, after watching "a rather lifeless" episode of their favorite TV cartoon *Itchy and Scratchy*, that they could write better cartoons themselves. After having their script rejected they resubmit it under Grampa's name because they suspect that, as children, they aren't being taken seriously. A structuralist would see a number of binarisms operating in this situation. The first is the opposition between reality and fiction. As they register their disappointment with the *Itchy* episode Lisa says, "The writers should be ashamed of themselves." "Cartoons have writers?" Bart asks, puzzled. "Well, sort of" Lisa says. This exchange suggests that

the distinction between constructed narratives and experienced reality operates only very limitedly in Bart's mind, a blurring of boundaries that is in fact one of the show's central tropes.

Another binary opposition suggested by this initial setup is that between youth and inexperience on one hand and age, experience, and wisdom on the other. This is, arguably, the structure on which this particular episode is largely based, and we will explore it in detail. Beyond this, we can also see a fundamental, indeed a classic, binarism at work in the *Itchy* genre itself: the cat-mouse opposition. A genre critic might examine this traditional structure of children's cartoons in terms of its long history, from *Tom and Jerry* through *Pixie and Dixie* and beyond. We might also ask what underlies this conception of the relationship between cats and mice, and why in traditional cat and mouse cartoons the mouse is cast as positive and the cat negative.[11] Structuralists, however, are less concerned with the historical or generic implications of these structures, and would likely focus instead on the implied distinction between the natural (animals) and the cultural (speech and human-like emotions) and how the cat and mouse cartoon tends to blur them.

Let us examine the episode's central structure, the opposition between youth and experience. It is evident from the outset that this fairly standard conception is to be offered up for examination and satire. Before Bart and Lisa's foray into cartoon writing is even set up we witness an inverted vision of the traditional, "natural" relationship between parents ("wise," "experienced") and their children ("naïve," "untutored") when we see Homer moaning because he's got a plunger stuck on his head. The basic signifiers being deployed here are the father figure, supposed generally to represent authority and sagacity, and the toilet plunger, clearly reductive of that authority. In fact, the combination of the two signifiers suggests a radical, scato-

[11] We could speculate at great length about *The Itchy and Scratchy Show*'s relationship to this genre, and in fact this is a matter of some extended discussion in *The Simpsons*. See for instance "The Day the Violence Died" in which Bart meets Chester J. Lampwick, creator of *Itchy and Scratchy* and self-proclaimed father of cartoon violence; see also "Itchy and Scratchy: The Movie" in which we see a history of *Itchy and Scratchy*.

logical undermining of the concept of parental authority. No explanation is given for Homer's predicament except that he says "Marge, it happened again." This suggests that this is a recurring problem, and that Homer seems unable to learn from the experience (in fact, the last scene of the episode shows him as an old man arriving at his 50th high school reunion suffering from the same problem). Bart and Lisa, on the other hand, appear to have the situation summed up and dealt with. "What are you changing your name to when you grow up?" Bart asks. The children have determined that the way to overcome the genetic tyranny that identifies them as Homer's experiential inferiors is to opt out of their family heritage altogether. Thus the episode's first scene presents us with a traditional structure and its refutation.

As the children confront the inadequacy of TV writing and storm the citadel of corporate cartoon production, they are faced again with the traditional binary opposition between age and youth that causes the grownups in charge to undervalue their efforts. At every turn the narrative works to undercut this binarism's validity. We discover that Grampa, whose name they use as a signifier of age and authority, doesn't even know his name, and has to check his underwear for confirmation. Again, this pair of signifiers (the wise old man and the underwear) effects a scatological reduction of the traditional age-youth binarism. Once Grampa is (fraudulently) installed as a staff writer at Itchy & Scratchy Studios, the president, Roger Meyers, introduces him to the other writers, whom Meyers excoriates as a pack of Ivy-League "eggheads" with no real-life experience. One pipes up: "Actually, I wrote my Master's thesis on life experience . . ." but Meyers silences him and asks Grampa to expound on his own fascinating life. "I worked for forty years as a night watchman in a cranberry silo," Grampa says. Meyers seems impressed, but we pick up on the implied absurdity of valuing this kind of deadening, definitively tedious labor as educative or empowering.

A structuralist reading of this episode would, then, focus largely on the ironic treatment of this binary opposition and reach the conclusion that the narrative draws satiric energy from the apparent reversal of our expectations about age and youth. As I suggested above, though, this approach is limited by the scope of the questions it chooses to ask. With a text like *The*

Simpsons, we can profit by a more detailed analysis not only of the structural oppositions the signifiers imply, but what those signifiers actually are and how they operate.

The Animated Signifier

Recalling Barthes's comments about the signifying power of the image, we would say that a drawing like a *Simpsons* character displays a high degree of conventionalization; that is, we must supply a fair amount of cultural knowledge for these images to make sense. Despite their similarity to human beings, most of the members of the Simpson family are highly stylized drawings, really only suggestions of the human form. Nonetheless we do recognize them as representations of a certain segment of American society: the drawings and characterizations are accurate enough that they can function as satire. Homer's weight problem and beer consumption and Bart's spiky, bad-boy haircut and skateboard are recognizable features of a late twentieth-century landscape, and they help us understand how these signifiers are supposed to function, what they're supposed to be making fun of. But the fact that the characters are patently not quite human increases their ability to function as satiric signifiers. Physical attributes, habits, and actions we could not accept as possible for a human (or a drawing supposed to represent a human) become a regular part of *The Simpsons'* repertoire, allowing them to venture further into the realm of the ridiculous than human actors or realistic drawings.

One example of this drawn from "The Front" is Grampa's method of verifying his identity. When he whips off his underwear to check on his name he doesn't bother to remove his pants. The children are stunned and ask how he managed such a feat, and he shudders and says, "I don't know." It is frankly difficult to pin down exactly what this combination of signifiers might mean beyond what we discussed above, but what is clear is that the scene moves the status of these signifiers as signifiers to the fore. The narrative is insisting here that we remember that these are cartoon characters. This, I think, is the key to the rhetoric of these images. The writers are having it both ways: by insisting up front that verisimilitude is not an issue, by exploiting the absurd and the fantastic, they can satirize American society more effectively. Because they can dislocate the relationship

between signifier and signified, they gain unlimited latitude in what they can depict or suggest, and this renders the show, predictably, more suggestive. Freed from the mundane restrictions of live action or realistic representation, the animation nevertheless retains an always-foregrounded referentiality. Comments about Marge's unfeasible blue hair or the family's yellow skin remind us regularly that the characters aren't real, and this enhances our reception of them as signifiers: their capacity to represent things is never clouded by the impression that they might also be real people. Nothing but the show's own self-referentiality intrudes on our suspension of disbelief.

Beyond this, the very status of *The Simpsons* as a television cartoon affects the way its signifiers operate. Our responses are conditioned because we know it's "only" a cartoon. This is precisely the fate of other "adult" cartoons like *The Flintstones* and *Wait 'Til Your Father Gets Home*. Originally intended as primetime shows for grownups, these were relegated, to a large extent by an imperceptive audience, to the realm of children's programming. The medium here obviates the message. We also see this in the way old movie theater cartoons like *Bugs Bunny*, originally short features intended to entertain adults, descended inevitably to Saturday morning. *The Simpsons* (as well as many of the newer generation of "postmodern" cartoons like *Beavis and Butthead, Ren and Stimpy, Family Guy,* and others) capitalizes on this misperception, flying under the radar, as it were, of our rational minds. Cartoons are safe, childlike, part of the world of play as opposed to more overtly serious television fare like soap operas or newscasts. Virus-like, the show lulls us into lowering our intellectual defenses, then infects us with satiric, subversive ideas.

The way signifiers are used in *The Simpsons* and their apparent dislocation from the kinds of signifieds we expect takes us slightly beyond the realm in which structuralism proper can answer our questions. Barthes, in the later, post-structural phase of his career, discusses this kind of textual play in his 1970 book *S/Z*. In this work, an in-depth semiotic analysis of a short story by Balzac, he defines what he calls a "classic text," one that is closed to the possibilities of connotation. Such a text works on a purely denotative level, and the reader is never encouraged to speculate beyond what the narrator or other authorial voice asserts. According to Barthes, this implies a kind of law or reli-

gion of "right" reading: the text cannot be "written" or added to substantively by the reader. Reading it is essentially a passive activity, and hence Barthes calls these "readerly" texts. The opposite of this classic or readerly text is the "writerly" or "plural" text, one that encourages free play on the part of both reader and writer and is richly connotative, is in fact open-ended with regard to its ultimate meaning. "To read," according to Barthes, "is to find meanings, and to find meanings is to name them; but these named meanings are swept toward other names; names call to each other, reassemble, and their group-ing calls for further naming: I name, I un-name, I rename: so the text passes: it is a nomination in the process of becoming, a tire-less approximation, a metonymic labor."[12] Reading is thus an activity that paradoxically effects its own undoing as the "tireless approximations" compound and are swept away by new asso-ciations. For Barthes, in this later phase of his career, the more valuable activity is not making meaning but *forgetting* it:

> . . . reading does not consist in stopping the chain of systems, in establishing a truth, a legality in the text, and consequently in lead-ing its reader into "errors"; it consists in coupling these systems, not according to their finite quantity, but according to their plurality . . . : I pass, I intersect, I articulate, I release, I do not count. Forgetting meanings is not a matter for excuses, an unfortunate defect in performance; it is an affirmative value, a way of asserting the irresponsibility of the text, the pluralism of systems . . . : it is precisely because I forget that I read.[13]

The Simpsons, I submit, is precisely an "irresponsible" text, one rich in associations and connotations and perversely unwilling to have those connotations pinned down. It is "postmodern" in the sense that it comes together as a self-parodic, self-referential pastiche of previous texts. It is satiric in that it occupies the sig-nifiers of the culture it wishes to lampoon and amplifies that cul-ture's foibles up to and beyond the point of absurdity. But it is irresponsible in that it cheerfully resists, indeed makes fun of, even the kind of friendly analysis we're attempting here.

[12] Roland Barthes, *S/Z*, trans. Richard Miller (New York: Hill and Wang, 1974), p. 11.
[13] Ibid., p. 11.

To solidify this point, let us take a final look at "The Front," this time specifically the *Itchy and Scratchy* episode that Bart and Lisa write because they find the ones being produced so unsatisfying. They choose a barbershop as the setting and Lisa invents a scenario in which Itchy cuts off Scratchy's head with a razor. "Aw, too predictable," Bart says: "The way I see it, instead of shampoo, Itchy covers Scratchy's hair with barbecue sauce, opens a box of flesh-eating ants, and the rest writes itself." What happens next, the part that "writes itself," deserves some attention. After the flesh-eating ants have stripped Scratchy's head to a bare skull, Itchy activates the lift on the barber chair, sending Scratchy crashing through the ceiling and through the bottom of a television set on the floor above. An Elvis impersonator is watching the television, and after staring at Scratchy's skeletal head for a beat he says, "Aw, this show ain't no good," pulls out a revolver, and shoots the television.

What I find interesting about this, beyond the plethora of bafflingly rich signifiers, is specifically the idea that such a scene could "write itself," that it could spring as it were unbidden from a reservoir of common, easily accessible cultural codes. That Itchy should ram Scratchy through the ceiling is in keeping with The *Itchy and Scratchy Show*'s rhythm of ever-escalating violence, but the presence of the Elvis impersonator seems less predictable. Bart's comment implies, though, that Elvis impersonators using handguns as TV remote controls are an organic part of the culture he's writing from; they are, to his eye, stable, reliable, easily-recognizable signifiers.

Signifiers of what? The television set is a familiar image in *The Simpsons*, and its presence at the forefront of Bart's imagination is not surprising. Each episode of the show, in fact, is preceded by what is called a "couch gag," a scene in which the family rushes into the living room to begin the evening ritual of TV watching. Directly following this scene the final frame of opening credits appears framed by a TV set, complete with VCR and rabbit ears, giving the impression that we and the family are watching the same TV. This occurs, as I mentioned, before every episode, and serves as a kind of index, a reminder that the show is formally concerned with television, and with it own status as television. In Bart's script for the *Itchy and Scratchy* episode the centrality of television is foregrounded when Scratchy becomes a television character (a cat in a cartoon) forced into the role of

a television character (an image in/on the Elvis impersonator's TV). The Elvis impersonator's critique of this "program," his judgment that "this show ain't no good" and his decision therefore to shoot his television, takes this act of mirroring one step further by replicating Bart and Lisa's original dissatisfaction with *Itchy and Scratchy*. Our own status as viewers and critics completes this circle and situates the discourse firmly on television and the many ways we consume it.

The presence of the Elvis impersonator is harder to pin down. We can read him, perhaps, as a signifier of our society's willingness to commodify and commercialize personality, an example of the potential of mass-produced star power to sell products across many media. Beyond this, of course, is the aura of obsessive craziness surrounding this icon of American popular culture. Elvis Presley the performer brought the genre of rock 'n' roll to the attention of the nation and the world, making up with energy what its detractors claimed it lacked in cultural significance. His work signaled, in the orgiastic adoration of the fans, some kind of turning point in the battle between high and low cultures. In the decades since his death his continued "presence," in the form of numerous "Elvis-sightings" and of the thriving industry of Elvis impersonators, testifies to the weird energy and durability of his memory.

The King, random handgun use, business-as-usual violence, and the ubiquity of television map out Bart's conception of his culture. He has acquired this culture, the show suggests, as a result of careless and misguided parenting, a slipshod educational system, an all-encompassing environment of consumerism and commodification, and, of course, television. Ultimately, this new Elvis narrative and its creation invite us to consider the cultural act of creating (televisual) texts: writing is a social activity, a way of having a voice. One of the specific signifieds of this segment is the search for quality television and the logical response to lo-grade TV (either shoot it or write something better).

The fact that we see Bart's text as more sophisticated than the *Itchy and Scratchy* being produced by Ivy-League graduates is itself richly suggestive. Our structural analysis of "The Front" discovered that its aim was to satirize the easy binarism that privileges age over youth, but we must also now question the very signifiers themselves, not just the structures they imply. We

might argue that this text satirizes a society in which such signifiers are readily available, where Elvis writes himself. Implicitly, the perfection of an *Itchy and Scratchy* episode has to do with arabesques of violence, specifically creative, intriguing violence. Merely to see a mouse strike a cat on the head with a hammer is too pedestrian, a readerly as opposed to a writerly situation, a classic text. Bart's text is more open to connotation, less stable.

Perhaps, then, we can define the richness of a *Simpsons* text as a matter of openness to connotation, an openness to the allure of free-floating signifiers that coalesce and disperse apparently randomly, "data," as Barthes puts it, "seemingly lost in the natural flow of discourse."[14] The apparent randomness with which *The Simpsons* cites particular signifieds defines its method of signifying. Of this kind of randomness of association Barthes says:

> This fleeting citation, this surreptitious way of stating themes, this alternating of flux and outburst, create together the allure of the connotation; the semes appear to float freely, to form a galaxy of trifling data in which we read no order of importance; the narrative technique is impressionistic: it breaks up the signifier into particles of verbal matter which make sense only by coalescing: it plays with the distribution of a discontinuity (thus creating a character's "personality"); the greater the syntagmatic distance between two data, the more skillful the narrative; the performance consists in manipulating a certain degree of impressionism: the touch must be light, as though it weren't worth remembering, and yet, appearing again later in another guise, it must already be a memory; the readerly is an effect based on the operations of solidarity (the readerly "sticks"); but the more this solidarity is renewed, the more the intelligible becomes intelligent. The (ideological) goal of this technique is to naturalize meaning and thus to give credence to the reality of the story.[15]

In a "classic" text, in *The Honeymooners*, in *All in the Family*, even in *The Flintstones*, the signifieds eventually coalesce into

[14] Ibid., p. 22.
[15] Ibid., p. 23.

"meaning." In *The Simpsons* that coalescence is deferred indefinitely. The classic text loses its plurality because we expect all the actions (eventually) to be coordinated; like an ear trained to hear the predictable cadences and resolutions of western music, the readerly eye demands an eventual uniformity. Like the narrative in a novel by Dickens, the storyline in an episode of *Dynasty* or *Fresh Prince of Bel-Air* takes us in a very predictable direction and culminates in a satisfying sense of resolution. The writerly or plural text like *The Simpsons,* however, resists this push to conform. By foregrounding its signifiers and cheerfully dislocating them from stable, predictable signifieds, the show permits a freer, more richly associative kind of reading, and effects a more penetrating social satire. Barthes's "galaxy of trifling data" aptly describes Bart's world of Elvis-impersonators and flesh-eating ants, the world with which *The Simpsons* presents us, the skill of the narrative arising, as Barthes suggests, from the "distance between" the data, between denotation and connotation, between signifier and signified. It's a random, absurd world; to admit that it is really our own, to admit that we have to this extent lost control of the mechanisms of stability and meaning would be too embarassing. We find instead that we must laugh, if only in self-defense.

18
What Bart Calls Thinking

KELLY DEAN JOLLEY

"What is called thinking?" At the end we return to the question we asked at first when we found out what our word "thinking" originally means. *Thanc* means memory, thinking that recalls, thanks.

But in the meantime we have learned to see that the essential nature of thinking is determined by what there is to be thought about: the presence of what is present, the Being of beings.

— Martin Heidegger

Once more and they think to thank you.

— Getrude Stein

Cowabunga, dude!

— Bart Simpson

Introduction

Strange, I guess, to take Bart Simpson as Muse. Stranger still, I guess, is taking Bart as the Muse for philosophy. (There is no Muse for philosophy—and if there were, it wouldn't be Bart Simpson!)

I take Bart as my Muse because of a feature of Bart's engagement with the world, whether that engagement is reflective or active. Bart's world, the world, just ain't in Bart's head. Bart's world is *out there*. This omnipresent *out-thereness* (for lack of a

better term) is what makes Bart a Heideggerian thinker. Bart's world is a world of faces, not facades; it is a world personified. And Bart's thoughts go out to meet it. But all this needs to be made clear.

I shall begin by discussing a philosophical example that deserves the fame of Socrates's triangle in the dirt, Descartes's lump of wax, or Price's red tomato—Heidegger's tree in bloom. Discussing the tree will clarify what Heidegger calls thinking. I shall finish by showing Bart Simpson as a Heideggerian thinker.

Since what is to follow is difficult, I want to say a few things by way of setting the stage. Arthur Schopenhauer opens his *The World as Will and Representation* by claiming that the beginning of philosophical wisdom is recognizing that *the world is idea.* Schopenhauer glosses this by claiming that the philosopher recognizes that the world is in his head. By 'the world' Schopenhauer means *everything.* I think Schopenhauer has put his finger on the live nerve of much philosophizing: the philosophical thought *par exellence* is that all I am acquainted with is the insides of my head. Everything else I get to by some type of wishful thinking—inferring, guessing, postulated causal connections. What I do here is trace out a response to the philosophical thought par exellence, a response that looks as radical as what it responds to. I want to trace out a way of thinking about thought itself on which not only is the world not inside our heads, but our thoughts are not inside our heads. Put it this way: when we think, our thoughts are wherever what we are thinking about is.

One helpful hint for following my discussion: the backbone of the discussion is the series of quotations from Heidegger, Schopenhauer, and Frege. And the most crucial of these is the one from Frege. Both Heidegger and Frege are trying to dislodge thoughts from inside the head. I try to show how Heidegger and Frege are akin, and how they are different. Getting clear about that will show both what Heidegger and Frege reject in Schopenhauer, and what Heidegger rejects in Frege. And *that* will lead us back to Bart.

Heidegger's Tree

In *What is Called Thinking?,* Heidegger introduces the tree in bloom:

We stand outside of science. Instead we stand before a tree in bloom, for example—and the tree stands before us. The tree faces us. The tree and we meet one another, as the tree stands there and we stand face-to-face with it. As we are in this relation of one to the other and before the other, the tree and we are. This face-to-face meeting is not, then, one of those "ideas" buzzing about in our heads. Let us stop here for a moment, as we would to catch our breath before and after a leap.[1]

I will, for now, set aside Heidegger's introductory "We stand outside of science." What I want to focus on is the way in which Heidegger *personifies* the tree in bloom. According to Heidegger, the tree and we both have *faces*: the tree faces us; we stand face-to-face with the tree; each of us is before the other. Why does Heidegger personify the tree in bloom?

I take it that the answer to this question comes in what Heidegger denies about the meeting with the tree: "This face-to-face meeting is not, then, one of those "ideas" buzzing about in our heads." Heidegger personifies the tree so as to *depersonalize* it. What I mean is that Heidegger personifies the tree as a way of insisting that the tree is, indeed, before us, separate from us. The tree is not our idea.[2]

To better understand what I take Heidegger to be doing, consider the following famous passage from Schopenhauer (Heidegger prefaces his tree-in-bloom-passage with a parallel passage from Schopenhauer):

[1] Martin Heidegger. *What Is Called Thinking?* trans. J. Glenn Gray (New York: Harper and Row, 1968), p. 41.

2 Since I shall use these terms, and since they may not be made completely clear in my use of them, let me say that to *personify* something is to treat it as an other, as independent of me, as something that is and does on its own and in its own way. Hence the importance of *faces*—something regareded as having a face is something personified. (Think here of C.S. Lewis's novel, *Till We Have Faces,* part of the point of which is that here—short of heaven—we are not fully personified, we do not have faces.) To *personalize* something is to treat it as mine, as dependent on me, as something that is and does dependently on me. So, for example, *ideas* as they figure in the coming quotations from Schopenhauer, Heidegger, and Frege, are *personal(ized)*. As Frege puts it, ideas are something we have, something we own. (Something personified is not something that we have or own.)

"The world is my idea":—this is a truth which holds good for every-thing that lives and knows, though man alone can bring it into reflective and abstract consciousness. If he really does this, he has attained to philosophical wisdom. It then becomes clear and cer-tain to what he knows is not a sun and an earth, but only an eye that sees a sun, a hand that feels an earth; that the world which sur-rounds him is there only as an idea, i.e., only in relation to some-thing else, the consciousness, which is himself. If any truth can be asserted *a priori,* it is this: for it is the expression of the most gen-eral form of all possible and thinkable experience. . . . No truth is therefore more certain, more independent of all others, and less in need of proof than this, that all that exists for knowledge, and therefore this whole world, is only object in relation to subject, per-ception of a perceiver, in a word idea. . . .The world is idea.[3]

Schopenhauer personalizes the world: the world is *our idea.* And so, too, of course, would be the tree in bloom. The tree, like the field in which it grows, the earth of which the field is part, the sun that shines—all are our ideas; all are buzzing about in our heads. Schopenhauer personalizes the tree, makes it ours.

Heidegger personifies the tree, makes it an other, other than ours. And he treats doing this as requiring a great leap: after doing it we must pause to catch our breath. Heidegger explains the need for rest:

For that is what we are now, men who have leapt, out of the famil-iar realm of science and even, as we shall see, out of the realm of philosophy. And where have we leapt? Perhaps into an abyss?[4]

Heidegger thinks that standing face-to-face with the tree requires that we leap from psychology and science, and even from philosophy. Evidently, in science and philosophy, trees lack faces.[5] (Personalized trees are not personified.) But where do trees have faces? Where *have* we leapt? Where is there to

[3] Arthur Schopenhauer, *The World as Will and Representation* Vol. 1, trans E.F.J. Payne (Indian Hook, Colorado: Falcon Wing Press, 1958), p. 1. I use this passage instead of its parallel since I think it is clearer. (The parallel passage can be found in Vol. II, pp. 3–4.)
[4] *What Is Called Thinking?,* p. 41.
[5] By 'philosophy' Heidegger means philosophy as it has been and is done by others—not philosophy as he does it.

be—besides in the realm of science or the realm of philosophy? Into what Looking-Glass World is Heidegger asking us to leap? Surely, beyond science and philosophy there is only the abyss.

Heidegger responds to his question, perhaps we have leapt into an abyss?, by replying

> No! Rather onto some firm soil. Some? No! But on that soil upon which we live and die, if we are honest with ourselves. A curious, indeed unearthly thing that we must first leap onto the soil on which we really stand.[6]

Heidegger's claim is that we have leapt onto the firm soil of our lives. What is striking here, and what Heidegger underscores as "curious, indeed unearthly" is that we have to leap from the familiar—science, philosophy—onto the unfamiliar, the firm soil of our lives. We have to leap to get to where we always already are.

Thinking Outside the Head

I want momentarily to step away from the tree in bloom. What I take Heidegger to be doing in this passage is battling a commitment shared by our familiar science and philosophy, namely a commitment to psychologism. Psychologism, briefly, is best thought of as a family of views. Each such view maintains that a subject-matter, say logic or morals or thought, is a branch of psychology. As a result, the laws of that subject-matter are rightly understood as generalizations over the goings-on in the human head. So, for example, a psychologistic logician would treat the laws of logic as generalizations over the inferential goings-on of the human head. Also, Heidegger's objection to the claim that the tree in bloom is an idea buzzing *in our head* is an objection to a psychologistic claim.

Psychologism personalizes trees—it personalizes the fields, etc. It does so by treating them as ideas, buzzings in the head, psychological. Heidegger hints at this in the passage immediately before the discussion of the tree in bloom, when he comments that in order to understand thinking we must leave

[6] *What Is Called Thinking?*, p. 41.

psychology to one side. Of course, given his indebtedness to Husserl, Heidegger's anti-psychologism is not exactly surprising. But what is surprising is the way in which, and the depth at which, Heidegger battles psychologism. To make this clear, I want to compare Heidegger's anti-psychologism with Frege's. The comparison will also serve as a bridge from the tree in bloom to what Heidegger calls thinking.

Frege waged a lifelong war with psychologism. Frege over and over again engages the psychologistic thinker, showing her that psychologism so misshapes her ostensible topics as to render them unrecognizable. For example, in his famous paper "Thought," Frege turns on the same notion that Heidegger turns on when discussing the tree in bloom, the notion of ideas. (Interestingly, Frege, too, uses a tree as an example.) Frege's argument is lengthy (but I quote it in full):

> Yet there is a doubt. Is it at all the same thought which first this and then that man expresses?
>
> A man who is still unaffected by philosophy first of all gets to know things he can see and touch . . . such as trees, stones and houses, and he is convinced that someone else can equally see and touch the same tree and the same stone as he himself sees and touches. Obviously a thought does not belong with these things. Now can it, nevertheless, like a tree be presented to people as the same?
>
> Even an unphilosophical man soon finds it necessary to recognize an inner world distinct from the outer world, a world of sense impressions, of creations of his imagination, of sensations...For brevity's sake, I want to use the word 'idea' to cover all these occurrences . . .
>
> Now do thoughts belong to this inner world? Are they ideas? . . .
>
> How are ideas distinct from the things of the outer world?
>
> First: ideas cannot be seen, or touched, or smelled, or tasted, or heard.
>
> I go for a walk with a companion. I see a green field, I thus have a visual impression of the green. I have it, but I do not see it.
>
> Secondly: ideas are something we have...An idea that someone has belongs to the content of his consciousness.
>
> The field and the frogs in it, the sun which shines on them, are there no matter whether I look at them or not, but the sense impression I have of green exists only because of me, I am its owner . . . The inner world presupposes somebody whose inner world it is.

Thirdly: ideas need an owner. Things of the outer world are on the contrary independent . . .

My companion and I are convinced that we both see the same field; but each of us has a particular sense impression of green . . .

Fourthly: every idea has only one owner; no two men have the same idea.

For otherwise it would exist independently of this man and independently of that man. Is that lime tree my idea? By using the expression 'that lime tree' in this question I am really already anticipating the answer, for I mean to use this expression to designate what I see and other people too can look at . . .[7]

Frege is trying to accomplish two things here: first, he's trying to show that the denizens of the inner world, ideas, are not thoughts. Ideas play no role in logic, as thoughts do. The things buzzing in our heads are not thoughts, nor are they parts of thoughts. Buzzings in our heads are not thoughts, since thoughts—like lime trees, fields, and frogs—are sharable and have no owner.

By 'thought' Frege means such ordinary, garden-variety things as "There are lime trees" or "Tigers are animals" or "2 + 2 = 4." Frege's denial that thoughts have owners needs to be understood in light of the act-content distinction: of course my *thinking* (act) of the thought (content) that tigers are animals is owned—I do the thinking; it's my thinking. But the thought is not mine: any number of different people could have it; the thought is sharable. If we both think that tigers are animals, then we share a thought.

Second, Frege is trying to show that ideas are not things, denizens of the outer world. Schopenhauer's claim that the world is my idea would be greeted with the same sort of response that the Frege gives to the question "Is that lime tree my idea?"

Now Frege goes on from this discussion of ideas to argue that thoughts, although they are like lime trees, fields, and frogs, are also unlike them: thoughts are not perceptible—they are grasped or thought, not seen, heard, touched, or tasted. Frege

[7] Gottlob Frege. *Logical Investigations,* trans Peter Geach and R. H. Stoothoff (New Haven: Yale University Press, 1977), pp. 13–16.

then takes this to show that thoughts are neither in the inner world nor in the external world. Instead, he takes thoughts to be in the Third Realm:

> So the result seems to be: thoughts are neither things in the external world nor ideas.
> A third realm must be recognized. Anything belonging to this realm has it in common with ideas that it cannot be perceived by the senses, but has it in common with things that it does not need an owner so as to belong to the contents of his consciousness.

So an integral part of Frege's anti-psychologism is his Third Realm. What is important here is that Frege's war with psychologism shares Heidegger's tactic of showing that ideas do not have any role to play of the sort we think when we do science or philosophy (they are neither things nor thoughts). However, Frege's war differs from Heidegger's in requiring that to avoid psychologism we must leap from psychology or science into a Third Realm—not onto the firm soil of our lives.

For Frege, thoughts are not in the head. But since they are not in the outer world, either, they must be in some third place, The Third Realm. Heidegger shares Frege's conviction that thoughts are not in the head. But he does not share Frege's conviction that there must be a Third Realm—or, better, Heidegger does not share Frege's conception of the Third Realm. Explaining this will take some effort.

What Is Called Thinking

Perhaps the best way to begin is by giving the game away: Heidegger thinks that the firm soil of our lives is the Third Realm. But what could this mean? The inner world is not the firm soil of our lives. Is the outer realm the firm soil? No, the outer realm is the realm of causation, science. When we stand on the firm soil we stand outside both psychology (inner world) and science (outer world)—so we stand in the Third Realm. But Frege's Third Realm seems a strange land, and, as fleshly creatures, we seem strangers in it. So how can the firm soil of *our* lives be the Third Realm?

Answering this requires thinking back to Husserl and then forward to Heidegger. Famously, Husserl called thinkers to phi-

losophy (phenomenology) with the cry, "Back to things them-
selves." The way back to things themselves was methodologi-
cally strait—it required mastery of a new kind of seeing, mastery
of *epoche*;[8] and it required mastery of a bizarre new vocabulary
in which to communicate the results of the new kind of seeing.
If Husserl's descriptions of the new kind of seeing and of what
is seen by it are looked at closely, we recognize how much the
intentional realm (what is looked into in *epoche)* resembles
Frege's Third Realm. Indeed, although there are particular prob-
lems with saying so, it makes useful sense to say that looking
into the intentional realm just is looking into Frege's Third
Realm.[9]

By the time of his later writings, Heidegger has brooded over
every feature of Husserl's method. In fact, Heidegger has inter-
nalized the method to a remarkable degree. But Heidegger
wants the method to yield what Husserl promised—a pathway

[8] Here are Husserl's instructions for *epoche*, for bracketing: "We put out of
action the general thesis which belongs to the natural standpoint, we place in
brackets whatever it includes respecting the nature of Being: this entire nat-
ural world therefore which is continually 'there for us', 'present to our hand',
and will ever remain there, is a 'fact-world' of which we continue to be con-
scious, even though it pleases us to put it in brackets. If I do this, as I am fully
free to do, I do not then deny this 'world', as though I were a sophist, I do
not doubt that it is there as though I were a skeptic; but I use the phenome-
nological [*epoche*], which completely bars me from using my judgment that
concerns spatio-temporal existence. Thus all sciences which relate to this nat-
ural world, though they stand never so firm to me, though they fill me with
wondering admiration, though I am far from any though of objecting to them
in the least degree, I disconnect them all, I make absolutely no use of their
standards, I do not appropriate a single one of the propositions that enter into
their systems . . . —so long, that is, as it is understood in the way the sciences
themselves understand it, as a truth concerning the realities of this world. I
may accept it only after I have placed it in the bracket. That means: only in
the modified consciousness of the judgment as it appears in disconnexion
. . . ." Edmund Husserl, *Ideas*, trans. W.R. Boyce Gibson (New York: Collier,
1962), pp. 99–100. When Heidegger personifies *epoche* as *the clearing* he
(putting this picturesquely and oversimply) takes the framing brackets of
epoche, which enclose a screen filled with two-dimensional intentional items
(ideas), tilts the brackets down to lie on the ground, and removes the
screen—so that the things themselves, and not their intentional counterparts,
can stand in the brackets, which now frame the clearing.
[9] I will side-step the problems with saying this, since they are not stumbling-
blocks in my path.

back to things themselves. From Heidegger's perspective, any method that takes me to the intentional realm is not a method that takes me *back to things themselves.*[10] (Husserl ends up sounding too much like Schopenhauer, despite Husserl's struggle not to sound idealistic, psychologistic. Things in the intentional realm show us facades merely, not faces.[11]) Heidegger contrasts Husserl's epoche with his own (which will become *the clearing*):

> For Husserl, [*epoche*] . . . is the method of leading phenomenological vision from the natural attitude of the human being whose life is involved in the world of things and persons back to the transcendental life of consciousness . . . in which objects are constituted as correlates of consciousness. *For us, [epoche]* means leading phenomenological vision back from the apprehension of a being, whatever may be the character of that apprehension, to the understanding of the being of this being . . .[12]

In Heidegger's terms, the problem of Husserl's method is that in *epoche* "objects are constituted as correlates of consciousness"—they are ideas. In my terms, the problem is that in *epoche* objects are personalized.

Heidegger responds to this problem by personifying the method itself and what the method shows us. The method, since in Husserl's hands it took us to the intentional realm, shows us what is personal, seemed itself to be personalized. Heiddegger depersonalizes it by personifying it. How?

Heidegger takes the key features of the method and finds a way to bring the practitioner of the method into a different relationship with those features, a different way of conceptualizing them. So, Heidegger takes *epoche* out of the intentional, per-

[10] Whether Heidegger is right about this is a difficult question. For now I will ignore the question, treating Heidegger as if he were right, without arguing that he is.

[11] For Heidegger, the tree in bloom that we stand before is not a two-dimensional section of our bracketed visual fields—it is not in our heads, a mere correlate of consciousnesses. Nothing in our heads could stand before us, meet us, face us. We cannot stand before, meet, or face an idea.

[12] Martin Heidegger, *The Basic Problems of Phenomenology*, trans. Albert Hofstadter (Bloomington: Indiana University Press, 1982), p. 21.

sonal realm and personifies it—the *epoche* becomes *the clearing*. In the clearing, we can apprehend the being of a being, apprehend the being as it is, where it is. In the clearing, the objects that we face, and that face us, are not correlates of consciousness. No, since they and we stand face-to-face, the objects are others—they are personified. It is in the clearing that we can come face-to-face with a tree, for instance, or with a Greek Temple. The *epoche* provides only the tree-in-brackets, only the Temple-in-brackets. The *epoche* moves them, so to speak, from the soil on which they stand into the intentional realm; the *epoche* personalizes them. But the clearing lets the tree and the Temple stand where they stand, allows us to come face-to-face with them, while standing on the soil with them. In brackets, the tree and the Temple seem to be all facing surface—seem to lack backs. But anything without a back is something that cannot really be confronted face-to-face. Only in the clearing do the tree and the Temple have backs, only there can I confront them face-to-face. In the clearing, the tree and Temple are personified. To replace the *epoche* with the clearing requires us to leap back to where we already stand. In the clearing we can come back to the things themselves.

In *What Is Called Thinking?*, Heidegger struggles to find a way to situate thinking so that we can find a way not to psychologize thinking—but also so that we can find a way not to put thinking into the Third Realm as Frege understood the Third Realm. To do so, Heidegger works back to Parmenides, and to Parmenides's famous and famously obscure lines—"One should both say and think that Being is"[13] and "For it is the same to think and to be." Now, I do not propose to follow the torturous windings of Heidegger's examination of these lines. All I propose to do is to characterize the motive behind the examination. What Heidegger is after is thought personified, not thought personalized. The attraction of Parmenides's line is that it seems to place thought in the clearing—it puts thought before us, so that we can stand face-to-face with it. For Heidegger, Parmenides is attempting to do for thought what Heidegger does for the tree.

[13] By the time Heidegger finishes with this line, it has become: "Useful is the letting-lie-before-us, so (the) taking-to-heart, too: beings in being". Cf. *What Is Called Thinking?*, p. 228.

Parmenides is attempting to show us how to meet our thoughts
and not merely how to have them. For Heidegger, correctly fol-
lowing Parmenides is a matter of thinking of our thoughts as
themselves such as to be what we are thinking of. To borrow a
line of Wittgenstein's, thought so understood would be thought
that "does not stop anywhere short of the fact."[14] To think such
thoughts would be to think outside the head. Fully articulating
such an understanding of thought is more than even Heidegger
tries to do. *What is Called Thinking?* ends by pointing us in the
direction of Parmenides's pointing, and by helping us to under-
stand why we should want to be pointed that way. (As I will try
to make clear below, and as I hinted at the beginning, what
Heidegger struggles to articulate is something that Bart manages
effortlessly to live.)

Back now to a question that I may seem to have forgotten:
How can the firm soil of *our* lives be the Third Realm? The short
answer is this: we have to see the firm soil of our lives *in the
clearing*—we have to personify the soil. Doing so requires that
we leap to where we already are, doing so requires us to stand
outside of psychology, outside of science. Put it this way: to see
the firm soil of our lives *in the clearing,* to personify it, is to see
(nothing other than) the spatial and temporal phenomena of our
lives. But it is to see these phenomena as we see a chess piece
when we are playing chess, and not as we see a chess piece
when we describe its physical properties.[15] So seen, the soil
stands before us, it stands where it stands. And we stand before
it: we come face-to-face with where we stand.

By personifying the firm soil of our lives, by seeing it in the
clearing, we see it as fit for thought, as fit to be the content of
thought. The things we think about no longer seem alien to our
thoughts, cut off from us, veiled by ideas. The things we think
about are now things that our thoughts reach out to and
embrace. Our acts of thinking have the spatio-temporal phe-

[14] Ludwig Wittgenstein, *Philosophical Investigations,* trans. G.E.M. Anscombe
(New York: MacMillan, 1953), 95. For more on this conception of thought, see
John McDowell, *Mind and World* (Cambridge, MA: Harvard University Press,
1994), pp. 27ff. See also his "Putnam on Mind and Meaning" in *Meaning,
Knowledge, and Reality* (Cambridge, MA: Harvard University Press, 1998), pp.
275–291.
[15] Compare *Philosophical Investigations*, 109.

nomena of our lives as their content. *The world is all the things that are fit for thought.* Or, to quote Wittgenstein once more, "The world is everything that is the case."[16] And, *what is the case is what we can think.*

What Bart Calls Thinking

Bart Simpson helps to clarify what anti-psychologistic, personified thinking is. Bart is, in all that he thinks and does, face-to-face with things. He stands outside of science, but squarely in front of whatever engages him, present to it as it is present to him. For Bart, nothing is merely in his head. There is no psychological, personal intermediary between him and the world. For Bart, everything is personified. Everything is in the clearing.

When Bart gets something right, he does not take that to be a matter of having something intermediary (between him and the world) correspond with the world. No, he takes that to be a matter of having taken the world in hand or in mind.

That he does so puts Bart firmly among things, a being among beings. Bart's thinking is determined by what there is to think about. That it is so determined makes Bart's thinking peculiarly responsive to what there is, to what presents itself to him. This, I think, is the source of many of Bart's singular existential powers: his mighty resourcefulness, his preternatural knack to court and avoid danger and trouble, his oracular gift for predicting the path of events. (I do not claim Bart always uses his powers for good!) Unlike the rest of us, the rest of Springfield, who are saddled with the personal, who take ourselves to be screened from the world by intermediaries—by ideas buzzing in our heads—Bart is undistracted by buzzings, he is without screens, he is unsaddled.

Bart's thinking is intrinsically directed to the world. Bart is not stymied by philosophical puzzlers like "How does thought hook onto the world?" A quick glance at Bart in action shows that Bart would reject that question, if he were asked it, with a blank stare. Bart takes the world to be in his thoughts, he takes his thoughts to be world-involving. Since he does, there's no

[16] Ludwig Wittgenstein, *Tractatus Logico-Philosophicus* (Mineola, New York: Dover, 1999), p. 1.

philosophical hooking of thought to world needed. It is Bart's lived rejection of this question that makes him appropriate to begin and end this paper. To his Heideggerian thinking I attribute Barts' powers to amuse, to bemuse, to be a Muse.

Now, can I prove that Bart is a Heideggerian thinker? No—at least not as proving is normally understood. The best I can do is what I have done: elucidate Heideggerian thinking and then lay the elucidation alongside Bart, hoping that an internal relationship (a relationship such that standing in it is essential to each relatum) between the two shows itself. (Think of this procedure as roughly comparable to the following: I make clear to you what ducks are, provide pictures of them, then present you with Jastrow's Duck-Rabbit. If all has gone well, an internal relationship between the duck pictures and the Duck-Rabbit should show itself.) No example I might provide from *The Simpsons* will clinch my claim—any example of that sort I might provide would be imponderable evidence at best. The relationship between what Heidegger calls thinking and what Bart calls thinking is something that I can help someone to see—and I have tried to do so. But the relationship is wrongly conceived if it is taken to be something that could fall out, consequentially, from a syllogism.

Episode Titles

Title	Airdate

SEASON ONE 1989–1990

1. "Simpsons Roasting on an Open Fire" (7G08) December 17, 1989
2. "Bart the Genius" (7G02) January 14, 1990
3. "Homer's Odyssey" (7G03) January 21, 1990
4. "There's No Disgrace Like Home" (7G04) January 28, 1990
5. "Bart the General" (7G05) February 4, 1990
6. "Moaning Lisa" (7G06) February 11, 1990
7. "Call of the Simpsons" (7G09) February 18, 1990
8. "The Telltale Head" (7G07) February 25, 1990
9. "Life on the Fast Lane" (7G11) March 18, 1990
10. "Homer's Night Out" (7G10) March 25, 1990
11. "The Crepes of Wrath" (7G13) April 15, 1990
12. "Krusty Gets Busted" (7G12) April 29, 1990
13. "Some Enchanted Evening" (7G01) May 13, 1990

SEASON TWO 1990–1991

14. "Bart Gets an F" (7F03) October 11, 1990
15. "Simpson and Delilah" (7F02) October 18, 1990
16. "Treehouse of Horror" (7F04) October 25, 1990
17. "Two Cars in Every Garage and Three Eyes
 on Every Fish" (7F01) November 1,1990
18. "Dancin' Homer" (7F05) November 8, 1990
19. "Dead Putting Society" (7F08) November 15, 1990
20. "Bart vs. Thanksgiving" (7F07) November 22, 1990
21. "Bart the Daredevil" (7F06) December 6, 1990
22. "Itchy & Scratchy & Marge" (7F09) December 20, 1990
23. "Bart Gets Hit By A Car" (7F10) January 10, 1991
24. "One Fish, Two Fish, Blowfish, Blue Fish" (7F11) January 24, 1991
25. "The Way We Was" (7F12) January 31, 1991
26. "Homer vs. Lisa and the 8th Commandment" (7F13) February 7, 1991
27. "Principal Charming" (7F15) February 14, 1991
28. "Oh Brother, Where Art Thou?" (7F16) February 21, 1991
29. "Bart's Dog Gets an F" (7F14) March 7, 1991
30. "Old Money" (7F17) March 28, 1991
31. "Brush with Greatness" (7F18) April 11, 1991
32. "Lisa's Substitute" (7F19) April 25, 1991

33. "The War of the Simpsons" (7F20) May 2, 1991
34. "Three Men and a Comic Book" (7F21) May 9, 1991
35. "Blood Feud" (7F22) July 11, 1991

SEASON THREE 1991–1992

36. "Stark Raving Dad" (7F24) September 19, 1991
37. "Mr. Lisa Goes to Washington" (8F01) September 26, 1991
38. "When Flanders Failed" (7F23) October 3, 1991
39. "Bart the Murderer" (8F03) October 10, 1991
40. "Homer Defined" (8F04) October 17, 1991
41. "Like Father Like Clown" (8F05) October 24, 1991
42. "Treehouse of Horror II" (8F02) October 31, 1991
43. "Lisa's Pony" (8F06) November 7, 1991
44. "Saturdays of Thunder" (8F07) November 14, 1991
45. "Flaming Moe's" (8F08) November 21, 1991
46. "Burns Verkaufen Der Kraftwerk" (8F09) December 5, 1991
47. "I Married Marge" (8F10) December 26, 1991
48. "Radio Bart" (8F11) January 9, 1992
49. "Lisa the Greek" (8F12) January 23, 1992
50. "Homer Alone" (8F14) February 6, 1992
51. "Bart the Lover" (8F16) February 13, 1992
52. "Homer at the Bat" (8F13) February 20, 1992
53. "Separate Vocations" (8F15) February 27, 1992
54. "Dog of Death" (8F17) March 12, 1992
55. "Colonel Homer" (8F19) March 26, 1992
56. "Black Widower" (8F20) April 8, 1992
57. "The Otto Show" (8F21) April 23, 1992
58. "Bart's Friend Falls in Love" (8F22) May 7, 1992
59. "Brother, Can You Spare Two Dimes?" (8F23) August 27, 1992

SEASON FOUR 1992–1993

60. "Kamp Krusty" (8F24) September 24, 1992
61. "A Streetcar Named Marge" (9F18) October 1, 1992
62. "Homer the Heretic" (9F01) October 8, 1992
63. "Lisa the Beauty Queen" (9F02) October 15, 1992
64. "Treehouse of Horror III" (9F04) October 29, 1992
65. "Itchy & Scratchy: The Movie" (9F03) November 3, 1992
66. "Marge Gets a Job" (9F05) November 5, 1992
67. "The New Kid on the Block" (9F06) November 12, 1992
68. "Mr. Plow" (9F07) November 19, 1992
69. "Lisa's First Word" (9F08) December 3, 1992
70. "Homer's Triple Bypass" (9F09) December 17, 1992
71. "Marge vs. the Monorail" (9F10) January 14, 1993
72. "Selma's Choice" (9F11) January 21, 1993
73. "Brother From the Same Planet" (9F12) February 4, 1993
74. "I Love Lisa" (9F13) February 11, 1993

75. "Duffless" (9F14) February 18, 1993
76. "Last Exit to Springfield" (9F15) March 11, 1993
77. "So It's Come to This: A Simpsons Clip Show" (9F17) April 1, 1993
78. "The Front" (9F16) April 15, 1993
79. "Whacking Day" (9F18) April 29, 1993
80. "Marge in Chains" (9F20) May 6, 1993
81. "Krusty Gets Kancelled" (9F19) May 13, 1993

SEASON FIVE 1993–1994

82. "Homer's Barbershop Quartet" (9F21) September 30, 1993
83. "Cape Feare" (9F22) October 7, 1993
84. "Homer Goes to College" (1F02) October 14, 1993
85. "Rosebud" (1F01) October 21, 1993
86. "Treehouse of Horror IV" (1F04) October 28, 1993
87. "Marge on the Lam" (1F03) November 4, 1993
88. "Bart's Inner Child" (1F05) November 11, 1993
89. "Boy-Scoutz 'n the Hood" (1F06) November 18, 1993
90. "The Last Temptation of Homer" (1F07) December 9, 1993
91. "$pringfield (Or, How I Learned to Stop
 Worrying and Love Legalized Gambling)" (1F08) December 16, 1993
92. "Homer the Vigilante" (1F09) January 6, 1994
93. "Bart Gets Famous" (1F11) February 3, 1994
94. "Homer and Apu" (1F10) February 10, 1994
95. "Lisa vs. Malibu Stacy" (1F12) February 17, 1994
96. "Deep Space Homer" (1F13) February 24, 1994
97. "Homer Loves Flanders" (1F14) March 17, 1994
98. "Bart Gets an Elephant" (1F15) March 31, 1994
99. "Burns' Heir" (1F16) April 14, 1994
100. "Sweet Seymour Skinner's Baadasssss Song" (1F18) April 28, 1994
101. "The Boy Who Knew Too Much" (1F19) May 5, 1994
102. "Lady Bouvier's Lover" (1F21) May 12, 1994
103. "Secrets of A Successful Marriage" (1F20) May 19, 1994

SEASON SIX 1994–1995

104. "Bart of Darkness" (1F22) September 4, 1994
105. "Lisa's Rival" (1F17) September 11, 1994
106. "Another Simpsons Clip Show" (2F33) September 25, 1994
107. "Itchy & Scratchy Land" (2F01) October 2, 1994
108. "Sideshow Bob Roberts" (2F02) October 9, 1994
109. "Treehouse of Horror V" (2F03) October 30, 1994
110. "Bart's Girlfriend" (2F04) November 6, 1994
111. "Lisa on Ice" (2F05) November 13, 1994
112. "Homer Bad Man" (2F06) November 27, 1994
113. "Grandpa vs. Sexual Inadequacy" (2F07) December 4, 1994
114. "Fear of Flying" (2F08) December 18, 1994
115. "Homer the Great" (2F09) January 8, 1995

116. "And Maggie Makes Three" (2F10)	January 22, 1995
117. "Bart's Comet" (2F11)	February 5, 1995
118. "Homie the Clown" (2F12)	February 12, 1995
119. "Bart vs. Australia" (2F13)	February 19, 1995
120. "Homer vs. Patty and Selma" (2F14)	February 26, 1995
121. "A Star is Burns" (2F31)	March 5, 1995
122. "Lisa's Wedding" (2F15)	March 19, 1995
123. "Two Dozen and One Greyhounds" (2F18)	April 9, 1995
124. "The PTA Disbands" (2F19)	April 16, 1995
125. "'Round Springfield" (2F32)	April 30, 1995
126. "The Springfield Connection" (2F21)	May 7, 1995
127. "Lemon of Troy" (2F22)	May 14, 1995
128. "Who Shot Mr. Burns? (Part One)" (2F16)	May 21, 1995

SEASON SEVEN 1995–1996

129. "Who Shot Mr. Burns? (Part Two)" (2F20)	September 17, 1995
130. "Radioactive Man" (2F17)	September 24, 1995
131. "Home Sweet Homediddly-Dum-Doodily" (3F01)	October 1, 1995
132. "Bart Sells His Soul" (3F02)	October 8, 1995
133. "Lisa the Vegetarian" (3F03)	October 15, 1995
134. "Treehouse of Horror VI" (3F04)	October 29, 1995
135. "King-Size Homer" (3F05)	November 5, 1995
136. "Mother Simpson" (3F06)	November 19, 1995
137. "Sideshow Bob's Last Gleaming" (3F08)	November 26, 1995
138. "The Simpsons 138th Episode Spectacular" (3F31)	December 3, 1995
139. "Marge Be Not Proud" (3F07)	December 17, 1995
140. "Team Homer" (3F10)	January 7, 1996
141. "Two Bad Neighbors" (3F09)	January 14, 1996
142. "Scenes From the Class Struggle in Springfield" (3F11)	February 4, 1996
143. "Bart the Fink" (3F12)	February 11, 1996
144. "Lisa the Iconoclast" (3F13)	February 18, 1996
145. "Homer The Smithers" (3F14)	February 25, 1996
146. "The Day the Violence Died" (3F16)	March 17, 1996
147. "A Fish Called Selma" (3F15)	March 24, 1996
148. "Bart on the Road" (3F17)	March 31, 1996
149. "22 Short Films About Springfield" (3F18)	April 14, 1996
150. "Raging Abe Simpson and His Grumbling Grandson in 'The Curse of the Flying Hellfish'" (3F19)	April 28, 1996
151. "Much Apu About Nothing" (3F20)	May 5, 1996
152. "Homerpalooza" (3F21)	May 19, 1996
153. "Summer of 4 ft. 2" (3F22)	May 19, 1996

SEASON EIGHT 1996–1997

154. "Treehouse of Horror VII" (4F02)	October 27, 1996
155. "You Only Move Twice" (3F23)	November 3, 1996

156. "The Homer They Fall" (4F03) November 10, 1996
157. "Burns, Baby Burns" (4F05) November 17, 1996
158. "Bart After Dark" (4F06) November 24, 1996
159. "A Milhouse Divided" (4F04) December 1, 1996
160. "Lisa's Date With Density" (4F01) December 15, 1996
161. "Hurricane Neddy" (4F07) December 29, 1996
162. "El Viaje Misterioso de Nuestro Jomer (The
 Mysterious Voyage of Homer)"(3F24) January 5, 1997
163. "The Springfield Files" (3G01) January 12, 1997
164. "The Twisted World of Marge Simpson" (4F08) January 19, 1997
165. "Mountain of Madness" (4F10) February 2, 1997
166. "Simpsoncalifragilisticexpiala (Annoyed Grunt)
 cious" (3G03) February 7, 1997
167. "The Itchy & Scratchy & Poochie Show" (4F12) February 9, 1997
168. "Homer's Phobia" (4F11) February 16, 1997
169. "Brother From Another Series"(4F14) February 23, 1997
170. "My Sister, My Sitter" (4F13) March 2, 1997
171. "Homer vs. the Eighteenth Amendment" (4F15) March 16, 1997
172. "Grade School Confidential" (4F09) April 6, 1997
173. "The Canine Mutiny" (4F16) April 13, 1997
174. "The Old Man and The Lisa" (4F17) April 20, 1997
175. "In Marge We Trust" (4F18) April 27, 1997
176. "Homer's Enemy" (4F19) May 4, 1997
177. "The Simpsons Spin-Off Showcase" (4F20) May 11, 1997
178. "The Secret War of Lisa Simpson" (4F21) May 18, 1997

SEASON NINE 1997–1998

179. "The City of New York vs. Homer Simpson"
 (4F22) September 21, 1997
180. "The Principal and the Pauper" (4F23) September 28, 1997
181. "Lisa's Sax" (3G02) October 19, 1997
182. "Treehouse of Horror VIII" (5F02) October 26, 1997
183. "The Cartridge Family" (5F01) November 2, 1997
184. "Bart Star" (5F03) November 9, 1997
185. "The Two Mrs. Nahasapeemapetilons" (5F04) November 16, 1997
186. "Lisa the Skeptic" (5F05) November 23, 1997
187. "Realty Bites" (5F06) December 7, 1997
188. "Miracle on Evergreen Terrace" (5F07) December 21, 1997
189. "All Singing, All Dancing" (5F24) January 4, 1998
190. "Bart Carny" (5F08) January 11, 1998
191. "The Joy of Sect" (5F23) February 8, 1998
192. "Das Bus" (5F11) February 15, 1998
193. "The Last Temptation of Krust" (5F10) February 22, 1998
194. "Dumbbell Indemnity" (5F12) March 1, 1998
195. "Lisa, the Simpson" (4F24) March 8, 1998
196. "This Little Wiggy" (5F13) March 22, 1998
197. "Simpson Tide" (3G04) March 29, 1998

198. "The Trouble With Trillions" (5F14)	April 5, 1998
199. "Girly Edition" (5F15)	April 19, 1998
200. "Trash of the Titans" (5F09)	April 26, 1998
201. "King of the Hill" (5F16)	May 3, 1998
202. "Lost Our Lisa" (5F17)	May 10, 1998
203. "Natural Born Kissers" (5F17)	May 17, 1998

SEASON TEN 1998–1999

204. "Lard of the Dance" (5F20)	August 23, 1998
205. "The Wizard of Evergreen Terrace" (5F21)	September 20, 1998
206. "Bart, the Mother" (5F22)	September 27, 1998
207. "Treehouse of Horror IX" (AABF01)	October 25, 1998
208. "When You Dish Upon a Star" (5F19)	November 8, 1998
209. "D'Oh-in' in the Wind" (AABF02)	November 15, 1998
210. "Lisa Gets an 'A'" (AABF03)	November 22, 1998
211. "Homer Simpson in: 'Kidney Trouble'" (AABF04)	December 6, 1998
212. "Mayored to the Mob" (AABF05)	December 20, 1998
213. "Viva Ned Flanders" (AABF06)	January 10, 1999
214. "Wild Barts Can't Be Broken" (AABF07)	January 17, 1999
215. "Sunday, Cruddy Sunday" (AABF08)	January 31, 1999
216. "Homer to the Max" (AABF09)	February 7, 1999
217. "I'm With Cupid" (AABF11)	February 14, 1999
218. "Marge Simpson in: 'Screaming Yellow Honkers'" (AABF10)	February 21, 1999
219. "Make Room for Lisa" (AABF12)	February 28, 1999
220. "Maximum Homerdrive" (AABF13)	March 28, 1999
221. "Simpsons Bible Stories" (AABF14)	April 4, 1999
222. "Mom and Pop Art" (AABF15)	April 11, 1999
223. "The Old Man and the 'C' Student" (AABF16)	April 25, 1999
224. "Monty Can't Buy Me Love" (AABF17)	May 2, 1999
225. "They Saved Lisa's Brain" (AABF18)	May 9, 1999
226. "30 Minutes Over Tokyo" (AABF20)	May 16, 1999

SEASON ELEVEN 1999–2000

227. "Beyond Blunderdome" (AABF23)	September 26, 1999
228. "Brother's Little Helper" (AABF22)	October 3, 1999
229. "Guess Who's Coming to Criticize Dinner" (AABF21)	October 24, 1999
230. "Treehouse of Horror X" (BABF01)	October 31, 1999
231. "E-I-E-I-(Annoyed Grunt)" (AABF19)	November 7, 1999
232. "Hello Gutter, Hello Fadder" (BABF02)	November 14, 1999
233. "Eight Misbehavin'" (BABF03)	November 21, 1999
234. "Take My Wife, Sleaze" (BABF05)	November 28, 1999
235. "Grift of the Magi" (BABF07)	December 19, 1999
236. "Little Big Mom" (BABF04)	January 9, 2000
237. "Faith Off" (BABF06)	January 16, 2000
238. "The Mansion Family" (BABF08)	January 23, 2000

239. "Saddlesore Galactica" (BABF09) February 6, 2000
240. "Alone Again Natura-Diddily" (BABF10) February 13, 2000
241. "Missionary Impossible" (BABF11) February 20, 2000
242. "Pygmoelian" (BABF12) February 27, 2000
243. "Bart to the Future" (BABF13) March 19, 2000
244. "Days of Wine and D'oh'ses" (BABF14) April 9, 2000
245. "Kill the Alligator and Run" (BABF16) April 30, 2000
246. "Last Tap Dance in Springfield" (BABF15) May 7, 2000
247. "It's A Mad, Mad, Mad, Mad Marge" (BABF18) May 14, 2000
248. "Behind the Laughter" (BABF19) May 21, 2000

SEASON TWELVE 2000–2001*

249. "Treehouse of Horror XI" (BABF21) November 1, 2000
250. "A Tale of Two Springfields" (BABF20) November 5, 2000
251. "Insane Clown Poppy" (BABF17) November 12, 2000
252. "Lisa the Tree Hugger" (CABF01) November 19, 2000
253. "Homer vs. Dignity" (CABF04) November 26, 2000
254. "The Computer Wore Menace Shoes" (CABF02) December 3, 2000
255. "The Great Money Caper" (CABF03) December 10, 2000
256. "Skinner's Sense of Snow" (CABF06) December 17, 2000
257. "НОМЯ" (BABF22) January 7, 2001
258. "Pokey Mom" (CABF05) January 14, 2001
259. "Worst Episode Ever" (CABF08) February 4, 2001
260. "Tennis the Menace" (CABF07) February 11, 2001
261. "Day of the Jackanapes" (CABF10) February 18, 2001
262. "New Kids on the Blecch" (CABF12) February 25, 2001
263. "Hungry Hungry Homer" (CABF09) March 4, 2001
264. "Bye Bye Nerdie" (CABF11) March 11, 2001
265. "Simpson Safari" (CABF13) April 1, 2001

*This was the most up to date information at the time this book went to press. For additional episode information see *The Simpsons Archive* http: www.snpp. com/.

Based on Ideas By

Thales (ca. 624–546 B.C.E.)
"All things are full of gods and have a share of soul."

Anaximander (ca.611–546 B.C.E.)
"From what source things arise, to that they return of necessity when they are destroyed; for they suffer punishment and make reparation to one another for their injustice according to the order of time."

Lao Tzu (born ca. 604 B.C.E.)
"He who knows does not speak. He who speaks does not know. Close the mouth."

Anaximenes (ca.585–528 B.C.E.)
"Air is the principle of existing things; for from it all things come-to-be and into it they are again dissolved."

Buddha (560–480 B.C.E.)
"All humanity is sick. I come therefore to you as a physician who has diagnosed this universal disease and is prepared to cure it."

Confucius (ca.551–479 B.C.E.)
"Great man is always at ease; petty man is always on edge."

Heraclitus (died ca. 510–480 B.C.E.)
"You cannot step twice into the same river, for other waters and yet others go ever flowing on."

Parmenides (515–445 B.C.E.)
"For never shall this be proved, that things that are not are."

Socrates (470–399 B.C.E.)
"Wealth does not bring about excellence, but excellence brings about wealth and all other public and private blessings for men."

Plato (428/7–348/7 B.C.E.)
"Until philosophers rule as kings or those who are now called kings and leading men genuinely and adequately philosophize, that is, until political power and philosophy entirely coincide, while the many

natures who at present pursue either one exclusively are forcibly prevented from doing so, cities will have no rest from evils . . . nor, I think, will the human race."

Aristotle (384–322 B.C.E.)
"That which is proper to each thing is by nature best and most pleasant for each thing; for man, therefore, the life according to reason is best and most pleasant, since reason more than anything else *is* man. This life therefore is also the happiest."

Epicurus (341–270 B.C.E)
"We recognize pleasure as the first and natural good; starting from pleasure we accept or reject; and we return to this as we judge every good thing, trusting this feeling of pleasure as our guide."

Epictetus (50–130)
"It is not the things themselves that disturb men, but their judgments about these things."

Marcus Aurelius (121–180)
"Everything that happens is as normal and as expected as the spring rose or the summer fruit; this is true of sickness, death, slander, intrigue, and all other things that delight or trouble foolish men."

Augustine (354–430)
"Even that which is called evil, when it is regulated and out in its own place, only enhances our admiration of the good."

Anselm (1033–1109)
"You exist so truly, Lord my God, that You cannot even be thought not to exist."

Thomas Aquinas (1225–1274)
"Among all others, the rational creature is subject to divine providence in a more excellent way, in so far as it itself partakes of a share of providence, by being provident both for itself and for others. Therefore it has a share of the eternal reason, whereby it has a natural inclination to its proper act and end; and this participation of the eternal law in the rational creature is called the natural law."

Francis Bacon (1561–1626)
"And not only must we look for and acquire a great number of experiments, and ones of a different kind from those used hitherto, but also a quite different method, order, and procedure must be introduced for the continuation and furtherance of experience."

Thomas Hobbes (1588–1679)

"[In the state of nature] the life of man [is] solitary, poor, nasty, brutish, and short."

René Descartes (1596–1650)

"And let [the evil genius] do his best at deception, he will never bring it about that I am nothing so long as I shall think that I am something. Thus, after everything has been most carefully weighed, it must finally be established that this pronouncement 'I am, I exist' is necessarily true every time I utter it or conceive it in my mind."

Baruch Spinoza (1632–1677)

"Nothing in nature is contingent, but all things are from the necessity of the divine nature determined to exist and to act in a definite way."

John Locke (1632–1704)

"The natural liberty of man is to be free from any superior power on earth, and not to be under the will or legislative authority of man, but only have the law of nature for his rule."

Gottfried Leibniz (1646–1716)

"The soul follows its own laws, and the body likewise follows its own laws; and they agree with each other in virtue of the pre-established harmony between all substances, since they are all representations of one and the same universe."

George Berkeley (1685–1753)

"To be is to be perceived."

David Hume (1711–1776)

"Reason is, and ought only to be the slave of the passions, and can never pretend to any other office than to serve and obey them."

Immanuel Kant (1724–1804)

"But though all our knowledge begins with experience, it does not follow that it all arises from experience."

G.W.F. Hegel (1770–1831)

"To help bring philosophy closer to the form of Science, to the goal where it can lay aside the title 'love of knowing' and be *actual* knowing—that is what I have set myself to do."

Arthur Schopenhauer (1788–1860)

"'The world is my representation': this is a truth valid with reference to

every living and knowing being, although man alone can bring it into reflective, abstract consciousness. If he really does so, philosophical discernment has dawned on him."

John Stuart Mill (1806–1873)

"It is better to be a human being dissatisfied than a pig satisfied; better to be Socrates dissatisfied than a fool satisfied."

Søren Kierkegaard (1813–1855)

"Had I to carve an inscription on my grave I would ask for non other than 'that individual'."

Karl Marx (1818–1883)

"As individuals express their life, so they are. What they are, therefore, coincides with their production, both with *what* they produce and with *how* they produce. The nature of individuals thus depends on the material conditions determining their production."

Charles Sanders Peirce (1839–1914)

"Few persons care to study logic, because everybody conceives himself to be proficient enough in the art of reasoning already. But I observe that this satisfaction is limited to one's own ratiocination, and does not extend to that of other men."

William James (1842–1910)

"My first act of freedom will be to believe in free will."

Friedrich Nietzsche (1844–1900)

"*From life's school of war:* What doesn't kill me makes me stronger."

Gottlob Frege (1848–1925)

"It is certainly praiseworthy to try to make clear to oneself as far as possible the sense one associates with a word. But here we must not forget that not everything can be defined."

Edmund Husserl (1859–1938)

"To the things themselves."

Henri Bergson (1859–1941)

"The eye sees only what the mind is prepared to comprehend."

John Dewey (1859–1952)

"The sense of an extensive and underlying whole is the context of every experience and it is the essence of sanity."

Alfred North Whitehead (1861–1947)

"Thus nature is a structure of evolving process. The reality is the process."

Bertrand Russell (1872–1970)

"Scepticism, while logically impeccable, is psychologically impossible, and there is an element of frivolous insincerity in any philosophy which pretends to accept it."

G.E. Moore (1873–1958)

"If I am asked 'What is good?' my answer is good is good, and that is the end of the matter."

Ludwig Wittgenstein (1889–1951)

"What is your aim in philosophy?—To show the fly the way out of the fly-bottle."

Martin Heidegger (1889–1976)

"Dasein is an entity which does not just occur among other entities. Rather it is ontically distinguished by the fact that, in its very Being, that Being is an issue for it."

Gilbert Ryle (1900–1976)

"Learning *how* or improving in ability is not like learning *that* or acquiring information."

Karl Popper (1902–1995)

"I propose to replace the question of the sources of knowledge by the entirely different question: 'How can we hope to detect and eliminate error?'"

Jean-Paul Sartre (1905–1980)

"Man is nothing else but that which he makes of himself. That is the first principle of existentialism."

Simone de Beauvoir (1908–1986)

"A woman is not born . . . she is created."

W.V.O. Quine (1908–2000)

"What the indeterminacy of translation shows is that the notion of propositions as sentence meanings is untenable. What the empirical underdetermination of global science shows is that there are various defensible ways of conceiving the world."

Albert Camus (1913–1960)
"There is but one truly serious philosophical problem, and that is sui-cide. Judging whether life is or is not worth living amounts to answer-ing the fundamental question of philosophy."

Featuring the Voices of

DAVID L.G. ARNOLD is an Assistant Professor of English at the University of Wisconsin, Stevens Point. Besides *The Simpsons* and popular culture, his research interests include the laments of William Faulkner and the social protest novels of Chester Himes. David believes he knows how Maude Flanders REALLY died.

DANIEL BARWICK is Assistant Professor of Philosophy at Alfred State College. He is the author of *Intentional Implications* and numerous articles. Barwick lectures widely on ethics, metaphysics, and assessment of general education. He enjoys Spanish peanuts (without skin), taking candy from babies (it's a larf), and wallowing in his own crapulence.

ERIC BRONSON is an instructor of Philosophy and World Civilizations at Berkeley College in New York City. He is also a Visiting Professor at Altai State University in Barnaul, Russia. Mmmmmm . . . kolbassa.

PAUL A. CANTOR is Professor of English at the University of Virginia, and has served on the National Council on the Humanities. He has published several books and numerous articles on such subjects as Shakespeare, Romantic literature, and literary theory. A collection of his essays on popular culture will be published under the title *Gilligan Unbound* (Rowman and Littlefield, 2001). His work on *The Simpsons* has been praised and quoted in the *National Enquirer*. And he has just landed the coveted Danny DeVito role in Fox Searchlight's remake of *Twins*, starring Rainier Wolfcastle.

MARK T. CONARD is a fiction writer, philosopher, and Steppenwolf dwelling in Philadelphia. His publications on Kant and Nietzsche have appeared in *Philosophy Today* and *The Southern Journal of Philosophy*. His article, "Symbolism, Meaning, and Nihilism in Quentin Tarantino's *Pulp Fiction*" was published in *Philosophy Now*. Mark doesn't believe in anything any more and has decided to go to law school.

GERALD J. ERION teaches philosophy at Medaille College in Buffalo, New York. He has published on philosophy of mind and ethics, but he never wins at Bible Bombardment.

RAJA HALWANI is assistant professor of philosophy in the liberal arts department at the School of the Art Institute of Chicago. His philosophical interests are in ethics, philosophy of art, and philosophy of sex and love. He has published a number of articles in professional journals and is currently writing a book on virtue ethics. However, Raja's greatest achievement was to have discovered a meal between breakfast and brunch.

JASON HOLT is Sessional Instructor at the University of Manitoba. He is the author of *Blindsight and the Nature of Consciousness* (forthcoming) and publishes on a variety of philosophical topics. None of his work bears the Krusty Brand Seal of Approval.

WILLIAM IRWIN is Assistant Professor of Philosophy at King's College, Pennsylvania. He has published scholarly articles on theory of interpretation and aesthetics, is the author of *Intentionalist Interpretation: A Philosophical Explanation and Defense* (1999), and the co-author of *Critical Thinking* (forthcoming, 2001). He is the editor of *Seinfeld and Philosophy: A Book about Everything and Nothing* and *The Death and Resurrection of the Author?* (forthcoming). Bill would like to thank David Crosby for keeping him out of Moe's Tavern and off the Duff.

KELLY DEAN JOLLEY is an Associate Professor of Philosophy at Auburn University. Among his recent publications is "Philosophical Investigations and a Philosophical Education" in *The Modern Schoolman*. Kelly owns the world's largest Malibu Stacy collection.

DEBORAH KNIGHT is Associate Professor of Philosophy and Queen's National Scholar at Queen's University, Kingston, Canada. She has published numerous articles on topics such as aesthetics, philosophy of film, philosophy of literature, and philosophy of mind, and always takes Bart's advice on the ponies.

JAMES LAWLER is an Associate Professor in the Philosophy Department at the State University of New York at Buffalo. He is the author of *The Existentialist Marxism of Jean-Paul Sartre*, and *IQ, Heritability, and Racism*, as well as articles on Kant, Hegel, and Marx. He is editor of: *Dialectics of the U.S. Constitution: Selected Writings of Mitchell Franklin*, to be published this year by MEP Press, Minnesota. Jim spends his spare time collecting early Bleeding Gums Murphy recordings, and is especially interested in information on Bleeding Gums's infamous Paris period.

J.R. LOMBARDO is a member of the faculty of the City University of New York, and provides counseling and psychotherapy in private practice. His is the winner of the regional title "Best New Poet" for his "Tripping through the Celestial Woods," and works in the area of mental illness and values. J.R.'s favorite Backstreet Boy is "the little rat-faced one."

CARL MATHESON is Professor of Philosophy and Head of the Department of Philosophy at the University of Manitoba. He has published in the philosophy of art, the history and philosophy of science, and metaphysics. With David Davies, he is currently editing an anthology in the philosophy of literature for Broadview press. Budget permitting, he hopes to hold students in place by means of giant magnets.

JENNIFER LYNN MCMAHON is Assistant Professor of Philosophy at Centre College. She has published on Sartre, Eastern philosophy, and aesthetics. While she hasn't had to take a second job to support her horse habit yet, with eight horses on her farm, Jennifer illustrates what can happen when fathers buy their daughters ponies.

AEON J. SKOBLE is Visiting Assistant Professor of Philosophy at the United States Military Academy at West Point. He is the co-editor of the anthology *Political Philosophy: Essential Selections* (Prentice-Hall, 1999) and author of the forthcoming *Freedom, Authority, and Social Order*. He writes on moral, political, and social theory for both scholarly and lay journals, and is Editor of the annual journal *Reason Papers*. He is also a contributing editor of *Corey Magazine*.

DALE SNOW is an Associate Professor of Philosophy at Loyola College in Maryland. She is the author of *Schelling and the End of Idealism* and has published numerous scholarly translations from the German. She agrees with Marge that all you college men are only interested in one thing.

JAMES SNOW is an eighth-grade math teacher in the Baltimore County Public School System. In addition, he is a member of the Graduate Faculty of Education at Loyola College in Maryland, and day trades on the stock market. He has published on the novels of Thomas Hardy, as well as the philosophy of Arthur Schopenhauer; his most recent article appears (in Dutch) in the journal *Philosophie*. His mantra comes directly from the lips of Homer Simpson: "My coffee break is whenever I say it is!"

DAVID VESSEY is Assistant Professor of Philosophy and Religion at Beloit College. His research focuses on contemporary European philosophy and he has published articles on Sartre, Foucault, and Ricoeur. Like Ned he drives a Geo, and although he doesn't have a Ph.D. in Mixology, he thinks he may have enough credits.

JAMES M. WALLACE is Associate Professor and Chair of English at King's College, Pennsylvania. He has published on American literature, is the author of *Parallel Lives: A Novel Way to Learn Thinking and Writing*, and is the co-author of *Critical Thinking* (forthcoming, 2001). Jim Fully expects to get pelted with tomatoes.

JOSEPH ZECCARDI's current research interests include Sartre and existentialist literature. You may remember Joe as the star journalist for such leading publications as *Montgomery* "I Can't Believe It's a Newspaper" *Life*. As a starving philosopher, he is the author of hundreds of newspaper articles, none of which have any relevance to this book. The important thing is, he does exist.

Index

aesthetics, 61, 82, 84, 96
akrasia, 19
Apu, 11, 12, 14, 92, 97–98, 129, 134,
 137, 155, 167, 190, 196, 236,
 237–38
Aristotle, 7–10, 12, 17, 19, 20, 27,
 46–54, 56, 57, 150, 184, 185, 196,
 225
art, 22, 56, 61–63, 67–68, 85, 87, 89,
 91, 93, 102–03, 107, 115, 117,
 121, 124, 142, 157, 197, 217,
 237–38, 241, 248, 254
authority, 26–27, 30, 60, 73–75,
 117–120, 154, 165–66, 252, 261,
 262
autonomy, 33, 173, 210, 212–14
Ayn Rand School for Tots, 85, 179
Barney, 12, 27, 47, 48, 129, 199
Barthes, Roland, 253, 255–59,
 263–65, 268–69
Bouvier, Patty. *See* Patty
Bouvier, Selma. *See* Selma
Brockman, Kent, 56, 74, 133, 174,
 176, 244
Burns, C. Montgomery, 2, 14, 15,
 18, 35, 40, 43, 47, 49, 50, 53, 57,
 60, 64, 73, 86, 114, 119, 127, 133,
 140–41, 161, 173–74, 181, 183,
 184, 187, 192–202, 242, 246,
 250–51
Carl, 12, 107, 108, 191, 246
Christianity, 57–58, 66, 69, 150, 184,
 203
Comic Book Guy, The 32, 34, 87,
 176, 177, 249
Confucius, 41
Corey, 31, 32
deontology, 47
Derrida, Jacques, 116–17, 119
Descartes, René, 60, 271

eudaimonia, 51–53
expertise, 24–31, 169
feminism, 138, 152
fiction, 65, 66, 93, 96, 136, 147,
 216–18, 221–28, 232–33, 260
Flanders, Maude, 50, 114, 129,
 149–50, 203–208
Flanders, Ned, 12, 15, 18, 20, 40, 46,
 48, 54, 56, 57, 74, 75, 87, 111,
 148, 148–150, 153–154, 168–172,
 184, 203–08, 214–15
Flaubert, Gustave, 38–40, 101
flourishing, 12, 21–22, 51
freedom, 113, 212, 244
Frege, Gottlob, 271, 272, 275–78,
 280
Frink, Prof., 32, 34, 176
Grimes, Frank, 11, 86, 114, 120,
 246
Groening, Matt, 2, 81, 84, 92, 128,
 162, 166, 175, 204, 216, 249
Gumble, Barney. *See* Barney
happiness, 2, 21, 51–52, 57, 153,
 154, 156, 157, 159, 192–94, 198,
 201–02
Heidegger, Martin, 43–44, 229,
 270–281, 283
Hibbert, Dr. Julius, 32, 176, 243
Hirsch, E.D., 87, 88, 91
Hitchcock, Alfred, 86, 89, 93, 102,
 103, 104, 111
honesty, 11, 48, 51, 52, 57, 153
irony, 1, 82, 84, 102, 103, 106–07,
 120–22
Itchy and Scratchy, 31, 56, 123, 128,
 133, 141, 174, 242, 249, 260, 261,
 262, 266–68
Kant, Immanuel, 60, 147, 152–54,
 157, 178, 210–14, 237
Kantian ideas, 47, 147, 210, 212

Krusty the Klown, 49, 54, 123, 129, 133, 136, 141, 174, 188, 242, 244–45

Lenny, 8, 12, 114, 246

literature, 3, 87, 90–91, 112, 127, 179, 217–222, 239–240

Lovejoy, Reverend, 46, 55–56, 74, 114, 140, 149, 150, 169, 170, 171, 181

Malibu Stacy, 31, 32, 128, 136

Marxism, 242, 245

Marxist ideas, 119, 236, 241–44, 248–252

McClure, Troy, 27, 128, 133

Mensa, 17, 32, 136, 138–39, 176–77, 178

Moe, 54, 56, 127, 133, 148, 150, 167, 177, 196, 199

Muntz, Nelson. *See* Nelson

Nahasapeemapetilon, Apu. *See* Apu

Nehamas, Alexander, 68

Nelson, 8, 65, 70, 73

Nietzsche, Friedrich, 2, 43, 59, 60–73, 75–77, 178

Nussbaum, Martha, 217–222, 224

Oprah, 36, 248

Parmenides, 280–281

parody, 2, 83, 88, 89, 93, 98, 100–03, 105–06, 107, 109, 110, 111, 124, 139, 140–41, 246, 249

Patty, 11, 16, 17, 52, 74, 129, 130

phenomenology, 278

Plato, 28, 37, 56–57, 66, 69, 167, 176, 217, 222

psychology, 38, 273, 275, 277, 281

Quimby, Mayor Joe 12, 14, 17, 33, 46, 54, 82, 139, 161, 173–174, 176, 179, 181–82

Rand, Ayn, 85

Riviera, Dr. Nick, 31

Rorty, Richard, 116–17, 119

Sartre, Jean–Paul, 38–40

satire, 2, 30, 33, 77, 82, 140, 160–161, 165, 172, 175, 177, 229, 239–240, 242, 245, 247, 248, 250, 251–52, 261, 263, 269

Saussure, Ferdinand de, 256

Schopenhauer, Arthur, 43, 61, 66, 271, 272–73, 276, 279

science, 28, 30, 31, 54, 116, 117, 147, 272–74, 277, 281–82

Selma, 11, 16, 17, 52, 64, 74, 129, 130

signifier, 255–56, 258, 262, 264, 267–69

Simpson, Bart, 2, 8, 12, 13, 14–15, 17, 20, 31, 39, 40, 41, 42, 46, 48, 50, 52, 54, 55, 57, 59–77, 83, 87, 89, 94–100, 103–07, 112, 114, 120–21, 126, 128, 129, 130, 134, 135, 136, 137, 138, 139, 141, 142, 143, 147, 148, 150, 151, 156–57, 158, 161, 162, 165, 166, 167, 168, 169, 170, 174, 179, 184, 190, 201, 203, 205, 217, 223, 229, 242, 244, 250, 260, 261, 262, 263, 266, 267, 268, 269, 270–283

Simpson, Homer, 2, 7, 10–23, 26, 30, 31, 33, 34, 37, 38, 39, 40, 46, 47, 48, 49, 50, 51, 52, 53, 55, 57, 64, 66, 75, 81, 82, 83, 84, 85, 86, 87, 88, 90, 92, 94, 95, 96, 97, 98, 106, 111, 114, 118, 119, 120, 121, 126, 130, 131, 133, 134, 135, 137, 139, 141, 142, 143, 148, 149, 150, 154, 155, 156, 158, 160, 161, 162, 166–171, 173, 177, 178, 182, 184, 187, 191, 193, 196, 199, 215, 216, 217, 222, 228–231, 233, 236, 237, 238, 239, 242, 245, 246, 247–48, 261–62, 263

Simpson, Lisa, 2, 7, 8, 12, 13, 14, 15, 16, 17, 19, 24–34, 40, 41, 42, 44, 49, 50, 52, 53, 54, 55, 60, 64, 66, 74, 75, 81, 82, 83, 85, 86, 87, 88, 92, 96, 113, 114, 118, 121, 126, 128, 129, 130, 134–35, 136, 137, 138, 139, 141, 142–43, 147, 148, 151, 154–55, 156–59, 162, 166, 167, 168, 169–170, 176, 178, 181–84, 189, 190–91, 193, 197, 203, 205, 210, 217, 229, 231, 241, 242, 244, 245, 246, 247–48, 260, 261–62, 266, 267

Simpson, Maggie, 13, 15, 35–37,
 39–40, 42–45, 52, 55, 64, 66, 74,
 83, 85, 111–12, 148, 159, 162,
 168–170, 203, 217, 229
Simpson, Marge, 11, 12, 13, 14,
 15, 16, 18, 19, 20, 39, 41,
 46–58, 64, 66, 83, 84, 85, 88,
 89, 92, 97, 106, 111, 113, 114,
 118, 119, 126, 129, 130–37,
 139–143, 148, 149, 151–54,
 158–59, 161, 162, 166–170, 172,
 173, 174, 182, 184, 189, 191, 217,
 222, 229, 230, 242–45, 247, 262,
 264
Skinner, Principal, 43, 74, 85, 94–95,
 105–06, 127, 168, 173, 176–77,
 182
Smithers, Waylon, 15, 35, 127, 129,
 195–97, 201
Socrates, 36–37, 60, 63–64, 271
Springfield, 46, 54, 64, 126–130,

 170–71, 172–78, 241–42
Springfield, Jebediah, 15, 31, 59,
 112, 121, 152, 154, 191
Szyslak, Moe. See Moe
television, 1–3, 53, 81, 86–87, 90,
 91, 93, 94, 96, 97, 100, 108, 109,
 110, 122, 126, 127, 128, 130, 131,
 132, 133, 135, 138, 139, 160–65,
 170–75, 216, 218, 240, 241, 242,
 248, 249, 250, 253–54, 259, 260,
 264, 266–67
utilitarianism, 47
vegetarian, 60, 137, 155, 166
vegetarianism, 31, 142, 155
virtue, 9–10, 12–13, 16, 18, 20, 22,
 46, 47–49, 51, 53, 57, 71–72, 114,
 200, 258
Wiggum, Police Chief, 43, 64, 173,
 179, 180, 182, 185–89, 196
Wittgenstein, Ludwig, 37, 43,
 281–82